Aesthetics and the Incarnation in Early Medieval Britain

Aesthetics

and the

Incarnation

in

Early Medieval Britain

Materiality and the Flesh of the Word

TIFFANY BEECHY

University of Notre Dame
Notre Dame, Indiana

University of Notre Dame Press
Notre Dame, Indiana 46556
undpress.nd.edu

Copyright © 2023 by the University of Notre Dame Press

All Rights Reserved

Published in the United States of America

Library of Congress Control Number: 2023930256

ISBN: 978-0-268-20515-7 (Hardback)
ISBN: 978-0-268-20517-1 (WebPDF)
ISBN: 978-0-268-20514-0 (Epub)

for

R I V E R

aglæcwif, ælfscinu

CONTENTS

FIGURES

NOTE ON
SPECIAL CHARACTERS

æ in Old English words, the vowel in Modern English *cat*

þ/ð in Old English words, used interchangeably for the sound of Modern English "th" as in *think* and *thy*

⁊ "and" in both Latin (*et*) and Old English (*and/ond*)

PREFACE

The mystery of the Incarnation has sparked the interest of writers since the time of Christ. Some of them ... have elected to think through their puzzlement over the "how" of the Incarnation in poetical or rhetorical forms rather than, for example, theological or philosophical treatises.
 —Cristina Maria Cervone, *Poetics of the Incarnation*

And the Word was made flesh and dwelt among us
 —John 1:14

This book is, at heart, about form in Insular art and literature, but it is also, inevitably, about theology. This is of course due in part to the absence of a distinctly secular realm of common life in the Middle Ages, meaning that most serious endeavors involved religion in some degree. It is also due to the demographics governing the means of production: much of what survives of early medieval art is in manuscripts and, to a lesser degree, stone sculpture, and both were the domains of the church.[1] And yet the inescapable presence of the church can lead to misunderstanding of its influence over individual artifacts and their meaning, for certain features of Insular art are difficult to account for if we assume that all art was controlled by patristic (orthodox) doctrine. While the objects and texts I treat are about the central themes of Christianity, these are often construed in surprising ways, ways that were sometimes explicitly condemned by contemporary authorities. Such waywardness, I contend, deserves to be approached with great interest rather than with discomfort or scorn.

Medieval Christianity inherited several pre-Christian intellectual and aesthetic traditions with diverse premises about the status of the felt world, or the sensible, and its relationship to a transcendent plane of abstractions—if the latter were imagined at all. A central question of metaphysical inquiry, both explicit and not, that attempted to sort out these differences was how and whether God could be perceived. It is a conundrum that informed in some way all religious representation (which was, in some way, all representation) and fueled centuries of controversy. Yet one thing was clear: the divine had come into the world of sense perception on at least one occasion, the Incarnation, when God had deigned to become a man. This was in many ways a hot potato, as the authorities recognized—where do you draw a line, contain divinity, once it has been brought into the world, lest it start popping up under every stock and stone (as it did among the pagans)? The problem would eventually be solved by circumscribing the Incarnation within Christ's human form, officially restricting it to the physical body plus its trace in the increasingly prescribed rite of the Eucharist.[2] Later medieval commentators would therefore emphasize the Incarnation as an act of humility—God lowering himself into a body for the purpose of suffering—and the need for all Christians to emulate that humility, if not that suffering. In early medieval Britain, however, amid diverse attitudes informed by distinct intellectual, cultural, linguistic, and religious traditions, an expansive rather than a restrictive interpretation of the "Word that was made flesh" prevailed, according to which the Word might in fact be sensed in the world in surprising ways. Understanding how form, as a manifestation of the sensible (not "form" in the Aristotelian or Platonic senses), embodies and construes theological precept is crucial to understanding the products of this tradition.

The particular character of Insular Incarnationalism has been obscured by several factors, notably the tendency of the study of Insular Christianity to bifurcate into Celtic studies, on the one hand, and "Anglo-Saxon" studies on the other (more on this term in the next chapter). The scholarship on the latter then tends to be overwhelmed by the copious evidence from Carolingian Francia, which provides tantalizing but also potentially misleading material, for the Carolingians had empire on their minds and continuity with Rome foremost in their rhetoric. The trends toward circumscription of the body of Christ and a regulated and uniform observance of the mass

were Carolingian projects, ones that had English contributors (notably Alcuin of York) and acolytes (Ælfric of Eynsham), but whose influence only trickled into England, widening with the Benedictine reform in the tenth century and again with the Conquest, with its influx of Continental power both sacred and secular. Insular artworks, however, often make it clear that they did not get the imperial memo. They embody the flesh of the Word in ways that show unconcern with their evident materialism and that emphasize Christ's divinity and its effect on his and our humanity as well as the ontological mystery of the hypostatic union. As Johanna Kramer has recently demonstrated the early English church to have had a characteristic way of conceiving of the Ascension (as *limen* and transit), this book will attempt to show that it had a similarly characteristic reception of the Incarnation.

Importantly, these tendencies did not simply choke off and die out after the Conquest. Like the literary technique of alliterative verse, either through going underground in the textual record or through a more absolute resurrection, the tendencies I highlight in the early period have late-medieval manifestations, as a string of recent books has documented.[3] The present book, therefore, ultimately suggests a *longue durée* for what Cristina Maria Cervone has named the "poetics of the Incarnation" and Curtis Gruenler has more recently termed the "poetics of enigma" in the English tradition. I will begin by laying some historical groundwork, documenting the particular circumstances in early Britain that conditioned its reception of the Word.

ACKNOWLEDGMENTS

The University of Colorado has provided consistent research support, including but not limited to a sabbatical semester and a fellowship from the Center for Humanities and the Arts. Many thanks to Lori Garner for reading a full draft of the manuscript at an early stage. Many heroic virtues apply to Lori—mildest, wisest, most generous of colleagues. Thank you. Rachael Deagman Simonetta, my colleague at the University of Colorado Boulder, read an early draft of chapter 1. Thanks as well to Charlie Wright, Jack Niles, and Chick Chickering for feedback at various points, and to Carole Newlands for some help with Latin translation. I would like to thank my former doctoral advisee, Tarren Andrews, who taught me so much and whose collegiality, sarcasm, and sharpness lent perspective in some dark times. Yo lémlmtš. Thanks to Sue Zemka, another colleague in the English department at Colorado, for generous feedback at a crucial time. Thanks for provocative discussion and camaraderie to the many participants in the Medieval Writing Workshop between 2014 and 2017, including Elizabeth Allen, Courtney Barajas, Dan Birkholz, Brantley Bryant, Lisa Cooper, Jonathan Davis-Secord, Mary Agnes Edsall, Jackie Fay, Denis Ferhatović, Matt Hussey, Sharon Kinoshita, Stacy Klein, Scott Kleinman, William Kuskin, Katie Little, Heather Maring, Britt Mize, Alex Mueller, George Shuffelton, Emily Thornbury, Elaine Treharne, and Jordan Zweck. If I have left anyone out of this list, I apologize sincerely. I thank Elaine Treharne, in particular, for leadership in addition to collegiality. She, too, possesses the heroic virtues. Thank you to Hilary Fox, Jay Gates, Susan Irvine, Karmen Lenz, Rosalind Love, the irrepressible Adrian Papahagi, and the also irrepressible Sharon Rowley for companionship and collaboration in that far-off time and

place of Cluj, Romania, 2019—for me the last trip abroad before the pandemic. It was such a pleasure to share time and thought with you.

I wish to thank the digitizers, who, like medieval writers, are often unrecognized. Thank you for making sustained manuscript work more accessible than ever before. I realize that some will balk at digital manuscript work being called "manuscript work." Nevertheless, what digitization has achieved has revolutionary potential, and I am deeply grateful for the time I have been able to spend, over years, with the products of these many hands, particularly at the Parker Library on the Web and at the British Library's digital repository. I am thankful as well for the research library at the University of Colorado Boulder, Norlin Library, for its ongoing stewardship of knowledge old and new, and for the competence and swiftness of its interlibrary loan and document delivery service department. May the librarians, faculty, and administrators of the libraries remain mindful of the sacredness of their trust.

I heartily thank Stephen Little, formerly acquisitions editor at the University of Notre Dame Press, for shepherding this project in its early stages and through peer review. Thanks to Eli Bortz, editor-in-chief, and the production team at the press for seeing the book through to publication. Many thanks to the press's anonymous reviewers for their critical, supportive feedback. Warm thanks to Kellie M. Hultgren for her attention to the manuscript. Her curiosity, resourcefulness, and patience are humbling and most appreciated. All the flaws that remain in this book I acknowledge as my own. Readers, like mothers, can only do so much. Finally, I thank my family, James and River, for support and love and balance.

Introduction

The common Insular styles then arose from the contacts and conflicts of peoples all of whom were experiencing some process of change.

—Rosemary Cramp,
"The Insular Tradition: An Overview"

In 664, Bede tells us, the Northumbrian monastery of Whitby held a council over two fairly technical questions of observance, the proper way to calculate Easter and the proper way for monks to wear their hair. The king himself, Oswiu, presided. The arguments went back and forth, and eventually it came down to the authority of St. Columba versus that of St. Peter, Ireland versus Rome. As Wilfrid summed it up for the Roman side, "Even if that Columba of yours— yes, ours, too, if he belonged to Christ—was a holy man of mighty works, is he to be preferred to the most blessed chief of the apostles, to whom the Lord said, 'thou art Peter and upon this rock I shall build my Church and the gates of hell shall not prevail against it, and I will give unto thee the keys of the kingdom of heaven'?" (*Ecclesiastical History* 3.25, p. 307).[1] When you put it that way, of course, only one authority will prevail, and the king found for the Roman practice

1

and saw his trusted Irish bishop, Colman, depart for his homeland "after the Irish had held the episcopate in the English kingdom for thirty years" (3.26, p. 309).[2] Yet despite Bede's emphatic belief in Roman authority on such matters as those decided at Whitby, he cannot quite disparage the Irish. Rather in the manner of Tacitus praising the rustic Germani in rebuke of Roman decadence, he commends Irish monks for their poverty and their learning, against, one infers, the excesses of the growing alliances between English chieftains and the Roman Church.[3] The Irish tradition both haunts and animates Christian culture in England throughout the pre-Conquest period, officially out of favor, yet indelible.

More than a century after the synod at Whitby, Alcuin of York (ca. 735–804), educated under the reformed, Roman-aligned dispensation, was a key figure in the court of Charlemagne. In a letter thought to be addressed to Hygbald, the bishop of Lindisfarne (an Irish foundation), he condemns the use of the harp for traditional, secular storytelling in the monastery. He famously asks, "Quid Hinieldus cum Christo?"—What does the Germanic hero Ingeld have to do with Christ? (183; trans. 124). Alcuin's interest as imperial reformer put him in a position to deplore what was clearly a cultural accommodation in the monastery, one which brought the conviviality of the hall in the form of oral storytelling into the fellowship of the refectory. In point of fact, the Irish had indeed found a way for "Ingeld" (or Cú Chulainn, or Cailte or Oisín) to have something to do with Christ, since the lore of early Irish Christianity includes mythic stories imagining revered pre-Christian figures passing knowledge forward into Christian learning, receiving Christian blessing in the process.[4] Lindisfarne was a site of Irish-English mixing, where the marginalized Irish still had influence over English practice and where vernacular traditions in both languages persisted.

Two centuries later, Ælfric of Eynsham (ca. 955–ca. 1010) explained that he had translated what would become his *Catholic Homilies* from authoritative Latin books into English because "I have seen and heard great error in many English books, which lewd [i.e., unlearned] men have innocently taken for great learning" ("Ic geseah 7 gehyrde mycel gedwyld on manegum engliscum bocum. ðe ungelærede menn ðurh heora bilewitnysse to micclum wisdome tealdon"; 174; trans. mine). He goes on to say that only someone who knows Latin or, at the least, the translations of King Alfred (r. 871–899) can have written proper

gospel teaching. Clearly, he implies, whoever wrote those *many* offensive English books did not have such learning (though somehow they had enough learning to know how to write). As has been emphasized of late, Ælfric was writing against the tide, a contrarian authority in a culture whose norms were otherwise.[5] Vernacular learning flourished even through the Benedictine reform, which has recently been suggested as the proper context for the vernacular poetry of the Exeter Book.[6]

Bede's story of the eclipsing of Irish influence over the English church; Alcuin's disapproval of secular entertainments in the monastery; Ælfric's contempt for vernacular lore. These well-known testaments to controversy and the struggle to impose authority, spanning what has been called the "Anglo-Saxon period," display both the accommodation and the contention that characterized the Christian church in Britain. One of the premises of this book is that it is important to foreground this multiplicity and dialogism, which is true not only of the ecclesiastical history of the period but also of the period more broadly.[7] It will be necessary here to be explicit about the commonplaces of the field that these statements contradict. I will attempt to clear some ground. As recent controversies have amply rehearsed, the idea of a unitary "Anglo-Saxon England" descends to us through many layers of fabulist historiography, beginning with Bede's *Ecclesiastical History* itself.[8] It was the goal of influential writers to establish the kernel of Englishness in the minds of their countrymen and, one imagines, ourselves, given the love with which we have tended it.[9]

Englishness served early Christian writers such as Bede who were interested in distinguishing English observance from Celtic heterodoxy. Alfred the Great, as well as various Christian clerics (such as Ælfric), had further reason for propagating Englishness in the face of the Viking threat. This idea—of a threatened but coherent people— would further coalesce in response to French conquest, exploited by both conquered and conquerors alike.[10] The Normans, for example, promoted Englishness as they sought to normalize conquest and consolidate power behind the idea of continuity of rule.[11] The post-Conquest period further gave rise to the cult of Alfred the Great as the mythic unifier of the kingdom, useful to Norman rulers as propaganda and to English subjects as an emblem of nostalgia, patriotism, and resistance. Centuries later, during the Reformation, English Protestants of course looked back to the Anglo-Saxon church to find

a pre-Catholic, "authentic" English observance, and American nation-builders likewise looked to the Anglo-Saxons for jurispruden-tial precedent (and proof of racialized claim to superiority).[12] The nineteenth-century imperialists and twentieth-century nationalists alike favored the conceit of a founding race of Englishmen—rational, stoic, and fit to rule—and, as Donna Beth Ellard and others have pointed out, our supposedly postcolonial, postmodern moment must understand its ties to these logics rather than asserting some kind of absolute break with our past. This is particularly true for early medi-evalists because our very discipline was formed under imperialist, na-tionalist, and white supremacist regimes that continue, as Ellard notes, to haunt the field.[13] One cannot erase this accreted historiography or the density of its lensing (if we imagine the past as a thing we might see or examine).

But I can point out that "Anglo-Saxon England" was neither a place nor a people nor a time.[14] It is a mythic construct, an idea, formed from many strands by many hands, over centuries.[15] It is a concept contradicted by the archaeological record (see Fleming); by the evident cosmopolitanism of every center of learning we know of, from Canterbury to Iona to the royal court of Wessex in Alfred's reign; by linguistic history (see McWhorter); by the existence of the Welsh and "Scots" (including the Irish) and eventually Danes side by side and intermingled with the various types of "English" throughout the period.[16]

Rather than complying with the rhetoric of medieval and modern writers whose motivations I do not share, I suggest that early medi-eval Britain comprised not burgeoning nation-states but rather what Mary Louise Pratt has termed "contact zones": "social spaces where cultures meet, clash, and grapple with each other, often in contexts of highly asymmetrical relations of power, such as colonialism, slavery, or their aftermaths as they are lived out in many parts of the world today" (34).[17] Early medieval Britain is not traditionally brought within postcolonial and political critical discourses, but, as I have already suggested, it is not only recent events inside and outside aca-demia that have made such convergences necessary.[18] The period has been heterogeneous, full of cultural contact, blending, and conflict of multiple kinds, all characterized by asymmetries of power, all along. Bede himself seems to anticipate Pratt's definition of the contact zone, of plurality with asymmetry, in his account of the peoples of Britain

in the *Historia ecclesiastica* (his history of the English church, completed in 731). He announces that there are five languages in use in Britain, with Latin a common and dominant force among them as the language of the church:

> At the present time, there are five languages in Britain, just as the divine law is written in five books, all devoted to seeking out and setting forth one and the same kind of wisdom, namely the knowledge of sublime truth and of true sublimity. These are the English, British [i.e., Welsh], Irish, Pictish, as well as the Latin languages; through the study of the scriptures, Latin is in general use among them all. (*Ecclesiastical History* 1.1, p. 17)
>
> ———
>
> [Haec in praesenti iuxta numerum librorum quibus lex diuina scripta est, quinque gentium linguis unam eandemque summae veritatis et uerae sublimitatis scientiam scrutatur et confitetur, Anglorum uidelicet Brettonum Scottorum Pictorum et Latinorum, quae meditatione scripturarum ceteris omnibus est facta communis.] (16)

It is particularly striking that Bede aligns the plurality of the five languages in Britain with the authority of the Pentateuch, since by doing so, rather than asserting a single, uniform orthodoxy, he leaves room for difference, for multiplicity. Bede's account of the triumph of Roman observance over Celtic practices is in many ways the main theme of his history, but it is nevertheless rife with jostling for both legitimacy and power. At the font, as it were, of "Anglo-Saxonist" mythologizing, we find plurality, with great effort to bring, out of the many, one.

DEFINING THE ZONE

Since the concept of "Anglo-Saxon England" is pernicious, outdated, and inaccurate all at once, I will henceforth try to avoid the misleading identifier *Anglo-Saxon*, opting instead for *Insular*, commonly used in art history, to encompass the mixed influences of Irish, British, English, Latin, Norse, and other cultures and traditions that coexisted on the island.[19] It allows me to avoid a monolithic caricature of what was certainly a variegated period, as my epigraph above

emphasizes. Cramp's characterization stresses plurality (*styles*, not *style*), diversity in the contact among peoples rather than the homogeneity of ethnonationalist visions, and lived time—the experience of change—contrary to monolithic stasis.[20] *Insular* also has the benefit of avoiding ethnic connotations whose toxicity and capacity to intoxicate remain potent in the modern world, as evidenced by recent resurgences of popular Anglo-Saxonism.[21]

It remains challenging to treat the complex situation of early medieval Britain evenly because the evidence, particularly the written evidence, tells such a one-sided story. As I have said, authoritative English writers were invested in the orthodoxy of their institutions, especially as distinguished from their Celtic neighbors. Accordingly, these writers often predicate their work upon a disavowed "Other." Bede wishes to affirm the alignment of his church with Roman orthodoxy against the venerable but provincial and marginal traditions of the Irish, even while the real magnitude (and, to some, the threat) of Irish influence cannot be fully ascertained from a triumphalist account such as his. One has to see the influence in manuscript styles, in texts with clear Irish affinities, still copied into the eleventh century. One has to remember the intimate proximity of Irish (including Scottish) people among the English-speaking Northumbrians, against the absence of the distant Roman authorities and the other communities of the "universal" church scattered across Europe, Africa, and Asia.[22] Eventually, the disavowed other would take the form of an enemy within, as reformist zeal led to the disparaging of endemic traditions, particularly in the areas of monastic observance and vernacular preaching, as evinced by Alcuin's and Ælfric's admonishments.

All three authorities I quoted at the beginning require a similar caution as well as the ability to perceive positive as well as negative space, the avowed and its background. Alcuin's disapproval of the monastic entertainments at Lindisfarne confirms that there was something to disapprove of, that the practice of singing secular songs with a harp was common enough to deplore, and Ælfric devotes great scholarly and creative energy to countering an ample corpus of vernacular writing *on Christian topics* that lies outside the bounds of both authoritative Latinity and the state-sanctioned and regulated accommodation of Alfred's translation project. There were clearly aspects of culture, including learned ecclesiastical culture, that were unacceptable to au-

thority and receive emphatic but cursory mention in authoritative sources. There are also, of course, nonauthoritative sources. These often choose, as Cristina Maria Cervone credits in later medieval vernacular writing, to embody rather than expound, to bear implicit rather than explicit significance. They comprise some of the most interesting artifacts of early Insular culture, which have been difficult to explain from a rationalist, mimetic, or expository point of view, or from within the harmonizing impulses of orthodoxy. Evidently, lying behind these artifacts and the high-profile condemnations I have rehearsed is a vast cultural field that was not unaffected by but certainly exceeded the dictates of authority: "As recent histories have shown with new clarity, throughout the early Middle Ages groups at [subelite] levels, especially when living at some distance from the principal cathedrals, monasteries, and courts—in the households of rural nobility away from the centers of elite power and wealth, on the lands they controlled, in small towns and peasant settlements—developed their understanding of Christianity to a large extent independently of the prevailing ideologies in elite circles."[23] It will be my contention that in Britain, even in certain "elite" centers, there were local understandings of Christianity, and that these animate to a large extent the artistic products of these locales.

What I hope I have established in a preliminary way is that Christianity was not unitary or uniform in Britain between 600 and 1100, despite the desires of key figures such as Bede (who remains conflicted), Ælfric, and Alcuin. The reasons are several, involving the disparate strains informing early Christian culture on the island. The Irish and British (i.e., Welsh) of course converted long before the English, who did not begin their piecemeal conversion process (chieftain by chieftain, with backsliding) until Gregory the Great sent a mission, in two stages, around the year 600.[24] Once the conversion began, Irish monks were the English converts' principal instructors until Rome prevailed at Whitby and sent reinforcements from the Mediterranean to establish a new center at Canterbury.[25] The great churchman Aldhelm (ca. 639–709) somewhat embodies the transfer from Irish to Roman power and influence, though he is not usually seen in this way. He is most commonly acknowledged as founder of a difficult style of ostentatious Anglo-Latinity that extends well into the Benedictine reform of the tenth and eleventh centuries, and for his great expansion

and adaptation of the riddles of the late antique poet Symphosius. Scholars have sought to distance Aldhelm and his Latinity from the Irish tradition for decades. Nevertheless, Aldhelm was trained by Irish teachers all his youth and early adulthood before coming to study at the newly founded Canterbury school, and he is given (by William of Malmesbury, ca. 1095–ca. 1143) the fable of having stood *on a bridge* singing secular songs to entice the people into church (5.190, p. 507).[26] He alone thus demarcates several contact zones at once: between the Irish and the English, between Irish and Roman Christianity, between secular verse and scriptural teaching, between orality and writing, between vernacularity and Latinity, and perhaps even between paganism and Christianity.

Aldhelm's Latin corpus is undoubtedly the mere tip of an iceberg, taking both William's reported legend and the fact of oral tradition into account. The extant corpus is what is visible to us, what was valued and legible under the regimes that held sway in his age and immediately after. It is revealing of modern scholarly preferences that work has steadily discouraged the consideration of Aldhelm's style alongside the production of Celtic writers of the same period.[27] Because Aldhelm's style is distinct from that of the "Hisperic" writers, he is therefore set entirely apart from Celtic Latinity. A more historicized, less polemic view, I would suggest, is that Aldhelm, upon coming under the influence of the Canterbury school (which had been founded five years after the Synod of Whitby had decided against the Irish in favor of Rome), found reason to temper his style. Aldhelm was a master synthesizer, and an adaptation of Hisperic Latinity to the more sober style of the Roman milieu would be entirely reasonable as well as consistent with what we know he was able to do in the other direction, in his transformation of Symphosius's "trifles" into something more profound and poetically interesting.[28] My point is this: although simple stories of the smooth adoption of orthodoxy by the English can be and have been told, the reality was not simple, for two principal reasons. First, it would be entirely unrealistic to imagine scores of communities casting off decades of interaction, interrelation, intellectual and spiritual indebtedness, and embodied praxis, in unison and without hesitation. Second, textual and material artifacts demonstrate quite the contrary; they evince hybridity, syncretism, complexity.

IRISH CONTACT AND INSULAR GRAMMATICALISM

Despite the long tradition in "Anglo-Saxon" scholarship of disparaging the products of Irish learning, recent Irish scholarship has contributed much to our understanding of the traditions that lie behind them.[29] Charles D. Wright and John Carey, along with Patrick Sims-Williams and Joseph Nagy, have drawn the lines of connection between the learned traditions that predate Christianity in Ireland and the Celtic church, focusing especially on the value of poetic mastery and experimentation among the Druids as a mode of cultivating esoteric knowledge and on the relation between this "mantic obscurantism" and some of the notorious tendencies of Irish verbosity.[30] In one permutation of *immacallam*, the genre of dialogue or "mutual conversing," for example, two poets compete to out-poeticize each other, the more obscure the locution, the better (the "sager").[31] Wright has shown the way this tradition incorporated Christian dialogues from the Mediterranean sphere, the *ioca monachorum* or "monks' jokes," which originated as light entertainment.[32] What may begin as a "trifle" such as Symphosius's riddles (*nugae* in Latin) may gain gravitas in another context, and that is exactly what took place, as Wright documents for the *ioca* making their way into learned Irish compendia.[33] Verbal esotericism persisted even as it was put to the service of Christian doctrine. It had a tendency, furthermore, to act as a filter, receiving diverse textual traditions in its own idiom. Further still, Vivien Law has shown how the numinous potential of words was connected by writers such as Virgilius Maro Grammaticus to the central figure of the Christian cosmology, the Word or Wisdom of God, Christ himself, who "became flesh" in the Incarnation.[34] Thus, in the Irish tradition, a poetic skill of dazzling with words as a means to achieve both social status and esoteric knowledge survived into the Christian era and fused with the wider Christian grammatical tradition, which had itself developed out of the literary culture of classical antiquity.[35] As a result, Irish writers contribute to the Insular tradition a tendency to see the Word as an uncannily virtuosic poetic speech act.

Patristic writers, of course, foremost among them St. Augustine, had also theorized the relation of the enigmatic Word to the words of human language, and, as Leslie Lockett has explained, medievalists

have long attributed a thoroughgoing knowledge of Augustine across the medieval period. Augustine's theology of language, though, contrasts significantly with Insular praxis. As Marcia Colish explains, for Augustine, the Incarnation

> solved the problem of [God's] own ineffability. Once joined to God in Christ, human nature is restored in mind and body, and man's faculty of speech is empowered to carry on the work of Incarnation in expressing the Word to the world. For Augustine, redeemed speech becomes a mirror through which men may know God in this life by faith. And Christian eloquence becomes, both literally and figuratively, a vessel of the Spirit, bearing the Word to mankind, incorporating men into the new covenant of Christ and preparing them through its mediation for the face-to-face knowledge of God in the beatific vision. (26)

For Augustine, the Incarnation's restoration of human nature enables human language to carry forward the Word of salvation. This preaching function brings human beings into the body of Christ on earth, the church, whose unity and authority was of paramount importance. Redeemed language, for Augustine, has an apostolic, pastoral function. It prepares the listener for a future, truer vision of God in the time to come.

Accordingly, language bears the Word, but it connects us only indirectly to the God we will one day see "face to face." Language is (only) a "mirror" through which to know God "by faith." And it is only, ultimately, by faith (which St. Paul defined as belief in what we cannot see; Heb. 11:1) that we allow the agency of grace to enlighten us. At the heart of Augustine's Incarnational linguistics there remains an ontological gap, the absolute distinction he took from the Platonists between the corporeal world of human life and the eternal, incorporeal realm of God. This is why Colish characterizes redeemed speech as a "mirror," for Augustine's epistemology was rooted in the Pauline "per speculum in aenigmate" (1 Cor. 13), through which we see God in our present life only "in a mirror, enigmatically." As Augustine most fully explains in *De Trinitate*, his speculative work on the nature of the Trinity and its likenesses in the human soul, there is a veil between the incorporeal and created worlds, one which cannot truly be lifted, even by the action of the impress of divinity—the

image—that resides within rational beings. Thus, the sensible realm is connected to God only by metaphorical relations—by the ratios (number, weight, measure) evident in creation, by *ratio* in man—and never by direct perception, which will only happen in eternity when we see God "face to face":

> But when the sight comes that is promised us face to face, we shall see this trinity that is not only incorporeal but also supremely insepa-rable and truly unchangeable much more clearly and definitely than we now see its image which we ourselves are. However, those who do see through this mirror and in this puzzle, as much as it is granted to see in this life, are not those who merely observe in their own minds what we have discussed and suggested, but those who see it precisely *as an image*, so that they can in some fashion *refer what they see to that of which it is an image*, and also see that other *by inference* through its image which they see by observation, since they cannot see it face to face. (*De Trinitate* 15.23.44, p. 522; Hill 429, emphasis mine)[36]

As Augustine, paradoxically, makes extremely clear in its unclarity, the perception of the divine as he understands it is always indirect in this life. We are divine insofar as we bear the image of the divine, not in our substance (elsewhere in book 15 he likens the "image" to an "impress"—a discernible trace in substance rather than a sharing of matter), and it is through perceiving this image "as an image" that we are able to follow its deixis "in some fashion" to its referent, which re-sults not in direct perception, as with a directed gaze, but in an "infer-ence." There is a lot of obliqueness here, and for Augustine it is essen-tial. The image we perceive is a mediating tool, a metaphoric vehicle. The ultimate goal is the referent of the Logos, the Word behind all signification, Derrida's bête noir the "transcendental signified," which we may never perceive in our current state except "by inference," through analogy.[37]

Thus, Augustine and other patristic shapers of Christian doctrine on how the intelligible divine relates to sensible corporeality as de-fined in the Platonist tradition emphasize a telos in which sensible language is at best a vehicle: like the Word in some way, but not the thing itself. Although the Scriptures come to us sensibly in the form of the letter, and though Christ himself did the same (the incorporeal Word becoming flesh), divine wisdom exists upon a different plane.

For an extreme case, Origen (ca. 185–ca. 253), for example, considers that it is not through sense perception at all that we come to knowledge of the divine, but through an inner perception, which may be sparked or set in motion by something the senses perceive, yet still must take place only in parallel or by analogy with the sensory: "Things that are intelligible must be sought not by corporeal perception but by some other one which [Solomon] calls 'divine'" (*On First Principles* 216). Origen's strict separation between the realms of divine and human would prove too extreme for later orthodoxy. For Augustine, we may approach the divine via *ratio*, or inner intellection, according to which we are created in the image of God. Yet, *ratio* is only an image, an impress or form, allowing us to grasp at divinity only by analogy (*De Trinitate* 15). Since for these thinkers the categorical distinction between the incorporeality of the divine substance and the sensible, created world is absolute and of doctrinal necessity, a leap must always be made from the processes of normal cognition, which are carnal, to the enlightenment of spiritual insight. Hearing a beautiful hymn or even ruminating upon scripture, according to this orthodoxy, imparts indirect, rather than direct, knowledge of the divine. The image of God may almost—asymptotically, it would seem—approach the divine, but it cannot truly grasp it while the spirit remains in the flesh. Such glimpses are glimpses alone, however much they partake, mysteriously, metaphorically, and spiritually, of divinity. It then goes without saying that the articulation of such spiritual insight is always an imperfect rendering of what is by nature ineffable. As Erich Auerbach explained in his lesser-known medieval work (less well-known than his masterpiece, *Mimesis*), Augustine arrived at an ideal Christian rhetoric that reflected his thinking about the imperfection of all articulated speech (however redeemed it was) in relation to the divine, ultimate Logos: *sermo humilis*, the humble style, the plain preaching that could serve as common denominator and guard against the pride of which he accused himself as a professional rhetorician.[38] Augustinian *sermo humilis* is the diametric opposite of the Irish "Hisperic" style.[39] While both traditions regard the enigmatic nature of the Logos, they are distinguished one from the other by the presence or absence of a Platonist insistence on transcendence, on an ontological aporia dividing human speech from the divine. For Augustine, plain speaking is best to allow faith and grace to enlighten inwardly. For a striking portion of Insular writers, highly wrought

poetic language bears the capacity to partake of or participate in the nature of the hypostatic union in the Incarnation, that is, in the divine, articulate enigma, the Word made flesh.[40]

As Lockett has painstakingly and perspicaciously explained, non-Mediterranean converts to Christianity had their own inherited epistemologies, and the most basic assumption of the Germanic converts in northern and western Europe seems to have been that what is real is that which we can see and experience—that is, the sensible.[41] Philosophic Platonism is a learned habit of mind, not a default, and Lockett seeks to overturn what she calls the "medievalist bias," which often assumes that because Augustine was a prolific authority, his full intellectual apparatus simply suffused all Christian thought as oxygen saturates the atmosphere. Much recent work on Britain and Francia, early and late, shows that Augustinian transcendentalism (a Platonist focus on the ultimate Signified of the godhead) was not the primary or exclusive epistemology in the Middle Ages.[42] Carolingian controversies over the nature of the Eucharist, for example, illustrate the discursive efforts undertaken to combat an intransigent materialist worldview in Frankish territories. The Carolingian state focused its attention on the Eucharistic rite as a way to regulate devotion as well as the perception of God's presence.[43] Frankish theologians increasingly consolidated power in the ritual words spoken by the priest. In this way, devotees were dependent upon authority in order to experience the divine presence (by seeing and then ingesting it). However, in newly converted territories like Saxony, even monks had some difficulty believing that Christ's "presence" in the Eucharist was real.[44] As Lockett explains, these resistances were due to a basic materialist epistemology, according to which only the sensible is "real"; the monks had difficulty believing that something totally indetectable was, in fact, there.[45] Both Paschasius Radbertus (writing 831–833) and Ratramnus of Corbie (writing ca. 850) wrote treatises on the Eucharist that in disparate ways address this one underlying sticking point.[46] The Eucharistic controversies and the iconoclastic controversies over representation in the form of religious art led to the doctrinal definitions that would inform the Scholastic debates of the High Middle Ages, "real presence" and "transubstantiation" among them.

It is telling, however, that the Eucharist is not much of a focus in Britain in the pre-Conquest period, with one important exception: the campaign of Ælfric of Eynsham against his people's native

materialism.[47] Lockett's important finding regarding the thoroughgoing materialist ontology among the English helps corroborate what Barbara Raw concludes about the difference between English and elite Carolingian attitudes toward representation more broadly. Where in Francia there was controversy and polemic, in Britain there seems to have been blithe iconophilia. Indeed, Lockett's manuscript survey explains why this should be so. Contrary to certain commonplaces in the scholarship (the "medievalist bias"), the English were not thoroughly steeped in the writings of Augustine, nor did any ruler or ruling dynasty have extensive or lasting enough dominion before the Conquest to impose the imperial project of the Carolingians, Alfred's reign and the Benedictine reform movement notwithstanding. Only the best libraries, of Bede, Alfred's court, and probably Ælfric, had access to full versions of Augustine's works, while the majority of English writers made due throughout the period with excerpts in florilegia.[48] As Lockett concludes, the most ubiquitous and influential writers read by the English were Gregory the Great (the *Soliloquia*) and Isidore of Seville (the *Etymologiae*), the latter of which, as Charles D. Wright notes, was considered by Irish scholars to be the apex, or *Culmen*, of knowledge.[49]

Gregory, whose special importance to Bede is well documented, placed a unique stamp upon Insular Christianity, notably his pragmatic embrace of a kind of hybridity in newly converted territories.[50] He charged the mission to Britain with rebranding and absorbing pagan practice as well as integrating Celtic and Roman custom into a viable whole. He instructed the Frankish abbot Mellitus, for example, who was en route to the Augustinian mission in Britain,

> When almighty God has led you to that most reverend man, our brother Bishop Augustine, tell him what I have long pondered over, while thinking about the case of the English. That is, that the temples of the idols among that people ought not to be destroyed at all, but the idols themselves which are inside them, should be destroyed. Let water be blessed and sprinkled in the same temples, and let altars be constructed and relics placed there. For if those temples have been well constructed, it is necessary that they should be changed from the cult of demons to the worship of the true God, so that, while that race sees itself that its temples are not being destroyed, it may remove error from its people's hearts, and by knowing and adoring the true

God, they may come together in their customary places in a more friendly manner.... For there is no doubt that it is impossible to cut away everything at the same time from hardened minds, because anyone who strives to ascend to the highest place, relies on ladders or steps. He is not lifted up in one leap. (*Registrum Epistularum* 11.56; Martyn 802–3)

[Cum uero Deus omnipotens uos ad reuerentissimum uirum fratrem nostrum Augustinum episcopum perduxerit, dicite ei quid diu mecum de causa Anglorum cogitans tractaui, uidelicet quia fana idolorum destrui in eadem gente minime debeant, sed ipsa, quae in eis sunt, idola destruantur. Aqua benedicta fiat, in eisdem fanis aspargatur, altaria construantur, reliquiae ponantur, quia, si fana eadem bene constructa sunt, necesse est ut a cultu daemonum in obsequio ueri Dei debeant commutari, ut, dum gens ipsa eadem fana sua non uidet destrui, de corde errorem deponat et Deum uerum cognoscens ac adorans ad loca quae consueuit familiarius concurrat . . . Nam duris mentibus simul omnia abscidere impossibile esse non dubium est, quia is qui summum locum ascendere nititur gradibus uel passibus, non autem saltibus eleuatur.] (*Registrum Epistularum* 11.56, 961–62)[51]

Of course Gregory makes ultimate recourse to the image of a ladder and a hierarchic ascent from lower to higher levels. But his emphasis on gradualness, his nod to the good construction (*bene constructa*) of the pagan temples, his value of "friendliness" (*familiarius*) all effectively embrace what will be an inevitable process by which old or preexisting (pagan) practice inflects and informs something new (Christian doctrine). In these gestures, however pragmatic in origin, Gregory sanctifies the contact zone.

Gregory also authorized a kind of participation in relation to the divine. As I will discuss more fully in chapter 1, for Gregory (as for Augustine), man was exalted by the Incarnation. Gregory's emblem for the Incarnation was the chiasm *divinitas humiliata humanitas exaltata* ("divinity humbled, humanity exalted"), in which Christ's glorified humanity was of special importance.[52] For Gregory, thanks to the mystery of the Incarnation, we have more than the dark meaning of the scriptures and the fleeting insights of our minds by which to perceive the divine; Gregory stressed the "sacraments of Christ's humanity," which would become a favorite phrase of Bede's.[53] These

are the palpable, sensible experiences in the world through which we contact divinity. Thus, for Gregory, and for the Insular tradition I attempt to adumbrate in this book through attention to its residues, the "aesthetic" (as that which is sensed, versus that which is intellected) is both valorized and intimately tied to the Incarnation. Appreciating the extent to which this is true helps us see even certain famous episodes afresh. For example, it is sometimes overlooked or perhaps regarded as trivial that in the *Ecclesiastical History,* it is the angelic *appearance* of the Anglian slave boys in Bede's legendary account that spurs Gregory's zeal to send a mission to Britain; furthermore, their beauty conspires with Gregory's etymologizing pun (*Angl/angeli*), forming a double emphasis on what may be called form:[54]

> We must not fail to relate the story about St. Gregory which has come down to us as a tradition of our forefathers. It explains the reason why he showed such earnest solicitude for the salvation of our race. It is said that one day, soon after some merchants had arrived in Rome, a quantity of merchandise was exposed for sale in the market place. Crowds came to buy and Gregory too amongst them. As well as other merchandise he saw some boys put up for sale, with fair complexions, handsome faces, and lovely hair. On seeing them he asked, so it is said, from what region or land they had been brought. He was told that they came from the island of Britain, whose inhabitants were like that in appearance. He asked again whether those islanders were Christians or still entangled in the errors of heathenism. He was told that they were heathen. Then with a deep-drawn sigh he said, "Alas that the author of darkness should have men so bright of face in his grip, and that minds devoid of inward grace should bear so graceful an outward form." Again he asked for the name of the race. He was told that they were called *Angli.* "Good," he said, "they have the face of angels, and such men should be fellow-heirs of the angels in heaven." "What is the name," he asked, "of the kingdom from which they have been brought?" He was told that the men of the kingdom were called *Deiri.* "*Deiri,*" he replied, "*De ira*! good! snatched from the wrath of Christ and called to his mercy. And what is the name of the king of the land?" He was told that it was Ælle; and playing on the name, he said, "Alleluia! the praise of God the Creator must be sung in those parts." (2.1, 133–35)

[Nec silentio praetereunda opinio, quae de beato Gregorio traditione maiorum ad nos usque perlata est, qua uidelicet ex causa admonitus tam sedulam erga salutem nostrae gentis curam gesserit. Dicunt quia die quadam, cum aduenientibus nuper mercatoribus multa uenalia in forum fuissent conlata, multi ad emendum confluxissent, et ipsum Gregorium inter alios aduenisse, ac uidisse inter alia pueros uenales positos candidi corporis ac uenusti uultus, capillorum quoque forma egregia. Quos cum aspiceret, interrogauit, ut aiunt, de qua regione uel terra essent adlati; dictumque est quia de Brittania insula, cuius incolae talis essent aspectus. Rursus interrogauit utrum idem insulani Christiani, an paganis adhuc erroribus essent inplicati. Dictum est quod essent pagani. At ille, intimo ex corde longa trahens suspiria, "Heu, pro dolor!" inquit "quod tam lucidi uultus homines tenebrarum auctor possidet, tantaque gratia frontispicii mentem ab interna gratia uacuam gestat!" Rursus ergo interrogauit, quod esset uocabulum gentis illius. Responsum est quod Angli uocarentur. At ille: "Bene" inquit; "nam et angelicam habent faciem, et tales angelorum in caelis decet esse coheredes. Quod habet nomen ipsa prouincia, de qua isti sunt adlati?" Responsum est quia Deiri uocarentur idem prouinciales. At ille "Bene" inquit "Deiri, de ira eruti et ad misericordiam Christi uocati. Rex prouinciae illius quomodo appellatur?" Responsum est quod Aelle diceretur. At ille adludens ad nomen ait: "Alleluia, laudem Dei Creatoris illis in partibus oportet cantari."]
(132–34)

The faces, skin, and hair of the boys make their ignorance of the truth a pity, and also make them especially well suited to the benefits of salvation. This is a troubling bit of early evidence, of course, of white racialization and exceptionalism.[55] It also attests to Bede's attitude, and possibly Gregory's, regarding form and appearance per se. Bede attributes to Gregory, approvingly, a recognition of fair appearance as reason for special spiritual attention, and from there a practice of corroborating this impulse with that mediator between the spiritual and material, language. The names of the people, the land, and the king are all subjected to a valorizing exegesis through which their special Christian destiny is revealed, and the very aspects of the legend of the Anglian slave boys that seem dubious and even reprehensible to us are, for Bede, evidence of its revelatory solemnity.

There are many ways in which this anecdote, like others in Bede, is important (among them what it may say about Bede's status as proto-modern historian), but my main point here is that Gregory, particularly as filtered through Bede, reads the sensible world in a grammatical-encyclopedic fashion, one given great impetus and stature by his contemporary Isidore of Seville. The perceptible surface, the boys' appearance, tells a truth, a truth that language itself reinforces. It is worth remembering here, too, that the controversies settled at Whitby were not primarily doctrinal but matters of form, of observance.[56] Where Paul could say that Christ had come to fulfill and thus obviate "the law" (what Protestants would later reify as external show, the "dead letter," and idolatry), for the Insular church the law was virtually synonymous with Christ.[57] Form, as I will elaborate in this book, is not external to devotion but integral to it, and the sensible realm is the plane of religious observance and experience, manifesting the flesh of the Word. Sensible manifestation in the material world was indeed the basic ontology of the English, and Gregory connected the sensible to the Incarnation in a powerful way.

Gregory's sacramentalism was joined in Britain by the grammaticalism of the Isidorean legacy, which well suited the poetic obscurantism of Irish learning. Words had a special relationship to the Word. The virtuosic concealment of meaning by means of elaborate locutions revealed, "as in an enigma" ("per speculum in aenigmate") the enigma of the verbal divine, but this was not exactly the enigma of St. Paul, through which we perceive only "darkly" what we will later perceive "face to face."[58] For, as I will discuss in chapter 1, Gregory had made explicit that the opacity of the flesh is glorified by the Incarnation. The Incarnation had joined the ineffable Logos to effability, an effability of sensible manifestation that extended beyond Christ's human body, and took the appropriate form of enigma. Because of the mismatch between Christ's divinity and his humanity, the fusion of these two natures was an absolute mystery, a true enigma. The very nature of enigma is ambiguity and polysemy, meaning as endlessly motile. In Insular Incarnationalism, this enigmatic dynamism is deployed in the sensible realm, not restricted to the intellective movements of the mind as in Augustine. It generates, accordingly, a poetics of participation. When we see enigmatically, we see Christ. The special understanding of the Word as verbal, as related to and

particularly revealed by words, is obviously something Augustine and other Fathers touted as well, often referred to as the "double Incarnation," by which the Word took on both human flesh and the form of the words of the gospel.[59] As this book will show, however, in the Insular tradition it multiplied far beyond doubling. It is not only the exact and particular words of the gospels that may express the Logos, but other words and other forms as well.

Two additional factors amplified the "grammatical materialism" already fed by the Isidorean, Gregorian, and Irish legacies in Britain. The first is orality. In oral cultures, there is a "thickness" or opacity to language in which speech, especially in patterned language, has a palpability and weight—a quasi-materiality—since texture must be thick to be memorable and since words are experienced directly from a body and a voice through the air rather than mediated by the flat, silent page.[60] The work of John Miles Foley, Alain Renoir, Ann Chalmers Watts, Jeff Opland, John Niles, Katherine O'Brien O'Keeffe, Carol Braun Pasternack, Mark Amodio, Lori Garner, and Heather Maring, among others, has explored the verbal texture of Old English poetic language and its relation to oral tradition. The most intense locus of linguistic weight and texture in the corpus is probably the Old English riddles of the Exeter Book, where words themselves stand in quiddity, insisting on themselves, by virtue of the irreducible ambiguity of their referents. The indelibly physical quality of word and utterance, the performative, temporal, spatial nature of any speech act in an oral context, renders legible some of the profound graphic strategies of Insular artists such as the creators of the Book of Kells, where time, space, words, and bodies seem to share a common ground. This somatic quality suggests how proximate to "flesh" the Word could be. Even further amplifying the verbal emphasis in this contact situation, finally, was the opacity of Latin, the language of the new religion, which was the purview of a learned elite but encountered by all in the form of the ritual performance of the liturgy. Language was never a transparent medium in such a context but rather apparent, noticeable, sensed. Insular Christianity, then, was primed in multiply reinforcing ways to receive the words of John's gospel with particular reverence and attention: the Word was made flesh. What could that mean?[61] One argument of this book is that the attempt was made over and over again not to explain what it meant but to reassert, to articulate, its enigma.

AESTHETICS, HISTORY,
AND THE FLESH OF THE WORD

Aesthetics, as the phenomenology of the sensible, and form, as that which is sensed, have received important recent scholarly attention, along with the renewed focus on matter and materiality.[62] The so-called New Formalism and New Materialism have their iterations in medieval studies and to a lesser extent in early medieval studies.[63] One of the important contributions of this recent trend in scholarship to our understanding of the medieval period is attention not only to the explicit, which by definition expresses that which is avowable and sanctioned by authority, but also to the implicit. Especially in the context of dominant ideologies so powerful that they govern the conditions of the afterlife (as, for instance, the stakes of "error" in Christian dogma), certain thought and feeling can only be implicit. As has always been stressed by scholars of the Middle Ages, the period was a time of conservative reverence for authority, a time when innovation and dissent had no particular cachet. Even bold new ventures couched themselves in the language of continuity, not of breach or revolution. Thus, the Middle Ages look one way when we attend to explicit theological treatises or the sermons and letters of important ecclesiasts. Such is largely the purview of traditional intellectual history and theology. What has long perplexed (or delighted) students of the period, however, is the clash (or frisson) between other products of culture — anonymous poems, manuscript illumination, devotional objects — and the intellectual corpus of officialdom. As Cervone explains, in relation to late-medieval vernacular writing on the Incarnation, "because [vernacular writers] speak only infrequently about their methods and seldom didactically about their message, their thought must be inferred from the form that both encodes it and reveals its essence" (3). It would be difficult to state any more clearly the methodology of the present book. The reading methods I employ are those of literary close reading, precisely because of the implicit nature of the evidence. I draw not only on the work of Cervone in this respect, but also on that of Arthur Bahr, whose extension of close reading to the "compilational poetics" of manuscript collections is important to my global reading of the margins of the Cambridge, Corpus Christi Col-

lege MS 41 in chapter 5 and of the Vercelli and Blickling collections in chapter 3.

I draw as well on the ethics and praxis of Heather Love's "thin description," a way of declining to "read into" material such as a text, especially at initial stages of approach. Thin description opposes itself to Geertzian "thick description," and it is the diametric opposite of Robertsonian exegesis. It assumes that it is best not to "preface" Chaucer, that in doing so too quickly we do violence to the past and reduce it to what we were already expecting to see. How literal and how attentive to detail can we be in describing a text or an object? What one finds quickly in attempting a thin description is that there is no innocent or objective lens, only different ones. Nor is there any "direct" encounter with the medieval past, only various ways of accounting for the opacities and distortions of history. But what is exciting about thin description when applied to the kinds of generically hard-to-categorize, often unattributed texts we find in medieval manuscripts is that it supplies a methodology other than either the imposed apparatus of authority or the equally imposed apparatus of modern hermeneutics (symptomatic reading, political critique); it avoids assuming that all texts should ultimately be made to say the same thing, to sing the same song. Rather, thin description can pair with the Benjaminian, formalist approach to history—historical materialism—for which Bahr advocates (first quoting Benjamin):

> "Historicism offers the 'eternal' image of the past; historical materialism supplies a unique experience with the past." Rather than being swept along by an inexorably linear historicity, in other words, the historical materialist must make of the present a temporality in which to capture an experience of the past's relation with that present. . . . Like the constellation, the compilation as I engage it is a collection of multiple, disparate pieces into a larger picture, a form that is meaningfully interpretable. This form is a tangible "standstill" of history's progression that prompts the profitable arrest and deployment of our own interpretive faculties, enabling that "tiger's leap into the past" on which Benjamin insists. This past is not a single point on the eternal time line, however, but rather the set of multiple, intersecting temporalities created by the histories of a compilation's authors, scribes, patrons, and later handlers. (12–13)[64]

One can come to a medieval text or compilation prepared to enter into a "constellation," to acknowledge that its forms disclose multiple histories, and that we ourselves view what we view from a particular vantage. Thus, one might come to a medieval text or manuscript rather as one comes to a poem, prepared to be taught how to read it, within a moment whose historical value is a construct of the multiple temporalities and agencies coming together in that act of reading. A historical-materialist thin description allows us to be gentle with our often isolated, fragmented, anonymous sources. It allows us not simply to extend the ideology of more forthcoming and well-attested sources to everything, not to read *Solomon and Saturn* in light of Augustinian or Ælfrician orthodoxy, for instance.[65] Implicit evidence is no less present than the explicit, but perceiving it requires a particular (formal) attunement as well as a kind of negative capability.

Thus, an orientation toward close reading, the surface, and form emphasizes what medieval readers would identify as the "literal" level, which happens to have been the particular obsession of early medieval Irish writers. I say this in part to anticipate the objection that my method willfully or perversely ignores the authoritative interpretive frameworks of the period. On the contrary, the literal level was a prestigious preference in some circles. It is important to distinguish, however, between "the literal level" and mimesis or verisimilitude. As Caroline Walker Bynum has noted, medieval representation is often not mimetic, not "representational" in the later terms of art history, but performative and embodying:

> The point was the power of the materials to evoke, to conjure up—to represent not so much in the sense of "looking like" as in the sense of "manifesting the significance of." . . . Medieval art did rely on what we tend to call "representation" or "similitude" (if not on mimesis). To be effective devotionally, an image of Christ or the Virgin or St. Barbara, at least in the sense of being recognizable as such, just as red must be recognizable as blood. But to be accepted as an image "of" a saint, the figure must not so much look like the saint (who knew what the Magdalen had looked like?) as have the attributes (palm branch, tower, chalice, etc.) conventionally associated with that saint or combine elements known from earlier depictions. Hence, being "an image of" or "representing" is not a matter of mimesis, although it can be a matter of reproduction (in Walter Benjamin's sense) or recombina-

tion. In other words, a figure can represent or be "like" a saint—that is, carry his or her power or presence—in the sense in which a person (for example, an ambassador or a friend) can represent another person—that is, not by looking like but by standing in for. (*Christian Materiality* 58–59)

The sensible world and the objects therein could reveal the divine in ways that did not merely "depict" or point (here, as well, too much emphasis has been placed on classical philosophical categories). Further, the vibrant colors and precious materials adorning reliquaries and images did not always or exclusively point devotees to transcendent splendor or to historical events but instead afforded them contact with what they understood to be holy matter.[66] A corollary to this participatory logic is that metonymy is sometimes at play and not metaphor. Metonymy is a semiotic phenomenon by which a "contiguity relation" rather than a "substitution relation" links one term to another. A metaphor is based on comparison, juxtaposing two appositive terms to suggest a likeness between them. A metonym, by contrast, may allow a part to suggest the whole (synecdoche), or a term that has coincided to suggest its coincident neighbor (as in Pavlovian salivation, where the bell has nothing to do with the food, but the dogs have learned to salivate at its ring nonetheless, so that, for them, the bell does have something to do with the food). In the context of medieval devotion, pieces and tokens often functioned metonymically, as in the relic of a saint bearing the whole saint's power or a traditional poetic phrase cuing an interpretive matrix.[67] Signs can thus function in ways unfamiliar to readers trained to favor metaphor. One must be on the lookout for what one might call "lateral" evocations, drawing on Roman Jakobson's association of metaphor with substitution and metonymy with combination.[68] A word might evoke not a meaning so much as the echo of other words that have often appeared around it. The logic of metonymy informs much of the Insular "Incarnational poetics" at the heart of this book, as writers and illuminators were evidently fascinated by the Word's relation to his own words and to anything else associated with him.[69] In the Book of Kells, for example, gospel letters disclose their nature as little images of Christ. Similarly, in the enigmatic Old English *Solomon and Saturn* dialogues, the Pater Noster letters come alive both individually and collectively (as the whole prayer, or as the name, *Pater Noster*, of the

prayer) to stand in for him who spoke them on the Mount. The landscape of the holy lands, where Christ came into the world and walked on earth and departed again into heaven, discloses divine properties that were endowed by this physical contact. Metonymy is evident, too, in manuscript arrangement, as when texts and fragments appear to be included because they contain specific phrases or themes. They function as tokens in what Bahr has termed the "poetics of compilation" (6–12).

My contention in *Aesthetics and the Incarnation* is that much fascinating cultural production in visual art, in homiletics, in wisdom literature, in the work of copyists and compilers, can be linked to the particular nature of the Christian story in Britain: 1) the Word was specifically verbal and bore relation to other words; 2) the Incarnation was a making visible and perceptible of what had been invisible; 3) the relation of the Word to words was not metaphorical but metonymic or participatory, meaning that language could constitute a sacramental trace like the Eucharist; and 4) further articulations of the Incarnation were possible. To be sure, prominent voices disapproved, but as I hope to have established, the culture was not a monolith and these voices (such as Ælfric's and Alcuin's) do not speak for everyone. Given that fact, there is no reason we have to be complicit in their nationalist, orthodox-imperialist projects. This book is not an exhaustive attempt to survey early medieval Incarnational theology in Britain. It is an attempt to read and illuminate—in some cases to rehabilitate—some particularly fascinating artifacts, to account for them as products of their cultural context, and to suggest that they adumbrate some of the less obvious contours of that context, specifically, an understanding of the Incarnation that was not authoritative but was, as one says, "honestly come by" as an inheritance of multiple circumstances unique to the history of Britain. It shares the goal of Bynum's recent work: "to understand the period's own character by taking seriously aspects usually treated cursorily or with incomprehension and condescension" (18). This book is not ultimately about a systematic, extractable theology—certainly not one applied from the top down—but about better understanding the actual products of a time and culture long past.

The following chapters are organized around key aspects of Insular Incarnationalism, aspects that are not discrete but interrelated. Chapter 1 concerns the principle of "supereffability" as opposed to ineffa-

bility. As I have discussed, ineffability is the emphasis of Augustin-
ian Neoplatonism. God is unitary, indivisible, complete, and eternal,
without end or beginning. The Logos, as belonging to that eternal
monad, is in its essence inexpressible or inarticulable—ineffable. The
Incarnation is the act that joins creation and its boundedness in time
with eternity, in giving form to the Logos. Where, under the pressure
of the Iconoclastic Controversies on the Continent, Carolingian
thinkers gradually hardened their insistence upon the ineffability of
the divine, carefully circumscribing the Incarnation as pertaining to
Christ's human body, in the Insular context the Incarnation more
broadly implied that it had become possible for the divine to appear
in the world. The Word had always been verbal and in some sense
enigmatic, since as Wisdom it had spoken the creation. This reiterative
speaking of the Logos, first in creation and then in the Incarnation,
implies an irresolvable heterogeneity in bridging or joining the inef-
fable and the effable, or, put another way, in effability's issuing from
ineffability. It is this very quality for which I adopt Cervone's term
supereffability. Supereffability implies the property of expressive or
semiotic excess arising from the otherwise unbridgeable difference be-
tween the two natures joined by the Incarnation. Thus, the very gap
of difference-cum-similarity that always divides the signifier from the
signified is rendered numinous or expressive of the divine mystery.
Supereffability is a property of Incarnational substance, which hu-
mans perceive in "sacraments of Christ's humanity," to use the phrase
Bede adopted from Gregory. These sacraments may be traces of the
Lord's body in the world (relics, places he visited, the Eucharistic
Host) or words he spoke (such as the Pater Noster or the gospel),
or inspired poetic words that embody him anew. The main texts in
chapter 1 are from Bede, who treats the Incarnation both explicitly,
in homilies that invoke Gregory's concept of sacramental humanity,
and in a more schematic, literary way, in the form of his well-known
account of the inspired poet Cædmon. Bede's story of Cædmon con-
nects the poet's words to the sacred words of the liturgy and, ulti-
mately, to the sacrament of the Eucharist.

Chapter 2, "Seeing Double: Representing the Hypostatic Union,"
is devoted to the ways in which Insular sources represent the hypo-
static union, the joining of two distinct natures, in the Incarnation. Vi-
sual images dominate this chapter because of their capacity to repre-
sent simultaneous ambiguity or ambivalence, in contrast to language,

whose linearity necessitates a toggling back and forth between terms. The Book of Kells is the focus of the chapter, among examples from other manuscripts, as Kells is intensely and relentlessly—and perhaps even programmatically—Incarnational in its conception (a word I intend in all its senses). Kells is also a showcase for why it is important to use a geographic designator such as *Insular*, since it is often simply left out when "Anglo-Saxon" or "Early English" visual culture is considered, even though it is not known exactly what the demographic makeup was at Iona—the likeliest venue for the manuscript's production—when Kells was produced. Visual representations related to the Word made flesh blend Christ's two natures and proliferate his perceptible appearance in provocative ways that frequently challenge the reader or viewer to find what is hidden and manifest at the same time, using Christ's very admonition, "seek and ye shall find" (Matt. 7:7). This amounts to a challenge to find, within the world, the Word, which lies behind all things and is always perceived through a "double vision" that can apprehend its essential ambiguity.

Chapter 3, "No Ideas but in Things: Aesthetics and the Flesh of the Word," considers the phenomenology of this apprehension and the topography of Incarnational matter, drawing on work in the New Materiality (such as that of Judith Bennett in addition to that of Bynum), the surface reading of Stephen Best and Sharon Marcus, and Gilles Deleuze's account of the baroque aesthetics of Leibniz to understand the way that signs, things, and matter itself could embody the Incarnational mystery. In sensibly perceiving, our flesh participates in a chiasm whereby, as God descended to man, man ascends to God. This phenomenology refuses a surface/depth (or material/spiritual) dyad, instead constituting the Incarnation as a palpable surface of endless folds. Aesthetic perception becomes a sacramental participation in the very flesh of the Word. The chapter ranges widely but begins with Bede and the Irish abbot Adamnán, whose account of the Holy Lands (*De locis sanctis*, written ca. 685) provides an extended contemporary account of Incarnational matter and its properties.[70]

The final two chapters comprise two parts of one overarching theme, "Concealing is Revealing," a logic by which the mysteries of the Word could be revealed through further, amplifying concealment, since opacity, or a thickening and proliferating of surface, recapitulated the "cloaking" action by which the Incarnation rendered the invisible visible. Part 1 (chapter 4, "Opacity and Enigma in the Wisdom

Tradition") treats some of the most difficult and confounding material of the early corpus, featuring Aldhelm's *Enigmata* and the neglected *Dialogues of Solomon and Saturn*. These arcane writings construe the Word as the Wisdom of God, whose utterance created the world and whose utterance by the faithful in the form of the Pater Noster invokes its cosmic and salvific power. Part 2 (chapter 5, "The Shadow Manuscript in the Margins of CCCC 41") argues for the learned, contemplative concealment of the Word as an organizing framework for an entire "shadow manuscript" in the margins of an Old English translation of Bede's *Historia*. Just as the reader of the word-images in the Book of Kells must look carefully and perceive a mystery in its many permutations of the Word, the marginalia in Cambridge, Corpus Christi College MS 41 provoke a journey of discovery whose teasing signposts similarly challenge the reader to find the Word that lies at the very center of the manuscript. This Word ultimately appears, literally, at the end of the manuscript, as twin images that emerge from and run into the text of the Passion, the Word as both human flesh and words. Thus, this book explores several important properties of the early Incarnational Word that tend to be obscured by the later orthodoxy as well as contemporary controversy concerning its nature: it was supereffable or iterable-in-excess (the major focus of chapter 1), dual or heterogeneous (chapter 2), sensible (chapter 3), and all the while an enigma, revealed best, paradoxically, through deferment and concealment (chapters 4 and 5).

What I hope to establish is not a new model for the Incarnation that can account for all the centuries and all the disparate cultures and thinkers of early medieval Britain. The Incarnationalism I document is problematic for orthodox thinkers, who refute, deride, and sanitize it, depending on the circumstance and author. Rather, this book suggests that several of the most fascinating outliers in the traditional literary and cultural history of Britain may be brought in from the margins, as it were, and read not with a shake of the head but with appreciation and a sense of historical understanding if we consider the way they appear to have received the central Christian formula, *verbum caro factum est*:

In the beginning was the Word and the Word was with God and the Word was God. The same was in the beginning with God. All things were made by him; and without him was made nothing that was

made. In him was life, and the life was the light of men. . . . And the Word was made flesh, and dwelt among us. (John 1:1–4, 14; Douay-Rheims)

[In principio erat Verbum, et Verbum erat apud Deum, et Deus erat Verbum. Hoc erat in principio apud Deum. Omnia per ipsum facta sunt: et sine ipso factum est nihil, quod factum est. In ipso vita erat, et vita erat lux hominum . . . Et Verbum caro factum est, et habitavit in nobis.] (Vulgate)

I have attempted to read and see closely not only the literary objects but also the circumstances of this early period, and the chapters that follow arise from that attempt.

"Supereffability" and the Sacraments of Christ's Humanity

At ipse cuncta, quae audiendo discere poterat . . . in carmen dulcissimum conuertebat; suauiusque resonando doctores suos uicissim auditores sui faciebat.

[But that one, all that he could learn by listening . . . he would turn into the sweetest song . . . and by echoing back more pleasingly, he made his teachers in turn his listeners.]
— Bede, *Historia ecclesiastica* 4.24

Verbum de verbo peto

[I seek the word from the Word]
— Aldhelm, *Carmen de virginitate* l.33

In this chapter I consider the supereffability of the Incarnate Word and its particular relationship to poetic words, specifically, the poetic words of Aldhelm, Cædmon, and Cynewulf. I argue that the supereffability of the Word makes its manifold iterations fully sacramental, unlike what has been argued for the later medieval context,

and I discuss the iconophilic background as well as the Incarnational theology of the two most important Fathers in early Britain, Gregory and Bede. For these writers, the manifestations of the Word in the world truly constitute "sacraments of Christ's humanity."

Cristina Maria Cervone developed *supereffability* to characterize how language behaves in the poetic experiments of later medieval English writers, in which "sacred fullness" may be "enacted through form," with Scripture itself providing the prime, perhaps originary, example: that "metaphor-that-is-more-than-metaphor, 'the Word made flesh'" (5). For Cervone, the capacity of language and especially poetic, figurative language for "fullness" (polysemy, allegory, other-speaking of any kind) provides Middle English writers such as William Langland and Julian of Norwich a medium through which to enact "the paradox underlying the connection between God and man" (5). There is an important distinction between Cervone's treatment of supereffability and my adaptation of the term. For Cervone, supereffability captures the "almost" sacramental capacity of language to embody the Word—"almost" because Augustinian orthodoxy would prohibit a fully sacramental embodiment. In my adaptation of the term I accept what appearances suggest, which is either that language could be sacramental or that the distinction between almost-sacramental and sacramental was not very important to the people whose crafted language and accounts of crafted language lack the careful caveats seen elsewhere. The Incarnational theology of such writers is largely implicit, and is certainly not, therefore, systematic. However, it has a logic, and I will try to make sense of it in (modern) semiotic terms.

The Incarnation joined an ineffable Logos to a sensible form, and the result was a mismatch or category error, an enigma. Rather than a one-to-one relationship of signifier to signified, as would normally or classically characterize a sign and serve as precondition for effability per se, the mismatch of the Incarnation generated an enigmatic, irresolvable polysemy internal to the Incarnational sign:

signifier : signified
flesh : Word

Since the signified, the Logos/Word, remains categorically ineffable, whatever serves as the articulated term, or signifier, in the dyad relates

to the Logos only in the most mysterious, enigmatic way.[1] The original Incarnational signifier was Christ's human body, but after the Resurrection and Ascension the instantiations or iterations of the "flesh of the Word" ramify, proliferating in other forms of language and matter.[2] It is the very permutability of these forms (mutability being an inherent quality of matter according to antique and medieval thought), combined with their enigmatic joining to the changeless and eternal Logos, that makes the Incarnational signifier "supereffable." Supereffability inheres in the semiotic excess of the juncture between iterable articulation and eternal monad. One can see, then, how the ambiguities of poetic language are particularly well suited to the nature of the Incarnation: "Medieval writers deliberate over Christ's humanity in a way that draws attention to the paradox underlying ['The Word was made flesh'] while de-emphasizing Christ's bodily suffering at the Passion. Their focus is not primarily on the 'flesh' side of the metaphor; rather, *they work from the middle term—the verb—that yokes language's active fluidity to both the divine and the human*" (Cervone 5; emphasis mine). Cervone's close readings of Middle English poems reveal the way an Incarnational poetic inheres in this "middle term" of the verb, in its capacity for polysemy, patterning, and suggestion, all of which allow for shifts and transformations conceptually, a movement among, for instance, different planes and registers. Christ, for instance, can be a man, and then a cloth, a parchment sheet, a lily (163–70, 197–208). We are made both *again* and to our *gain*, in Julian, by Christ's *geynmaking* (48–52). In the above examples, the first involves substitutions of images and the second involves substitutions between possible senses of a given word—a pun.

Cervone's conception of Incarnational poetics is fundamentally relational, mystery and paradox being thought through by means of (literally "thought through") likeness, which is predicated upon difference. This relationality and difference in language link Incarnational poetics to flesh as matter, since Bynum similarly defines matter in the Middle Ages as that which can change, that which can differ from itself (25). In holy matter, both wondrous change and wondrous preservation from change paradoxically coexist and stand as proof of divine presence (35, 284–86, inter alia). The transformative potential of words especially as set in motion in poetic language provides an analogue, then, to the dynamism of medieval matter. Both were

capable of embodying the divine, and both conspire to give Christ's fleshly form an amplitude and mobility that are surprising to post-Reformation expectations of a focus on Christ's becoming "like us," that is, a human subject, rather than "like us" in the sense of being visible in the world, in words, in things. The capacity to transform or to be other than itself, to leap across realms of experience and states of being—this is an important capacity of the Incarnate Word.

For Cervone, in the Incarnational poetics of Middle English writers, "meaning does not transcend or supplant the form through which it is expressed, but abides within poetic and linguistic form even as it exists ideationally and abstractly in a 'hypostatic union' of linguistic form and metaphorical thought. Here the specificity of words—their very quiddity—thickens abstraction" (4). The "thickening" of abstraction Cervone points to relates intimately to the notions of opacity, cloaking, and clouding in the Incarnationalism of the early period, as well as to Bynum's emphasis on texture and solidity in the material devotion of the Middle Ages. However stridently a theologian might insist upon objects and images as mere pointing devices toward the incorporeal divine, actual practice as well as the very stridency of insistence otherwise confirm that medieval people experienced the divine in thickly sensory terms. In the Insular context, language was frequently one such term, with various kinds of opacity and texture precluding purely spiritual abstraction. Sometimes the esotericism of liturgy, sometimes vernacular poetics, sometimes the defamiliarizing modes of enigma were preferred. Insular writers such as Bede, Aldhelm, and the poet Cynewulf all relate poetic language to the sacrament of Christ's flesh in a way also recognizable in late-medieval Incarnational or enigmatic poetics, whose sacramental status may or may not be as hypothetical as orthodoxy would require. For these early writers, poetic words can embody the Word. I will first consider some of the theology of the sensible as received from Gregory the Great before turning to the Incarnational poetics of Bede, Aldhelm, and Cynewulf.

HUMANITAS EXALTATA

Medieval materiality has both orthodox and vernacular and even heterodox iterations, and it forms a continuum along which official

church teaching and practice and what used to be called popular piety may be found.[3] But its defining characteristic is that it gives prominence to the sensible. Some manifestations emphasize the Incarnation as the event that made the divine visible or perceptible to humanity and in so doing endowed the visible and the perceptible realm—endowed matter—with divinity.[4] If Christ's humanity made the Incarnate son visible to us, and in the process redeemed our humanity, then further realizations or "makings-visible" may be seen as acts of contemplation and devotion that approach, as Cervone points out, sacramental status (42). Indeed, both Gregory the Great and Bede valued such sensory forms and described them in Incarnational terms as the "sacraments of Christ's humanity."[5] These were not only acts of devotion of a representational or metaphoric nature. They express a particular understanding of Christ's Incarnational journey. Since Christ glorified (his) humanity, all instances, iterations, and particles of his humanity were glorified. And since Christ's humanity was inseparable from his divinity (though distinct), all iterations of his humanity bore his divinity as well—his *mægenþrym* ("divine power, majesty"). Unlike iconoclastic writers who emphasized the superiority of Christ's spiritual (rather than physical) presence in the "present" time after the Resurrection, Insular writers outside the Carolingian circle emphasized the continuity of Christ's presence as an "indwelling" that might suffuse earthly things.[6] As I say, this is not an absolute distinction but a difference in emphasis. As Barbara Raw and Leslie Lockett have noted, the Carolingians are the ones who brought a Neoplatonist angst to the table. Their rhetoric is careful to carve out a distinction where the default cultural norms observed no special vigilance.

Carolingian theologians were often following Augustine in their distrust of the material and emphasis upon the spiritual. Raw catalogs several writers whose model for how humanity relates to Christ and to the Incarnation is essentially Augustinian. Pope Leo I (d. 461) had made a clear demarcation between the fleshliness of the Incarnate Christ and the spiritual nature of our relationship to him after his Ascension:

> For the son of man, dearly beloved, was revealed more perfectly and more solemnly as the Son of God once he had returned to the glory of his Father's majesty, and in a mysterious way he began to be more

present to them in his godhead once he had become more distant in his humanity. Then faith gained deeper understanding and by a leap of the mind began to reach out to the Son as the equal of the Father. It no longer needed contact with Christ's bodily substance, by which he is less than the Father. For though the glorified body remained a body, the faith of believers was being drawn to touch, not with the hand of the flesh but with the understanding of the spirit, the only begotten Son, the equal of his father. (Raw 5)

[Tunc igitur, dilectissimi, filius hominis Dei Filius excellentius sacratiusque innotuit, cum in paternae maiestatis gloriam se recepit et ineffabili modo coepit esse Diuinitate praesentior, qui factus est humanitate longinquior. Tunc ad aequalem Patri Filium eruditior fides gressu coepit mentis accedere, et contrectatione corporeae in Christo substantiae, qua Patre minor est, non egere, quoniam glorificati corporis manente natura, eo fides credentium uocabatur, ubi non carnali manu, sed spiritali intellectu, par Genitori Vnigenitus tangeretur.] (458; quoted in Raw 4–5)

According to Leo, the substance of the Incarnate Christ is categorically inferior to his spiritual nature, and because after his Ascension we touch him only spiritually, not physically, our contact is now more perfect, taking place by a "leap of the mind" by which we are able to connect with the fully spiritual divine. This "leap of the mind" metaphor, which derives from Augustine, captures the gulf between the human mind and the divine nature, like to each other only by analogy.[7] Similar to Leo is the Carolingian reformer Benedict of Aniane (d. 821), who emphasizes God's transcendence and separateness from the created world as well as the imprint of the Trinity that the human mind bears, through which, in Raw's paraphrase, "we can . . . come to know and love God through knowing and loving his image within us" (15–16). Just as in Augustine, the divine within is a likeness, an image, not the thing itself. Similarly, John of Fécamp (d. 1078) and Anselm of Canterbury (d. 1109) emphasized the separate otherness of God and the arduous task of utilizing the inner likeness in contemplation (Raw 16–18). Though these writers have their differences, they share a very clear view of the ineffability of the divine and the goodness of creation as predominantly residing in abstraction.

The transcendentalist position of these Continental writers (Anselm was Italian and trained in France) was honed in the iconoclastic controversies of the eighth century concerning representation, particularly of Christ.[8] According to the iconoclastic position, God had no visible form and spoke only in words to his people, and this was the case both before Christ's coming, in the Old Testament, and after the Ascension. Christ's visible, Incarnate presence was a special and temporary dispensation. Since a representation was material and not spiritual in its substance, any representation of divinity was essentially heretical, and representations of Christ specifically erred in only being able to capture his human nature, not his divinity. Christ's Incarnation had indeed rendered him visible on earth, but only for a time:

> Even though we once knew Christ according to the flesh, yet we no longer know him this way, for we walk by faith, not by sight; *and from the same Apostle who said*: So faith comes from what is heard, and what is heard comes by the word of God." (Acts of Nicea II 285/6C, Sahas 111; quoted in Raw 60)

> [Et si noveramus secundum carnem Christum, sed nunc jam non novimus eum: per fidem enim ambulamus, non per speciem: *& eodem approbante dicente*; Ergo fides ex auditu, auditus autem per Verbum Dei.]

Images could show only Christ's external appearance, not his divine nature (though I note that Mansi has seen fit to print *Verbum* with a capital *V* in his edition of the *Acta*, granting to the sense of hearing, if not sight, the perception of Christ).

Insular materiality was much more harmonious with the theology of the iconophiles, who "stressed the change which had taken place at the Incarnation: whereas the patriarchs and prophets had merely heard God's word, Christians were able to see his Word in the person of Christ, the image of God" (Raw 60–61). Images could render visible the whole unity of Christ Incarnate just as Christ rendered visible the divine within a "cloud," as Bede put it, of humanity:

> The very Light invisible, the very Wisdom of God, put on flesh in which he could be seen. Appearing in the condition of a human being and speaking to human beings, he gradually brought hearts purified

by faith to the recognition of his divine image. There was sent before him a man of great merit [John the Baptist], by whose testimony all would be prepared to hear the very Wisdom of God as soon as he appeared, and to see the very Sun of justice now covered over by the cloud of [his] body, that is, to see and hear the human being who would be God. (Gospel Homily 1.8, p. 77)

[Ipsa lux inuisibilis ipsa Dei sapientia carne in qua uideri posset induta est quae in hominis habitu apparens et loquens hominibus paulatim fide purificata eorum corda ad cognotionem suae diuinae uisionis proueheret. Missus est ante illum homo magni meriti cuius testimonio pararentur omnes ad audiendam mox ut appareret ipsam Dei sapien-tiam ad uidendum ipsum solem iustitiae nube iam corporis tectum, id est ad uidendum audiendumque hominem qui Deus esset.] (*Homiliae evangelii* 55)

For Bede, the divine image is conveyed by means of the human ap-pearance and is not easily extricable from it. This is even clearer where Bede somewhat surprisingly describes Christ's humanity, not his di-vinity, as that which shines from the cloud (see below). By the end of this passage, the divinity and the humanity are fused in a rhetorical chiasmus: "the Sun of justice now covered over by the cloud . . . that is, the human being who would be God." Bede's chiasm—one of many I will consider—reenacts the trajectory of the Incarnate Christ, from God to man to God, from heaven to earth and back again, in a way that binds the two in one set of ideas, one structure. John's preparatory words in anticipation of Christ are just that, merely pre-paratory, in contrast to the iconoclasts' insistence upon a return to "words alone." Once Christ has arrived, the seeing and hearing of the Incarnate God take prominence. Nor does Bede see the need for the caveats of the iconoclasts or of Augustine regarding Christ's (and thus our) bodily form.

Bede's iconophilia is the stronger of two main iconophilic posi-tions, both of which consider the images by which we perceive the di-vine as tied to the Incarnation in some fashion.[9] Either an Incarna-tional image reminds viewers of its transcendent truth (soft version) by representing it, or it recapitulates its central fact, its making visible (strong version). This difference is the distinction between metaphoric signs (images as reminders of the Incarnation) and metonymic partici-

pation in the Word made flesh. The former, representational semiotics may be seen as Augustinian, an iconophilic adaptation of his transcendentalism, and the latter, I argue, as more characteristic of Insular thought. The view of sensory (aesthetic) experiences as vehicles by which the mind is drawn upward is a commonplace among medieval writers. It is the easier iconophilic case to make: one experiences the sensual object (word, sound, image) and then leaps from it to the shadowy outline of the true Word (Logos) of the divine. It is a matter of internal reflection to know whether this leap is in fact being made. The fact that the contemplation of objects may look very like veneration of objects with no leap at all is of course one of the major grounds for reformation throughout the medieval and early modern period. Insular attitudes, in contrast, often attest both a lack of concern with a spiritual/material binary and an enthusiasm for the capacity of matter to contain spiritual power. In short, they represent a strong version of the iconophilic position, in which representations may bear a metonymic rather than strictly metaphorical relation to Christ.

Similarly, while iconoclastic writers emphasize the superiority of spirit over body and of Christ's divinity over his humanity, Insular writers are more positive about Christ's humanity, framing it as something he had lacked before and had gained in the process of the Incarnation—"he assumed, in time, true humanity, which he had not possessed" (Bede, Homily 1.8, p. 81)[10]—and further as something special and valuable in itself as a product of the Incarnation, as captured by a phrase from Gregory that Bede also emphasizes: *humanitas exaltata.*[11] According to Gregory's formulation, which was extremely influential in Britain, by deigning to take on humanity, Christ not only humbled his divinity (*divinitas humiliata*) but also glorified his humanity (*humanitas exaltata*). The chiasm suggested by Gregory's language, with the homophonic *hum-* at the crux, is illustrative of both the theology of Christ's dual nature and the way the Incarnation would be imagined in Britain.

This substance Christ had gained, this humanity, had the property of rendering Christ visible to the created world. Christ's taking on of humanity is very much like the donning of a cloak, going from invisible divinity to visible humanity with divinity inside: "The very Light invisible, the very Wisdom of God, put on flesh in which he could be seen" (Bede, Homily 1.8, p. 77).[12] We might think from this

formulation that the light of Christ remains exactly this invisible, divine resplendence, even once the flesh-cloak has been put on. But Christ's assumption of humanity is not an assumption of body alone, after all: "In this place where it is said, *and the word became flesh*, we should understand nothing other than [we would] if it were said, 'and God became man,' evidently by putting on flesh and soul, so that just as each of us, as one [being], is composed of flesh and soul, so from the time of his Incarnation Christ, as one [being], was composed of divinity, flesh, and soul" (Homily 1.8, p. 81).[13] Christ's human nature is both body and soul. While he is careful to explain here that the Incarnate Christ is divinity joined with a human body and soul, elsewhere he expands *flesh* to specify not "human" but more generally "visible form": "[The shepherds] said, '*let us see this Word which has come to be* — for before it came to be we were unable to see this [Word] . . . *which the Lord has made and shown to us* — what the Lord made to become flesh and thereby displayed to us in visible [form]'" (Homily 1.7, p. 67).[14] Bede here knits together a reading that gives *flesh* this more general sense. Further, Bede's explanation of the way in which humanity is now able to perceive Christ after his Incarnation specifies that his humanity is that which illuminates mankind: "The glory of Christ, which before the Incarnation human beings had not been able to see, they did see after the Incarnation, as they beheld his *humanity* shining out from miracles and understood that his divinity was hidden within" (Homily 1.8, pp. 81–82; emphasis mine).[15] It is not his divinity that shines out from the miracles; the purely divine light remains invisible light. What shines out from the miracles is a resplendent humanity, a product of the joining of the divine light with human flesh (body and soul) in the Incarnation. Just as Christ Incarnate is fully God and fully man, the visible property of this union, light, likewise seems to partake of both natures.[16] For Bede, as for other English writers, Christ's divinity infuses his humanity, and the resulting quality is visible, perceptible light, an Incarnational light. This is why Bede links the Incarnational light to the light of Christ's transfiguration upon the Mount of Olives[17] before the Passion, and to the descent of the Holy Spirit upon those who had witnessed the Resurrection and the Ascension (from the same Mount of Olives): "By all of these things they clearly recognized that glory of this kind was not appropriate to any of the saints, but only to that human being who, in his divinity, was the only-begotten of the Father" (Homily 1.8, p. 82).[18]

The Incarnational light of Christ, while originating with him, is visible to human beings and becomes the agent of their enlightenment on earth.

This Incarnational light has the property of infusing both objects and people. Augustine attributes this agency to the Holy Spirit, but English writers give it something more like physio-spiritual properties of its own. Although the light is a special quality originating in Christ's person, it can be extended to others: "Holy human beings are also properly called 'light.' The Lord says to them, 'You are the light of the world,' and the apostle Paul says, 'At one time you were in darkness; now, however, you are light in the lord'" (Homily 1.8, pp. 77–78).[19] As I will show in my discussion of the vernacular homilies, this transitive quality of Incarnational light often takes the form of the word preached by people in the form of the Gospel, in addition to the many other sensible forms. The transitivity or communicability of the Incarnational light is one of the key properties of the Insular Incarnational Word and thus of the sacraments of Christ's humanity as Bede invokes them: "Let us hope that through those sacraments of his humanity with which we have been imbued, we will be able to attain to the contemplation of the glory of his divinity" (Homily 1.19, 187–88).[20] Humanity alone as a quality is inferior to divinity, and when directly treating the two natures of Christ, Bede is, as his commentators affirm, thoroughly orthodox, asserting the inferiority of the humanity in comparison to the divinity. However, in treating the nature of humanity's relationship to the Incarnation, particularly the phenomenology of coming to know Christ through his visible light, Bede does not recapitulate the Augustinian formulation in which the perceiving mind comes to glimpse divinity only through its own internal workings, which bear the divine image or imprint in a ghostly fashion. Instead, Bede opts for the idea of sacramental humanity, which implies a sanctified state, a fusion of divine and human. This is precisely the idea that Bede develops in Homily 1.19 (for after Epiphany), for example. For him, the sacraments of Christ's humanity are manifold, that is, not a closed set, being both the ways in which Christ behaved as a moral example while on earth and the earthly vehicles for our illumination that still remain with us.

A further sense of the implications of Christ's sacramental humanity can be gleaned from the treatment of the Ascension in early medieval England, which in key texts of the canon complements the

Incarnation to form a balanced descent and ascent. Johanna Kramer highlights the way that the Ascension was imagined as a boundary crossing in which Christ, in ascending to heaven in both his natures, remained connected to humanity in a way that emphasized continuity (6–13). Images such as the Tiberius Psalter Ascension (fol. 15r; Kramer pl. 1; see fig. 1.1) display Christ with his head in the clouds, invisible, and his feet or lower body still in the earthly realm. Christ straddles both realms in his two natures, and the earthly church is of course readable as that body, still on earth, while Christ the head is in heaven. The emphasis is not on the disappearance of Christ's human self and replacement with spirit (as, for instance, Leo and also Ælfric would assert), but rather on the dual presence of Christ and his continued connection to humanity through the doctrine of the *totus Christus*.[21] Through Christ's ascended humanity we are drawn up to God, just as through Christ's humanity God came down to us. It is further significant that in related images such as the Bernward Gospels Ascension of Christ and the Evangelist John (fol. 175v; Kramer pl. 8; see fig. 1.2), Christ's feet are shown to leave behind the book of the gospels—specifically the Gospel of John—Christ's Incarnational presence on earth being in the form of the gospel word. In the particular formulation of Insular thinkers, then, *humanitas exaltata* has an extended scope, referring not to the one-off mystery of a localized Incarnation but instead to lasting effects according to the ascended Christ, a fact celebrated by Bede in the sacraments of Christ's humanity.

We partake of these sacraments by imitating Christ's example, which may be aligned with metaphor, and by soaking in Incarnational illumination, more like metonymy. Bede says, for instance, in his prayer at the end of the *Historia ecclesiastica*, "You have graciously granted that I should drink in sweetly the words of your learning" ("propitius donasti uerba tuae scientiae dulciter haurire"; 5.24, p. 570; trans. mine). Origen made the distinction between human knowledge and spiritual knowledge, but here Bede equates the two in the image of drinking in special—specifically sacramental—words. Furthermore, although Bede's prayer concludes with the desire to see the face of the Lord in the next life, recapitulating the Pauline assertion that we will see the Lord "face to face," Bede does not present the two planes in as hierarchical a way as either Paul or Augustine: "Teque deprecor, bone Iesu, ut cui propitius donasti uerba tuae scientiae

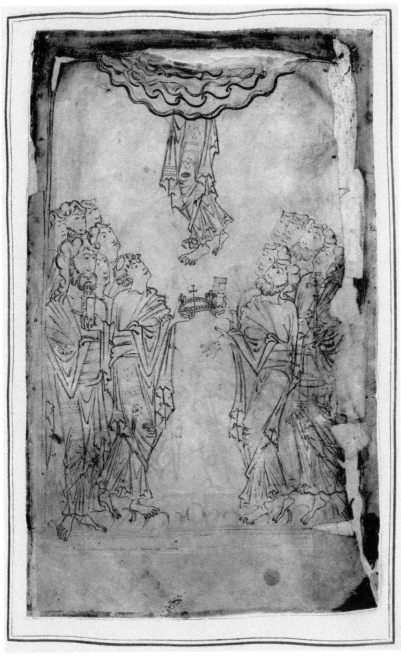

Figure 1.1. BL MS Cotton Tiberius C.VI, fol. 15r. Christ's Ascension into the clouds. © The British Library Board.

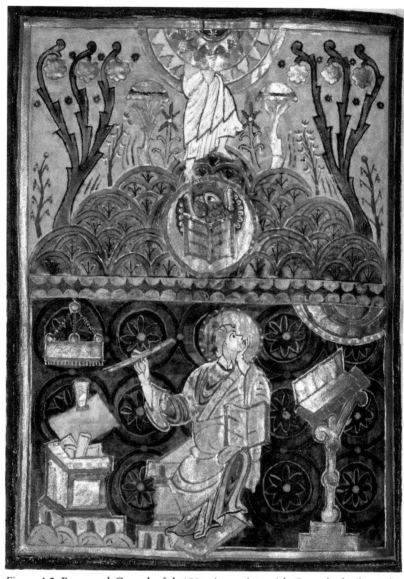

Figure 1.2. Bernward Gospels, fol. 175v. Ascension with Gospel of John. John was understood to have had special access to Christ's divinity and thus the mystery of the Incarnation. © Dommuseum Hildesheim.

dulciter haurire, dones etiam benignus aliquando ad te, fontem omnis sapientiae, peruenire, et parere semper ante faciem tuam" ("I pray, merciful Jesus, that as you have graciously granted me to drink in sweetly the words of your learning, you may also kindly grant that I come to you one day, fount of all wisdom, and remain ever before your face"; 5.24, 570; trans. mine). Coming before the face of the Lord is presented in terms of continuity, as a further blessing, a tracing to the source, not the granting of what had been longed for all along while the faithful servant made do with partial knowledge. "Ut . . . donasti . . . dones etiam" ("as you have granted . . . may you grant"). This continuity in Bede's formulation contrasts with the disjunction and difference in Augustine and in St. Paul between seeing only in riddling images and seeing directly. For Bede, the temporal words themselves bear the divine quality of sweetness, and while remaining before the face of the Lord does have the benefit of eternity, as opposed to ephemerality, it does not emphasize qualitative difference.[22] According to the metonymic, participatory nature of sacramental humanity, there is a continuity between the temporal and divine realms, occasioned by Christ's Incarnational assumption of full humanity and the subsequent ascension of that humanity. The sacraments of Christ's humanity form the crux of this chiasm, as I have said, the double *hum-* of Gregory's *divinitas humiliata, humanitas exaltata*.[23]

For Bede, the perceptible, sacramental humanity is a thoroughly positive, holy thing, and sacred words hold a special status as embodied divinity, reflecting the verbal nature of the Word and the monastic reading practices by which it was contemplated. Contrast Bede's savoring of sweet words with the following image for contemplative reading offered by Peter of Celle (12th c.): "A cell . . . is a prison of the body, a paradise of the mind. It is a market where the butcher sells small and large amounts of his flesh to God, who comes as a customer. The more of his flesh he sells, the greater grows the sum of money he sets aside. Let them therefore increase their wealth and fill their purse by selling their own blood and flesh, for 'flesh and blood will not possess the kingdom of God' (1 Cor. 15:50)" (quoted in Carruthers 3). Peter's distinctive version of *lectio divina* reflects the later medieval focus on *imitatio Christi* in its imagery of giving one's blood and body in spiritual pursuit, following the savior's sacrifice, and his use of 1 Corinthians 15:50 offers a renunciatory view of flesh

as temporary and salable. It will not inherit the kingdom. In contrast, Bede's sacramental drinking of words not only declines to inflect its sensuality as grotesque but imagines the point of contact with the savior in a fundamentally different way. Rather than the process of study and mortification of the flesh that in effect renders the latter unto God in imitative sacrifice, Bede's reading process is like communion, a sacramental act of taking into the flesh (body and soul) the divine words, which partake of the Word. Flesh is not punished in favor of spirit but rather redeemed by sacramental agency.

Aldhelm has a similar way of figuring the Word as manifest (incarnate) in human phenomena other than Christ's discrete physical person. In the *Carmen de virginitate* this takes the form of poetic words:

> I do not seek verses and poetic measures from the rustic Muses, nor do I seek metrical songs from the Castalian nymphs . . . nor do I ask that Phoebus grant me a tongue, expressive in utterance; never do I deign to speak by means of unutterable verses, as the clear-sounding poet [Virgil] is once said to have proclaimed. . . . Rather, I shall strive with prayers to move the Thunderer, who grants us the divine declaration of the gentle Word. *I seek the word from the Word*: the psalmist sang this Word engendered in the heart of the father, that which is the only Offspring, the Word by which the Almighty Father created all things throughout the world. (103–4; emphasis mine)

> [Non rogo ruricolas versus et commata Musas
> Nec peto Castalidas metrorum cantica nimphas . . .
> Nec precor, ut Phoebus linguam sermone loquacem
> Dedat . . .
> Versibus infandis non umquam dicere dignor,
> Ut quondam argutus fertur dixisse poeta . . .
> Sed potius nitar precibus pulsare Tonantem,
> Qui nobis placidi confert oracula verbi;
> **Verbum de verbo peto**: hoc psalmista canebat
> Corde patris genitum; quod proles unica constat,
> Quo pater omnipotens per mundum cuncta creavit.] (lines 23–35)

Aldhelm's logic makes the Word generative and recursive, as well as analogous to the pagan Muses in inspirational power of a specifically poetic kind. The Word can grant further words, as he did for the

psalmist, and Aldhelm prays that he may do so in the case of his own present verses, that his verses might be Incarnational, or begotten by the begotten Word—"the word from the Word." Thus Aldhelm's *Carmen*—his song—to virginity, is given a unique status in relation to the flesh of the lord. While the original, prose version of Aldhelm's ode refers to purity and to those saints associated with that central virtue, the *Carmen,* as its author professes, enacts and embodies the paradox of clean flesh, which is the mystery of the Incarnation. This is one function of his mention of the rejected alternative of the Muses at the opening of the invocation: I do not seek the inspiration of the pagan Muses, which would result in impious, idolatrous language. Instead, I seek the word from the Word, language that partakes of a purified, sacramental form, the Incarnation itself. In his rejection of the pagan Muses and recuperation of poetry by recourse to the Incarnation, Aldhelm does something similar to what Boethius does in the *Consolation of Philosophy.* Boethius has Philosophy banish the Muses as harlots, which would seem to condemn poetry as false. Yet Philosophy then proceeds to sing her own songs, indicating that while *some* poetry is bad, other poetry is good. There is a licit, salutary use for poetry, so long as it comes from the proper source (Philosophy, aligned with true knowledge) as opposed to a fatuous or vicious one. However, even Philosophy's verses are regarded as merely a necessary vehicle to bring Boethius to a transcendent truth, a truth that he aligns with the relative transparency of prose. In contrast, Aldhelm's trajectory is toward rather than away from poetry, insofar as the *Carmen* was written after the prose version. Further, Aldhelm sees poetry as capable of embodying divinity in its very form. There is no such invocation in the prose *De virginitate,* which would seem to indicate that only the verse is Incarnational—words from the Word. While the prose version may hold up virginity as a sacrament of Christ's humanity, the *Carmen* offers its very form as another such sacrament.

SUPEREFFABILITY AND THE VERNACULAR WORD

As one might expect, vernacular poetics bear particular Incarnational potential, and the remainder of this chapter will be concerned with

the way supereffability is manifest in the vernacular word. Though my discussion of Bede has thus far only considered his treatment of scripture, both Bede and Aldhelm present similar cases in being English writers of the highest learning whose bodies of written work are in the language of learning (Latin), but whose attitudes, reputation, and writing allow glimpses of a vibrant vernacularity. My use of *vibrant vernacularity* intentionally invokes Jane Bennett's *Vibrant Matter* and thus gestures toward a relationship between the demotic vernacular and demotic matter in the authoritative discourse of the Middle Ages. Bennett seeks the agency and "aliveness" in inorganic agglomerations, rehabilitating, for Western philosophy, both nonhuman and nonanimate as somehow vibrant, playing a part in the cause-and-effect dance of the world.[24] In the hierarchies of medieval orthodoxy, both matter and the common tongue resided below the elevated ideals of the eternal and authoritative. Yet both could be rehabilitated by the Incarnation. This is often seen in praxis rather than in explicit theology. Here again I eschew reliance on explicit propositions in order to apprehend the embodied, implicit sense of things.

Bede's *Historia ecclesiastica* is an account, in the authoritative language of the church, of the national salvation history of the English. One of its most famous vignettes is Bede's story of Cædmon and the yoking of Christianity and vernacular verse. It schematizes the relationship of vernacularity and poetry to Bede's Incarnationalism. Bede's account of Cædmon joins Christian Eucharistic and Incarnational theology directly to vernacular poesis. In his story of the illiterate cowherd turned vernacular poet, both vernacularity and Christianity are joined in the body of Cædmon, whose sweet verses explicitly perform an Incarnational poetics. At the heart of the story, an angel of some sort visits Cædmon in his sleep and commands him to sing a song of the creation.[25] The request to sing of creation, specifically, is an opportunity to overwrite the Word, to recapitulate or harness the Logos, the Word that was with God in the beginning and through whom all things were made. Cædmon protests that he does not know how to sing but nevertheless produces what is sometimes presented as the founding poem of the English literary tradition, which we call *Cædmon's Hymn*. The newly minted—christened— poet is thenceforth able to sing verses of "much sweetness and penitence, in English."[26] The central miracle is the joining of sacred truth

(God's word) with vernacular verse. This is a very big deal in Bede's overtly nationalist history of English Christianity, as well as in English literary history, for it yokes the traditional Germanic verse form and its aesthetic and ethical values—its cultural capital—to the adopted, internationally ascendant religion of Rome and, conversely, the religion of Rome to vernacular verse (another chiasm parallel to *divinitas humiliata, humanitas exaltata*). England is revealed as blessed within the divine plan, since God has selected both an Englishman and vernacular verse as vessels for divine teaching. Both choices, furthermore, bear within themselves an Incarnational potential, as they recapitulate the relationship of humble chosen vessel to the glory of the divine.

Bede plays up the Incarnational resonance, for instance by emphasizing Cædmon's corporeality, opting for conspicuously physical terms for his quasi-apotheosis. Upon disclosing his new gift, Cædmon is instructed to take orders and enter the monastery as a brother, where he is able to take in sacred story and, "ruminating, like a clean animal," convert it into sweet-sounding song:

> But that one, all that he could learn by listening he would turn into the sweetest song, by re-remembering for himself and ruminating like a clean animal, and by echoing back more pleasingly, he made his teachers in turn his listeners. (Trans. mine)
>
> ------
>
> [At ipse cuncta, quae audiendo discere poterat, rememorando secum et quasi mundum animal ruminando, in Carmen dulcissimum conuertebat, suauiusque resonando doctores suos uicissim auditores sui faciebat.] (4.24, p. 418)

Thus, by God's granting, Cædmon takes in divine truth and, within the confines of his body, in a process evocative of intense physicality—digestion with all its attendant associations with the flesh and the belly in particular—produces "sweet" vernacular poetry. The parallel with Mary's conception of Christ should be clear. *Ruminatio* is a common trope in monastic literature, but its involvement here shows it to be used not in a hackneyed or conventional way as a dead metaphor, but rather in a way that makes use of its figurative meaning. Bede adds, for instance, "quasi mundum animal" ("like a

clean animal"), reinforcing the image of the animal chewing the cud and preventing an idiomatic leap straight to monastic contemplation. He keeps the emphasis on the body. Cædmon's verse production is also given the multiple reflective surfaces and iterative stages we recognize from modern theory as hallmarks of art: recalling within the mind what was heard, turning it about for oneself, transforming into beautiful form, teachers taking new roles as audience. There is not a monologic sound, a pure note, but a cascade of speech begetting more speech, and in this we glimpse the recursive potential of the Word, generating more words.

Bede ends the story of Cædmon with yet another Incarnational parallel, this one between the image of Cædmon's *ruminatio* and the eating of the Host. In the latter, less often discussed account of Cædmon's death, Bede shows Cædmon's verse-making to have been an analogue for the Word made flesh of the Incarnation. His death scene features a passage that closely reflects, in precise rhetorical echoes, Cædmon's earlier visitation by the angel. Bede tells us that Cædmon sensed his impending death and sought out a hospice for the dying. Once there, after a time of fellowship with the other inmates, he asks for the Eucharist, and, eating it, he is strengthened for his passage to the next life; in the same sentence, upon eating the viaticum and being strengthened, he asks if the hour is near when the brothers will awaken to sing. He says he will wait for that time, crosses himself, falls asleep, and dies. Most striking, perhaps, is the structural similarity between this scene and the scene of his earlier miracle, both of which involve: 1) a request, followed by 2) resistance, and then 3) an overriding reassertion (translations and emphases are my own):

Cædmon's singing for the angel (4.24, p. 416):
1) "Cædmon," inquit, "canta mihi aliquid." ["Cædmon," he said, "sing me something."]
2) At ille respondens, "Nescio," inquit, "cantare, nam et ideo de con-uiuio egressus huc secessi, quia cantare non poteram." [But he responded, "I do not," he said, "know how to sing; for that reason I left the feast to come here because I could not sing."]
3) *Rursum ille*, qui cum eo loquebatur, "*At tamen*," ait, "mihi cantare habes."
[*Again the one* who was speaking with him: "*Nevertheless*," he said, "you shall sing to me."]

Cædmon's request for communion (4.24, p. 420):

1) Et iam mediae noctis tempus esset transcensum, interrogauit, si eucharistiam intus haberent. [And when the time had passed midnight, he asked if they had the Eucharist within.]

2) "Quid opus est eucharistia? neque enim mori adhuc habes, qui tam hilariter nobiscum uelut sospes loqueris." ["What need is there for the Eucharist? For you shall not yet die, since you speak with us so cheerfully, like one who is perfectly healthy."]

3) *Rursus ille*, "Et tamen," ait, "afferte mihi eucharistiam." [*That one again*: "Nevertheless," he said, "bring me the Eucharist."]

In each passage, a request for the Word is rebuffed and then repeated: "rursum/us ille . . . at/et tamen" ("that one [said] again . . . nevertheless"). The passages also share a bodily transformation of the Word, whether by *ruminatio* or *viaticum*. The death scene foregrounds transit, the movement between realms of existence implied by the term *viaticum*, the morsel one takes "for the road," to be conveyed as by a vehicle from one place to the next, which, as Kramer has explained, would have indexed the movement of Christ's body at the Ascension. By *vehicle* I also suggest, as I think Bede means to suggest, the conveyance of metaphor, which, thanks to the Incarnation, is more than metaphor. As the *viaticum* transforms or transports Cædmon, so does the Word within him transform. Thus the process of translation in language that is Cædmon's signature talent is made to reflect the transit to salvation effected by Eucharistic celebration. These transformations echo the founding transformation of the Incarnation itself, which involves Mary hearing the words of the Annunciation and giving form to Christ. In the relationship between Cædmon's vernacular rumination and the ingestion of the Host, both of which take place within the body of Cædmon, Bede suggests the Incarnational quality of Cædmon's verse. The digestive, transformative process of poesis is both byproduct and reiteration of the Incarnation—of the joining of Logos and humanity—as Cædmon's verse seems to constitute a perfectly acceptable parallel, and a chiastic response, to the mysteries of Eucharistic consumption: as Christ made the leap to humanity in the Incarnation, meeting in the belly (synecdoche for flesh), as it were, of the believer, so humanity, reciprocally, may reach to him. Here again we see the chiastic nature of Insular Incarnationalism in the founding myth of vernacular poetic words joining Christian truth.[27]

As I have noted, Bede's text emphasizes not only the corporeality of Cædmon's rumination but also its transformative properties, lingering upon the traverse of ontological states in a way that reflects upon the complexity and inherent paradox of the Word that was made flesh. In the final details of Cædmon's death, Bede arranges something of a semiotic tableau, presenting the dynamism of the Incarnational presence as manifest through Cædmon's person. He deploys a set of relationships among flesh, the cross, and words as they all pertain at once to various substances, to signs that refer, and to the lord himself:

> And in this way, fortifying himself with the viaticum, he prepared to enter another life; and he asked how near the hour was when the brothers should wake to say evening lauds to the Lord. . . . And signing himself with the sign of the holy cross, he reclined his head on the pillow, and softly falling asleep, thus ended his life in silence. . . . And that tongue, that had composed so many wholesome words in praise of the Creator, and also last words in praise of him, by signing himself and commending his spirit into his hands, was stilled. (trans. mine)

> [Sicque se caelesti muniens uiatico, uitae alterius ingressui parauit. Et interrogauit, quam prope esset hora, qua fratres ad dicendas Domino laudes nocturnas excitari deberent . . . Et signans se signo sanctae crucis reclinauit caput ad ceruical, modicumque obdormiens, ita cum silentio uitam finiuit . . . Illaque lingua, quae tot salutaria uerba in laudem Conditoris composuerat, ultima quoque uerba in laudem ipsius, signando sese, et spiritum suum in manus eius commendando, clauderet.] (4.24, p. 420)

This passage forms another chiasm, moving from substance (tongue) to language (*salutaria verba*) to gesture (the sign of the cross) to silence and back again in such a way that the ontological states of matter, sign, spirit, and flesh are thoroughly ambiguated. At the center is the gesture of the sign of the cross. An iconic (nonarbitrary), or symbolic, sign, it bears a similarity to its referent. It is also physical— made with the hands on a body, which itself resembles the body that was crucified. Thus the sign of the cross occupies a position somewhere between linguistic sign and physical reality, obviating a clear

boundary, for example, between spirit and flesh. Further, instead of ending on a gesture toward the transcendent, which would enact a teleology toward the spiritual realm, the account ends with a rhetorical flourish that brings the focus back to Cædmon's tongue, a metonym for poetic production while at the same time a literal, physical part of the body. The tongue is indexed by the main verb postponed to the end of the sentence ("Illaque lingua . . . clauderet"), ending the passage with a reassertion of that very tongue's importance in a way that does not privilege or distinguish between the physicality of the fleshly muscle and the sanctified words it metonymically represents. Thus, in this moment of Cædmon's death, we see the problematics of the Incarnational mystery teased out into some of its constituent parts. The cross was a real historical object, but it is also a potent sign. The word may invoke an invisible reality, but it is spoken on the tongue. The sign of the cross refers to a particular holy body, but it is made upon a body that shares the holy body's nature. These paradoxes converge in the form of the Word.

Irina Dumitrescu has drawn attention to the importance of the English tongue for Bede, both as a part of individual Englishmen and as a term for vernacular language. She reads the story of Cædmon's poetic inspiration alongside John of Beverley's healing of a mute and languageless youth in book 5, chapter 2, as two instances of Christian teaching "[empowering] . . . the English vernacular."[28] Dumitrescu traces, further, the importance Bede seems to place on the English tongue as a semiotic organ, giving it rather the rhetorical prominence for Bede that Logos has for Augustine, with the crucial implication that the most semiotically prominent object for Bede is not ineffable, not a purely theoretical construct (Logos, the transcendental signified), but an inherently ambiguous sign (referring to a body part but also to language, to flesh as well as to something abstract). Bede notes that his own tongue was healed (of an ambiguous malady) while singing the miracles of St. Cuthbert.[29] Poesis here has healing properties located within the body: Bede sings the miracles and they miraculously heal his singing tongue.[30] The tongue is the locus of language for Bede, and its ambivalent status as physical and abstract is an apt emblem for the embodied nature of poesis and its relationship to the Incarnational idea of a Word that is also "flesh." This set of assertions appears elsewhere in Old English writing, as when the Vercelli X

homilist cites Christ's fleshly mouth having said that whenever the word is preached the lord is present.[31] The vernacular tongue is a metonym for the Incarnate Word.

Another metonym is the cross. If the tongue is an organ of language and poetry, the cross is a symbol, iconic and meaningful but not verbal. It thus stands on the border of signification, pointing the way to the Word. The youth, mute since birth, who is healed by John of Beverley has the sign of the cross made upon his tongue before he is instructed to repeat a single vernacular word ("yes") and commence with a recitative conflation of language-learning and literacy (first letters, then syllables, then words, and so on).[32] The gesture of the cross upon the youth's tongue echoes the gesture of the cross that the dying Cædmon makes just before the final stilling of his tongue, and in this echo one may see how the gesture of the cross forms a gateway to (and from) the symbolic order.[33] The youth enters language through the gesture upon his tongue, since it enables him to speak his first word. The cross is also the gesture that ushers one out of language, as it stills Cædmon's physical tongue so that his soul may depart. Most significantly for its status as symbolic gateway, the cross indexes the Crucifixion, the event in which Christ's Incarnate, conjoined self showed its seams. Word and flesh were sundered for a time. That an Incarnationally disruptive moment should mark the borders of the symbolic shows the intimate relationship Bede imagines between language itself and the Word made flesh.

Bede's elaboration of a sacramental poesis exemplifies his valorization of the vernacular and of poetry in material-cum-spiritual terms. For Bede, poetic language is not a fallen form but a vessel for the divine. The uttered word—and certainly Cædmon's vernacular, poetic word—produced by a tongue sanctified by the sign of the cross and issuing from a body inspired with the capacity for rumination, partakes of the Word made flesh, as the Eucharistic parallel with Cædmon's poetic inspiration confirms, and the sweetness of that word is the mystery of the hypostatic juncture itself, the joining of human and divine. Bede's treatment of vernacular language and vernacular poesis resists dissolution into a transcendental nullification of difference. As Dumitrescu points out, the final act of the Beverley miracle sees the boy refusing an invitation to enter the Church, opting instead to return to his (secular, vernacular) home. So, too, does Cædmon's death

end with a focus on the vernacular and the material, with the silencing of his tongue (*clauderet*). Bede's vision of the salvific effects of Christianity even upon the English tongue nevertheless leaves room, as Dumitrescu concludes, for resistance and reality, for speaking back and speaking up, and demonstrates a vision of Britain's place within Christendom as more than an absorbed, colonized territory.

I have devoted many pages to Bede's elaborate Incarnational poetics, but it is helpful to consider (I hope) at such length his treatment of the relationship between poetic language and the Word because it confirms and contextualizes what poetic language actually *does* elsewhere in the corpus. In widely disparate texts and contexts writers use poetic form to construe the esoteric truth of the Word. For example, the Cynewulfian poem *Christ II*, on the Ascension, links prophecy of Christ's Incarnation with "conception" in a way that explicitly invokes and enacts an Incarnational poetic.[34] Lines 627 to 632 of the poem summarize the relief brought to fallen humanity by the Incarnation and later the Ascension (note, not by the death and Resurrection):

Hwæt, us þis se æþeling yðre gefremede
þa he leomum onfeng ond lichoman,
monnes magutudre! Siþþan meotodes sunu
engla eþel up gestigan
wolde, weoroda god, us se willa bicwom
heanum to helpe on þa halgan tid.

[Lo, the noble one made this easier for us when he assumed in limbs and body the race of man! Afterward the creator's son would ascend to the angels' land, god of hosts, the will came down to aid the lowly in that holy time.] (trans. mine)

I discuss this passage in more detail below, but the Incarnation sets in motion here a salutary traverse of the boundary between earth and heaven. The poem shifts abruptly from this New Testament summary to the Book of Job and a prophetic reading suggested by Gregory the Great, in which the naming of Christ coincides with both conception and metaphor, abetted by the formal feature of rhyme (emphasis mine):[35]

Bi þon giedd awræc Iob, swa he cuðe,
herede helm wera, hælend lofede,
ond mid siblufan sunu waldendes
freonoman *cende*, ond hine fugel *nemde*,
þone Iudeas ongietan ne meahtan
in ðære godcundan gæstes strengðu.
 (lines 633–38)

[About that Job made a song, as he could, praised the savior, lauded the leader of men, and with familiar love *conceived* the name of the wielder's son and *called* him a bird, which the Jews could not perceive, with the strength of the divine spirit.] (trans. mine)

This passage draws upon Gregory's reading of Job 28:7 as a reference to Christ, in which the bird prophecy anticipates the exaltation of humanity that is confirmed by the Ascension: "In respect to this raising up of our body Job referred to the Lord as a bird" (233) (the poem goes on to amplify the exegetical metaphor of the bird in flight as a master of the domains of heaven and earth). In the rhyming pair "freonoman *cende*, ond hine fugel *nemde*" ("*conceived* [his] true name, and *called* him a bird"), Cynewulf condenses Gregory's logic into a poetic figure. It conflates Christ's Incarnational humanity (*cende*, "conceived") and his verbal nature as the Word (*nemde*, "named") within the also-verbal act of poetic prophecy. The multiple natures within the hypostatic union are expressed and embodied in Cynewulf's poetic language. Job's prophetic power is twofold at least, making songs and "conceiving" of the divine name.[36] Conception links this knowing to the conception of the Virgin, making the prophetic and poetic knowing itself an Incarnational act. This Incarnational conception is further linked to prophetic naming through the rhyme between *cende* and *nemde*. The two verbs are alike in form, embodying the asserted likeness between conceiving (of) the future savior and naming him in metaphorical, allegorical words. Job's prophetic naming is a kind of giving flesh to the Word before the Incarnation, and Cynewulf's (or Cædmon's, or Aldhelm's) later poetic namings reflect back upon it, supereffably.

Cervone identifies similar instances of poetic embodiment and the projection of the Word backward or forward in time in Middle English Incarnational poetics. She highlights a passage in *Piers Plowman*,

for example, in which *Imaginatif* projects from the moment of the Incarnation, not into the past and the word of prophecy by which Christ's coming was foretold, but rather into the future and the word of scripture, by which Christ's coming is learned of and understood. The linking of different temporalities and different ontological categories enabled by language is a feature of the Incarnational poetic mode:[37]

> For the hey holi gost heuene shal tocleue
> And loue shal lepe out aftur into þis lowe erthe
> And clennesse shal cach hit and clerkes shollen hit fynde.
> (14.84–86; quoted in Cervone 114)

In this passage, the holy ghost "cleaves" heaven and love "leaps" out (a leaping Cervone traces back to *Christ II*, which expands upon the motif it takes from Gregory). Love, itself a metonym for Christ, leaps into "cleanness," a metonym for the Virgin's pure flesh, which actively "catches" it. The verbs themselves are oddly physical and visual, this leaping and catching rendering vivid the abstractions of Incarnation and conception. But even having tracked the chain of actions to the point of the Virgin's catching, a reader must make an extreme turn in the final clause, where all of a sudden not the biblical actors but "clerks" appear. It is they who "shall find" the final form of the Incarnation, the word. It travels, as "love," from the heavens to "cleanness" to the "clerks" in a deceptively short sentence, traversing several levels of ontology and temporality, ending on the provocative verb that is also a challenge: find it. That is, find it *here*. Clearly, the verbal acrobatics of the passage are indicative of their Incarnationalism, but so, too, does the passage explicitly confirm the link between the conception and scriptural words. Cleanness "catches" love, and from there the clerks find it. Job conceived Christ's holy name and called him another one (a bird). An Incarnational poetic invokes both the physical nature of Christ's embodiment and its intimate relationship to words, specifically, to poetic words capable of the "fullness" of polysemy and metaphor and of the joining of temporalities in prophecy and scriptural narrative.

The Old English corpus itself provides a formulation structurally similar to the descent motif I just discussed in *Piers Plowman*. Elsewhere I have written about the poetic strategies of Blickling Homily

IX/Vercelli X, which famously names Christ *se goldbloma* ("the golden blossom"), and I will discuss it again in chapter 3.[38] It contains a passage quite similar to that in *Piers*, in which the holy spirit (not the Third but the Second Person) descends to the Virgin from an opening in the sky:

> Heofenas tohlidon, & seo hea miht on þysne wang astag, & se halga gast wunode on þam æþelan innoþe, & on þam betstan bosme, & on þam gecorenan hordfæte. (*Blickling Homilies* 105)

> [The heavens opened, and the high might descended to this plane, and the holy spirit dwelt in that noble belly and in that best bosom and in that choice vessel.] (trans. mine)

The heavens open at the top of the sentence here as they do in *Piers*, and the *hea miht*, rather than *loue*, descends, contained in a series of terms for the Virgin. Instead of cleanness catching and clerks finding, here the verbal movement is from noble "belly" to a less visceral (*viscera* being literally the belly, the guts) "breast/bosom" to a final, inorganic "chalice" (literally "treasure-cup"). As I have argued, this trajectory effects a reverse, chiastic uncarnation or immaculation by which Mary's body begins as womb and ends as precious vessel. The agent of that change is the Word which has taken up residence there.

Cervone associates the capacity of language for intensive transformationalism within a grammatically coherent sentence with linguistic dilation, an extending of a linguistic term while various changes of reference or connotation or even syntax are rung upon it (80–84, inter alia). It is an important feature of her Incarnational poetics and of the supereffability of the Incarnate Word. I return here to the Incarnational lines just before the Job passage in *Christ II* quoted above, as they exhibit a kind of dilation that involves the formal properties of Old English verse embodying more than they say referentially:

> Hwæt, us þis se æþeling yðre gefremede
> þa he leomum onfeng ond lichoman,
> monnes magutudre! Siþþan *meotodes sunu*
> engla eþel up gestigan

wolde, *weoroda god,* us *se willa* bicwom
heanum to helpe on þa halgan tid.

> (lines 627–32)

[Lo, the noble one made this easier for us when he assumed in limbs
and body the race of man! Afterward *the creator's son* would ascend
to the angels' land, *god of hosts, the will* came down to aid the lowly
in that holy time.]

The normal mode in Old English prosody is, famously, an appositive
style, in which a single syntactic actor (often a noun phrase) is "re-
peated" by appositive alternatives filling the same syntactic role
within the same sentence.[39] To many readers, and certainly in the case
of poorer poetry, the effect is a tedious redundancy, endless repetition
of the same idea. In good poetry, however, apposition can have pow-
erful effects, as in *Beowulf*, where appositive phrases are often ironiz-
ing, casting doubt upon what has seemed a straightforward mention
of a name or action. In this passage from *Christ II*, apposition enacts,
instead of irony, an Incarnational mystery. After Christ's Incarnation
is invoked—his taking of the "limbs and body" of mankind—the sen-
tence that follows enumerates in three appositive phrases the three
Trinitarian persons that accompanied Christ's Incarnational embodi-
ment: *meotodes sunu, weoroda god, se willa*—the Son, the Father, and
the Holy Spirit (often referred to in exegetical tradition as the will
of the son and the father, going back to Augustine's *De Trinitate*). The
first two phrases are clearly and necessarily in apposition, as there is
no other way to read the nominative *god*: "meotodes sunu . . . astigan
wolde, weorode god." The subject of *astigan wolde* ("wished to as-
cend") is both *meotodes sunu* ("the ruler's son") and *god*. The refer-
ence of *se willa* is more ambiguous syntactically in that it has its own
verb (*bicwom*), but it is ambiguous in a way that reinforces its identity
with the original "son" as well as in one further respect. *Willa* nomi-
nalizes the verb *wolde* in the phrase just before. The will is the will
that is willed by the father and the son—Trinitarian theology enacted
in poetic form. Syntactic ambiguity further imbricates *se willa* with
the other Persons. *Se willa*, as subject of a separate clause, may be read
independently in a way that suggests the Holy Spirit. The Spirit
would descend "heanum to helpe" ("as an aid to the lowly") after the

Ascension. But the passage could also be read as a recapitulation of the prior clause, making *se willa* refer to the Incarnate lord (already both the son and the father) who had both come down to us and become us in order to help us. As in so many instances of poetic ambiguity, the choice of interpretation is not either/or but both/and. *Se willa* is both the Holy Spirit, which descended at Pentecost, and the Son who descended into a human body. The first sentence invokes the Incarnation, and the second sentence, using the same words, at once confirms the culminating events in the drama (Ascension and the granting of the Holy Spirit) and articulates the Trinitarian unity (the Son is God is the Will). Finally, the will is what is willed by the son and the father; it is their action personified. Poetic language embodies these mysterious truths.

Early Incarnational poetics shows what Bynum has averred for medieval Christian materiality more generally, which is an underlying (not doctrinally explicit) tendency to see matter, including language, as capable of embodying divinity. This is the place Cervone cannot quite go in her treatment of late-medieval English writers. For all her focus upon the capacity of the vernacular to harness supereffability in order to conduct poetic thought experiments, Cervone's analysis ultimately maintains the Augustinian distinction between the divine and the sensible, between the Word and words. For Cervone, the vernacular meditations on the paradox of the Incarnation remain representations, analogies alone, however much they act as vehicles for approaching the divine, because she relies upon Augustine's language theory and Trinitarian theology as the basis for the vernacular poetics she surveys. The evidence that forms the basis of the present book instead suggests that supereffability was a virtue of vernacular representation long before the later Middle Ages, and that it was conceived of in Incarnational terms, not by analogy but by substance, by the transitivity of the glorification of Christ's humanity.

In the Augustinian formulation, the divine is ineffable and utterly separate from the created world (though everywhere present). Insular writers such as Bede, Aldhelm, and Cynewulf accept the invisibility of the divine in its pure form but focus on the Incarnation as a making visible to the world the glory of that divinity. Where, for writers in the Augustinian tradition, subsequent attempts to articulate divine truth must always in some sense fail (the divine being ineffable and anything sensible a simulacrum thereof), Insular writers suggest that

they may be sacramental, infused with the light of Christ's humanity. Where Augustine sighs at the enigma of human epistemology in relation to the divine, Insular writers seem energized by it, not because there is an absolute distinction between the two kinds of enigma, but because the two views of the human have different emphases. Augustine cleaves to the imprint of the divine within his own mind, but the Insular writers I have surveyed consider their minds less problematic on the whole, in part because they focus on their humanity as having been shared and elevated by Christ. After all, even the Augustinian tradition asserts that in Christ, God became man so that men might become gods. This chiasm had a special purchase in early Britain, as the sacraments of the humanity of Christ served as manifold vehicles for the perception of the divine and thus the ameliorating illumination of humanity generally. Where Augustine's trace is an image of the divine, Insular thinkers posit a contiguous relationship between earthly manifestations of Christ's Incarnational light and Christ himself—by which an Incarnational instance (object, image, word) is not a mere image of the Incarnate Second Person but his very hypostatic substance. As Christ's divine substance retained its nature in the Incarnation, inseparable from God, so too did his human substance retain its tie to the rest of us. Furthermore, the Christ who became human is, in Insular writings, also the Word who becomes words (and signs more broadly), a formulation potent to a culture whose learned traditions were intensely verbal. Much esoteric writing and visual representation, as I argue in the chapters that follow, participates in an Incarnational semiotics devoted to these mysteries.

Seeing Double

Representing the Hypostatic Union

The point was the power of the materials to evoke, to conjure up—to represent not so much in the sense of "looking like" as in the sense of "manifesting the significance of."
—Caroline Walker Bynum, *Christian Materiality*

Potius angelica quam humana diligentia . . . composita.

[The work not of men, but of angels]
—Gerald of Wales, *History and Topography of Ireland*

The distinctiveness of Insular style has long been recognized.[1] In both literature and visual art, the formal (and intellectual) ebullience of Insular writers and artists was so marked that it drew the ire of sober authorities, whose iconoclastic affiliations or commitment to Augustinian plain style or to high classical decorum made the complexity and copiousness of Insular art—which Umberto Eco associated with the "baroque"—unacceptable.[2] But in a tradition that understood the Incarnation as having glorified visible form, form and representation bore a potent capacity to embody the divine, to perform, as it

were, sacraments of Christ's humanity. In this chapter I consider the way that visual representations depict and in some cases embody the visible Incarnation. Images are uniquely suited to represent the simultaneous duality of Christ in his two natures, divine and human, and the Celtic and Germanic traditions were well prepared to embrace the ambiguity necessary to embody the Word. Insular styles, deriving from before the adoption of Christianity, have ambiguity and baroque intricacy as fundamental structural principles.[3]

The images I consider in this chapter demonstrate supereffability as a basic function, with their multiple, even endless permutations exploring Christ's dual nature as a mystery and an object of contemplation. The chapter will draw heavily upon that great monument to early Insular book art, the Book of Kells, because, as Heather Pulliam has argued, that book is devoted to the synergy of word and image in a way directly related to the Incarnation.[4] Kells presents itself unabashedly as a sacramental object, showing most fully and completely what is visible elsewhere only in discrete instances: that the "double Incarnation" of the Word's relation to words, particularly those of the gospel, was taken very seriously and, furthermore, involved a kind of recursion by which the Word produced words that were also *him*.[5] The result can be, as it is in Kells, a dizzying, kaleidoscopic quality with fractal properties, as Meyer Schapiro noted in the 1960s, before the widespread currency of fractal mathematics.[6] Kells, along with the other monuments to the Incarnational mode, displays a particular devotion to the irreducible complexity of the Incarnation, to the opacity, in terms of occlusion and texture, that it entails. A visible, sensible divinity achieved its chiastic embrace by means of becoming double, joined, ambiguous. Hybrid images, historiated text, mixed media, and heteroglossia are all put to the service of contemplating such an esoteric—but perhaps also culturally familiar—point of doctrine.

On the most basic level, Christ's Incarnation was understood, as I discussed in the previous chapter, as the making visible of what had been invisible, as the taking on of "flesh" as a cloak or covering. This is rendered in an extremely clever way in the Durham Ritual (10th c.), as Sarah Larratt Keefer has suggested, on folio 59r and 59v ("Use of Manuscript Space" 101–4; see figs. 2.1 and 2.2). It may be a youthful Christ who is waving out from behind a vellum patch on the front side (59r) and a bearded Christ who is waving in an exactly mirrored position on the flip side.[7] The youthful Christ points down to a fish

and the bearded Christ to what Keefer speculates to be bread, but which I suggest may be a Eucharistic wafer.[8] Thus, out from behind a patch of skin that interrupts the seamless surface of the vellum page to call attention to its material surface *as skin*, someone has drawn what may be Christ—twice—in mirrored positions that suggest both identity and transformation. The youthful Christ is Christ as he appeared on earth, and he points to the fish, with which he fed the multitude. The bearded Christ is, perhaps, Christ glorified, and he points from behind his flesh-patch to the Host, which is what he feeds us with now, after his Ascension.[9] This striking use of the literal flesh of manuscript vellum to represent the flesh of the Incarnation links the Word to written words in a literal, physical way. It also, again literally, gestures (in the figures' gesturing) toward further iterations. The youthful Christ's gesture toward a fish not only indexes his feeding of the multitude but also the fish symbol that early came to stand for Christ himself, often indicating his divinity.[10] Fish, Eucharist, pre- and post-Resurrection Christ, vellum surface, and the liturgical words of the manuscript are all brought into intimate association here in a way that may be playful but is also resonant with meaning. The Incarnation brought the Logos into visible form by the donning of the flesh-cloak, here rendered starkly by the grafted patch of skin. It also, however, joined two natures, and doubleness or mirroring itself is the headier significance of these Durham images. There is not one correct or essential image of Christ in the flesh; rather we see two sides of the same flesh-page, mirroring one another, the same but different, and they point to two further objects associated with them, in some ways the same, but also distinct.[11] Christ's taking on of flesh is not a single event but an inception of the union of disparate things in a way that instantiates difference and iterability through its rehabilitation of form. Ultimately, it may be significant that these images appear in a liturgical book, suggesting sacramental participation. The skin of the vellum patch, in its rupture from the smooth vellum page, provides a momentary revelation of Christ in his various iterations, within and appended to the language of the liturgy—emerging, that is, from the very flesh that contains the liturgical words.

The marginal revelation of Christ in Durham provides what turns out to be a complex and multivalent example of Incarnational semiotics. Christ's double nature is elsewhere seen in images that simply combine two things. The famous "fish-man" image on folio 201r of

Figure 2.1. Durham Ritual, Durham Cathedral Library MS A.IV.19, fol. 59r. A figure, likely Christ, gestures from behind a vellum patch. Published by kind permission of the Chapter of Durham Cathedral.

Figure 2.2. Durham Ritual, Durham Cathedral Library MS A.IV.19, fol. 59v. The reverse side of the vellum patch. Published by kind permission of the Chapter of Durham Cathedral.

the Book of Kells, for example, depicts the Incarnate Christ as a kind of merman, with a human torso and a fish tail that bifurcates into foot-like fins at the end (see fig. 2.3). Above the head, attached to the figure's hair, sit three birds, possibly peacocks (in Kells, as elsewhere, a symbol for Christ), all connected to one another as though interlaced, whose feathers swirl into what may be Eucharistic wafers.[12] Below the fin-feet of the "divine" part of the figure (since the fish is the divinity, joined to the torso's humanity), three peacocks stand unattached to one another and unattached to the figure, with no circular objects. The human part of the fish-man crosses his arms awkwardly, one under the other, gesturing out to the same side, and one hand clasps the crossbeam of the *t* in *fuit* (the text is the genealogy of Christ in Luke 3). Clearly an abundance or excess of signification surrounds this depiction of the Incarnation. At core it represents the joining of Christ's two natures, human and divine. Indeed, the emphasis is upon joining per se. The joined birds above the figure contrast with the unjoined ones below it, placing the composite fish-man Christ centrally as a kind of answer to the question of juncture or disjuncture. The intense joining represented by the Q's in the vertical repetition of *Qui* down the left side of the page reinforces joining as the focus of the page. The repeated letters are interlaced inextricably with one another. Further, they appear animated by the same Incarnational forms that appear throughout the Book of Kells, for they have bird heads and quadruped feet, and off to the left of all but the first few at top and bottom, circles (always, in Kells, possible Eucharists) contain triple dots that signify the grapes of the true vine. This genealogy page thus does more than record Christ's lineage and depict his two natures. It schematizes the Incarnation, construing the implications of Christ's appearance at once in a human lineage and in a hypostatic union between human and divine. In other words, we see in these intensely conjoined *Qui*'s the way we (imagining ourselves as original audience for the manuscript) partake of Christ's conjoined humanity, both as humans born to a human lineage and as participants in the sacraments.

Relatedly, in many instances in the Book of Kells the conjunction *et* ("and") receives illumination, specifically illumination that conjoins Christological elements. A striking example is on folio 95r, where the torso of a human figure pops out of an *et* that introduces Christ's speech, a bird forms the bulk of the *e* into the *t*, and an ornate cross

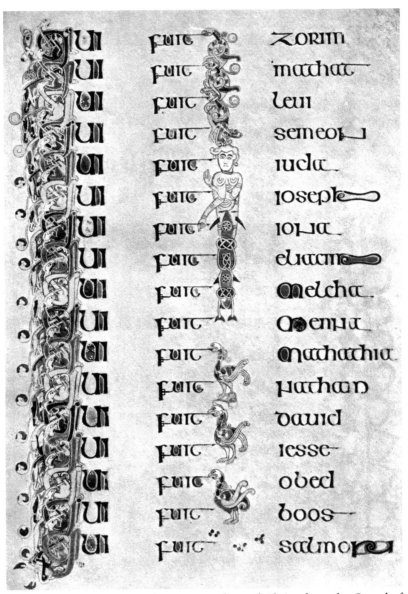

Figure 2.3. Book of Kells, fol. 201r. Genealogy of Christ, from the Gospel of Luke. Alamy.

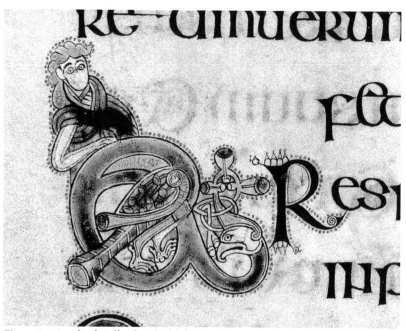

Figure 2.4. Book of Kells, detail of fol. 95r. *Et* introducing the speech of Christ is populated by several images. © The Board of Trinity College Dublin.

forms the top of the *t* (see fig. 2.4). Thus, Christ's humanity, his divinity, and the cross are combined to form this graphic, linguistic conjunction that gestures toward the actual speech of Christ in the gospel. The multimodal punning is playful but also profound. A linguistic conjunction (*et*) joins in its graphic form several signs associated with Christ's nature. It also performs as a word, which participates in the nature of the Word in an overdetermined and recursive way because it marks the speech of Christ, as depicted or reported in the gospel words.

On folio 96r a human figure forms the *T* of *Tunc*, reaching to grasp the neck of a peacock (see fig. 2.5). *T*'s are often vehicles for the Christ-heads that emerge, as Pulliam notes, throughout the manuscript, possibly because *T* is an obvious emblem for the cross (96–117).[13] The *et* that joins the hypostatic Christ with the cross visually on folio 95r (above) makes this association explicit. The 96r "human-imated" *T* appears in a passage in which Jesus instructs that many are called, but few are chosen ("multi enim sunt vocati, pauci vero electi"; Matt. 22:14). "Chosen" (*electi*) sits alone on the line that is otherwise

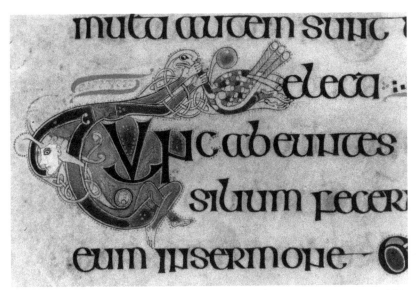

Figure 2.5. Book of Kells, detail of fol. 96r. A Christ image grips one of his avatars, the peacock. Alamy.

filled in with orange design work, next to the peacock that is grasped by the human figure forming the *T* in the line below. The elect are privileged to witness Christ's divinity "face to face," as Paul avers. Thus, *electi* appear in contact with the peacock of Christ's divinity, which is in turn connected to his humanity, the anthropomorphic *T*. Certainly there is no privileged plane of representation here. We are not in the realm of pure language, or purely "representational" visual mimesis, or pure iconography. Modes are fundamentally mixed.[14] This is one of the central mysteries of the Book of Kells, one that has been recognized for the enigma that it is, but which I think deserves to be recognized further for its relation to *that enigma*, the riddle of the Word made flesh.

Another relatively simple though multimodal representation of Christ's duality is the Temptation page from the Book of Kells, folio 202v, where Christ's upper body is human and his lower body is apparently a physical building, at once the temple he is set atop by the devil and the typologized church that will form his future, expanded "body" (see fig. 2.6).[15] Christ's physical body (indicated by its realism and also by the grapes that cover his arms, which, throughout the manuscript, seem to indicate the Incarnation, the true vine) is tempted

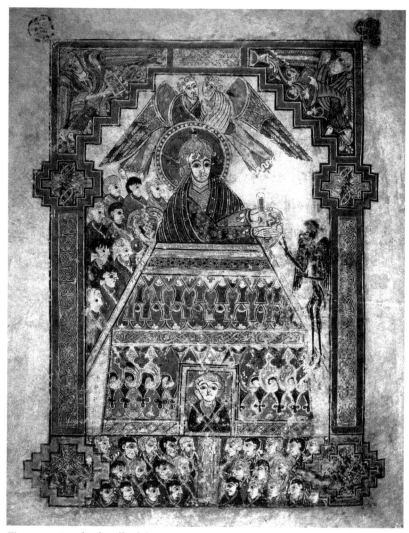

Figure 2.6. Book of Kells, fol. 202v. Alamy.

by the devil in the desert, but at the same time that body forms the
apex of the church, a structure built upon the "rock" of Peter, who (in
my reading) holds two flabella at bottom center, and whose founda-
tion is a group of apparent monastic brothers, who all look inward to-
ward that central authority.[16] A group of lay congregants is gathered
behind the Christ/church, who shields them from the devil. They

have in their midst a Eucharistic wafer, symbolic again of Christ's physical presence and protection. I say more below about this page and its Eucharistic and scriptural imagery, but I mention it here to note the representational mode of combining Christ's physical, historical body with the typological image of the church to form a whole. That whole is not internally consistent with regard to its representational field. It does not follow Aristotelian rules. The image at once illustrates the Temptation scene and expounds a larger set of theological principles.

The images discussed above depict Christ's duality, but it is not simply the joined human and divine that we see in Kells or in other visual representations. Rather, as Pulliam argues in the case of Kells, a systematic logic governs the representations, one that extends meditation upon Christ's being to the "double Incarnation" of the gospels, linking both body and scriptural words to the sacraments (206–7). For Pulliam, as for Cervone's Incarnational poetics, this link remains an "almost" or "as if," since both scholars rely upon Augustine's Neoplatonic framework whereby the inaccessibility of the Logos is paramount. What I wish to emphasize, however, is the recursive generation of the word from the Word, as Aldhelm suggested in seeking "verbum de Verbo," "the word from the Word." The word partakes of the flesh of the Word in a way that makes the word itself sacramental, and in Kells, this takes the form of explicit and sustained treatment that harnesses the different gospel writers and their distinct relationships to Christ.

Perhaps the clearest rendering of the sacramental nature of the gospel word occurs in the scheme comprising the four gospel incipits in the Book of Kells.[17] These portraits and incipit pages collaborate to form a meditation upon the gospels, which they themselves of course are, as seen from four distinct perspectives. Matthew and John each have a facing-page opening with a portrait of the author facing an ornately illustrated and practically unreadable incipit for the book. Mark and Luke begin with portraits of all four evangelists (as represented by their symbols) facing similarly ornate incipits. The incipit pages all share key structural elements that together ring changes upon the idea of the Word that was made flesh. As all recent commentators suggest, the book was meant for display during services, and initiate viewers (that is, members of a monastic community) would have been able to contemplate the deep mysteries of the Incarnation

using the images in these pages, both alone and as compared to one another in the memory.[18]

Matthew's gospel, as first of the synoptic group, is traditionally understood to treat the humanity of Jesus Christ as John's gospel treats his divinity. These two thus bookend the gospels and also suggest a telos, from an understanding of Christ's human nature to that of his more esoteric divinity. In the portrait of Matthew, the evangelist holds the gospel book in his left hand, while his right hand reaches in underneath his cloak (see fig. 2.7). The gesture resembles that of someone reaching into a blazer for a pen, but however fitting that would be, Matthew is not reaching inside his robes to fetch his writing quill. Rather, the gesture seems to emphasize his contact with his body and even his "cloak," as, again, Christ's human flesh was often figured, a possibility emphasized by the patterning on his cloak, which resembles the clusters of grapes denoting the "true vine" of the Incarnation elsewhere in the manuscript. Christ's flesh as "cloak" appears elsewhere in the incipit scheme, as I will discuss below, and elsewhere in the manuscript, for example, on folio 183r, a full-page illustration corresponding to the Crucifixion scene in Mark, in which Christ appears to be split apart by the Crucifixion (see fig. 2.8). He is in the process of departure, with his head and shoulders in the upper right corner, looking upward toward heaven, while the prominent bottom folds of a cloak and two fainter feet remain down at the lower left corner, to be left behind. Matthew's contact with his flesh-cloak on folio 28v seems, then, to emphasize Christ's humanity and even the chiasm, as the one hand reaches under the robe while the other reaches down in the opposite direction, holding the gospel book.

On the incipit page facing Matthew's portrait, a figure, possibly the evangelist again, stands holding his book, next to the ornately drawn *Liber generationis* ("book of the genealogy [of Christ]"; see fig. 2.9). In a little pocket next to the *L*, it appears that a divine torso, with no face but shining yellow hair and wings, is being stuck together with a pair of human legs; the two parts are at an odd angle to each other, which, I suggest, might be read as an indication of "artifice" or non-naturalness, the bringing together of two disparate natures in the Incarnation. Confirmation that this is what is intended may reside in the grape clusters (triple dots) that adorn the space in which the legs dangle. The *B* of *Liber* takes the shape of an enormous jug or chalice,

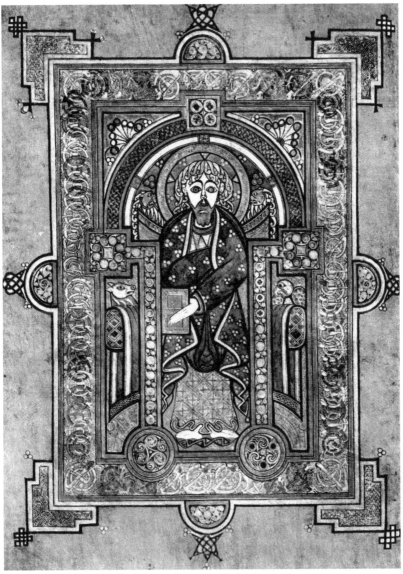

Figure 2.7. Book of Kells, fol. 28v. Portrait of Matthew. Alamy.

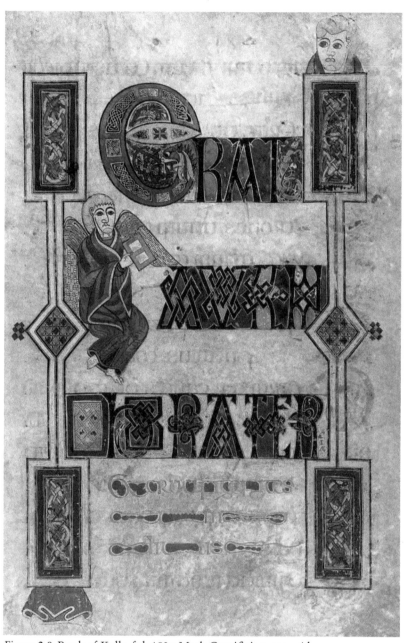

Figure 2.8. Book of Kells, fol. 183r. Mark Crucifixion page. Alamy.

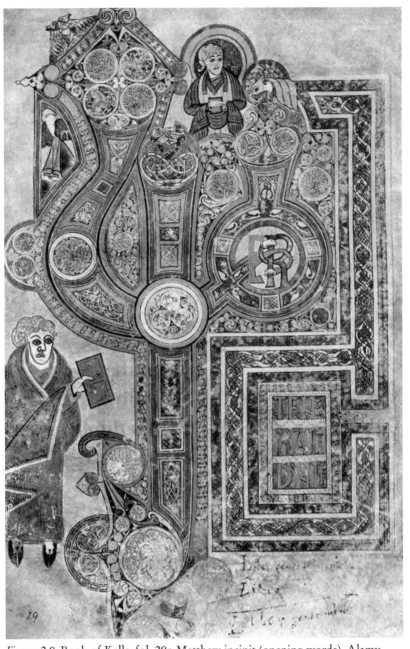

Figure 2.9. Book of Kells, fol. 29r. Matthew incipit (opening words). Alamy.

a form that recurs throughout the manuscript. The *E* and *R* of the word reside in the belly of this vessel, and a lion is speaking or spewing into its top. If the emphasis of the Matthew pages is upon Christ's humanity, then the chalice here makes the sacramental nature of Christ's humanity strikingly apparent. The lion is apparently speaking the opening word of the Gospel of Matthew (a reading reinforced by the other three incipits to be discussed below: all feature the speaking lion in upper right); the lion's body, however, is also the frame for the border of the text, extending all around the word *generationis*, with a space opening up to the right, seemingly out onto the rest of the gospel on the following pages. This lion's head is framed by a circular shape that resembles a halo, and since all commentators point out that the lion is always a possible symbol for Christ, I would suggest that here this is exactly the lion's function.[19] A haloed, humanoid figure appears just to the left of the speaking/spewing lion, looking right at it and holding his book in his hands. The meaning of this set of images seems to be that Christ *is* the text (the border frame) and that he generates himself. The human figure, whether this is Christ himself or the evangelist, takes his book directly from this process, the self-generation of the word from the Word. Another human figure, most likely Matthew, stands at lower left with the book; taken together, Matthew's portrait and this incipit page emphasize the book of the gospel as manifestation of Christ and thus as an adjunct of his Incarnation.

In the Mark incipit, folio 130r, Pulliam considers the lion in the upper right to be violently biting and struggling with a human figure (186–88; see fig. 2.10). It is further evidence for struggle, for Pulliam, that the human figure pulls on his own beard and on the tongue of the lion, wrapping his arms crosswise and his legs around the frame of the page. But the figure is only wrapped up, not flailing in any obvious way, and his beard flowers into interlace bearing leaves as well as a pair of birds. Further, his hip bears the three-dot grape pattern of the true vine. What this page appears to be showing, rather, is the intertwinedness of the Incarnate Word. The human Christ and the speaking lion are bound up as one and together flow into the pattern of the rest of the page, whose text is "Initium evangelii Jesu Christi" ("the start of the gospel of Jesus Christ"). Word and flesh, and word and image, are balanced and united in this gospel page.

If the Mark incipit is balance and hypostatic union, the Luke incipit represents something out of whack (see fig. 2.11). The lion head

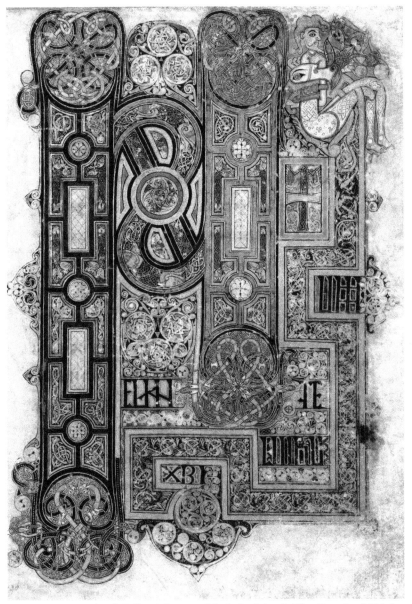

Figure 2.10. Book of Kells, fol. 130r. Mark incipit. © The Board of Trinity College Dublin.

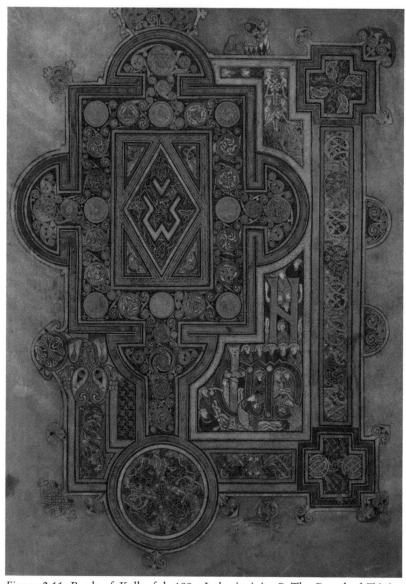

Figure 2.11. Book of Kells, fol. 188r. Luke incipit. © The Board of Trinity College Dublin.

at top right opens its mouth, but no tongue flows out into anything else; the head simply emerges from the straight edge of the top frame, its mouth hanging open to the left. Facing it, though, is an empty robe! Meehan considers this an unfinished image, since the frame below contains human heads being chewed by lions and the drawing-in of a head would make the empty robe echo those (24). But in the context of the other incipits, the empty robe is fully legible. The image seems to depict Christ's divinity (the lion) and his humanity (the robe) without the mystery of their union. Inside the frame, which is closed, with no opening onto further pages as in all the other in-cipits, human figures are in various forms of confusion. Near the top, they are seminude and possibly fornicating. At the bottom they are either lost in debauchery or partaking of an inverted mass, as Pul-liam suggests (189–91). Lions chew the heads of two of them.[20] The realm of humanity is here cut off from the divine, lost. Without the mystery of the Incarnation, wine is just wine and humans are vulnerable to the dangers of the world, to their own natures, their own vices. At the bottom of the page, a pair of quadruped legs the same color as the empty robe at the top dangle down from a fishy-looking body the same color and pattern as the lion head, with a tail that wraps around it all. It would seem that all of creation, including human society, would still be bounded by the divine nature without the Incarnation, but chaos and misery would be our fate, with no hope of divine commerce or divine aid.

Finally, there is the marvelous John portrait with its facing incipit page, folios 291v and 292r (see figs. 2.12 and 2.13). John, as the "disciple whom Jesus loved," was privileged with special access to Christ's divinity.[21] Matthew's portrait shows the evangelist touching the human flesh of his body, flesh he shared with the humanity of Christ, and John's portrait accordingly emphasizes his contact with the divinity of the Word. John sits enthroned, with a large pen in his right hand and the book of his gospel held up in his left (see fig. 2.12).[22] What is most remarkable about John's portrait is the fact that the frame around the whole has two feet, two hands, and a resplendent head of blond hair: the Word. Its face appears to have been scratched out for some reason (there are vertical scratch marks all the way across the surface of where the face was or would be), but it is striking that the image from the Matthew incipit of the winged figure being stuck together with the human feet also has a blank face. This may be an

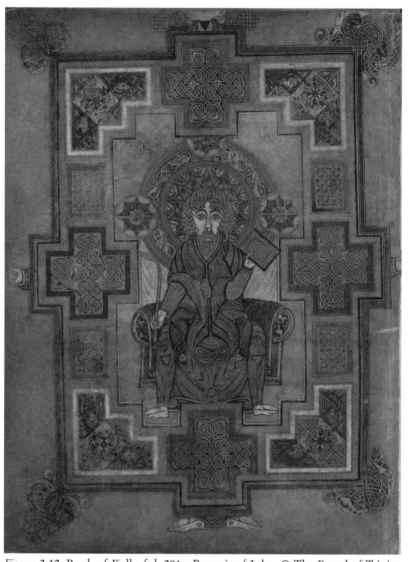

Figure 2.12. Book of Kells, fol. 291v. Portrait of John. © The Board of Trinity College Dublin.

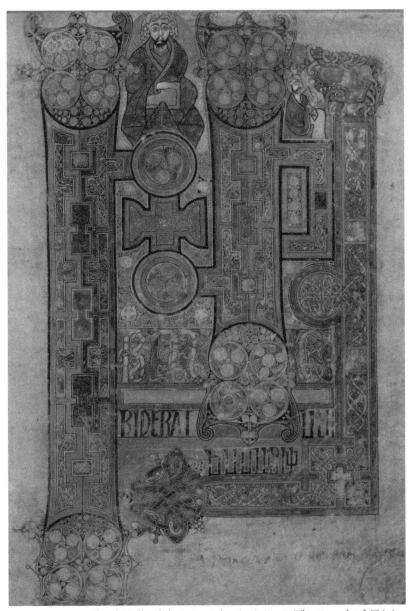

Figure 2.13. Book of Kells, fol. 292r. John incipit. © The Board of Trinity College Dublin.

attempt to render the principle that Christ only has a visible face in his Incarnate form, that his pure divinity bears a face that we will only see in the world to come (*facie ad faciem*). The text frame we see on the page *is* the book John has produced; it is another form of the flesh of the Word, another manifestation of the Incarnation. Confirmation of this is in details noted by Schapiro: John has an inkwell by his right foot, and the tip of his pen touches the frame precisely—he is in the act of writing.[23] In his other hand John holds the book, and its curved top edge corresponds and contacts, as Schapiro noticed, the arc of his own halo, while one of its corners touches the outer frame (just like the pen in his other hand). John writes the book that he holds that holds him that is also Christ the Word.[24] Making the divinity of Christ visible around the frame shows the greater access to this divinity afforded to or by John's gospel.[25]

The incipit on the facing page (292r) plays out the logic already set up by the other three incipits, drawing upon the uniqueness of John's gospel to illustrate the sacramental nature of the gospel word (see fig. 2.13). If the Matthew pages illustrated the Incarnational nature of the book, Mark's incipit the hypostatically joined nature of its text, and Luke's incipit a contrasting hypothetical of the letter without the spirit, as it were, with the hypostatic union unjoined, John's incipit makes explicit that to imbibe the word of the gospel is to take in the flesh of Christ in another form. In the upper right, as expected, a large lion head curls its tongue gently down onto the lap of a seated figure facing it, where it ends in a circle that joins the circular bottom of a chalice from which the figure drinks. Thus the lion's tongue flows directly into the chalice: the seated man drinks the words of Christ's divinity. As Pulliam suggests, a larger seated man to the left of the seated figure, behind his back, appears to be the glorified Christ holding a book (180–86). Given the other images I have considered, the fact that he has a face most likely indicates that the image is meant to depict the Logos's embodied, Incarnate form. The vivid yellow striations around Christ are similar to other instances in the manuscript, apparently illustrating Christ's radiance, and the small seated figure's legs are clothed in a similarly splendid color—the same yellow (Pulliam 183). This echo calls to mind Gregory's account of humanity's exaltation as a consequence of Christ's Incarnation (*XL homiliarum* 29). Is the humanity of the seated man glorified because he imbibes the sacramental word? The sacramental presence of the chalice is joined on the page

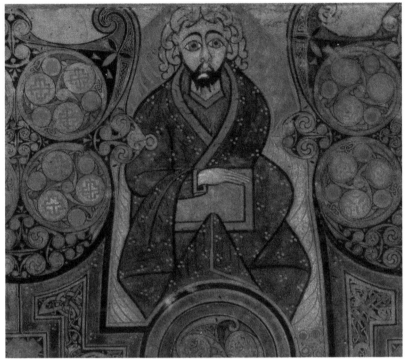

Figure 2.14. Detail of Book of Kells, fol. 292r (figure 2.13).

by the presence of multiple Eucharistic hosts at the bottom of the frame, sprouting as it were from a dense knot of interlace joined to the frame of the text itself. Thus, at one end of the page frame there are Eucharistic hosts, and at the other the lion pours out the word to be drunk. Presiding over all, and dominating the page, is the image of Christ in splendor, and the last detail to be mentioned is that he holds in his lap the book. The way the image renders the book in relation to the figure carefully demonstrates that Christ, the Word made flesh, and the flesh of the gospel word are one and the same thing. Christ is "held" at the bicep by a circular page decoration that almost looks like a paperclip. The text thus "contains" him. But his own form is styled in such a way that his robe looks like a folded envelope, and the bottom end of it folds up and over the book, containing *it* in a hold similar to that by which Christ's form is held by *it* at the upper arm. The Word contains the word which contains the Word, and so on (see fig. 2.14). This robe of Christ enfolding the book of the gospel occurs

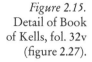

Figure 2.15.
Detail of Book
of Kells, fol. 32v
(figure 2.27).

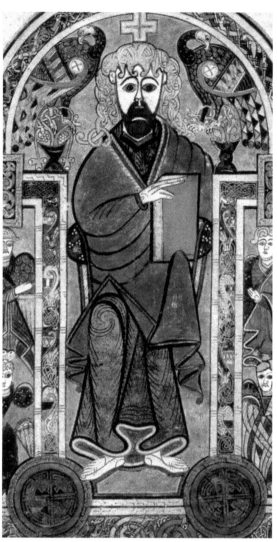

in the portrait of Christ page on folio 32v as well (see fig. 2.15). The Incarnation is recursive. The gospel word is an iteration of Christ, linked to his ascended person just as surely as the substance of the Eucharist.

The recursive tableau on the John incipit page is not the only image of the Word speaking the word in Kells. I have already described pages in which the lion head emerges from the text frame that it in turn produces (such as fols. 29r, 124r, and 292r). A more humanoid head does the same thing on the *Breves causae* (summary) page facing

the Virgin and child portrait (fols. 7v and 8r, respectively; see figs. 2.16 and 2.17). This head looks a little like the man in the moon, and Pulliam takes his interlaced speech lines and his grasping of his own hair to indicate confusion and, thus, a confused reader (196–97). However, in light of the fact that this page faces an illustration of the Nativity, and that the text on this page is a summary of the major events of the

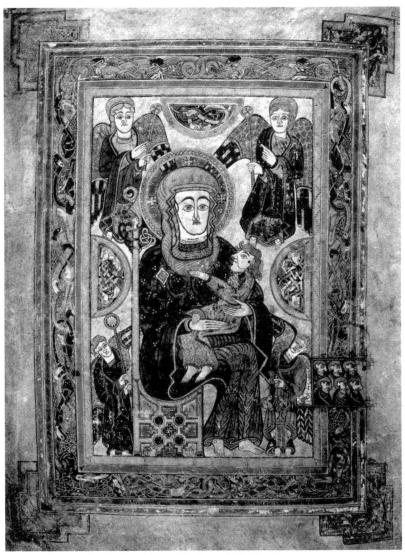

Figure 2.16. Book of Kells, fol. 7v. Virgin and Child. Alamy.

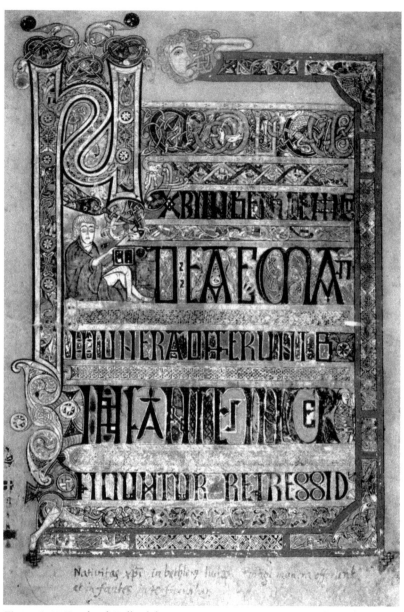

Figure 2.17. Book of Kells, fol. 8r. *Breves causae* (summary) of Matthew 1–3. Alamy.

Nativity, it seems more likely that the figure whose head speaks and holds onto lines that form the frame of the page and culminate in the lower left in a pair of legs is meant to be Christ.[26] Christ speaks the text and is the text. Pulliam further points out the group of people embedded in the frame of the Virgin and child page who look *from* the holy family toward the text on the facing page (23–31). Their attention indicates that the Nativity scene has something to do with the next page, which features not only the body speaking itself but also a man, possibly an "everyman" monastic reader, in the center of the page with a book on his knees.[27] It is also possible—and perhaps likely— that the figure with his bare legs so languidly crossed, emphasizing both his robe and his flesh, is Christ, whose body displays the book for our view. We are meant to look with the looking figures from the Nativity toward its further manifestation. Christ appeared in the world in human form (nativity), but he appears to us still in the form of the words of the gospel (facing page).

In several initials Christ appears to speak himself. On folio 68v, complementing a passage in Matthew (13:34) in which Christ is said to have spoken "only in parables to the crowds" ("haec omnia locutus est Jesus in parabolis ad turbas"), the *h* of "haec omnia" is formed by a human figure grasping his own leg and midsection (see fig. 2.18). From his mouth issue lines of interlace that form his very body. Christ's own person takes the form of one of the difficult parables he spoke; they are an extension (or recursive iteration) of the enigma that Christ himself represents. A similar initial occurs during Mark's account of Christ's sentencing before Pilate (Mark 15:14–15), where the *P* of *Pilatus* takes the form of a man speaking interlace that becomes

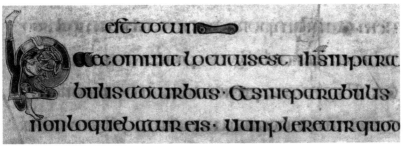

Figure 2.18. Book of Kells, detail of fol. 68v. © The Board of Trinity College Dublin.

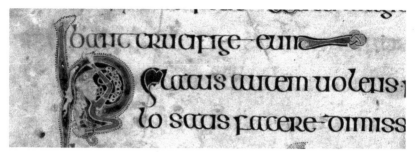

Figure 2.19. Book of Kells, detail of fol. 182r. © The Board of Trinity College Dublin.

his own hair, which he grasps along with his midsection (see fig. 2.19). Here one could say that Christ has control of the narrative, that even at the time of his greatest helplessness he was the author of his fate, which is, after all, the narrative of the divine plan of salvation. It represents in this light an ironic undermining of the power of those who seemed to betray Christ.

In addition to speaking himself and his text into being, the initials from which Christ emerges represent only a small group of letters, and, as Pulliam notes, thematic contexts, places where the text mentions Christ speaking or appearing or being recognized (96–117). I have mentioned the letter *T* and suggested that its resemblance to the cross may account for this choice. The *h* from the parables text may represent one of the sacred letters of Christ's abbreviated name (Tilghman 296). Another prominent choice is *P*, to which I will add the ostentatious *Rho* on folio 34r, which has the same form. I have already discussed the instance of the (talking) head forming the *P* of *Pilatus* on folio 182r (above). In the St. Gall Gospels (8th c.), Christ's head appears in the descender of the *P* in *Pater Noster* beginning Christ's famous prayer on the Mount (Matt. 6:9–13; see fig. 2.20). The association of Christ with the Pater Noster is enormously important for understanding the full extent of the Word's potential for recursion in the Insular tradition. The Pater Noster was the prayer Christ gave as a prototype and as such was authoritative, but it also represented Christ's very words and thus the recursive quality of the "double Incarnation" as the words of the Word. These words could take on a life of their own, as when the prayer as well as its individual letters come alive and fight the devil in the *Dialogues of Solomon and*

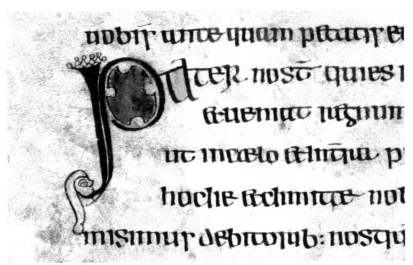

Figure 2.20. St. Gall Gospels, detail of p. 16. Christ begins the Pater Noster. Stiftsbibliothek St. Gallen. Published by kind permission.

Saturn (which I treat in chapter 4). In the dialogues, the Pater Noster stands in for Christ, not in a purely ambassadorial sense but in a synecdochic sense as an actual instance or particle of the Incarnate Word:

And se ðe wile geornlice þono Godes cwide
singan smealice and hine symle
lufian wile butan leahtrum, he mæg þone laþan gesið,
feohtende feond fleande gebringan,
gyf þu him ærest ufan yorn gebringeð
prologo prim þam is .P. nama;
hafað guðmaga gyrde lange,
gyldene gade, and þone grymman feond
swiðmod swapeð. And on swaðe filgið
.A. ofermægene, and hine eac ofslehð
.T.

 (lines 84–94; Anlezark 64)[28]

[And he who wishes zealously to sing God's utterance accurately and will love it unimpeachably, he may then bring the loathed traveler, the fighting fiend, to flight, if you first bring eager[29] upon him *prologo prim*,[30] whose name is P; that warrior has a long staff, a golden goad,

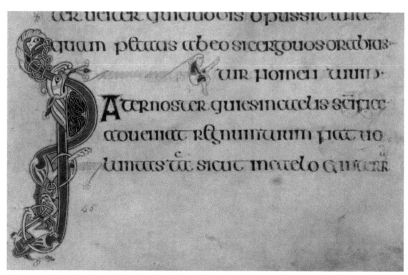

Figure 2.21. Book of Kells, detail of fol. 45r. Pater Noster. © The Board of Trinity College Dublin.

and fiercely swipes the grim fiend. And in his track follows A with super strength, and T pummels him also.] (trans. mine)

The individual letters making up the prayer each carry the force of Christ himself, who spoke them and *is* them; they are the letters of the words of the Word. *Solomon and Saturn I* thus contextualizes Christ's form emerging from the *P* of *Pater Noster* in St. Gall, reminding the viewer that *Pater Noster* is Christ himself. Folio 45r in Kells contains a Pater Noster *P* inhabited not by a humanoid Christ but by the two speaking lions associated with his role as the Word speaking himself (see fig. 2.21). Not only is the *P* of *Paternoster* animated by the two lions, but the insertion mark indicating that *tur nomen tuum* belongs at the end of the following line is a human form with yellow hair and golden loincloth, possibly another Christ image. He is joined to the historiated *P* by a thick orange line of ornament extending from the top of his head back to some three-circle foliage emerging from one of the lions' mouths. This arrangement thus appears to engage the meaning of the text to be inserted, *nomen tuum*. Pater Noster speaks the gospel words which contain his holy name, itself indicated by and one with his Incarnate body.

Similarly, perhaps, the *Rho* of the *Chi Rho* page in Kells shows the Christ head as the culmination of the curling head of the *P* (*Rho*; see figs. 2.22 and 2.23).[31] Not only does the *P* culminate in Christ's head, but its base is a cross, one arm of which extends up into the *I* and opens out at the top into a kind of flowering chalice. Christ is here apparent as cross, as letters (of a word, his name), as Incarnate body, as

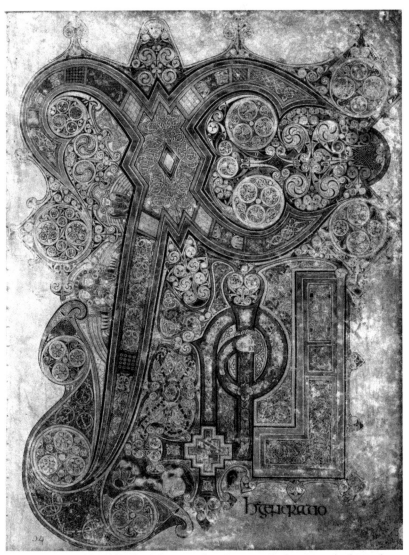

Figure 2.22. Book of Kells, fol. 34r. *Chi Rho* page in the Gospel of Matthew. © The Board of Trinity College Dublin.

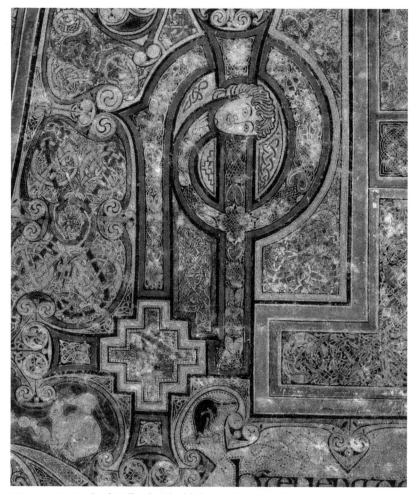

Figure 2.23. Book of Kells, detail of fol. 34r (figure 2.22).

Eucharistic vessel, as flowering vine. I will have more to say about the *Chi Rho* page as part of the manuscript's grand manifestation of the Incarnation in the Gospel of Matthew below.

Christ's head also emerges from a couple of prominent *C*'s, arguably indices for *Christus*. On folio 292r of Kells, the John incipit page, the *C* of *principio* is in the form of a yellow lion that is intertwined with a human figure that I take to be another Christ, who also points with his left hand up at the huge, ornate *P* (see fig. 2.24). Here, again, is the Incarnate Word one with the word, identified as proper name

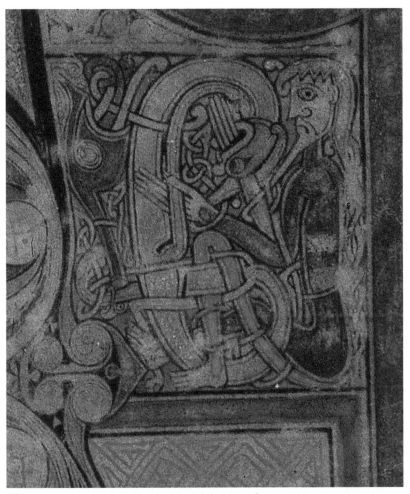

Figure 2.24. Book of Kells, detail of fol. 292r (figure 2.13). *In principio erat verbum.*

(Christus) and indexing another prominent word associated with his Incarnation, perhaps *Pater*, the sacred letter *Rho*, and *Principio* all at once. Christ similarly emerges from the C of John's incipit in the Lindisfarne Gospels (see fig. 2.25).

Another, rather delightful kind of index for Christ's Incarnation appears at the beginning of Luke 2 in the St. Gall Gospels. There, Christ's head emerges from the descender of the *F* of *FActum* in the chapter's opening verse, which is mangled but ought to read, "Factum est autem in diebus illis exiit edictum a Caesere Augusto ut

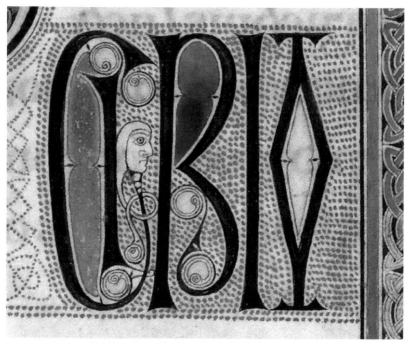

Figure 2.25. Lindisfarne Gospels, detail of fol. 211r. *In principio erat verbum.* © The British Library Board.

describeretur universis orbis" ("And so it came to pass that in those days there went out a decree from Caesar Augustus that all the world should be taxed"; see fig. 2.26). This verse begins the narrative proper after the preliminaries of Luke's gospel, and so the initial with its human head serves as a signal that Christ's story, the story of his appearance on earth, begins here. Christ's head emerges, however, from the same word, *factum,* that anchors the Incarnational formula in John, "verbum caro *factum* est." As the Lucan text begins its narrative of the nativity of the Word in the flesh, the scribe illustrates the flesh of that Word using the very word, *factum,* that every contemplative would have turned over and over in his mind as the hinge point of the central mystery of his or her faith. In decorating that *F,* the scribe makes the word flesh there on the page in the very word that describes this action, and exemplifies Cervone's "Incarnational poetics," her account of which I quoted in chapter 1 but will reproduce here: "Medieval writers deliberate over Christ's humanity in a way that draws attention to the paradox underlying ['The Word was made

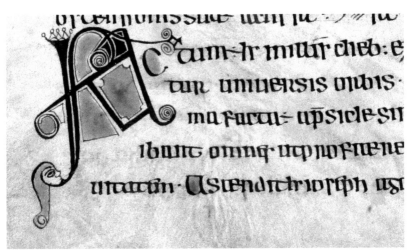

Figure 2.26. St. Gall Gospels, detail of p. 134. A visual pun on *factum est* in Luke 2. Stiftsbibliothek St. Gallen. Published by kind permission.

flesh']. . . . Their focus is not primarily on the 'flesh' side of the metaphor; rather, *they work from the middle term—the verb—that yokes language's active fluidity to both the divine and the human"* (5; emphasis mine). Uncannily, this moment in the St. Gall Gospels provides a literal example of the medieval emphasis upon the *factum*, as Christ in fact emerges from its very form.

Rendering the Incarnate Christ visible in multiple inventive ways may be seen as the primary function of the Book of Kells. The *Chi Rho* page is part of a triptych of sorts (a sequence of three) that may express the Incarnation's relationship to form and visibility per se as it announces the narration of the Incarnation in Matthew's gospel. *Chi Rho*, with its Christ letters, identifying Christ with words, text, and book, as well as the other signs I discuss above (cross, chalice, vine) is the last of the series, the culmination. The first page is the Christ portrait on 32v, in which Christ holds the book within the fold of his robe, flanked by two peacocks with Eucharists as well as the four evangelists (see fig. 2.27). The peacocks not only bear Eucharistic disks but also stand atop vines sprouting out of the tops of two chalices on either side of Christ's head, with a cross descending from the arching frame above him. The second page in the sequence is the so-called carpet page, which is pure patterning, echoing, I think, the heavy interlace that fills all the frame space of the Christ portrait (see

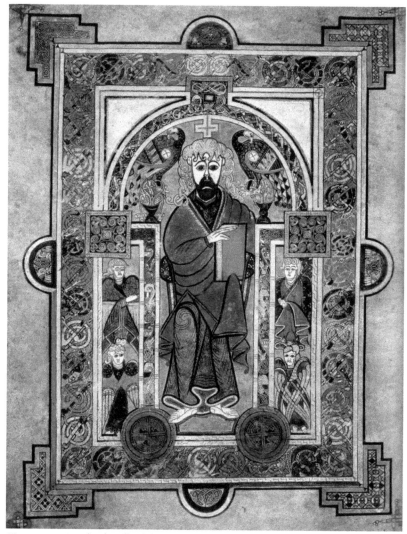

Figure 2.27. Book of Kells, fol. 32v. Christ and his many forms. Alamy.

fig. 2.28). The Christ portrait and the carpet page form a two-page spread. We look to the left and contemplate Christ in his recognizable human form, surrounded by symbols of himself (such as the peacocks) and metonyms for himself (Eucharists, as well as the book) and his evangelic messengers. Facing this portrait full of Christological signs of all these diverse kinds is a page of fractal complexity, its

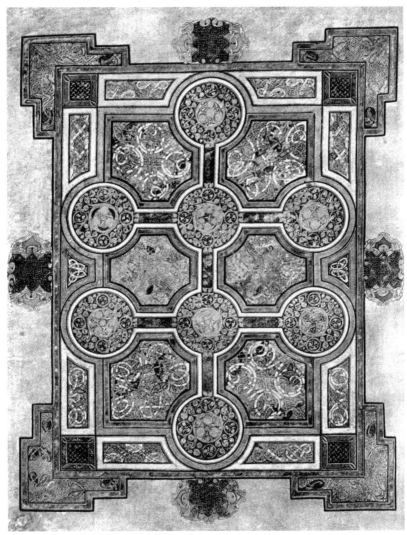

Figure 2.28. Book of Kells, fol. 33r. Carpet page, or form per se. Alamy.

dominant shape the circle, superimposed upon the cruciform grid. I think this page is meant as a mirror or a key, distilling the principle underlying the variety on the facing page (32v). The Incarnation is the donning of visibility, of texture and pattern and articulation. What is eternal (as referenced by the endless circles within circles) lays itself out in a grid—recalling the cross but also gesturing through it to

whatever kind of measure and order we can see in the created world. As I discussed in the previous chapter, the cross could function as a boundary marker between realms, in particular between the symbolic order and the physical world.

When the page is turned and we consider folio 34r (the carpet page's verso is blank, with the recto decoration heavily bled through and visible on that side), the *Chi Rho*, we encounter now the amalgam and culmination of the portrait-carpet-page spread, the Word made flesh in *words*, the one thing absent from the earlier two images (see fig. 2.22). The humanoid image of Christ is still there, in the little head animating the *P*, and the carpet page's circles are there, swirling, surrounding, exceeding, and receding into the letters. This is the Logos in its Incarnate complexity. What this three-page sequence offers at this point in the manuscript, at the first gospel narration of the Incarnation, is a meditation on the very process of the Incarnation's making visible of the Logos. Christ is first seated amid all the semiotic accoutrements by which we know him, including the object of the book but not any of its words. On the facing page, we see in the carpet page almost the abstract representation of visibility itself: pure texture, the infinite made finite on the grid of the page. Turning the page we encounter, suddenly, everything from the first two images set in an endless motion by the manifest letters of the holy name, literally the Word made flesh. Below I will say (even) more about this page and its embedded references to reading, specifically to reading as an endless pursuit of the sacraments.

As I have said, the consensus is that Kells was a display copy, meant not for reading but for use as an object of contemplation. It was designed for those already familiar with the texts of the gospels, to deepen their devotion and understanding. The manuscript seems everywhere "aware" of its contemplative function and of the intimate, even concomitant relation between that role and the Incarnation itself. Books are ubiquitous in the manuscript, as are Eucharistic images such as flabella, hosts, chalices, vines, peacocks, lions, and snakes (snakes were understood, in addition to being symbols of Satan and the Temptation in the Garden, as symbols of the Resurrection because the snake sheds its skin and thus rejuvenates itself [B. Meehan 53]). Christ is thus everywhere in Kells, including in the very script and in the way that script and image are synergistic rather than merely complementary.[32]

In two important places I have yet to discuss, Kells directly and explicitly references the visibility of the Word. The first instance makes use of the motif of viewers looking across the page spread, from one frame to the opposite page, which I discussed in relation to folio 7v, the Virgin and child page (see fig. 2.16). There, a group of men framed in a little box looks *from* this image toward the following page, folio 8r, which, as Pulliam describes it, "meditates upon the various earthly manifestations of the Logos" (28–29; see fig. 2.17). Christ speaks the frame, which is his own body, and displays the resulting book in the center on his bare legs, flesh and Word. It is not so much that the illustrations instruct the viewer to look away from one and toward the other, but rather that they demonstrate that having seen the one, we now contemplate its ramifications. This mimesis of Incarnational contemplation is further borne out in the Crucifixion image(s) on folios 123v and 124r (see figs. 2.29 and 2.30). The latter contains a stark geometric frame in which a pair of lions rages at the Crucifixion.[33] The lions' fierceness bears a special poignancy. The lion on the right forms the Christological *T* of *Tunc* and spews an elaborate cloud of interlace. The other lion breathes what looks like fire, which becomes the very controlled and severe page frame, forming its own "body." Here, as elsewhere, even in the surrender of the Crucifixion, the power of the Word is manifest, an intense paradox only underscored by the *X* shape that contains the words after *crucifixerant* in "Tunc crucifixerant xpi cum eo duos latrones" ("Then they crucified Christ with two thieves"; Matt. 27:38). Three separate groups of viewers similar to those on the Virgin and child page look not away from anything (two groups are on the far right edge of the frame and thus look across their own page toward the facing page, encompassing the whole two-page spread), but toward a blank page of vellum that most commentators assert was intended to be a Crucifixion scene.[34] William Endres, in an unpublished dissertation, has suggested that the omission may have been intentional, perhaps to allow for inner, spiritual, or imaginative contemplation of the Crucifixion (106–9). Indeed, given the very readable empty cloak at the top of folio 188r (which Meehan and others consider "surely" to have been intended for filling in with a head [Meehan 24]), I think it likely that the dramatically blank page conveys, within the larger scheme of the manuscript, the corollary to the logic of the Nativity image on 7v and 8r, according to which Christ's birth into the world initiates his visibility in the world and

Figure 2.29. Book of Kells, fol. 123v. © The Board of Trinity College Dublin.

the group of viewers are shown in the act of looking, of seeing. On 123v and 124r, Christ is *leaving* the world (temporarily), leaving us with nothing to see. More dramatically still, what we are able to see— clearly and starkly for lack of any writing—is the flesh of the vellum page itself. What illustration of the emptiness and loss implied by the sundering of Christ's crucified body from his animating spirit could

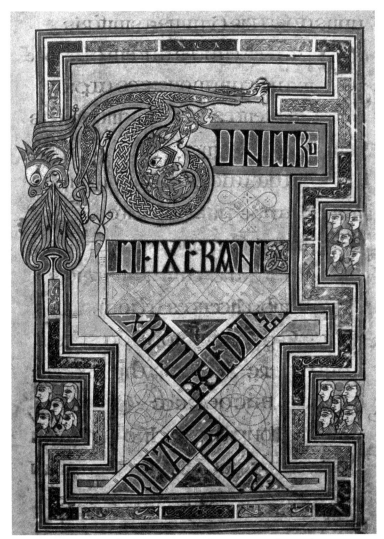

Figure 2.30. Book of Kells, fol. 124r. Crucifixion in Matthew. Alamy.

be more poignant? I argue that this poignant effect exists as effect regardless of any original intention to fill in the blank page with an illustration.

It is not possible to decide definitively whether the page was deliberately left blank or was merely unfinished. Nevertheless, other elements of the manuscript provide a meaningful context for the blank

page that supports my reading. Emptiness appears to stand elsewhere for Christ's absence, as in the empty cloak on folio 188r. Similarly, the illustration of the Crucifixion in Mark's gospel, folio 183r, which I discussed above, features Christ's divinity and his humanity in the process of separation. The manuscript's evident utilization of multiple modes and multiple channels for signification (sometimes representational, sometimes abstract, sometimes meta-aware, sometimes straightforwardly referential) makes it unsurprising, if no less striking, that a blank page made of flesh on folio 123v would serve to illustrate in another way the moment in which the spirit and flesh were sundered. Finally, there is the symmetry with the Nativity spread (fols. 7v–8r), in which we see nativity initiating the visibility of the Word. In the reverse sequence on folios 123v and 124r, the Word that tells of the Crucifixion directs our gaze to the withdrawal of visibility, the disappearance of the Word, leaving only the flesh of an empty page.

Additional context for thinking about visibility versus invisibility and the crux of folio 123v is provided by the fact that Crucifixion and Ascension images were often paired in the period. The blank Crucifixion "scene" on folio 123v is matched by the absence of an Ascension scene at the end of Matthew, whereas Mark has a detailed Crucifixion image on 183r and a detailed Ascension image on 187v. Again, symmetry supports a reading of the blank Crucifixion page as intentional. Luke's gospel has no large Crucifixion illustration and no Ascension either. It features instead a full-page illustration of the entombment of Christ (fol. 285r; see fig. 2.31), a page bounded firmly by a rectangular frame formed by a lion's body. The focus upon the entombment of Christ's body recalls the Luke incipit page's depiction of humanity's separation from the divine, its emphasis upon the flesh without the spirit. Finally, the final portion of John's gospel is missing. It is tempting to read even this absence as suggestive, pointing us at last beyond the book to the divine realm.

The images of the Crucifixion and Ascension in Mark are interesting in their own right in the context of representing the nature of the Incarnation, since, as I have said, the Crucifixion image seems to depict the process of sundering Christ's divinity and humanity, his feet and robe dangling in the lower left and his head looking up and away in the upper right corner of the vertically unbounded image (see fig. 2.8). The large initial e (not E) appears to reinforce the stakes of the image in another way, as the lion head, elsewhere symbolic of Christ

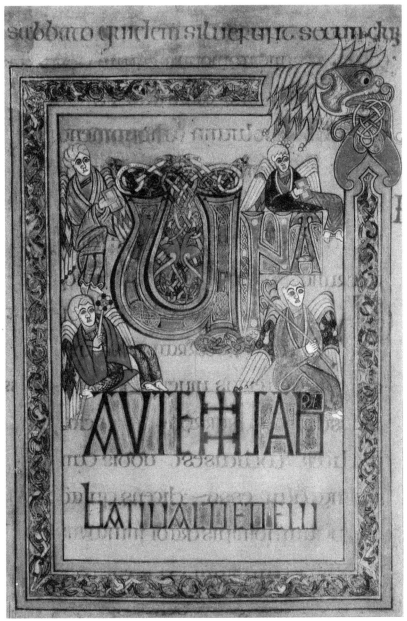

Figure 2.31. Book of Kells, fol. 285r. Entombment of Christ in Luke (24:1). Alamy.

or his divinity, emerges from the upstroke, meeting in the middle a prominent yellow mandorla. The mandorla is the almond shape often used to represent the wound in Christ's side, and here it is certainly both an index of the event being narrated rather abstractly (the Crucifixion itself, where the wound occurred) and a symbol for Christ's flesh and humanity.[35] The whole scheme presents a bit of a word puzzle, as the e of erat ("was") joins in itself the two natures (human and divine) that the larger frame of the image shows being split asunder. This word uniting the two natures is, evocatively, a *past-tense* verb. Just as the Incarnation is expressed in John through the (verb) *factum*, here the moment of the Crucifixion renders that union as (however briefly) past. One can see the *erat* and then consider the little feet and robe far apart from the upward-looking head, and visually contemplate the magnitude of the Crucifixion in a way different from the identification with Christ's suffering that would become so common later in the Middle Ages. Similarly schematic is the Mark Ascension page, in which much remains inscrutable, but one can discern that two natures are again prominent (see fig. 2.32). A saltire cross, which is both a cross and the X of *Chi*, for Christ's name, is made up of two lion's feet and two human feet, the latter of which rest upon the haunches of the two lions that make up the frame. The cross forms four quadrants. In the one on the right, Mark's lion—if that is what it is—looks back toward the juncture of the cross, which is the juncture of the lion and humanoid forms. In the left quadrant, a winged figure holds a book right at the cross juncture, and the upper and lower quadrants hold the final words of Mark's gospel. The text of the gospel is what is left behind after the Ascension, the remnant of Christ that we have now. Johanna Kramer cites similar depictions in the Tiberius Psalter (11th–12th c.) and Bernward Gospels (11th c.; Kramer pls. 1, 8; see figs. 1.1 and 1.2).

The question of the remnants of Christ brings me back to the question of sacraments. In her influential 1980 article on the *Chi Rho* page of the Book of Kells, Suzanne Lewis concludes, "Pervasive visual allusions to the Eucharist provide a constant focus on the sacramental function of the Kells Gospels. Like the peculiar variations and multiplication of collects and prayers with which the Irish celebrated the early liturgy, the rich imagery of the illuminations offers a stream of permutations on the Eucharistic theme" (158). Indeed, as Lewis suggests, the Eucharist is everywhere in Kells, emphasizing the

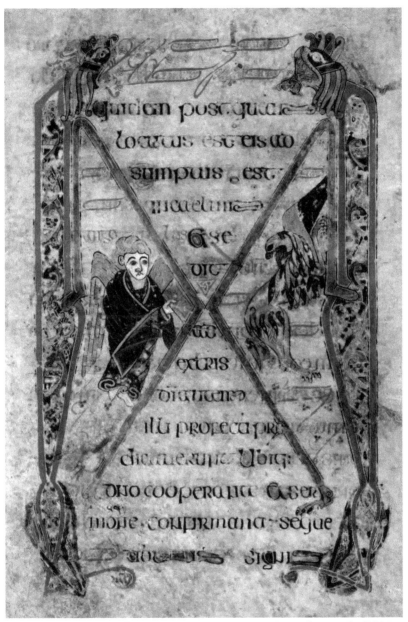

Figure 2.32. Book of Kells, fol. 187v. Ascension in Mark. © The Board of Trinity College Dublin.

"sacramental function of the Kells Gospels" themselves. I have already discussed the John incipit's depiction of the lion's tongue leading directly into the sacramental chalice, behind which sits the Incarnate Christ with a book. The Matthew incipit also depicts a chalice or vessel containing words (or letters, the *ER* of *LIBER*). The Temptation page, folio 202v, which I have thus far not extensively discussed, contains a series of images in which the speaking lion, scripture, books, and Eucharistic images are all connected to one another and given an apotropaic function as potent guardians of Christ's church against the devil. If John's incipit offers a kind of culmination, in which we see that drinking in the word gives us access to the Word and constitutes a sacramental act of devotion, the Temptation page places the word in the context of the church and its basic mission as an institution (see fig. 2.6). This page has posed difficulties, in part because it does not depict the single historical event of the Temptation in the desert. Rather, as I have said, it forms a partly historical, partly typological tableau. Another way of saying this is to describe it as a mashup, a structural principle that will become more important later in this study. The page depicts the devil confronting Christ, having placed him atop the temple following the scriptural account. But the lower half of Christ's body seems to constitute the church, whose base harbors two groups of people, perhaps monastic brethren. A more mixed congregation of people huddles behind Christ, who protects them from the devil. It has been well noted that the scriptures appear in Christ's hands (Pulliam 204), but less so the presence of a little lion in this moment of scriptural production, echoing the "speaking lion" that appears in the upper right of every incipit page (see fig. 2.33). It is part of a pair of hornlike structures in lion shapes that appear at both ends of the gabled roof and is thus a "naturalistic" or incidental detail. The two lion "horns" on the left side offer the traditional protective function of the double beasts at the same time as they infuse this traditional form with Christological power by virtue of their specifically Christian iconography. The lion on the right has the position and attitude vis-à-vis the scripture—and in relation to Christ—that we see in the incipit pages. Here, too, multimodality characterizes the artist's representation. The devil's hand reaches up toward Christ, but the lion speaks the scripture. This is a rather potent moment of Incarnational articulation. The devil confronted Christ in the desert while Christ was in the flesh (Luke 4:1–3, Matt. 4:1–11, Mark 1:12–13). The

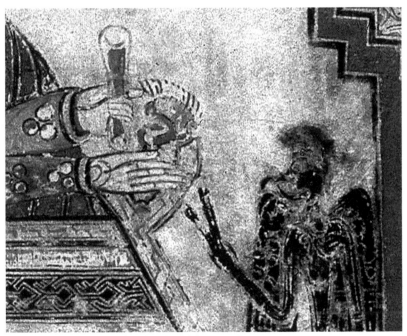

Figure 2.33. Book of Kells, detail of fol. 202v (figure 2.6).

manuscript's illustration scheme appears to take the moment as an opportunity to articulate the extended ramifications of that meeting, suggesting that the sensible remainder of Christ's presence in the world, the word, takes the place of Christ's physical presence in the structural configuration of the Temptation scene, which extends itself in time to the situation of the church and Christ's people. Just as the devil tempted Christ, he tempts the faithful every day, and in the stead of Christ's protective bodily presence in that confrontation we are given a stand-in, the scripture itself. The twin lions on the gable protecting the congregation show in their echo of the scriptural lion on the right the apotropaic power of scripture along with the Eucharist, which they also bear among them. This is not a mimetic image, but it is sophisticated and readable just the same.

The upper corners of folio 202v confirm the Incarnational/Eucharistic status of the scripture in Christ's hands. In the upper right corner, a chalice pours out a vine, from which a closed book emerges and is received by a winged figure, perhaps an angel. In the upper left

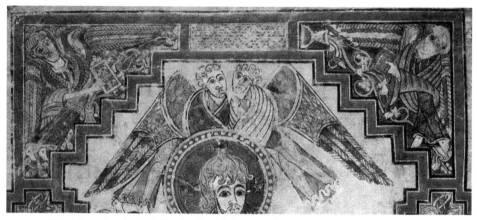

Figure 2.34. Book of Kells, detail of fol. 202v (figure 2.6).

corner, another winged figure holds open a book, from which emerge vines interlaced with birds (see fig. 2.34). Here, I think, is another instance of the recursive nature of the Word. The book emerges from the vine and in turn produces the vine. The birds are indications of Christ's divinity, and they entwine with the flesh-in-the-world significance of the vine: the word is Incarnational; it is Eucharistic. This Temptation page, then, joins the illustration scheme of the rest of the book in connecting the gospel scenes that the book depicts to its own status as the gospel, giving itself a fundamental role, rooted in the events of Christ's life, in Christ's continued presence in the world.

This Eucharistic role of the gospel word may be brought to bear upon a lingering question regarding the Eucharistic symbols in the Book of Kells, which is the cat-and-mouse imagery on both the *Chi Rho* page (fol. 34r) and on folio 48r illustrating the "ask and ye shall receive, seek and ye shall find" portion of the Sermon on the Mount (Matt. 7:7–8). At the bottom of the *Chi Rho* page, two cats appear literally "on the tails of" two mice, who hold between them a Eucharistic disk (see fig. 2.35). Two further mice perch upon the backs of the two cats. Attempts to read this image have focused on the holy nature of the Eucharist and the injunctions against its desecration (Pulliam 29, Meehan 59, Lewis 146–50).[36] The mice thus represent vermin and the Eucharist is caught in a profane act of defilement. This reading has not been wholly satisfactory, however, since the cats cannot really be brought into the reading unless they become allegorized as "our vigi-

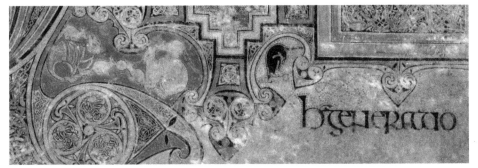

Figure 2.35. Book of Kells, detail of fol. 34r (figure 2.22). Cats, mice, and Eucharist.

lance" or something to that effect. There is, too, the absence of corroborating anxiety in the *Chi Rho* page overall—this doesn't seem to be a page like the Luke incipit, with its thoroughgoing sense of disorder. Suzanne Lewis's perceptive and thoroughly researched analysis of the *Chi Rho* page's Eucharistic program comes extremely close to solving the problem of the cats and mice. She draws on contemporary Irish traditions of animals as helpmeets and protectors, and cats in particular as protectors of food supplies, to suggest that in the *Chi Rho* image, the cats are likely "protectors of man's nourishing sustenance," the Eucharist (147).

There is an additional valence to the cats and mice on 34r, however, and it involves the connection between the Eucharist and the gospel word. Lewis notes briefly a contemporary Old Irish poem about a scholar and his cat, Pangur Bán, that appears in the early ninth-century St. Paul (Irish) Codex (Lewis 146).[37] Lewis remarks on this poem as an example of the affectionate regard of an Irish monastic for a cat, but the poem is structured around the parallel between the scholar's hunting for insight and the cat's hunting for mice (punctuation, layout, and emphases are my own, to highlight the opposition between the scholar and the cat; italics set off lines describing the scholarly speaker):

White Pangur and I
Each of us at his distinctive calling:

His mind on hunting,
my own mind on my own distinct craft.

I love to sit still—better than any fame—
at my book, with bright understanding;
white Pangur is not jealous of me:
He loves his youthful art.

When we are—a tireless tale—
in our house, just the two of us,
we have—an unending feat—
something to which to apply our sharpness.

It is usual at times that because of bold attacks
a mouse sticks in his net;
and as for me, there falls into my own net
a difficult rule with robust meaning.

He hones against an inner-wall hedge
his eye, the full bright one;
I myself hone against clarity of knowledge
My clear eye, though of little consequence.

He is joyful when with swift motion
a mouse sticks in his sharp claw;
when I understand a difficult, prized question
I too am joyful.

Though we be thus at any time
neither one disturbs the other;
each of us likes his calling;
[each] enjoys them separately.

It is he himself who is master
of the service he performs every day;
of bringing clarity to difficulty
I am capable in my own service.

 (Toner 3–4)[38]

The poet's comparison between the sharp claws of the cat catching mice and the bright, clarifying understanding of the scholar is not necessarily facetious or even playful, as Gregory Toner, an editor and

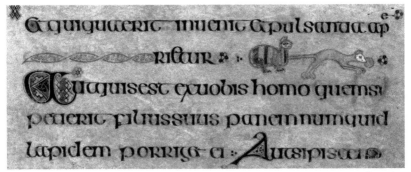

Figure 2.36. Book of Kells, detail of fol. 48r. *Qui quaerit invenit* ("s/he who seeks will find"). © The Board of Trinity College Dublin.

translator of the poem, points out (4–5). Toner ultimately emphasizes the cat's value as an officer of God's creation, on par in some sense with the scholar, as both of them are said to have *dán* ("art, skill"; "trade, office, calling, profession"), which seems to have a similar semantic range as Old English *had* (21). The poem's relation of the work of the cat to the work of reading and scholarship can, I believe, be extended to the cat/mice/Eucharist cruces in Kells. For the mystery of the Word was the ultimate enigma in Christian scholarship, and the cat catching the mouse with the Host appears not only on the *Chi Rho* page but also on folio 48r, where it seems to encourage the seeker with the very words of Christ: "seek and ye shall find" ("qui quaerit invenit"; Matt. 7:8; see fig. 2.36). This very line, "qui quaerit invenit," will feature in chapter 4 in a word puzzle whose solution is "Christ."[39] Christ himself as the (Eucharistic) object of scholarly reading and seeking forms a satisfying reading for this cat and mouse, drawing in both Matthew 7:8 and verse 9, which follows below the image: "Or what man is there among you, of whom if his son shall ask bread, will he reach him a stone?" ("Aut quis est ex vobis homo, quem si petierit filius suus panem, numquid lapidem porriget ei?"). The object of seeking is the bread of life, Christ.

On the Chi Rho page, the two cats have set upon the tails of two mice who hold between them one Eucharistic circle (see fig. 2.35). This multiplicity and mirroring, not one cat and mouse but multiple, seems an elegant rendition of many paths, such as we see in the several gospels, to one truth, the Word himself.[40] The cats may be about to pounce, about to grasp the truth for themselves, but here again we see

circularity and recursion and recapitulation, as there are two ad-
ditional mice on the cats' backs. The cats may catch the mice before
them, but there are further mice; in a cartoon version of the scenario,
the Eucharist would pop up, out of the mouths of these caught mice
and into the teeth of those on the cats' backs, and the chase would
begin again. The helpful otter to their right may be grasping the fish
and bringing it to humankind (Lewis 145)—his coat is strikingly
black, lending him an affinity, I think, to the ink marks of writing it-
self (his body the same color as the ink of the letters beside him)—but
the cats and mice are representative of the drama of active reading, its
endlessness in this world, which is why these scenes seem to pour out
of the openings at the bottom of the frame and onto the rest of the
book, and perhaps why the book itself remained unfinished, opening
outward onto the world, into the landscape. I do think that both
Lewis and Toner are correct, that the animals such as the cat in the
poem and the cats, mice, and otter on the Kells *Chi Rho* page are, in
some sense, literal, not merely metaphors. In this literal sense they
still stand as metonyms, for the way knowledge (of Christ, of any-
thing) is sought through creation. They function, too, though, as
metaphors for reading and writing as paths to the Word.

It is with the world and its landscape that this chapter will end,
gesturing toward the following chapter, where Christological presence
will map itself onto topographies both geographic and phenomenal.
Monumental stone carving predates the adoption of Christianity
in Britain (and Scandinavia), and "preaching crosses" such as the
Ruthwell and Bewcastle monuments (8th c.) adopt this form of me-
morialization and annunciation to inscribe Christ's name upon the
landscape.[41] They represent another way that divine doctrine took
articulate form, and I include these examples because a striking fea-
ture of the crosses is their use of mixed scripts and languages in the
visual, three-dimensional display of the holy name. Here, too, the am-
biguity inherent in Insular style is put to Incarnational use (see figs.
2.37 and 2.38).

The main panels of the Ruthwell Cross depict biblical scenes bal-
ancing Old Testament and New, and both include animals—indices, as
I have discussed in relation to the Kells *Chi Rho* page, of creation.[42] As
a major illustration in the scheme focuses on Christ dominating "the
beasts," there seems to be a focus on Christ in the world, his manifest
dominion. The main panel of the Bewcastle Cross similarly depicts

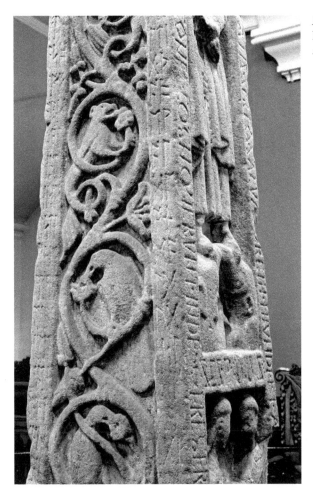

Figure 2.37.
Ruthwell Cross.
Alamy.

Christ trampling the beasts. Flanking the main panels on Ruthwell, the minor panels contain a Crucifixion poem related to *The Dream of the Rood*, which celebrates Christ's heroic sacrifice in vernacular terms, in Old English verse inscribed in runes. The cross itself, then, combines Latin biblical language in Roman script with Old English in runes to monumentalize Christ's dominion over creation and triumphal death. Further, Ruthwell's larger panels, containing biblical passages in Latin, also depict Christ's name in Greek, using Roman capitals: + IHS X[P]S (Howlett 75). The Bewcastle Cross displays on its west face "GESSUS KRISTTUS," Christ's Latin name, written in runes.[43] It is striking that both monuments inscribe Christ's name using disparate language and script—runes for Latin in Bewcastle, and

Figure 2.38.
Bewcastle Cross.
Alamy.

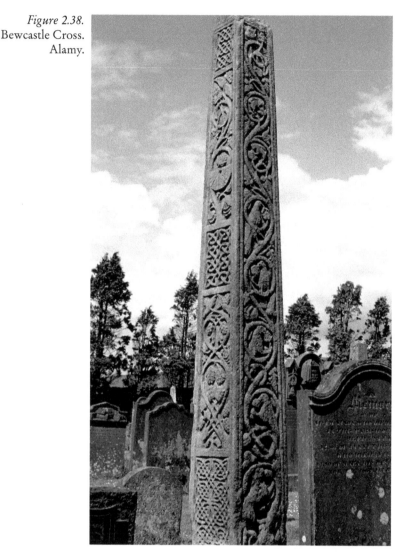

Roman capitals for Greek in Ruthwell, and that these hybrid inscriptions superintend depictions of the created world per se (the beasts). Beyond the usual Insular penchant for mixing and ambiguity, these inscriptions onto the landscape of Christ's name in mixed media (three-dimensional stone and writing, word and image, runes, Roman letters, Latin and Greek) represent another example of an Incarnational invocation of the Word, one that asserts itself in the three-dimensional world beyond the confines of manuscript page or liturgical rite.

The Word was capable of supereffability in its visible, Incarnate forms, and these forms were by definition not simple or straightforward since, again, the Incarnation was a semiotic mismatch that joined the ineffable to the effable. The sacraments of Christ's humanity were often enigmas, puzzles and problems requiring the application of intense contemplative thought. Such is surely the case with the dark language of the scriptures, which the Book of Kells builds into a multimedia, multimodal tour de force. Such was also the case with the deliberate obscurantism of the so-called wisdom tradition, as I will discuss in the book's final two chapters. Before arriving at the deliberate, further concealment of what had entered the world under the cloak of the flesh, however, I will turn to flesh itself: creation, the visible, actual, "opaque," dark, articulate surface of What Is. Exegesis was keen to conduct surface to depth, to sublimate it into abstraction, from sensible to intelligible as quickly as the Spirit could ferry. But recent trends in scholarship, in both the "new materiality" and "surface reading," make it possible to consider afresh the status of the substance that was touched by the Incarnation. Chapter 3 will consider just that, those things and places that shared in Christ's substance as well as the phenomenology by which humans, too, absorbed it. Accessing Christ involved, I will argue, an "objective correlative." No ideas but in things.

No Ideas but in Things

Aesthetics and the Flesh of the Word

Anglo-Saxon styles in general are characterized by 1) ambiguity, and 2) a love of complex pattern and surface ornament. These are interrelated phenomena.
—Catherine Karkov and George Hardin Brown,
Anglo-Saxon Styles

I am forever unfolding between two folds, and if to perceive means to unfold, then I am forever perceiving within the folds.
—Gilles Deleuze, *The Fold*

Then the lord, within the maiden's bridebower and on the comely high-seat, took the cloak of a body for his divinity.
—Blickling Homily I

As I have discussed, and as the Blickling homilist suggests in the epigraph above, Christ's flesh could be imagined as a cloak or covering, a flowing, folded surface that renders the invisible opaque, which is to say, paradoxically, both "dark" or resistant to interpretation and at the same time "apparent" or perceptible. The very quality that allows

God to be seen renders him a difficult enigma. As a surface, the In-
carnation manifests itself topographically, inviting a "surface read-
ing" that can resist Logocentric, authoritative allegoresis in favor of
attention to surface contours, for these manifest the shining humanity
of Christ that Bede affirms.[1] In search of a way to account for both
the surface and its perception—for its material properties and its
aesthetics—I turn in this chapter to the surface reading of Stephen
Best and Sharon Marcus as well as to Gilles Deleuze, whose account
of perception itself as the geometry (or more precisely the calculus) of
infinite "folds" addresses the phenomenology central to what the In-
carnation *is*—sensory contact with the divine—within a mathematical
framework based on the structure of the flowing surface. The primary
evidence of the chapter will include several kinds of Incarnational to-
pography. I begin with the Irish abbot Adamnán's account of the holy
lands (*De locis sanctis*), which is at once a spiritual, a literal, and a tex-
tual topography, intimately concerned with the Incarnation at all these
levels. I supplement Adamnán's sustained treatment with accounts of
holy locales and of the earth itself in the anonymous Old English
homilies, particularly those of the two most well-known collections,
the Blickling and Vercelli Homilies. These manuscript compilations in
turn have their own contours, or topographies, a feature I consider
briefly in this chapter and then in a more extended way in chapter 5.
The present chapter concludes with a consideration of the Fuller
Brooch, whose emphasis upon the senses has, I argue, the Incarnation
at its core. This object confirms the aesthetic focus of Insular Incarna-
tionalism: humanity comes to the body of Christ through the various
senses. Through "our" flesh we touch the flesh of the Word.[2]

Medieval *spirit/flesh* has a modern counterpart in *depth/surface*,
which is often similarly laden with asymmetrical moral judgment. In
literary studies, Best and Marcus have noted the affinities between
twentieth-century "hermeneutics of suspicion" (prominently repre-
sented by psychoanalysis and Marxism) and Christian allegoresis.
They cite, for example, Fredric Jameson's frank acknowledgment of
the similarity between his own wielding of the master code of Marx-
ism and Augustine's hermeneutics of orthodoxy (Best and Marcus
15). As an alternative, Best and Marcus call for a reading praxis that
eschews such totalizing master codes. After decades of "deep" analy-
sis under the regimes of psychoanalysis and various forms of decon-
structive reading, they argue for a return to "the surface" of a literary

text. The surface offers a corrective to the biases of a critic, and this corrective is as important as any "hidden depths" a text may divulge. It is precisely the resistances, remainders, and opacities of a textual surface that push back against any hermeneutic. In this regard, surface reading dovetails with the ethics of thing theory, asserting the agency of the "object" against the impositions of the subject.[3] Surface reading brings form—the textual surface—to the foreground, emphasizing its agency and its capacity to surprise rather than to conform to critical desire. As I suggested in the introduction to this book, surface reading and its renewed call to critical skepticism, affirming both the authority of the object and the inevitability of subjective distortion or lensing, are of particular urgency for medieval studies, given the field's historical positivism as well as the extreme historical gulfs between ourselves and the target period. Furthermore, in the case of the material I wish to consider, which is the manifestations of the divine in perceptible forms, surfaces are precisely the point.[4] I accept the risk I run of naïve reading—that there will sometimes be howlers—and yet, as I hope to demonstrate, the surfaces I will consider have always seemed to insist upon their own prominence, frustrating those who, like Ælfric, would rather they were a bit less dazzling. The shimmering surface is, after all, not ancillary at all in the Insular paradigm. It is not "decorative." It is where we touch and are touched by the Incarnate divine.

To account for the irreducibly intricate Incarnational surface, then, I turn to Deleuze's baroque aesthetics, a phenomenology of the surface per se, which arises from a sustained consideration of Leibniz. Deleuze presents a method of accounting for the infinitely, even fractally complex and extensive geometries of baroque forms, and suggests that "baroque" is equally a mode of construction and of perception. It is thus well suited to the creator–created chiasm. Deleuze imagines the aesthetic—the perceived—in terms that do not privilege the subject and reduce to fixity the object, and forces neither form nor perception into rectiformalisms. Deleuze's account is thus also well suited to the infinitely complex semiotics of the Incarnation's mismatch between effable signifier and ineffable signified, which I discussed in chapter 1. Meaning slips and slides—is deferred, as in Derrida, but rather than horizontal deferral leaving a trace, Deleuze imagines a three- or even four-dimensional topography of "folding" whereby signs do not simply displace or defer signification, but alter

the fabric of signification itself through their articulation. Every moment of articulation performs another "fold," a collision and distortion, a warping of the world. This model is Lucretian in imagining endless collisions and a kind of democracy of particles of existence.[5] But where Lucretius is atomized and thus granular, Deleuze's Leibniz is topographic, charting a landscape not of careening particles so much as undulating surfaces in endless folds. The fold has a similarly democratizing function, nevertheless, specifically in terms of signification, in that it can characterize the implicit without resorting to "depth" and treats authoritative as well as all other kinds of meaning. As did the calculus that Leibniz developed, "the fold" describes the surfaces of things. This baroque topography provides a way of thinking about the contours and behaviors of a surface that is our very medium and means and ground of perception, the Word that was with God and was God, through whom all things were made. Perception is not "above" or "applied to" the surface, but we ourselves emerge within the surface as one of its vectors.

In considering the aesthetic topographies of the Incarnation I will first turn to an explicit medieval topography, *De locis sanctis*, in which Adamnán's treatment of the lands touched by Christ's presence reveals much about the properties of Incarnational matter. These properties in turn form the basis for a wider consideration of the manifestations of Christ's substance in the perceptible world. All exemplify the "leaping," bridging quality of Christ as he performs the transit—in perpetuity—between visible and invisible realms.

ADAMNÁN'S *DE LOCIS SANCTIS* AND THE FLESH OF THE WORD

Adamnán, abbot of Iona from 679–704, offers, as I have said, an explicitly topographical account of Christ's earthly presence in the *De locis sanctis*. This work was widely disseminated, both praised and paraphrased by no less an authority than Bede. It purports to relay the experiences of a Gaulish bishop named Arculf (about whom nothing else is known), who traveled in the holy lands for a number of years before casting up on the shores of Britain and making his way to the island monastery of Iona, off the far northwest coast.[6] There, he

told his tale to Adamnán, who wrote it down for its obvious interest. Bede recognized both the importance and the danger of Adamnán's text, and he is careful in the *Historia ecclesiastica* and in his own abridgment and overwriting of the work (also called *De locis sanctis*) to contain and neutralize its potential heterodoxy. He paints Adamnán in the *Historia* as a product of the recalcitrant Columban tradition who came around to the correct, Roman way of thinking before his death:

> The priest Adamnan, abbot of the monks on the island of Iona, was sent by his people on a mission to Aldfrith, king of the Angles, and stayed for some time in his kingdom to see the canonical rites of the church. He was earnestly advised by many who were better instructed than himself that he, in company with a very small band of followers, living in the remotest corner of the world, should not presume to go against the universal custom of the church in the matter of keeping Easter and in various other ordinances. He altered his opinion so greatly that he readily preferred the customs which he saw and heard in the English churches to those of himself and his followers. He was a good and wise man with an excellent knowledge of the scriptures. (trans. Colgrave and Mynors 505–7)
>
> ———
>
> [Siquidem Adamnan, presbyter et abbas monachorum qui erant in insula Hii, cum legationis gratia missus a sua gente uenisset ad Aldfridum regem Anglorum, et aliquandiu in ea prouincia moratus uideret ritus ecclesiae canonicos, sed et a pluribus, qui erant eruditiores, esset sollerter admonitus, ne contra uniuersalem ecclesiae morem uel in obseruantia paschali uel in aliis quibusque decretis cum suis paucissimis et in extremo mundi angulo positis uiuere praesumeret, mutatus mente est; ita ut ea quae uiderat et audierat in ecclesiis Anglorum, suae suorumque consuetudini libentissime praeferret. Erat enim uir bonus et sapiens et scientia scripturarum nobilissime instructus.] (5.15, pp. 504–6)

Bede calls Adamnán learned and pious ("bonus . . . sapiens . . . nobilissime instructus"), and so frames his text as trustworthy. Nevertheless, he finds it necessary not to reproduce the text but to modify and abridge it substantially. Bede wants his readers to know about the contours of the holy land insofar as they have been carefully sanded

down. Likewise, in his own preface he praises Adamnán's Latin style as *sermo laciniosus*, "full of folds, corners, and lappets," and *pulcherrima historia* ("a most lovely history"), while nevertheless effectively writing over it with his own, smoother prose.[7] Still, Bede seems to intuit that it is "within the folds" that the powerful properties of both Irish learning and Christ's humanity reside.

One anecdote from Bede's *Historia ecclesiastica* bears directly upon his reception of Irish learning such as Adamnán's, and specifically its quasi-physical contours, which is to say, its topography. Bede's treatment of the Irish church is profoundly ambivalent, since his work is devoted to the premise of the triumphal emergence of the English church from the wrongheaded traditions of the Irish, and yet he cannot disavow the profundity of Irish learning. The anecdote that famously encapsulates Bede's attitude toward that learning (and has long provided a litmus test for the attitudes of modern scholars regarding its "obvious" facetiousness or earnestness) is his remark, in book 1, chapter 1, about the quality of Irish manuscripts, amid a larger introductory discussion of the topography of Britain and Ireland.[8] Bede conveys the almost mythical *sanitas* of Ireland, from its temperate climate to its lack of snakes, the animal that stands at the junction of the mythic and the ecological (in the form of the serpent): "Ireland is broader than Britain, is healthier and has a much milder climate, so that snow rarely lasts there for more than three days. Hay is never cut in summer for winter use nor are stables built for their beasts. No reptile is found there nor could a serpent survive; for although serpents have often been brought from Britain, as soon as the ship approaches land they are affected by the scent of the air and quickly perish."[9] His list extends finally to the physical manifestations of learning—the books and writing—of the Irish: "In fact almost everything that the island produces is efficacious against poison. For instance we have seen how, in the case of people suffering from snakebite, the leaves of manuscripts from Ireland were scraped, and the scrapings put in water and given to the sufferer to drink. These scrapings at once absorbed the whole violence of the spreading poison and assuaged the swelling" (1.1; trans. Colgrave and Minors 19–21).[10]

While it has been tempting for scholars claiming Bede as a forefather of modern rationality and modern historiography to dismiss this account as facetious or mocking of Irish outlandishness, what happens if we look at Bede's topographical account for its physics,

laying aside the evaluative question of earnest or jest? Like Adamnán's writings, the scrapings of the manuscripts from Ireland are surely *laciniosus*, full of lappets and folds, as was the case in the last chapter's consideration of manuscripts in the "baroque" tradition whose epitome was Kells. It is fascinating that Bede describes exactly their surfaces as efficacious: "scrapings" (*rasa*) from these surfaces absorb the poison of a snakebite. A folded, involuted, invaginated surface has a greater surface area than a smooth one, and imagining the manuscript scrapings in this way makes sense of their absorbency in almost physical terms, in which their complex surfaces make them like sponges. Indeed, they absorb the poison and so assuage the swelling in the sufferer.

Moments such as these are allowable for a lucid and avowedly Roman-aligned, orthodox thinker such as Bede, I submit, because they perform the fold, the opacity and relationality that he seems able to live with because of their connection to the Incarnational tradition. The topography of the fold escapes orderly interpretive control, the vertical, Logocentric regulation of meaning. Instead, meaning glides, slips, skims, or "surfs" along the undulate surfaces that proliferate unexpected points of contact, metonymies of surprising character that abound in the medieval record.[11] Deleuze places the dark enigma of perception, of seeing in folds, within the long tradition of Western epistemology; seeing in folds is how we "see into God" (94). On some level, Bede understood the convoluted, folded style of Adamnán and other Irish masters to bear a relation to the folds of Christ's humanity, and he valued it as revelatory even while he sought to control it, much as the wider patristic tradition both valued the dark difficulty of scripture and sought to control its interpretation as well as its accessibility.

Adamnán's *De locis sanctis* is not only a topographic surface with Incarnational resonance but also an Incarnational landscape in its own right, accounting, especially in its first book, for the places, objects, buildings, and phenomena that were associated with Christ. And the prominence of physicality, the centrality of the senses, to the topography of the holy lands is striking. Bynum's reconsideration of matter in Christian ontology is helpful here because the logic of Adamnán's account is highly schematic, making sense only when read not in terms of realism, but rather as a kind of physics, an account of the behavior of matter of a certain type, specifically that which has come into contact with Christ's person.[12] This matter behaves in a way that,

as Bynum helps us understand, is at once spectacular and natural, miraculous or numinous precisely because it is simultaneously ordinary and revelatory (34–36, inter alia). Further, it has physical properties rather than simply comprising a series of wondrous signs. After all, an omnipotent God could project apparitions of whatever he chose. He could turn the whole world purple for a day or change a butterfly into an eagle or a gourd. Instead, holy matter is more constrained. Substances associated with Christ have solidity and are capable of penetration as well as flow. They must be contained, and they will replenish themselves or keep themselves whole within their containment. They are a part of a physical world that also includes the profane and the threat of desecration, and they perform their power within that context.

The stable properties of holy matter are at once powerful because they confirm faith and a cause for anxiety over matter's vulnerability. Recognition of the threat of desecration, and repudiation of that threat, frames De locis sanctis. Adamnán's account of Jerusalem opens with a description of its walls, a literal boundary defining the sacred space, and it pairs this, unexpectedly, with an image of the city covered in shit. He explains that during the September market festival, the streets are filled with offal from all the animals converging on the city at once. Remarkably, God sends torrential rains as soon as the beasts have departed, cleansing the city of the filth, which works extremely well because the city was sited on a perfect incline so that the waters could wash everything away. Such providence is entirely on account of the city's association with Christ: "Thus one should carefully note the magnitude and character of the honour which this chosen and famous city has in the sight of the eternal father, who does not suffer it to remain soiled for long, but quickly cleanses it out of reverence for his only begotten son, who has the honoured places of his holy cross and resurrection within the compass of its walls" (trans. D. Meehan 43).[13] God is unwilling to allow the carefully circumscribed sites of Christ's physical presence to be covered in filth. Containment and threat of contamination thus attend each other and frame the holy land as a place marked by both the need for definition and a certain vulnerability. Similarly, as a kind of caveat to the containment of the pristine city, Adamnán concludes the chapter with a mention of the roughly built but ample prayer house the "Saracens"

have built on the site of the former temple.[14] The enclosure of the holy is imperfect, and even the former Holy of Holies has been over-written (not by Christ's fulfillment of the law, but by Muslim encroachment).

The threat of being covered in shit reappears at the end of the work, in an anecdote about a wooden icon of the Virgin Mary. A disbelieving Jew (it is often a Jew in the case of threats to Mary's body, as I will discuss below) sees the icon hanging in a house in Constantinople (whence, incidentally, the iconoclastic controversies first emanated) and tears it off the wall, runs to a latrine, throws it in, and shits on it, whereupon a pious Christian comes to do his business and, somehow knowing what has happened, rescues the icon and cleans it in "the clearest water." Thenceforth it oozes a holy oil that Arculf himself has seen with his own eyes, which "proclaims the honour of Mary, the mother of the Lord Jesus" (trans. D. Meehan 119).[15] The Jew, bound in medieval Christian tradition by the flesh and the dead letter of the law, rejecter of the Incarnation, desecrates the icon of Mary in the lowliest way. Mary herself is representative of the humanity of Christ, the flesh that received divinity. The Christian who rescues the icon also has physical functions and needs—he comes to the latrine to excrete just as the Jew does—but his pious recognition of the icon performs the abstemious restraint and sublimation of the flesh that is the purview of the Christian dispensation. The water with which he cleanses the icon is a kind of baptism, and the holy oil oozing from the icon transfigures the filth to which it had been subjected.[16] Adamnán's text is thus aware of its stakes, that it concerns the sensible, perceptible representatives of the divine in matter, and that as matter, these are volatile things, in need of control and containment and always vulnerable to degradation as *mere* matter, whose lowest form is filth.

The sites of the Nativity, Crucifixion, Resurrection, and Ascension receive detailed treatment by Adamnán, and they convey particular information about the physics of Christological matter. In many ways, the properties of Christological matter resemble the properties associated with relics that we see throughout the Middle Ages.[17] The importance of containment, the prospect of penetration, and the properties of flow and partition run throughout the accounts. The church erected on Golgotha, the site of the Crucifixion, contains the chalice

that Christ drank from at the Last Supper as well as after the Resurrection, and this vessel further contains the sponge that was soaked in vinegar and given to him to drink at the Crucifixion (50–51). Both chalice and sponge thus contained liquid that went into Christ's body and suggest a further, transitive potential, since the wine of the sacrament passes from Christ's body into our own, as well. The chalice is a vehicle for that communion. The liquid that was poured out for us is further emphasized by the presence in the same church of the lance that pierced Christ's side, which has been cloven in two (50–53). The lance caused blood and water to flow, depicted in some medieval representations as pouring right into a cup or into the mouth of a supplicant. People flock, Adamnán says, to kiss or touch both the chalice, which held the liquid that entered and came out of Christ's body, and the lance, which penetrated that body. Arculf, we learn, had himself touched the chalice with his own hand (which he had kissed), through holes in the reliquary that contained it. The importance of both containment and the penetration of containment is evident throughout the Middle Ages, in various permutations. It is a central fact of our physicality that we are permeable but also, we imagine, bounded and whole. That the remnants of Christ's body, the relics of contact with that body, confirm those basic facts about ourselves is a striking affirmation of our physical humanness per se, confirming the logic of the chiasm by which the Incarnation in some way glorified humanity. As Bernard of Clairvaux demonstrates in his sermon on the "kiss" that he takes to prefigure Christ in the Song of Songs, Christ's physicality is an intimate aspect of our access to God.[18]

Flow and containment are also prominent at the site of the Nativity, where, Adamnán explains, a hollow in a rock preserves the water that was used to wash Jesus's "little body" (*corpusculum*; 74–75). Here, despite many centuries, the very water that touched the body remains undiminished, and it is available for contact and use by pilgrims. Arculf himself washed his face in it! This is both a baptism and not a baptism. No ritual is attached, and I think none was needed because the water is especially holy. In the usual sacramental rites, the words of the priest effect consecration, but the bathwater of the Nativity is consecrated by physical contact, by continuity with the very body of Christ. Importantly, the liquid associated with Christ has both natural and divine properties, as Bynum emphasizes for numinous matter. It behaves like normal water: it must be contained and

can be washed in, but it also miraculously resists evaporation and drainage, preserving itself like the incorrupt body of many a saint.

The containment strategies for holy matter themselves may be seen to recapitulate the logic of the Incarnation, by which divinity was surrounded by a cloud or covering. They offer new sites of engagement with the Incarnate divine. The church of the sepulcher offers an obsessive portrait of enclosure in Adamnán's account, recalling, of course, the opening account of the entire work, which describes the many walls, gates, and towers surrounding Jerusalem. The church of the sepulcher, according to Adamnán, is entirely round ("wondrously round"—*mira rotunditate*; 42) and made of stone. It has three layers of concentric walls, with passages in between, and inside they contain a domed structure enclosing Christ's tomb. Its shape and dimensions were so important that Adamnán had Arculf make a sketch of it on a wax tablet (42–43).[19] No relics or objects other than altars are mentioned in the account of the church. Its form is given entirely over to having contained Christ's body, its roundness protecting the empty space that stands as evidence of his past presence, as God on earth, and present absence, as resurrected man.

The substantive presence attesting Christ's absence is also evident in the behavior of matter at the church of the Ascension on the Mount of Olives (64–69). The site of the Ascension is marked by the footprints of Christ, which bear the property of infinite partition while keeping their shape.[20] Pilgrims carry away dirt every day as a kind of relic, and yet the imprints never fade or diminish. Presumably, the dirt is powerful because, like the water that washed the baby Jesus, it came into contact with the holy body. The site of the footprints, however, is powerful not only for the substance of that contacted dirt, but also for the shape of the negative space it surrounds, which is the form left by the physical feet of Christ. There is thus an impress, which is the figure that Augustine uses for the *imago* of God that we all bear within, a stamping or negative likeness that is not substance but form. The impress does not stand alone, however, for the earthly matter bears the conferred holiness of Christ's substance. Physicality is further emphasized by the fact that one of the two reasons Adamnán gives for the enclosure around the footprints being open to the sky, with no roof, is that pilgrims must have a clear line of sight from the ground where liftoff occurred when Christ ascended to the heavens. This emphasizes the importance of sensory contact with the site and story of

the Ascension: Christ ascended in the body, and our bodily eyes must trace the path upward, following him. The second reason that no covering protects the footprints is that any attempt to cover them results in a violent rejection: paving stones are flung back into the faces of anyone attempting to cover the site (64–65). Perhaps "faces" is important here, given the relation between the Augustinian impress, the *imago*, and the projected future in which we will see God "face to face." The Incarnational mystery is what establishes the special connection of the chiasm between God and man. The footprints are special and maintain a special link from the earth to the sky. When mere humans attempt to cover over the prints, which are both impress and substance, matter backfires, repudiating their merely human faces. Further, not only can earth fly up into the face of a human trying to mess with the Incarnation, but power comes down from heaven to that site once a year on the feast of the Ascension, in the form of a blast of wind that knocks everyone to the earth (68–69). Christ's coming to earth may have glorified humanity, but the power of the hypostatic union remains a formidable and specific force, tied to certain places and objects physically associated with the body of Christ.

The Mount of Olives is a particularly important Incarnational site, as it is not only the site of the Ascension but also the locus for the Sermon on the Mount, metonym for the gospel message (whose further metonym, as I have argued, is the Pater Noster). The connection between the Mount and the gospel itself is rendered in by-now-familiar physical terms, as bright light that has at once a material and a spiritual manifestation, two sides of the same phenomenon. In eight windows in the church of the Ascension are eight lamps that burn night and day, and their light is visible from Jerusalem (66–67). Adamnán accounts for the spiritual effects of this light using an example of Cervone's "dilation," crossing the boundary between literal and apparently (but not necessarily) figurative in the course of a single sentence to render a specifically Incarnational meaning:

> The bright and remarkable glow from the eight great lamps shining by night from the holy mount and the place of the Lord's ascension, as Arculf relates, pours into the hearts of the faithful who behold it greater eagerness for divine love and imbues them with a sense of awe coupled with great interior compunction. (trans. D. Meehan 67)

[Haec fulgida et praedicabilis octenalium magnarum coruscatio lucer-
narum de monte sancto et de loco Dominicae ascensionis noctu reful-
gentium maiorem, ut Arculfus refert, diuini amoris alacritatem cred-
ulorum respicientium cordibus infundit quendamque pauorem mentis
cum ingenti interna conpunctione incutit.] (1.23.13, p. 66)

The light from the lamps "pours into the hearts" of those who see it,
effecting a material-cum-spiritual enlightenment that mimics the hy-
postasis of the Incarnation. That light should "pour" also relates it to
the liquid flow that characterizes Incarnational substance such as the
wine/blood of the chalice and the water of the Nativity bath. An Old
English homily that translates this portion of *De locis sanctis*, Blick-
ling Homily XI, makes the association between this illumination from
the mount and the light of the gospel even more explicit, explaining
that when men see the light, they remember Christ's life and death
and are mindful of their sins and either repent or are converted (129).
Thus, being filled with the Incarnational light is being filled with the
gospel. The gospel words connect a hearer to the Incarnate, ascended
Christ, and the light from the Mount is a physical light with the same
effect, because it is Christ's Incarnational power in another form.

At this point it may be helpful to acknowledge that it is tempting
for readers trained in the allegorical tradition to take all of the ac-
counts of these holy locales as symbolic, not meant to be taken lit-
erally. Of course it is always possible to claim allegory, as D. W. Rob-
ertson demonstrated. But unlike medieval exegetes who were careful
to break the fourth wall and expound upon the hidden significance
behind a surface reading, Adamnán maintains throughout the premise
that the holy lands are real geographic locales that happen to reveal,
because of their physical contact with Christ, doctrinal truth. Their
physical properties are a living book inscribed with the Word. The
surface of the very earth and, it follows, the surface of Adamnán's text
suffice. Ultimately, the binary dividing literal and metaphorical is a
false one in any regard (all language being "metaphorical"). What
Adamnán's text insists upon strongly is that its world is best seen not
as a "surface" in the sense of something "superficial" and thus ex-
pendable; instead, it is itself a resonant plane, a "surface" in Deleuze's
baroque sense, inviting a surface reading, according to which words
mean exactly what they say, which is, to be sure, often more than
one thing.

OF MARY AND THE FLESH OF THE WORLD

I stress again that the Mount of Olives is not simply an allegory for gospel truth. The physical locale features prominently in post-Ascension apocrypha concerning the assumption of the Virgin Mary, who is herself a key example of matter as a vessel for divinity. In Blickling Homily XIII, for example, the Mount of Olives functions in a way reminiscent of its role as Incarnational beacon in *De locis sanctis*. Mary receives news of her impending death in a scene mirroring the Annunciation, in which an angel appears and gives her a *palmtwig* (apparently a palm branch, associated with Christ's victory over death explicitly earlier in the collection, in Blickling Homily VI [for Palm Sunday], 67).[21] Mary carries the palmtwig up to the Mount of Olives, where it shines with resplendent light, and then she brings it back down again. The palmtwig then figures prominently in the eventual drama surrounding Mary's body on its bier, as the apostles carry it through the city to its tomb. Disbelieving Jews plot to destroy the body, whereupon their hands are affixed to the bier, and in the meantime, whole crowds of them are struck blind. After their leader repents and believes, he is given the palmtwig to touch the eyes of the blind and restore their sight. Thus, the palmtwig in the Old English *Assumptio Mariae* (recorded, in different versions, in both Blickling XIII and the margins of CCCC 41, which I discuss in chapter 5) works like a kind of magic wand that has been charged up with at least twofold Incarnational power: 1) as an object through being brought to the Mount, and 2) as a sign through its symbolic association with victory and specifically Christ's victory on Calvary. Thus, the Mount of Olives is a kind of Incarnational power station, concentrating the word of the gospel, the body of Christ, the splendor of his resurrected form, and the lasting connection between the earth and the heavens that was established and traversed in the Incarnation and Ascension. None of this topography is merely symbolic, a fact that is rendered succinctly by Adamnán's assertion that a solstice column in Jerusalem proves it to be the very center of the world, which he shores up with a quotation from Psalms: "God our king before the ages hath wrought our salvation in the center of the earth" (trans. D. Meehan 57) ["Deus autem rex noster ante saecula operatus est salutem in medio terrae," Ps. 73:12]. The Mount of Olives is

the center of Incarnational power, located at the geographic center of the world.

The center of the world is marked by boundaries in the form of walls and gates and towers, which contain and demarcate even while they do not keep out "alien" presences such as the mosque. Concentric walls surround Christ's tomb, and most relics of the holy body itself were subject to further enclosure in reliquaries, with access only through apertures that enacted a fantasized penetration of Christ's body while conducting the adorer from the profane physical realm to the holy one. The archetypal container for Christ's body was not the tomb but a womb, however, and Mary is an adjunct to the body of Christ throughout the *De locis sanctis*. For example, adjoining the church of the sepulcher there is a church dedicated to "Mary, mother of the Lord" (1.4, p. 49). Mary's status as provider of the brute matter of the Incarnation is well-known and derives ultimately from Aristotelian gender theory.[22] In the Old English Blickling Homily XIII (*Assumptio Mariae Virginis*) as well as IX (Vercelli X), Mary's function as container is extolled as a series of dilatory variations on a theme, involving different forms of matter (trans. and emphasis are my own):

Se halga gast wunode on þam *æþelan innoþe*, & on þam *betstan bosme*, & on þam *gecorenan hordfæte* (Blickling IX, 105)[23]

[The holy ghost dwelled in the *noble womb*, in the *best bosom*, in the *precious vessel*]

Wes þu gemyndig, þu gewuldroda cyning, forþon ic beo þin *hondgeweorc*, & wes þu min gemyndig, forþon ic healde *þinra beboda goldhord*. (Blickling XIII, 147–49)

[Be you mindful, thou glorified king, that I am your *handiwork*, and be you mindful that I hold the *treasure* of your commands.] (spoken by Mary's "dead" or soul-separated body)

Ne forlæte ic þe næfre min *meregrot*, ne ic þe næfre ne forlæte, min *eorclanstan*, forþon þe þu eart soþlice godes *templ*. (Blickling XIII, 149)

[I will not forsake you ever, my *pearl*, nor will I ever forsake you, my *jewel*, for you are truly God's *temple*.] (spoken by Jesus)

Mary is a vessel and container, a temple and a treasure box, and, strikingly, her flesh can speak, for in the *Assumptio*, it is her dead body that addresses the Lord. Mary's body is a prototypical reliquary, precious and perfect and artificed, fit for bearing holy matter and capable of a special eloquence.[24]

Shrouds, coverings, and bodies are central to the *Assumptio*, as Mary herself seems to serve as a remnant or remainder on earth demonstrating the special nature of Christ's flesh. While Mary's flesh can somehow speak, her soul, when it is taken up from her body, has in turn a physical appearance, being "seven times whiter" than snow. She is also keen to take the apostles to her closet to show them what she wants to wear in the tomb. The Latin *cubiculo suo* is translated in the Blickling text as *hire hordcofan*, encouraging a reading that connects Mary's body with the treasure hoard that she will later invoke herself:

Ond þa æfter þon þa cegde seo halige Mariæ to eallum þæm apostolum on hire hordcofan, & him æteowde ealne hire gegyrelan þe heo wolde æt hire byrgenne habban. (143)

[And then after that the holy Mary called all the apostles into her treasure chest, and showed them all her garments, which she wished to have at her burial.]

In Old English, the word for body, *lichama*, is a compound that includes the simplex "cloak" (*hama*), literally "body-cloak." Mary's body shares its properties with the body of Christ, as is seen in the similar behavior of the shroud that covered Christ's body and the body of Mary on its bier, with the aid of the shining palmtwig.

According to Adamnán, Christ's shroud still exists and is taken out from time to time for pilgrims to touch and kiss; it is a stand-in for the absent body of Christ, a contact relic (therefore a metonym) that is also a metaphor, a literal cloak or shroud standing in for the body, itself a cloak or shroud (53–55). He tells a long, parable-like story about it that he is careful to attribute to Arculf as hearsay ("We learned from the holy Arculf [who saw it with his own eyes] the following account . . . for the holy Arculf got this statement on the testi-

mony of very many of the faithful of Jerusalem, who often told it to him in these terms while he listened intently"; trans. D. Meehan 53).[25] In his account, the shroud was stolen right after the Resurrection, predictably by a Jew—but this time a "good" one, "decent enough" (*satis idoneus*) and "believing" (*credulus*). Again, the logic is consistent with standard medieval Christian antisemitism, associating Jews in particular with Christ's body and implicating them in the Crucifixion.[26] Since that time, the shroud has been passed down the generations, from the original pious thief to his believing sons, whom the shroud has prospered in material wealth. Finally, "three years ago" the shroud was discovered and contested between the believing and the unbelieving Jews (52–53). The Muslim ruler of Jerusalem steps in to adjudicate the dispute, and the climactic scene has the shroud placed upon a fire only to rise "like a bird" above the factions and ultimately decide in favor of the believers.

This story is rich in Christological symbolism. The birdlike rising from the flames obviously evokes the phoenix and with it the Resurrection. The question of prosperity and reward recalls the parable of the vineyard (Matt. 20:1–16). The earthly presence and power of the shroud are also striking in Arculf's story. It brings worldly wealth even to unbelievers who possess it. When animated by the fire (perhaps recalling the Holy Spirit and the fire of Pentecost), the shroud possesses a kind of volition, choosing the believing faction and prefiguring the separation of the saved from the damned that Christ will perform at the Last Judgment. When fluttering above the divided crowd, it calls to mind not only the phoenix but also both Bede's parable of the sparrow and the Valkyries flying over the battlefield, ready to divvy up the slain. Both winged creatures are mediators between the heavenly or cosmic and earthly realms, and the shroud functions here similarly. It hovers above the disputing factions, signaling its divinity in this behavior while inhabiting as well its connection to the earthly and now glorified body of Christ. Adamnán/Arculf thus imagines the shroud as a multivalent object, or thing, like the palmtwig, able to invoke multiple literary images at once, possessed of material power, and similarly contentiously related to the Jews.[27]

In the *Assumptio Mariae*, Mary's body has a similar power over and fixation for the Jews, who plot to destroy it and are rendered helplessly attached to it and also blinded as a result. Only after believing are their hands freed from the bier, and only after being touched

by the palmtwig of Christ's radiance is their eyesight restored. The specific threat to the body in at least one recension of the *Assumptio* is destruction by fire. Thus, Mary's body possesses a power in the world similar to that of Adamnán's shroud of Christ in relation to the unbelief of the Jews, who are associated, again, in Christian tradition with the body, the letter, and the law. The ossification of this power into fetish is the target several centuries later of Chaucer's satire in *The Prioress's Tale*. The little clergeoun's mindless devotion to the Virgin is given full and awful expression in the tale when the boy's dead body sings songs in the Virgin's praise from the latrine, indirectly echoing Adamnán's remarks about the icon of the Virgin being rescued from a similar pit.[28]

Adamnán gives no clear reason why it matters to do so, but he relates that Mary has her own "cloth" in Jerusalem. Her shroud is larger than the shroud of Christ, and she wove it herself. It contains "interwoven" (*intextae*) the forms (*formulae*) of the twelve apostles plus the *imago* of the Lord. "One side of the cloth is red in colour, and the other part, on the opposite side, is green like plants" (57). As Christina Lee has discussed, weaving was associated both with women and with healing and thus with the body. Cloth and coverings were associated with seeing the divine, from the many images in the Book of Kells depicting Christ's Incarnation as a cloak to an image Bynum discusses from the Rothschild Gospels (ca. 1300), in which a triple knot of cloth contains the three persons of the Trinity, at once covered and, as it were, disclosed (Bynum, *Christian Materiality* 26).[29] Mary's cloth is remarkable for being larger than the Lord's shroud, reflecting perhaps her broader association with the "flesh" of this world. It includes the apostles and the visage of Christ himself, all of whom lived as men among other life on earth for their time, and it seems to provide a ground for their lives, to imply the living backdrop of the earth itself. Its two colors may denote the red and green of flowering plants, or perhaps Christ's sacrifice coupled with the green that is the life of the natural world.[30] I also note the appearance of red and green as well as a two-sided object with an image (of Mary) on one side and a woven image, an "endless knot," on the other, in the much later Middle English poem *Sir Gawain and the Green Knight*.

The figure of Mary is integral to the fabric of Christ's flesh and to the containment or boundedness of his flow and substance. This is apparent not only in the commonplace of Mary as a vessel, building, or

enclosure, but also in the devotional importance of the boundary or opening of that enclosure. As has been well established, medieval writers and illustrators saw the wound in Christ's side as somehow "like" the opening to Mary's womb, or at least like such an opening in general.[31] The wound was often rotated to vertical and, in the later Middle Ages, depicted with labial folds. The link between Christ's wound and the vagina is firmly established in the literature on the later Middle Ages. Bynum describes the shape as "the opening from which the salvation of the world was born and into which saved souls return to rest in the center of Christ" (*Christian Materiality* 199). The wound's association with the vagina was unmistakable in its use on birthing girdles "in the hope that one gaping slit would aid another in opening," in Bynum's memorable phrasing (200). Karma Lochrie, Amy Hollywood, and Luce Irigaray have each considered the erotics of the wound as a vagina in the context of later medieval mystical de-votion, an erotics that Lochrie in particular takes Bynum to task for minimizing (182–84). It seems clear that in the later Middle Ages, the coincidence of wound and vagina was an intensely eroticized de-votional nexus, upon which the ardent flesh and spirit of the devo-tee could converge. In the early period, however, the wound-vagina nexus has a more schematic, less erotic character. It stands between the visible and invisible realms, indicating the gateway status that Christ's flesh shares with Mary.[32]

One of the elements of this nexus in the early period is the man-dorla or almond-shaped halo that often surrounds Christ. It appears from the earliest centuries of Christian art.[33] I have not seen the man-dorla frame of the earlier period connected to the vagina wounds of the later period in the scholarship, but there are striking connec-tions. They share the obvious association with Christ's Incarnation. The mandorlas surrounding Christ in the early period were the size of his body, emphasizing his body, and the later vagina/wounds assume those same dimensions.[34] Also relevant is the fact that holes in the parchment of manuscripts often look like mandorlas, as a rip of any length tended to widen in the center as the skin—actual skin—pulled away. I have already discussed how one such hole, patched, provided a marginal illustrator with an occasion to connect parchment skin to the skin of Christ and the Eucharist (see ch. 2). That the vertical man-dorla is a universal female symbol should be self-evident, certainly as self-evident as the swordlike shaft for the phallic male. Continuity

across the period in the association of the mandorla with Christ seems to represent an emphasis upon Christ's flesh, whether it be his body, his skin, his side wound, or the vaginal opening through which he came into the world. This shape constitutes a kind of nexus surrounding Christ's flesh and emphasizes liminality, the crossing of the threshold between this world and the spiritual realm, between the pure divinity Christ always possessed and the humanity he assumed. The Harley Psalter in particular (British Library, Harley MS 603, an eleventh-century copy of the ninth-century Utrecht Psalter) exemplifies the Incarnational emphasis of the mandorla, as it not only uses the shape to outline Christ in several images but also depicts the (prefigured) Eucharist multiple times as laid out upon a horizontal mandorla in the form of a table, on lion's legs, with a hand gesturing down out of the clouds above (see figs. 3.1 and 3.2). The exemplars in the Utrecht Psalter of the two images (on 13r and 31r) have ovoid tables rather than mandorla-shaped ones, and they appear to be attempts at perspective, rendering a round table from an oblique angle. The Harley illustrator substitutes clear mandorla shapes.

I stress the function of the mandorla as opening: Christ entered into the world through the opening of the flesh, and this is the same opening through which he left the world with his death. It is through this liminal structure, a construct of both the earthly and the heavenly, the seen and the unseen, through the person of Christ, that the conciliatory commerce between God and humanity is possible. Openings, however, also have their own contours. Not simply negative space, they have edges, surfaces of their own. This is where I would return to Deleuze's phenomenology of the fold. The mandorla frames the presentation and reception of the Word and of the divine as an aperture of Incarnational folds. The folds of Christ's flesh are the very fabric of perception, connecting the earthly and spiritual realms because they are both opening and surface, divine and human, negative and positive. The opening of the mandorla into and out of the world of sense perception is a rather precise rendering of a specific Incarnational phenomenology by which the Word is perceived not so much in *ratio* or fixed Euclidian geometries, but in the emergent geometries of folds. This phenomenology of folds is another way of visualizing, I think, what Cervone describes as the Incarnational "focus on the verb" (in *verbum caro factum est*) (5). The mandorla, through the medieval longue durée, gathers to itself an indexical capacity to

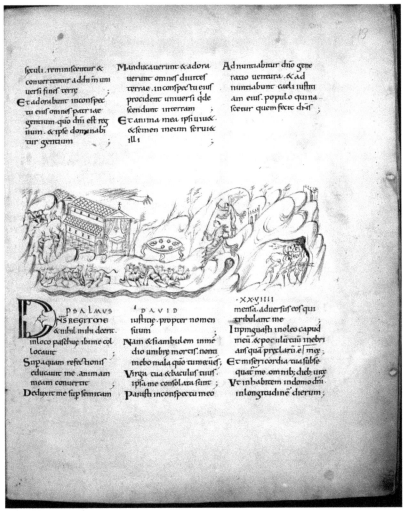

Figure 3.1. BL Harley MS 603, fol. 13r (Ohlgren 168). © The British Library Board.

reference the flesh of the Word as well as many of its mysterious properties.

I return now to landscape and to the world of the senses, considering some of the ways that vernacular texts in particular construe the sensible in relation to the Incarnate Christ. I have discussed various enclosures, such as caves, churches, tombs, and wombs, in Marian apocrypha and in Adamnán's account of the holy lands. Blickling

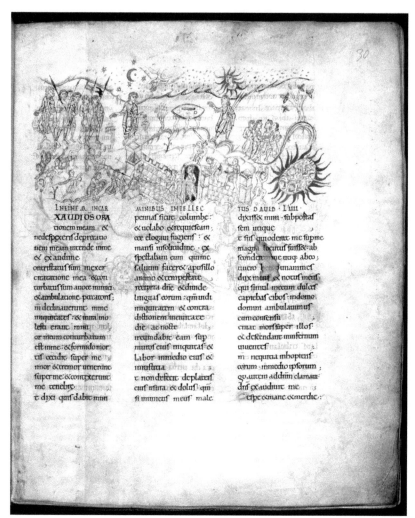

Figure 3.2. BL Harley MS 603, fol. 30r (Ohlgren 198). © The British Library Board.

Homily XVII features another such enclosure, one with a close affinity to a benign, green, and flourishing natural landscape. The homily pairs the legend of the founding of St. Michael's church in Campania with the *Visio Pauli*'s account of a hellish mere.[35] Michael's church is found, not built, in a quasi-magical landscape that bears certain features of Celtic folklore. Somewhat like the Green Chapel of *Sir Ga-*

wain, the church is rude but otherworldly, with a green field above it.[36] Its power or numinousness seems to arise not from connection to biblical events but as a manifestation of the natural landscape. The church is really a large cave, which a man stumbled upon while searching for his cow. When he found the cow, he shot an arrow in anger at the animal, and it miraculously turned back upon him (199). This was a sign, apparently, that the cave should be a place of reverence. St. Michael then appears to the people and announces that the new "church" does not require consecration because he built it himself—it is a kind of echo of the divine manifestation of which the Incarnation is prototype, and it possesses a power independent of and superseding institutional authority. No one enters this hallowed space at night, for example, but normal offices and rites are observed there during the day. I think this is an example of "thingness" worked into the homily's accommodation of multiple traditions. Authority prevails at daytime, but there is a time when the cave keeps other secrets—or maybe when the cave is just a cave. The sacraments are observed, but in addition, there is a glass vessel filled with holy water that "after taking the sacrament" ("þonne hie to husle gegangen hæfdon"; 209) the people climb up to and drink for its taste as well as its healing properties. The cave regulates its own penetration with its diurnal restriction of entry, and as in the holy sites in *De locis sanctis*, water with special properties grants benefits to the faithful. There are even footprints in the marble floor, "as in wax," that stand as proof of Michael's (absent) presence (203).

Michael's bucolic church is juxtaposed in this homily with the northern landscape of the *Visio Pauli*, often compared to if not credited for Grendel's mere in *Beowulf*. There, in the north ("on norðanweardne þisne middangeard"), from whence all waters flow down, according to the homilist, Paul saw:

ofer ðæm wætere sumne harne stan; & wæron norð of ðæm stane awexene swiðe hrimige bearwas, & ðær wæron þystro-genipo, & under þæm stane wæs niccra eardung & wearga. (209)

[above the water an ancient stone; and north of the stone there had grown very rimy woods, and there were dark mists, and under the stone was the dwelling of serpents and wargs] (trans. mine)

Black, bound souls hang from branches on a cliff twelve miles above the black water. When the branches break, they fall into the fathomless, infested waters below. The baleful landscape of this vision is clearly a counterpart to the wholesome green chapel of St. Michael with its good, clear water and altars of natural stone. Here, the water teems with monsters, and instead of climbing up to a glass vessel, the doomed souls have no volition—their hands are bound and they hang helplessly—and then they fall a horrifying distance to the water and are seized. The salvific waters of life have their counterpart in these turgid waters of death. Neither of these two landscapes can be easily allegorized. They seem to exist as "real" places, emblematic, in their realness, of a blessedness and a cursedness to which people could readily relate.

And relating—perceiving—is certainly the point. The Blickling Homilies open with a sermon on the Annunciation, when Mary heard the news that she would bear the divine into the world. This event was depicted and theologized in the Middle Ages as a kind of aural insemination (*conceptio per aurem*), the words of the angel Gabriel pouring into Mary's ear the seed that would grow into Christ, or the words coinciding with the inpouring of the Spirit. But the Blickling homilist emphasizes not the physiology of conception but the reciprocity of a speech act:

> Gabriel was the messenger of these nuptials. What did he say to her, or what did she hear, when he spoke, "Be you well, Mary, full of grace, the Lord is with you," and from this greeting she conceived, because he brought her eternal salvation on his tongue. (trans. mine)

> ———————

> [Hwæt cwæþ he to hire, oþþe hwæt gehyrde heo, þær he cwæþ, 'wes þu hal, Maria, geofena full, drihten is mid þe,' & from þisse halettunge heo was geeacnod; forþon þe he hire þa ecean hælo on his tungon brohte.] (Blickling I, 3)

"What did he say to her, and what did she hear?" is a question that remains unanswered and mysterious. Here, as in the sweet verses and liturgical song in the story of Cædmon, there is a mystery borne by holy words themselves, one that bridges the divide between the spiritual and the material, the invisible and the visible, the divine and the human. The frequent invocations of hearing that vernacular homilies

borrow from vernacular heroic poetry (the *Hwæt we gefrugnon . . .* ["Lo we have heard . . ."] formula) bear a compound resonance in their traditionality and in their connection to the mystery of the Word. "What did he say to her, and what did she hear?" It is a real question. We should all have what she is having/hearing.

Vercelli Homily X appends to the portion it shares with Blickling Homily IX a prologue that affirms the special nature of holy speech:

> Here it says in these holy books about the almighty lord's gospel, which he made out of himself through his own holy might as an example to men and as teaching. And he himself said with his holy mouth: "Though one should say the gospel to a single man, then am I thereamid." (trans. mine)
>
> ---
>
> [Her sagað on þyssum halegum bocum be ælmihtiges dryhtnes godspelle, þe he him sylfum þurh his ða halegan mihte geworhte mannum to bysene ⁊ to lare. ⁊ he sylf gecwæð his halegan muðe: 'þeah man anum men godspel secge, þonne bio ic þæronmiddan.'] (Vercelli X, 196)

Scragg gives several analogues to this equation of Christ with gospel speech (*Vercelli Homilies* 214, note on lines 3–8). Christ may have meant his biblical sentiments metaphorically, but in the early Insular context, Christ's own words were seen more materially, as having a quasi-physical power. Speaking the gospel was so important that the Vercelli homilist avers that whoever knows the words and does not share them is cursed. Blickling Homily III remarks that Christ himself used the "word of scripture" (*worde þæs godcundan gewrites*; 33), rather than his might, to defeat the devil during his temptation in the desert, something that the Book of Kells Temptation page (fol. 202v) shows explicitly. The vernacular homilies emphasize this verbal dimension of the Christological landscape. Words are a physical force.[37]

Blickling Homily V connects the holy speech of the gospel to Christ's redemption of the natural world, emphasizing not the fallenness or inferiority of that world, but rather its tragic ephemerality. What we love in the "too much loved earth" (as Sidney put it) is indeed beautiful—not, for example, inherently treacherous—but we are doomed to its loss through change and decay (9). A long and poignant

section of this homily is devoted to the transitoriness of nature (emphasis mine):

We know that Christ himself said *through his own mouth*, "When you see all the fruits of the earth growing and blooming, and they exude the sweet smells of the plants of the woods, then soon after they will dry up and pass away because of the summer's heat." Just so then be the mortal nature of the body, when youth first blooms and is fairest, the glory then quickly leaves and turns old, and it thenceforth is troubled by suffering, with sundry aches and infirmities; and all the body despises to perform youthly delights which it before had passionately loved, and were to it sweet to suffer. They will then seem very bitter to him, after which death will come to announce God's judgment. The body then will be turned into the hardest stench and the foulest, and his eyes then will be sealed up, and his mouth and his nostrils closed, and then the dead one will be uneasy for every man to have in the neighborhood. Where is indeed the desire for idle things, and the sweetness of the sexual congress which he had passionately loved? Where is then the feasting and the idleness and all the intemperate laughter and the false boast and all the idle words which he had wrongly uttered? All of them have departed just as a cloud, and just as a stream of water, and moreover will never appear again. Such is the end of all the body's fairness, which the foolish and the unwise now love so much. (trans. mine)

[We witon þæt Crist sylfa cwæþ þurh his sylfes muþ, 'Þonne ge geseoþ growende & blowende ealle eorþan wæstmas, & þa swetan stencas gestincað þara wuduwyrta, þa sona eft adrugiaþ & forþ gewitaþ for þæs sumores hæton.' Swa þonne gelice bið þære menniscan gecynde þæs lichoman, þonne se geogoþ-had ærest bloweþ & fægerost bið, he þonne raþe se wlite eft gewiteþ & to ylde gecyrreþ, & he þonne siþþon mid sare geswenced bið, mid mislicum ecum & tyddernessum; & eal se lichoma geunlustaþ þa geogoðlustas to fremmenne þa þe he ær hatheortlice lufode, & him swete wæron to aræfnenne. Hie him þonne eft swiþe bitere þencaþ, æfter þon þe se deað him tocymeþ Godes dom to abeodenne. Se lichoma þonne on þone heardestan stenc & on þone fulostan bið gecyrred, & his eagan þonne beoþ betynde, & his muþ & his næsþyrlo beoþ belocene, & he þonne se deada byð uneaþe ælcon men on neaweste to hæbbenne. Hwær bið la

þonne se idla lust, & seo swetnes þæs hæmedþinges þe he ær ha-
theortlice lufode? Hwær beoþ þonne þa symbelnessa, & þa idelnessa,
& þa ungemetlican hleahtras, & se leasa gylp, & ealle þa idlan word þe
he ær unrihtlice ut forlet? Ealle þa gewitaþ swa swa wolcn, & swa swa
wæteres stream, & ofer þæt nahwær eft ne æteowaþ. Þyllic bið se
ende þæs lichoman fægernesse, þe nu dysige men & unwise swiþe lu-
fiaþ.] (57–59)

It is noteworthy here that the world is not despised as such, for being
world, material, physical. We are not in a Neoplatonic landscape of
fallenness. The words quoted from Christ's "sylfes muþe" affirm and
valorize the sweetness of the blooming, growing world. Its weakness
is its transience. This is what is so horrifying when the example is ap-
plied to the beauty of the human body. Everything that was so lovely
becomes hideous, in a way that recalls the reciprocal phenomenology
of the angel's annunciation to Mary. For it is not simply that we are
to gawk at the disgusting worms gnawing the flesh of the corpse, as
is the case in many such exempla. Rather, as the body becomes dis-
gusting to those around it, it in turn is robbed of its capacity to sense:
"his eyes then will be sealed up, and his mouth and his nostrils
closed." The two-way intercourse with the world that is life and aes-
thetic perception will cease to operate in its reciprocal flow. This
thought then leads into the ubi sunt list that lingers upon sex and con-
viviality, all pleasures that are erased "just as a cloud" or washed away
"as a stream of water" but, unlike those natural processes, will never
appear again.

Christ as Word steps into this gap of loss. Just as the horror of
death is the loss of one's sensory interaction with the living world, the
greater horror posed by the homily is of the word of the gospel falling
on hard soil. The gospel is the "*wyrtruma* [root] of holy speech" that
is meant to bear fruit. This imagery draws not only upon biblical
topoi such as Christ as the true vine. Together with Blickling IX,
it presents a unique "fold," drawing together the botanical with
the other nexus of images I have discussed that associate Christ with
enduring, precious substances, wherein Christ is often a goldhoard
entering the treasure chest of Mary, for example, and Mary herself is
a pearl, a precious stone, a temple, a chalice. In Blickling Homily IX
we see the famous and famously perplexing epithet of *goldbloma* for
Christ at the Incarnation:

Þa ealre fæmnena cwen cende þone soþan scyppend & ealles folces frefrend, & ealles middangeardes hælend, & ealra gasta nergend, & ealra saula helpend, þa se goldbloma þa on þas world becom & menniscne lichoman onfeng æt Sancta Marian þære unwemman fæmnan. (105)

[Then the queen of all women conceived when the true creator and helper of all people and savior of all the earth and redeemer of all spirits and helper of all souls, then, when the golden blossom came to this world and took a human body from Sancta Maria the unblemished woman.] (trans. mine)

I have discussed this passage before but have different things to say about it here.[38] It is remarkable. This section forms a ring of sorts, beginning and ending with *fæmn(e)*. Its action is also, like the speech of the Annunciation, reciprocal. *Mary* conceived (*cende*) when the savior (cue the string of transformations or variations on his theme) took his body from *Mary*. *Mary* bounds the structure, and the savior takes many different forms within, culminating in *goldbloma*. This term combines the botanical *bloma* and the metallurgical *gold* for a potent synthesis in the context of a world that is loved but ever passes away. Christ is the blossom that will not fade, the thing of the world that never dies to the senses. Of course the term could simply indicate color as opposed to metallic substance, but poetic suggestiveness is always availing itself of associative connection. And here, as I have tried to show, an existing discourse of Christ-as-treasure would have made the metallic sense easily accessible.

Here I stretch out even further on my limb. The Blickling Homilies have their own particular topography when taken as a collection, as some kind of "whole" (distinct from, say, that of the Vercelli Book, which intersperses homilies with verse texts). They begin with the Annunciation, with the reciprocal speech event that brought Christ to earth and surrounded him with flesh. The *goldbloma* homily is almost exactly at the center of the collection, and the collection ends with a prose telling of the story of Andreas, which has at its heart a drama of the flesh, as well. The Mermedonian cannibals who capture the apostle have the habit of putting out the eyes of their victims and dissolving their hearts and minds with poison, making them effectively zombies. The threat that drives the plot of *Andreas*, then, is the threat

of being made into mere flesh (*mete*, "meat"), robbed of the power of perception. The Blickling collection therefore bounds itself with the flesh, first with Christ's Incarnation and at the end with the worst form of baseness that one could conceive—brute matter—not death but a living death, and a kind of empty or profane Eucharistic consumption in the Mermedonians' cannibalism. Bounded by these endpoints, the golden blossom in the center of the collection poses Christ Incarnate as a kind of fully realized solution, the blossom that will never fade, the flesh that endures.[39]

Christ's unchanging, golden form also lies at the center of the Vercelli Book, in the poem usually called *The Dream of the Rood*, where it appears to a perceiver by surrogate through the vision of the Cross. Here, too, perception and physicality are central to the logic by which Christ is manifest. The poem's galvanizing image is a vision of the cross in which it oscillates between being decked out with gold and covered with gore:

> Geseah ic þæt fuse beacen
> wendan wædum ond bleom; hwilum hit wæs mid wætan bestemed,
> beswyled mid swates gange, hwilum mid since gegyrwed.
>
> (lines 21b–23)

[I saw that lively beacon change coverings and form; sometimes it was covered in wet, soiled by blood flow, at times richly adorned.] (trans. mine)

This contrast provokes in the speaker profound distress; having at first merely been in awe at the splendor of the cross, he is now "beset with sorrows" (or "by surges"),[40] "forht . . . for þære fægran gesyhðe" ("afraid on account of that fair sight"). This spectacular shock seems to render him receptive to the Passion story that the rood proceeds to tell. Indeed, the poem in its opening twenty-five-odd lines emphasizes the act of seeing or beholding, repeating the verbs *geseon* ("to see") and *behealdan* ("to behold") multiple times and couching them in the further subjectivity of "seeming" ("*þuhte me þæt ic gesawe*" [it seemed to me that I saw]; line 4a) and "perceiving" ("hwæðre ic þurh þæt . . . ongytan meahte" [however beyond that I could perceive . . .]; line 18). In the middle of the intense passage narrating the vision of the cross, the dreamer expresses his experience in the form of the

now-familiar chiasm, of which, as we have seen, Christ is the mid-point:

Forht ic wæs for þære fægran *gesyhþe. Geseah* ic þæt fuse beacen

(line 21)

———————

[I was afraid for that fair *sight.* I *saw* that lively beacon]

"Gesyhþe. Geseah" right in the center of this line makes seeing the fulcrum, the point of tangence. Vision here joins a subjective state ("forht ic wæs") in the observer to an active state in the observed object ("þæt *fuse* beacen")—vision, which is the very purpose of Christ's having taken human form, making the invisible visible to men. Thus, the contact point of aesthetic experience, which negates the distinction between subject and object or closes the gap between them, is the catalyst, the door to revelation and gospel truth, Christ himself. Christ happens to be a "door" in more than one text in the manuscript that is central to the final chapter of this book, CCCC 41, where he is both "door of the deaf" and "sight of the blind," accomplice to sensory perception per se. Christ is at the contact point of sensing the divine. He *is* that contact.

Once the cross begins to tell its tale, the poem plunges even further into subjective experience as the drama of the Passion is retold not only from the specular perspective of the eyewitness, but also from the embodied perspective of one who was fused with the body of the Lord:

Þurhdrifan hi *me* mid deorcan næglum.On *me* syndon þa dolg gesiene, opene inwidhlemmas . . .

Bysmeredon hie *unc butu ætgædere.* Eall *ic* wæs mid blode bestemed

(lines 46–48, emphasis mine)

———————

They drove *me* through with dark nails. The wounds were visible *on me,* open afflictions. They mocked *us both together. I* was all covered with blood. (trans. and emphasis mine)

In perceiving (in touching) Christ's body itself in the course of its experience of the Passion, the cross is granted a special revelation of the

Word. While it could be said that the cross's suffering during the time when cross and Christ are most unified—while Christ's body actually hangs upon the cross—is meant to amplify the suffering of Christ, it is not exactly suffering, either on the part of the cross or on the part of the dying human body, that is the focus. The focus seems to be the alignment of perception and experience with Christ's physical person. Almost like an eclipse, the cross beholds as Christ approaches, and the two briefly share the same physical space (the experience of which only the cross narrates), after which the cross again "beholds" as men approach to take the body down and history resumes its course. The experiential, phenomenal space occupied by both bodies is a singular event, not because eclipse and transit never happen anywhere else, but because in this case one of the bodies is Christ's.[41] The rood experiences coincidence with Christ at the very point of his body's penetration and outflowing and is thus imbued with Incarnational energy in a way similar to the "charging" of the palmtwig on the Mount of Olives in Blickling Homily XIII. Thus the cross becomes a "beacon" (*beacen*, lines 21b, 83a) of the Incarnational light.

The cross itself declares that the privileged contact it has had with the Incarnate body renders it exalted or glorified in the same way that Mary has been glorified through her contact with Christ's body as Theotokos, or God-bearer:

Hwæt, me þa geweorðode wuldres ealdor
ofer holmwudu, heofonrices weard!
Swylce swa he his modor eac, Marian sylfe,
ælmihtig god for ealle menn
geweorðode ofer eall wifa cynn.

(lines 90–94)

[Lo, the elder of glory has then honored me above the forests, guardian of heaven, just as he has also honored his mother, almighty God, for all men over all womankind.] (trans. mine)

Both the Rood and Mary are therefore contact relics, serving as beacons of Incarnational presence for humankind precisely as representatives of the created, material world. The cross is exalted among the trees of the forest and Mary is exalted among women, bearers of

fleshly matter (as opposed to spiritual virtue) since antiquity. The two figures exemplify Christ's sacramental humanity, *humanitas exaltata*. One can see them as exceptional, with patristic orthodoxy, or instead as merely exemplary, as I have here. In glorifying the Rood and St. Mary, Christ's Incarnation exalts their substance, demonstrating the possibility and potential for its glorification.

The Dream of the Rood foregrounds experience, phenomenology, as Christ himself never speaks in this poem, even while he is central to it. His body is visible, and the language of the poem is the language of witness and of experience of that body. Christ is there in the gap or seam between the perceiver and the perceived, in the unfolding of perception, on the part of the dreamer, the cross, and ourselves as readers or listeners. In the Insular ontology of surfaces, Christ is not sought primarily in the *ratio* that derives from his divinity and subtends creation. He is the topography created by Incarnational folds. These are contact points of tangence, which create their own mysterious surfaces.

For my last example I will turn to an object, the Fuller Brooch (see fig. 3.3). Dating to the late ninth century, the brooch by all accounts contains a scheme devoted to the senses.[42] A central human figure privileges sight, and four human figures surrounding it depict taste, smell, touch, and hearing. The outer edge of the circle is lined with further circles containing human, animal, and plant representations, each in their respective spheres. While it is clear that the brooch celebrates the world of the senses, it has gone unnoticed that the senses, as part of creation, are here connected to the Eucharist and thus the Incarnation.[43] The human figure in the center appears to have a chalice or vessel, marked with a cross, in front of him. Further, the figure holds two flabella, which in the Book of Kells (as I discussed in chapter 2) index the Eucharist (again, they were used to keep the Host free of flies and other contaminants). I submit, then, that the central figure depicts the Incarnational presence in association with vision, with seeing that which had been invisible, the Word made flesh.[44] Each of the other senses is framed within a mandorla, and the circles around the perimeter of the brooch populate it with the representatives of the created realm: man, beast, and plant. The Fuller Brooch affirms the physical senses, and thus aesthetic experience, as the means by which we contact the Incarnate divine. In the next chapter I will invert my argument and consider, instead of surface manifestation, the elaborate

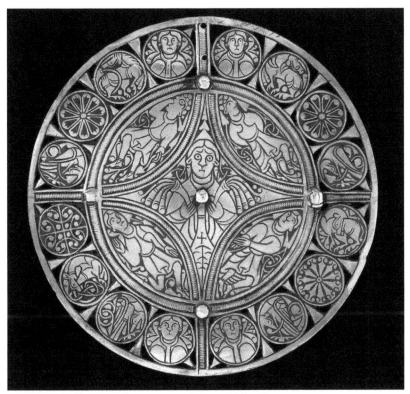

Figure 3.3. Fuller Brooch, courtesy of the British Library.

modes of concealment that were cultivated by writers in the wisdom tradition. If the world could disclose the Incarnational presence, as this chapter has discussed, the Word could also, and paradoxically, be disclosed through further concealment, by folds within folds.

APPENDIX

Arculf's Account of the Legend of the Shroud, as Recounted by Adamnán

Concerning the holy shroud of the Lord also, which was placed over his head in the sepulchre, we learned from the holy Arculf (who saw

it with his own eyes) the following account which we now set forth, and which all the people of Jerusalem assert to be true. For the holy Arculf got this statement on the testimony of very many of the faithful of Jerusalem, who often told it to him in these terms while he listened intently:

The holy cloth, which a decent believing Jew had stolen from the Lord's sepulchre immediately after the resurrection and hidden at home, about three years ago, by favour of the Lord himself, was discovered after the passage of many years, and came to the knowledge of the whole people. For when he was in his last extremity that fortunate and believing thief summoned his two sons, showed them the Lord's shroud that he had originally stolen, and offered it to them saying: "My sons, you now have a choice. Let each one of you say then what his wish is, so that I can know for certain to which one of you, according to his wish, I ought to bequeath either all the substance I have or just this sacred shroud of the Lord." On hearing these words from the lips of his father, one, whose wish it was to get all his father's wealth, took this from his brother, his father bequeathing it to him by will according to his promise. Wonderful to relate, from that day forward all his wealth and patrimony for which he had bartered the Lord's shroud began to dwindle, and everything that he had was dissipated in one way or another and reduced to nothing. The other, however, blessed son of the above-mentioned blessed thief, who preferred the shroud of the Lord to all the patrimony, from the day that he received it from the hand of his dying father, buy God's favour grew more and more prosperous, and was enriched even with earthly goods while not being deprived of heavenly ones. And so fathers born of the seed of this thrice-blessed man kept handing on the Lord's shroud faithfully to their sons, from one believing custodian to another up to the fifth generation, by a sort of hereditary right according to the sequence of their line. But after the time of the fifth generation when, with the passage of many years, believing heirs of this line began to fail, the sacred shroud came into the hands of some Jewish unbelievers. They too indeed, however unworthy of such an office, cherished it honourably and by divine generosity became enriched to a high degree with goods of various kinds. But when the true story of the Lord's shroud became known among the people, the believing Jews began to contend boldly with the infidel Jews about the sacred cloth, seeking with all their might to get it into their hands.

The rivalry aroused divided the people of Jerusalem into two factions, the faithful believers, that is, against the infidel unbelievers. Upon this the king of the Saracens, Mavias by name, when invoked by both sides, in judgment between them said to the infidel Jews (who stubbornly held on to the Lord's shroud) in the presence of the Christian Jews: "Give unto my hand the sacred cloth that you have." They obeyed the behest of the monarch, took it forth from its reliquary, and laid it in his lap. The king took it with great reverence, and bade a pyre be prepared in the court before all the people. When it was burning with great intensity, he got up, went right up to the pyre, and said in a loud voice to the dissident parties: "Now let Christ the saviour of the world, who suffered for the human race, who had this shroud (which I now hold in my arms) placed on his head in the sepulchre, judge by the flame of the fire between you who contend for this cloth, that we may know on which of these two contending bands he will deign to bestow such a gift." And so saying he cast the Lord's sacred shroud into the flames. But the fire was completely unable to touch it. Whole and unimpaired it arose from the pyre, and began to flutter on high like a bird with outstretched wings gazing down from above on the two factions of the people thus at variance with one another, two armies set as it were in battle array. For a space of some minutes it fluttered about in the empty air, then gradually coming down it swerved by God's guidance towards the Christian party, who meantime kept beseeching Christ the judge, and it settled in their midst. Lifting their hands to heaven they give thanks to God with great rejoicing, and falling on their knees they receive with great honour this venerable gift sent down to them from heaven. They render hymns of praise to Christ its donor, and wrapping it in another cloth deposit it in a reliquary in the church. One day our brother Arculf saw it raised up from its reliquary, and in the crowded church kissed it himself amongst the multitude of people who were kissing it. It measures about eight feet in length. Let these remarks concerning it suffice. (trans. D. Meehan 53–55)

[De illo quoque sacrosancto Domini sudario quod in sepulchro super capud ipsius fuerat positum sancti Arculfi relatione cognouimus, qui illud propriis conspexit obtutibus, hanc quam nunc craxamus narrationem, quam totus Hierusolimitanus ueram esse protestatur populus; plurimorum namque testimonio fidelium Hierusolimitanorum ciuium

hanc pronuntiationem sanctus dedicit Arculfus, qui sic ipso intentius audiente sepius pronuntiarunt dicentes:

Ante annos ferme ternos sacrosanctum linteolum, quod quidam satis idoneus credulus Iudaeus de sepulchro Domini statim post eius resurrectionem furatus multis diebus apud se occultauit, ipso donante Domino post multorum circulos annorum repertum in notitiam totius populi uenit. Ille igitur felix et fidelis furax illud Dominicum sudarium quod in primis furanter abstulit in extremis constitutus duobus filiis manifestans accersitis detulit dicens: "O filioli mei, nunc obtio uobis datur. Dicat ergo quisque e duobus quid potius obtare desideret unus, ut et ego indubitanter scire possim quis ex uobis erit cui iuxta propriam obtionem aut omnem substantiam meam quam habeo commendare debeo aut hoc solummodo sacrum Domini sudarium." Quibus auditis ex ore patris uerbis unus qui obtauit genitoris diuitias accipere uniuersas suscipit eas a patre iuxta promissionem sub testament o commendatas. Mirum dictu, ex illa die omnes eius diuitiae et patrimonia omnia propter quae sudarium Domini uendidit decrescere coeperunt et uniuersa quae habuit diuresis casibus perdita ad nihilum redacta sunt. Alter uero supradicti beati furacis filius beatus, qui sudarium Domini omnibus pretulit patrimoniis, ex qua die illud de manu morientis accipit genitoris magis ac magis crescens donante Deo terrenis etiam opibus est ditatus nec fraudatus caelestibus. Et ita hoc Dominicum sudarium patres filiis de eiusdem ter beati hominis semine nati quasi hereditario iure fideles fidelibus secundum eorum prosapiae seriem fideliter usque ad quintam commendabant generationem. Sed post quintae tempora generationis annorum multis processibus transactis eiusdem cognationis deficientibus hereditariis fidelibus sacrum linteolum in manibus aliquorum infidelium deuenit Iudaeorum; qui et ipsi quamlibet indigni tali munere tamen illud honorifice amplexi diuina donante largitione nimis diuresis locupletati opibus dites facti sunt. Iudaei uero credentes orta in populo de sudario Domini certa narratione coeperunt cum infidelibus Iudaeis de sacro illo linteamine fortiter contendere totis uiribus illud appetentes in manus accipere; quae subnixa contentio Hierusolimitanam plebem in duas dirimit partes, hoc est fideles credulos contra infideles incredulos. Unde et Saracinorum rex nomine Mauias ab utrisque interpellatus partibus ad eos incredulos Iudaeos qui sudarium Domini pertinaciter retinebant coram praesentibus Iudaeis Christianis inter utrosque deiudicans dixit: "Sacrum quod habetis linteolum date in mea manu."

Qui regis uerbo obtemperantes illud de scrinio proferentes regnatoris in sinum deponunt. Quod cum magna reuerentia suscipiens rex in platea coram omni populo rogum fieri iussit; quo nimia inflammatione ardente surgens ipse et ad ipsum accedens rogum eleuata uoce ad utrasque discordes dixit partes: "Nunc Christus mundi Saluator, passus pro humano genere qui hoc quod nunc in sinu conteneo sudarium in sepulchro suum super capud habuit positum, inter uos de hoc eodem linteo contendentes per flammam iudicet ignis, ut sciamus cui parti horum duum exercituum contentiosorum hoc tale donum condonare dignetur." Et haec dicens sacrum Domini sudarium proiecit in flammas. Quod nullo modo ignis tangere potuit, sed integrum et incolome de rogo surgens quasi auis expansis alis coepit in sublimae uolare et utrasque desidentes contra se populi partes et quasi in procinctu belli consertas sedentes acies de summis prospiciens duas in uacuo aere per aliquorum interuallum momentorum circumuolans proinde paulatim discendens Deo gubernante ad partem Christianorum interim Christum iudicem exorantium declinans in eorum consedit sinu; qui Deo gratias leuatis ad caelum manibus agentes cum ingenti laetatione ingeniculantes sudarium Domini magna cum honorificentia suscipiunt ad se de caelo uenerabile emisum donum ymnificasque laudes Christo eius donatori refferunt et in scrinio eclesiae in alio inuolutum linteamine recondunt. Quod noster frater Arculfus alia die de scrinio eleuatum uidit et inter populi multitudinem illud osculantis et ipse osculatus est in eclesiae conuentu, mensuram longitudinis quasi octonos habens pedes. De quo haec dicta sufficiant.] (52–54)

Concealing Is Revealing, Part 1

Opacity and Enigma in the Wisdom Tradition

Lamana he is læce, *leoht winciendra,*
swilce he is deafra duru, *deadra tunge,*
scildigra scild, *scippendes seld,*
flodes ferigend, *folces neriend,*
yþa yrfeweard, *earmra fixa,*
wyrma wlenco, *wildeora holt,*
westenes weard, *weorðmynta geard.*

[He is healer of the lame, light of the blind, so is he door of the deaf, tongue of the dead, shield of the guilty, creator's hall, water's mover, people's redeemer, shepherd of the waves, of the poor fishes, pride of dragons, wood of the beasts, keeper of the wastes, ceremonial place.]

—*Solomon and Saturn I*, lines 77–83

Fungar quo nomine

[What name do I make]
—Aldhelm, *Enigma 100*
(*Creatura*), line 83

155

The Incarnational surface formed, as the last chapter argued, an aesthetic contact with divinity. It was always also an enigma, a puzzle and a mystery. While the Incarnation made visible what had been invisible, it did so in a cryptic way. Even while Christ was in a human body, there were those who denied him. He did not manifest his nature in an obvious manner, and his own disciple Thomas demanded not only ocular but tactile proof of the savior's resurrection (John 20:24–29). This chapter considers the contemplative frameworks developed by esoteric writing of the "wisdom tradition" to engage with precisely this enigmatic aspect of the Word. Given that the Word was a word, a sign, the esoteric traditions applied naturally to the pursuit of its mysteries, and the texts I treat employ language and writing both to conceal and reveal the Incarnate Christ, and thus to amplify the enigma of the Incarnation. Medieval enigmatists understood that the Word was not an allegory, in the sense of a sign to be decoded. Rather, the Incarnate Word was fundamentally or irreducibly enigmatic. Its iterability, which could also be called a generative metonymy, made possible a form of participation that in obscuring simultaneously exposed ever further facets of the Word for contemplation. Engaging in this mode, medieval writers demonstrated another approach to the baroque surface I dealt with in the last chapter, in which the infinitely complex "surface" is tracked or pursued by the recombinant complexity of language as well as the play of its signs.

I argue in this chapter for a discursive community or context—a tradition, even—devoted to the Incarnational enigma, a tradition that has been difficult to see, in part because it was contested and sometimes disavowed, and in part because it is still subject to both of those responses. Specifically, I bring together the arcane Latinity of Virgilius Maro Grammaticus, the *Enigmata* of Aldhelm, and the Old English *Dialogues of Solomon and Saturn*. These unlikely bedfellows share an enigmatic approach to the Incarnation and its semiotics as well as ties to Irish learning that together adumbrate an understanding of the Word as infinitely opaque and complex, best revealed through concealment and deferral, and self-generative through metonymy and recursion. The way these texts approach the enigmatic concealment of the Word forms a context for the final chapter of the book, which will set forth a reading of an entire "shadow manuscript," devoted to a similar or commensurate concealment, in the margins of an Old English Bede—hiding, as it were, in the plainest vernacular sight.

OBSCURITY AND THE WISDOM TRADITION

Many of the texts associated with the wisdom tradition are among the most badly neglected of the medieval period; they span a huge swath of time and incorporate varied influences, thus resisting easy categorization and *reductio*.[1] Further, their moralizing and aphoristic tendencies have rendered the texts opaque to literary sensibilities. Nevertheless, in the postmodern era, bit by bit, wisdom literature has come back into view, not so much because of its moral concerns but because of its form, its often cobbled, patched-together surfaces—its obvious pastiche. That is, the very structural features that marginalized wisdom texts under regimes of unity, cohesion, and "deep" meaning now commend them as resistant to the author function, revealing of their own construction, and available for deconstructive and object-oriented play. As I will show, "play" as a lively movement of signs was central to the treatment of the Word in wisdom texts, in often multiply convoluted and ingenious ways.[2] The concealment of the Word revealed something essential about its nature as "the verb"— as semiotic process, as perceptual frisson, the enigma through which we see.

Vivien Law, Elaine Tuttle Hansen, and Jan Ziolkowski have defined wisdom literature not so much as a genre as a content category embracing disparate traditions from the ancient Near East through the European Renaissance. One could fairly say the wisdom tradition as these scholars imagine it is the networked product of an enormous Afro-Eurasian contact zone, concerned with received wisdom regarding both moral action and existential or cosmological truth but also often containing within itself the mechanisms for challenging received wisdom, built-in pressure tests, perhaps, in the form of the frequently used dialogue format and in the mixed form of the prosimetrum, in which text is not stable or uniform but alternates between verse and prose.[3] Such heterogeneous forms are potentially destabilizing and resistant to univocality, though they are often put to univocal ends, as in the asymmetrical Platonic "dialogue."[4] The wisdom books of the Hebrew bible record statements about the nature of the world, the fleetingness of life, and the nature of human knowing that can be loosely related to the purview of modern philosophy. The Christian wisdom tradition is particularly hard to pin down because of its incorporation

of pre-Christian learning, including not only the Hebrew but also the classical literary tradition. Martin Irvine has documented how classical literary culture led to the textual culture of medieval *grammatica*, with its reverence for the text and its authoritative modes of interpretation. The classical corpus was a rich source but an awkward, precarious one for medieval Christian writers seeking to find moral truths in authoritative writings. Allegoresis of the *Aeneid*, for example, gives an idea of the strange lengths Christian readers had to venture to preserve both a prestigious heritage and the truth of Christian doctrine. For Bernardus Silvestris, the first six books of the poem allegorize the life of man, who must endure, stage by stage, the epic-moral struggle of the soul (pious Aeneas) to break free of the flesh (poor doomed Dido). The endless contortions of prescribed reading and interpretive practice were ripe for parody, and parodies did emerge, only to be incorporated themselves into authoritative textual transmission. The jokes of the monks, as Charles D. Wright has argued, became the school texts of future generations, obscuring their levity.[5] What had been meant as humorous now took on a quality of esoteric inscrutability. This resignifying effect demonstrates the layering and bricolage of wisdom texts, which are motivated by urges to preserve (wisdom, knowledge) but whose very techniques of preservation lead to recontextualization and renewal.

Other traditions further complicated learned Christian culture as they were incorporated into the church, notably that of the Irish.[6] As I discussed in the introduction, the Irish tradition seems to have contributed to the Christian wisdom tradition what John Carey termed its "mantic obscurantism," a tradition of verbal performance in which difficult, obscure language paradoxically reveals esoteric truths (24). This vernacular tradition was a natural fit for the existing vein in Christian learning that understood the capacity for human language investigation to explore the nature of the Logos. Exploring the Logos was also, in some sense, exploring the cosmos, given the role of the Word in creation. Thus the nature of the Word was linked to cosmology, to the very biggest and most fundamental questions of existence. It seems like a profound mistake, then, to dismiss wisdom texts because they seem playful or obscure.[7] They were more like speculative fiction, thinking through difficult truths in a vivid way. If the Word was an enigma, then the mysteries of being, begotten by that Word, may well be explored through various kinds of esoteric learning.

VIRGILIUS AND THE MANY PATHS TO TRUTH

If orthodox writers tended to emphasize the transcendental, unitary nature of the Logos, writers such as Virgilius Maro Grammaticus (fl. ca. 650) stressed plurality and permutation.[8] Virgilius belongs to a group of Irish-associated writers who used classical nicknames and cultivated the so-called Hisperic ("western," and thus "urbane" or "fancy") style.[9] A basic aspect of the pluralism of Virgilius and his cohort was an extreme form of verbal *varietas*, drawing upon the Irish vernacular tradition of poetic esotericism as well as classical models of wordplay and puzzle making. Michael Herren describes the style of the anonymous *Hisperica famina* ("Hisperic sayings") as, "scarcely poetic artistry, as we know it . . . [but] distinctiveness and variety of word and phrase."[10] Virgilius's two "grammars" of Latin, the *Epitomae* and *Epistolae*, celebrate verbal plurality as an explicit guiding principle. According to Virgilius, there are not one but twelve "Latins"—not an insignificant number—according to which any word has twelve variants.[11] Instead of stressing unitary transcendence, the oneness of the eternal monad, the Word to end all words, Virgilius goes in the opposite direction—not, I think, out of caprice or perversion. Rather, the splitting of Latin mirrors the splitting of the spirit into tongues of fire for the apostles, the splitting of the one seed into the twelve tribes of Israel. In other words, Virgilius stresses, as we have seen elsewhere in Incarnational thinking, the world, the dissemination and proliferation of the Word. Indeed, Law contrasts Virgilius's focus on the value of philosophy (worldly knowledge) with other writers' emphasis on spiritual obedience and morality (100–101). The twelve Latins entail different views upon or approaches to a truth, as opposed to singular and authoritative answers. As Law interprets the underlying ethos, "Latin is so huge and so profound that to expound it fully one must use a multiplicity of methods, words, forms, and meanings" (77). Although Law sees Virgilius's texts as heterodox and his approach to Latin "anti-Isidorian," Virgilius's insistence upon plurality is not without precedent in Isidore (ca. 560–636), whose encyclopedic linguistic writings became arch-authorities for later writers. One finds in Isidore a willingness to give multiple alternative etymologies rather than insisting upon one because, for him, as Law also avers, etymology is a matter not of phonological form but

rather of moral and cosmological truth (Law 98–101). The universe having been spoken into being by the Logos, the forms of this divine language lurk behind those of human language. Isidore's etymologies are authoritative explanations not of how given human words derive from older ones but rather of how these words fit into a moral cosmology that we are always striving to ascertain more clearly. Isidore, therefore, approaches language itself as though it were a poem, as though it had intention and structure that could be reconciled into a meaningful whole, the language of God.

Seen in this light, Irish writers' striving to reveal the Logos through elaborate concealments of language appears less of an aberration and more a ramification of early medieval literary culture.[12] As Law indicates in the case of Virgilius, the "implicit presence of the Verbum" is pervasive in his approach to grammar (39). Consider, for example, several of Virgilius's made-up authorities, whose coded names Law carefully explains, all of which connect to aspects of Christ. One Ursinus speaks a Latin "associated with earthly matters" appropriate to his animal name, from *ursus* ("bear") (Law 12). The wise Fassica's name connotes Passover or Easter, according to a derivation suggested by Jerome (*Interpretationes Hebraicorum nominum* 12–13). Virgilius's uncle has the nickname Goelanus because he is "precious to his mother," from the Hebrew word *goel* that Jerome translates as "redeeming," recalling Jesus's relationship to Mary (13). Andreas is given (again by Jerome) a derivation from Greek *andros* (Latin *vir*) (13). *Sophonias* means "hiding him"; *Balapsidus*, "spirit abiding with the stars at creation" (13). There seems to be in these names a great deal of pointing toward the Word that was made flesh, the "redeemer," "precious to his mother," who had become a man. Perhaps the twelve Latins are meant after all to suggest the twelve disciples who partook of Christ's fellowship on earth and to whom he sent the spirit after the Ascension. The *Epitomae* and the *Epistolae*, in their dense and baffling obscurantism, strive in this way—and for an in-crowd, to be sure—to reflect and to contemplate the Word along with the words of scripture and learning through which it is made known.

Although both Herren and Law consider Hisperic obscurantism to represent a blip or a bubble, a tradition that faded out and was replaced by the more orthodox Latinity of Aldhelm, it may be more accurate to see certain continuities despite the explicit disavowals and antipathies of Aldhelm and Bede. It is important to consider the social

realities both writers faced. Aldhelm grew up entirely under Irish tutelage, only entering as a grown man the ascendant Roman sphere. Surely he would have had something to prove and specifically would have had to perform his Latinity and his orthodoxy more assiduously than someone who had entered the Canterbury school as a boy. Likewise Bede, in his Northumbrian milieu, must criticize and in some sense disavow Irish learning in the name of progress. Yet Irish learning was a venerable force and remained so after the Synod of Whitby and the coming of Theodore and Hadrian, and it took decades of polemics to marginalize its influence. In the case of Aldhelm and the enigmatic (and possibly the hermeneutic) tradition, and in light of Bede's valorization of vernacular poetry as a medium for Christian truth, is it not fair to say that a commitment to the capacity of language to conceal and reveal the central Christian mystery persisted?

I consider two examples here, one Anglo-Latin and the other Old English, both with ties to Irish learning. Aldhelm's *Enigmata* deploy Latin to create opacity, to defamiliarize the landscape of the world so that we may feel its textures, and thus to affirm the particularity of creation and its multiplicity, suggesting even at the very end of a hundred-riddle collection that we still cannot guess creation's name. The Old English *Solomon and Saturn* dialogues blend catechism, philosophical dialogue, and verbal contest from the Christian, classical, and Irish vernacular traditions, respectively, within an Old English poetic idiom, to contemplate the relation of the Word to the cosmos and to the holy language of scripture and liturgy. These Insular texts conceal as much as they reveal, to us at least, because they are committed to concealing as revealing and because their concealment of the Incarnate Word is deeply, fittingly, implicit rather than expository. These works explore the problematics of supereffability, its shadow side, the negative quality of the mismatch between ineffable signified and the Incarnate-articulate signifier. The texts do not conceal something that would otherwise be straightforward or clear (as beginning poetry students sometimes expect of poetic language, that it is some kind of "code"). Rather, they treat the Incarnational enigma precisely as enigma. It is in this sense that they at once conceal and reveal. In the cryptic texts of the wisdom tradition, more than anywhere else, and as a matter of basic epistemic principle, one must read between the lines.

ALDHELM'S ENIGMA(TA) OF CREATION

Aldhelm of Malmesbury was the first English speaker to master the learned Latin tradition. It is for this that he is usually extolled, but equally formative to Aldhelm's achievements was his training in the Irish tradition by Máeldub, namesake of Malmesbury, prior to entering under the tutelage of Theodore and Hadrian at Canterbury around the age of thirty — that is, around the age when many modern scholars are completing their doctoral degrees. Aldhelm is fundamentally a product of both Irish and Roman learning, and his hybridity is evident in his elaboration of the riddles he adopted from Symphosius, the "party-boy," as Erica Weaver calls him, playing on his playful nickname.[13] While the late Latin poet called his *enigmata* "trifles" (*nugae*), Aldhelm spun riddling into a vast meditation upon the mystery of creation.[14] His one hundred riddles span multiple scales and registers in turning the familiar into an object of wonder. The preface to the *Enigmata* announces creation, the "hidden mysteries of things" ("enigmata clandistina rerum"), as its focus (emphasis mine):

> Arbiter, aethereo iugiter qui regmine sceptrA
> Lucifluumque simul caeli regale tribunaL
> Disponis moderans aeternis legibus illuD,
> Horrida nam multans torsisti membra VehemotH,
> Ex alta quondam rueret dum luridus arcE,
> *Limpida dictanti metrorum carmina praesuL*
> *Munera nunc largire, rudis quo pandere reruM*
> *Versibus enigmata queam clandistina fatV:*
> Sic, Deus, indignis tua gratis dona rependiS.
> Castalidas nimphas non clamo cantibus istuC
> Examen neque spargebat mihi nectar in orE;
> Cynthi sic numquam perlustro cacumina, sed neC
> In Parnasso procubui nec somnia vidI.
> Nam mihi versificum poterit Deus addere carmeN
> Inspirans stolidae pia gratis munera mentI;
> Tangit si mentem, mox laudem corda rependunT.
> Metrica nam Moysen declarant carmina vateM
> Iamdudum cecinisse prisci vexilla tropeI
> Late per populos illustria, qua nitidus SoL

Lustrat ab oceani iam tollens gurgite cephaL
Et psalmista canens metrorum cantica vocE
Natum divino promit generamine numeN
In caelis prius exortum, quam Lucifer orbI
Splendida formatis fudisset lumina saecliS.
Verum si fuerint bene haec enigmata versV
Explosis penitus naevis et rusticitatE
Ritu dactilico recte decursa nec erroR
Seduxit vana specie molimina mentiS
Incipiam potiora, sui Deus arida servI,
Belligero quondam qui vires tradidit IoB,
Viscera perpetui si roris repleat haustV.
Siccis nam laticum duxisti cautibus amneS
Olim, cum cuneus transgresso marmore rubrO
Desertum penetrat, cecinit quod carmine DaviD.
Arce poli, genitor, servas qui saecula cunctA,
Solvere iam sclererum noxas dignare nefandaS.

(*Aldhelmi Opera* 97–99)

[Eternal judge, you who with heavenly authority rule perpetually the scepters (of power) and the resplendent royal court of heaven, controlling it with eternal laws—for in punishment you tortured the disgusting limbs of Behemoth when the ghastly (creature) once fell headlong from the lofty citadel (of heaven)—(you), protector, *grant now to me, who am composing bright songs in verse, your aid, that I may be able, (though) unskilled, to reveal by your decree the hidden mysteries of things through my verse.* Thus, God, do you freely bestow your gifts on unworthy (recipients). I do not declaim my verses in the direction of the Castalian nymphs, nor has any swarm (of bees) spread nectar in my mouth; by the same token I do not traverse the summits of Apollo, nor do I prostrate myself on Parnassus, nor am I entranced by any poetic vision. For God shall be able to augment the poetic undertaking for me, freely breathing his holy gifts into my obtuse mind: if he should touch my mind, my heart shall at once requite (the gift) with praise. For biblical verses make it clear that the prophet Moses long ago had chanted the glorious praises of an ancient victory far and wide among peoples everywhere, where the bright sun, on raising its head from the ocean's flood, shines forth. And the Psalmist, singing aloud the verses of his songs, announced a Child born

through divine procreation which had risen in the skies before the morning star had poured its radiant light on the world when the ages were newly formed. But if these (present) *Enigmata* in verse, after all blemishes and awkwardness have been completely expunged, are to come off well at an hexametrical pace, and if no delusion seduces my mental efforts with empty deception, I shall begin (to sing of) even mightier (themes), if God—who once strengthened his warrior Job— shall refresh the parched inwards [*sic*] of his servant with a draught of everlasting dew. For you (God) once led streams of water from dry rocks, when the throng (of Israelites), having crossed the Red Sea, entered the desert: David sang of this in a psalm. You, Father, who protect all ages from the citadel of heaven, deign now to forgive the unspeakable faults of my sins.] (*Poetic Works* 70–71)[15]

The acrostic that Aldhelm embeds in the preface, "ALDHELMUS CECINIT MILLENIS VERSIBUS ODAS" ("Aldhelm has composed songs in a thousand verses"), does two things (at least) at once. First, it visually forms a cross, its letters running crosswise to the main text and embodying the Christian symbol (cross) and the ultimate sign (Logos) behind creation. Second, the form of the acrostic is also a poet's boast, going further than the later bare (if brilliant) signatures of Cynewulf to declare the prolific output of the poet. In this, Aldhelm's acrostic is quite like the poetic demonstrations of the Irish verbal contest, the *immacallam*, in which poets declared their mastery and sought to outperform one another in dazzling and utterly baffling displays of virtuosity.[16] Aldhelm links his poetic acumen to the divine Word and applies both to the abundant variety of creation.[17]

Variety and multiplicity are reaffirmed in the culminating Riddle 100 (*Creatura*, "Creation"), whose opening sentence invokes the variety of creation: "Me varium fecit, primo dum conderet orbem" ("He made me in all my variety when he first created the world"; line 4, 145).[18] As Benjamin Saltzman (1008) has noted, Riddle 100 is devoted to the irreducible complexity, amounting to paradox, of creation:

The creator, who supports the world on eternal columns, the ruler of (all) kingdoms, restraining lightning-bolts with (his) law while the suspended summits of the wide skies revolve, made me in all my variety when he first created the world. I am vigilant at the watch; for it shall never be my pleasure to sleep; and yet my eyes are closed sud-

denly in sleep. For as God governs the universe with his own edict, so do I encompass all things beneath the pole of heaven. Nothing is more retiring than I, since a (mere) ghost terrifies me; again, I am bolder than a bristly boar. No one, seeking the banners of victory, can conquer me—except God himself, who rules on high in his ethereal citadel. I am more fragrant than perfumed incense, exuding the scent of ambrosia, and I can surpass the lilies, growing in the earth in combination with ruby-red rose-bushes, through the full sweetness of the redolent nard; and then again I stink with the putrid stench of reeking filth. I rightly rule all things which lie beneath the sky and are subject to its sway, as the omnipotent father ordained. I contain the most gross and the most delicate forms of things. See, I am higher than the sky and can examine God's secrets; and nevertheless, being more lowly than the earth, I gaze into foul hell. Being older than the world I existed from time immemorial; yet look: this year I shall be born from my mother's womb. I am more beautiful than golden bosses on a shining brooch, more ugly than buckthorn, more vile than worthless seaweed. I am wider than the broad limits of earth and yet I can be enclosed in the middle of someone's fist. I am colder than winter and glistening hoar-frost, although I burn hot in the searing flames of Vulcan. I am sweeter on the palate than a taste of smooth nectar; yet again, I am more bitter than the grey wormwood in the field. I ravenously gulp down meals after the manner of gluttonous Cyclopes, although I can equally well live content without food. I am swifter than eagles, faster than the wings of Zephyrus, fleeter than a hawk; and yet the nasty earthworm and the slug and the slow swamp-turtle and the black beetle, offspring of stinking dung, all outpace me in a race more quickly than the telling. I am heavier than lead, I tend to the weight of rocks; I am lighter than a feather, to which (even) a pond-skater yields. I am harder than flint, which pours dense flames from its entrails, or iron; but I am softer than cooked offal. I have no curly locks on the top of my head which adorn my forehead with fringe or my temples with ringlets, even though a crimped hair-do flows from my crown more kempt than that produced by curling-irons. I grow fatter by far than the grease of sows, as they stuff their bodies with beech-mast and swineherds are gladdened by the fattened flesh; but grim starvation shall torment me, wasted with hunger, as I, pallid, am perpetually deprived of rich feasts. I am clear, I confess, brighter than Titan's orb; whiter than the snows, when the clouds let fleeces fall;

and darker by far than the black shadows of the dungeon and the gloomy shades which hell encloses. I am made smooth and round like the orb of the stars, or the globe of a ball or a crystal sphere; and, on the other hand, I am extended like Chinese spun-silk, stretched out to make smooth thread or the fibres of a garment. See, I reach much farther, marvelous to relate, than the six zones by which the wide world is measured. *Nothing exists in the world beneath me nor above me, except the creator of all things, controlling the world with his Word.* (I am) larger than the black whale in the (sea's) grey waves, and smaller than the thin worm which bores through corpses, or the tiny atom which shimmers in the rays of the sun. I march on a hundred feet through the grassy fields; I never ever walk on earth as a pedestrian. Thus my wisdom excels that of wise men; yet the precious letter in books did not instruct me, nor was I ever able to recognize what made up a syllable. I am dryer than the burning heat of the summer sun; yet again, dripping with dew I am moister than the water of a fountain. I am saltier by far than the waters of the swelling sea, but I trickle fresher than the icy water of streams. Adorned with the manifold beauty of all the colours with which the structure of the present universe is painted, I am now of ghastly hue, deprived of all colour. Pay heed, you who believe the words of my utterance! A learned teacher will scarcely be able to expound them orally; and yet the doubting reader ought not to think them trifles! I ask puffed-up wise men to tell what my name is. (*Poetic Works* 92–94)[19]

Note the paean to the Word controlling the world embedded here (in italics), and the pervasive principle of paradox structuring the whole. "I" never sleep, yet I sleep. I am fragrant; I stink like filth. I am cold; I burn. I walk on a hundred feet; I never walk the earth. Creation encompasses all—all the opposites and all the variety that make up the world.

Saltzman has highlighted the glosses of one scribe in Cambridge, University Library MS Gg. 5.35, which pick up on the theme of multiplicity and then amplify it (976–83). Next to line four the scribe notes that it "mentions the multiform creation of the world" ("creatura mundi hic multiformis loquitur") and he or she "proceeds to notate each time he [*sic*] believes a new creature has been introduced into the riddle, at first with the phrase 'alia creatura' (another creature), twice shortened to the word 'alia,' and eventually with just a

series of crosses (+)" (Saltzman 979). Thus, "the glossator treats [Riddle 100] as a series of individual riddles" (979). Multiplicity inheres not only in creation itself, but in the riddle that stands as summation of the *Enigmata* as a whole, gathering the *varia* into itself but refusing to perform a resolving synthesis into unity. The individual *creatura* constituting *Creatura* stand as riddles on their own, relating to one another, but irreducible all the same. It is, further, almost cheekily provocative that at the very end of the very last riddle of one hundred, all of which have their solutions announced at their head, the "creature" itself challenges the reader to guess its name. In the *Enigmata* we have been given one hundred names and one hundred concealing elaborations of those names, showing them to be anything but simple one-to-one labels for things in the world. "Creation," the very totality of the *Enigmata*, cannot in fact be encompassed by a name, a word — it is a riddle that evades solution. Aldhelm has taken the "trifling" example offered by Symphosius and deployed it in praise and in contemplation of the Word behind creation and of its irreducible, enigmatic surface, *creatura* itself.

SOLOMON AND SATURN'S DIALOGIC WORD

Aldhelm's *Enigmata* celebrate plurality in a way similar to Virgilius's plural Latinities, and they further stress the part-for-the-whole relation (the metonymic subtype of synecdoche) common in Insular Incarnationalism. Creation comprises all one hundred *enigmata* but is also summed up and contained in *Enigma* 100, even while its very articulation in some sense fails, given the challenge to say its name. Some word, behind creation, remains yet to be named. My Old English example in some sense provides the answer. It is a group of texts that demonstrates rather magnificently the relationship between the wisdom tradition and the Logos, and it has long been marginalized and even execrated by scholars. These are the *Dialogues of Solomon and Saturn*, found in two manuscripts from the Benedictine reform period: Cambridge, Corpus Christi College 422 (Part I; ca. 950) and CCCC 41 (early 11th c.; the book was part of Leofric's donation to Exeter before 1072).[20] Scholars of the nineteenth and most of the twentieth century saw *Solomon and Saturn* mostly as a mine for interesting and perhaps scandalous quasi-pagan and mythic material,

evidence for older strata of the Germanic and Indo-European past. The opacity and disjointedness of the dialogues, with their "wild" and "exuberant" Irishness, had little allure for the New Critics of the mid-twentieth century seeking unity and irony after Tolkien's influential reading of *Beowulf*. Persistent nationalist divisions between English and Irish studies has further marginalized them. In the last few decades, in addition to the continued interest in their obscure allusions and a renewed interest in their Irish influences, the dialogues have been seen as staging the inevitable defeat of the pagan Saturn by Solomon, representing Christian authority. I have argued that the contest between the two reflects, rather, the generous ethos of the wisdom tradition, particularly as hybridized in Irish learning, and that the exchanges are not obviously one-sided or meant to caricature Saturn as utterly in error ("Wisdom and the Poetics of Laughter"). Both figures seek after truth, and a joyful Saturn ends up winning in defeat—had asked precisely for that outcome all along, forming the rhetorical framework for their exchange. Of primary interest to me here, however, is the fabric of their discourse, which exudes the *Logomystik* cited by Law (39–40), the fundamental capacity for Logos to be permuted in abstruse language.

Four dialogue texts make up the *Solomon and Saturn* group, all of which are collected in a twenty-six-page booklet bound to a much larger and very unusual missal collection in CCCC 422, with one also appearing in partial form in the extensive marginalia of a copy of the Old English translation of Bede's *Historia ecclesiastica*, CCCC 41.[21] Two of the *Solomon and Saturn* texts concern the power of the Pater Noster, one in verse and one in prose. The verse is known as *Solomon and Saturn I*, and this is the text that appears twice, with the beginning portion appearing in the margins of pages 196 to 198 of CCCC 41 (much more on this context in the next chapter). CCCC 422 contains a portion with an ending but no beginning (2–5). Anlezark calls the prose dialogue on the Pater Noster the *Solomon and Saturn Pater Noster Prose* (CCCC 422, 6–12). A small (nine-line) poetic fragment (Anlezark's *Solomon and Saturn Poetic Fragment*, CCCC 422, 13) recounts Saturn's joy in losing the contest, and *Solomon and Saturn II* is a verse dialogue with wide-ranging exchanges that often feature riddles and other esoterica (CCCC 422, 13–26). The poetic fragment is often considered the "stray" ending to *Solomon and Saturn II*, which comes after it, though the fragment may suggest itself as a general

ending for the whole group, marooned as it is and floating in the middle of the collection. The *Pater Noster Prose* breaks off at the end of the page in the middle of an enumerated list, and the next page begins with the *Poetic Fragment*, so it is likely that at least a page is missing. A diagram might make the groupings of the Solomon and Saturn texts more clear:

CCCC 422 (at the front) CCCC 41 (in the middle, in the margins)
Solomon and Saturn I (2–5) *Solomon and Saturn I* (196–98)
Solomon and Saturn Pater Noster Prose (6–13)
Solomon and Saturn Poetic Fragment (13)
Solomon and Saturn II (13–26)

In both manuscripts *Solomon and Saturn* is compiled with texts for the mass, the celebration of the Lord's body and presence on earth, and this manuscript context is the first clue to the dialogues' association with the Incarnation. They present a vernacular reflection upon the language of the liturgy.[22]

One thing that has made the *Solomon and Saturn* dialogues' Incarnationalism particularly inscrutable is their complex, polyvalent use of the Pater Noster as a signifier for Christ. At the outset of *Solomon and Saturn I*, Saturn lays down a challenge that asserts what he understands the aim of book learning to be, and it is "the palmtwigged Pater Noster" (the reader will recall the palmtwig borne by Mary in the *Assumptio* homily, Blickling Homily XIII, discussed in chapter 3):

Hwæt! Ic iglanda eallra hæbbe
boca onbyrged þurh gebregdstafas
larcræftas onlocen Libia 7 Greca,
swylce eac istoriam Indea rices . . .
 swylce ic næfre on eallum
þam fyrngewrytum findan ne mihte
soðe samnode. Ic sohte þa git
hwylc wære modes oððe mægenþrymmes,
elnes oððe æhte eorlscipes:
se gepalmtwigoda Pater Noster.
 (Anlezark 60, lines 1–4, 7b–11)

[*Hwæt!* I have tasted books of every island through woven letters, unlocked the learning of Libya and the Greeks. So, too, the history of the kingdom of India. . . . Such I never could find in all those ancient writings truly gathered. I sought then still that which would be, of bravery or power or in possession of nobility, the palmtwigged Pater Noster.] (trans. mine)

Saturn here has been faulted (by scholars) for "tasting" as opposed to spiritually seeking knowledge, but as I have already argued, metaphors for "tasting" holy words abound in scripture and in the Christian tradition, and this verb cannot be taken as a mark of his wrongheadedness ("Wisdom and the Poetics of Laughter" 139–40). Rather, the point seems to be the literate nature of the tradition, the books from far-flung places through which even provincial outposts (such as Britain) have gained access to truth. Saturn does aver that something has been missing, suggesting that there is a special end to book knowledge that has eluded him, and he names it at the end of his sentence, in the manner of the Irish *roscada*.[23] The circuitous list of the books of the world ends with the Pater Noster. The "palmtwigged" Pater Noster.[24] I discussed in chapter 3 how the palmtwig functions as a metonym for Christ and, in chapter 2, how the Pater Noster functions similarly in display script, so by this point the term should suggest already that the "palmtwigged Pater Noster" may have something to do with the Incarnation. The Pater Noster is the end of all letters, Saturn suggests, with a metonymic relation to the Logos behind all signification. What plays out in the dialogue itself, once Solomon begins to demonstrate in words the power of these special words, is a revelation in poetic language (and thus a revelation through concealment) of the nature of the Word in the world.

The Pater Noster is a hero in these dialogues, with the attributes of the conquering and "adorable" Christ. He "hides hunger, harrows hell, suppresses the surge, erects glory, is braver than the earth's foundation, stronger than stones," for example (paraphrasing lines 73–76).[25] He is "the heart of the wise and the soul's honey, mind's milk" (lines 66–67a).[26] He has a golden head and silver hair, and eyes twelve thousand times brighter than the sun, a heart twelve thousand times brighter than the seven heavens, arms that encompass the world many times over, and he shoots the devil with arrows (*Pater Noster Prose*

74–75). Many of these martial aspects of Christ are found in the anonymous homilies, and the hyperbolic descriptions are found in many kinds of apocrypha and wisdom literature associated with Irish spheres of influence. Here, though, all the adoration is directed toward the Pater Noster, which is treated exactly as though he/it were Christ. The Pater Noster is "Christ's line" ("Christes linan"; *Solomon and Saturn I* line 17b) and "God's utterance" ("se godes cwide"; line 63a), the Word. As I have discussed, the Pater Noster is a special example of "God's speech," comprising the words the Incarnate Christ actually spoke out of his physical mouth in the gospels. It was spoken not just at any place, but on the Mount of Olives, which is the site of the Ascension and thus marked with Incarnational resonance within the scriptures and in Christian tradition thereafter, as we have seen in Adamnán's account of the holy lands and in the homiletic tradition. Referentially speaking, the two words *Pater Noster* address the Father within the language of the prayer, but they also metonymically represent the whole whenever used elsewhere, as in these dialogues, in addition to their metonymic reference to Christ. The words of the Pater Noster are Christ's words addressing his father, the words of the Word, which is itself the "only begotten son" of a father—there is a recursion implied here, of source begetting words which travel back to the source.

If there were any question about the Pater Noster's metonymic relation to the Word that spoke its words in the world, the climax of *Solomon and Saturn I* puts the matter to rest. The most famous, and to some egregious, feature of this poem is the sequence in which the individual letters of the Pater Noster one by one give the devil a beating reminiscent of the violence in the *Psychomachia*, the late antique allegorical poem of Prudentius. In the CCCC 422 version, the Roman letters are even joined by runes (see fig. 4.1). Not only does the Pater Noster stand in for Christ as his very own words, but the individual letters of the Pater Noster carry the force of the whole, and by extension, of Christ himself. *P*, the *prologo prim*, can smite the devil with a staff, *T* can stab his tongue, *S* spray his teeth throughout hell, and so forth.[27] Such images have been taken as childish or unserious, but in a milieu in which writing carries the highest learning and a mysterious and inarticulable Word is the source of creation itself, that the components of the words of this Word should bear its attributes and be seen

Figure 4.1. Cambridge, Corpus Christi College MS 422, p. 4. *Solomon and Saturn I*, ll. 91b–121. The Parker Library, Corpus Christi College, Cambridge.

as conquering forces is perfectly imaginable as a serious contemplative endeavor, particularly in light of a tradition fusing classical and Celtic strands. And seriousness does not preclude playfulness or enjoyment, particularly within communities of initiates, as Martha Bayless (*Parody* 177–212) and more recently Weaver (59) have made clear. The words of the Word, and the very letters of the words of the Word, have the power of the Word in the world.

The Word's capacity for metonymy is matched in the Pater Noster dialogues by its capacity for transformation or iteration. In the *Pater Noster Prose*, this is strikingly apparent in a shapeshifting contest between the Pater Noster and the devil. Saturn asks, "How many forms (*bleo*) will the devil and the Pater Noster have when they contend with one another?" Solomon says thirty:

Ðæt deofol bið ærest on geogoðhade on cildes onlicnisse, *ðonne bið se Pater Noster on Haliges Gastes onlicnisse.* Ðriddan siðe bið ðæt deofol on dracan onlicnisse. Feorðan siðe bið se Pater Noster on stræles onlicnisse, ðe brahhia dei hatte. Fiftan siðe bið ðæt deofol on ðystres onlicnisse. Sixtan siðe bið se Pater Noster on leohtes onlicnisse. Seofoðan siðe bið ðonne ðæt deofol on wildeores onlicnisse. Eeahteoðan siðe bið se Pater Noster on ðæs hwales onlicnisse, ðe Leuiathan hatte. Nygoðan siðe bið ðæt deofol on atoles swefnes onlicnisse. Teoðan siðe bið ðonne ðæt Pater Noster on heofonlicre gesihðe onlicnesse. Enleftan siðe bið ðæt deofol on yfles wifes onlicnesse. Twelftan siðe bið se Pater Noster on heofonlicre byrnan onlicnisse. Ðreoteoðan siðe bið ðæt deoful on sweordes onlicnesse. Feowerteoðan siðe bið se Pater Noster on gyldenre byrnan onlicnisse. Fifteoðan siðe bið þæt deofol on bremles onlicnisse. Sixteoðan siðe bið se Pater Noster on seolfrenes earnes onlicnisse. Seofonteoðan siðe bið ðonne ðæt deofol on sleges onlicnisse. Eahtteoðan siðe bið se Pater Noster on seolfrenes earnes onlicnesse. Niogonteoðan siðe bið ðæt deofol on fylles onlicnisse. *xx. siðe bið Pater Noster on Cristes onlicnesse.* On xxi. siðe bið ðæt deofol on ætrenes fugeles onlicnisse. On xxii. siða bið ðæt Pater Noster on gyldenes earnes onlicnisse. On xxiii. siða bið ðæt deofol on wulfes onlicnisse. On xxiiii. siða bið se Pater Noster on gyldenre racenteage onlicnisse. On xxv. siða bið ðæt deofol on wrohte onlicnisse. On xxvi. siða bið se Pater Noster on sybbe onlicnisse. On xxvii. siða bið ðæt deofol on yfeles geðohtes onlicnes. On xxviii. siða bið se Pater

Noster on arfæstes gastes onlicnesse. On xxviiii. siða bið deoplicor gehwyrfed ðæt deofol on deaðes onlicnesse. Saloman cwæð: *Domlicor bið ðonne se Pater Noster gehwyrfed on Dryhtnes onlicnesse.* (72; emphasis mine)

[The devil will be first in youth, in the likeness of a child, *then will the Pater Noster be in the likeness of the/a holy spirit.* The third time the devil will be in the likeness of a dragon. The fourth time the Pater Noster will be in the likeness of an arrow, which is called Brahhia Dei. The fifth time the devil will be in the likeness of darkness. The sixth time the Pater Noster will be in the likeness of light. The seventh time the devil will be then in the likeness of a wild beast. The eighth time the Pater Noster will be in the likeness of a whale, which is called Leviathan. The ninth time the devil will be in the likeness of a baleful sleep. The tenth time the Pater Noster will be in the likeness of a heavenly vision. The eleventh time the devil will be in the likeness of an evil woman. The twelfth time the Pater Noster will be in the likeness of a heavenly byrnie. The thirteenth time the devil will be in the likeness of a sword. The fourteenth time the Pater Noster will be in the likeness of a golden byrnie. The fifteenth time the devil will be in the likeness of a bramble. The sixteenth time the Pater Noster will be in the likeness of a silver eagle. The seventeenth time the devil will be in the likeness of a blow. The eighteenth time the Pater Noster will be in the likeness of a silver eagle. The nineteenth time the devil will be in the likeness of a fall. *The twentieth time the Pater Noster will be in the likeness of Christ.* On the twenty-first time the devil will be in the likeness of a venomous bird. On the twenty-second time the Pater Noster will be in the likeness of a golden eagle. On the twenty-third time the devil will be in the likeness of a wolf. On the twenty-fourth time the Pater Noster will be in the likeness of a golden chain. On the twenty-fifth time the devil will be in the likeness of an accusation. On the twenty-sixth time the Pater Noster will be in the likeness of peace. On the twenty-seventh time the devil will be in the likeness of an evil thought. On the twenty-eighth time the Pater Noster will be in the likeness of a virtuous soul. On the twenty-ninth time the devil will be more profoundly changed into the likeness of death. Solomon said: *Then the Pater Noster will be decisively changed into the likeness of the Lord.*] (trans. mine, with consultation of Anlezark 73)

This list certainly has a moral, didactic purpose in showing the many forms the devil may take, and the way that these forms may be thwarted.[28] It also shows clear affinities with the interest in spiritual ontology that we see elsewhere in the wisdom tradition. The Pater Noster takes on all the forms it must to combat the devil, moving through, notably, "holy spirit," "Christ," and finally, "the Lord." There is a kind of trinitarianism in these marks, as they happen at the beginning, middle (stage 20), and end of the sequence. These three stages form the key roles of the Word in salvation history. In the beginning, the Word takes part in creation, meeting the devil's form of "youth." The Word as the Incarnate Christ matches the devil's "fall." The final form of the Word is the *domlic* Lord presiding over judgment. The Pater Noster energetically displays its identity with Christ in this sequence in its capacity for transformation, its opposition to the devil, and its carefully structured assumption of the canonical forms of the Word as creating spirit, Incarnate savior, and final judge.

The dramatic display of transformation is tied to questions of substance, and this is precisely where *Solomon and Saturn II*, the wider-ranging verse dialogue, leads. The early parts of the poem display multiple kinds of wisdom learning, asking riddles, staging paradoxes, considering inexorable and mysterious forces such as fate and old age, and drawing upon myth and folklore as well as biblical truth. Throughout these questions and answers, the Logos seems very much a background consideration, perhaps the enabling ground for the discourse itself or its ultimate end somewhere off in the unattainable distance. Eventually, however, the poem arrives at a consideration of substance that brings the Incarnation to the fore. Specifically, Saturn asks about substances that share Christ's dual, hypostatic nature and are linked to various aspects of his Incarnational presence (water, bread, and light). Solomon's answers make use of poetic "couplets" in the form of alliterating word pairs to disclose the mysterious doubleness of these substances, showing each to have a physical and a spiritual nature that somehow mutually reflect. Saturn first asks about water (emphasis mine):

Ac forhwam winneð ðis wæter geond woroldrice,
dreogeð deop gesceaft? Ne mot on dæg restan,
neahtes neðyð, cræfte tyð,

cristnað ond clænsað cwicra manigo,
wuldre gewlitigað. Ic wihte ne cann
forhwan se stream ne mot stillan neahtes.

<div align="right">(lines 215–20)</div>

[But why does this water struggle across the worldly realm, suffer lowly/deep creation? It may not rest by day, moves at night, works cleverly, *christens and cleanses* many alive, gloriously beautifies. I do not know at all why the current cannot cease by night.] (trans. mine)

Saturn's question has to do with the endless flow of water's liquid substance; it is a naturalistic question. We do not have Solomon's reply because a leaf is missing at this point in the manuscript. However, Saturn's very question embeds a couplet that becomes especially lucid in light of the questions and answers that follow. He notes that water "christens and cleanses" (*cristnað ond clænsað*), a locution that indicates both the spiritual cleansing of baptism and the physical cleansing that "beautifies" and is strengthened by the naturalistic context of the rest of his description. The alliterative mutual reflection of the two words demonstrates, through the form of the language, their shared nature, their unity in duality.

We next find Solomon in the middle of a response to an unknown question, a response that resolves into a treatise on Incarnational substance. First, he describes the Host (emphasis mine):

Ðonne snottrum men snæd oððglideð,
ða he be leohte gesihð, luteð æfter,
gesegnað ond gesyfleð ond him sylf friteð.
Swilc bið seo an snæd æghwilcum men
selre micle, gif heo gesegnod bið,
to ðycgganne, gif he hit geðencan cann,
ðonne him sie seofon daga symbelgereordu.

<div align="right">(lines 224–30)</div>

[When a morsel slips away from a wise man, then he sees by the light, bends after (it), *blesses and dresses* and eats it himself. Such is the one morsel to any man much better to consume, if it is blessed, if he knows how to conceive it, than a seven-day feast would be for him.] (trans. mine)

The bread of the Host is considered here as an everyday object, a thing that can be dropped on the floor in a conceivable, and somewhat comic, scenario. "What do you do then?" one imagines one monk asking another within the confines of their learned community. The answer draws, once again, on the dual nature of the bread. It is "blessed and dressed" (*gesegned* and *gesyfled*; line 226a)—given both spiritual efficacy and physical palatability—and consumed, and the result further affirms duality in its hyperbolic comparison between a blessed morsel and a "seven-day feast."

Solomon cannot contain himself at this point, and continues on to a discussion of light as having the "heow ond had" ("form and character") of the Holy Spirit (emphasis mine):

> Leoht hafað *heow ond had* Halige Gastes,
> *Cristes gecyndo*; hit ðæt gecyðeð full oft.
> <div align="center">(lines 231–32)</div>

[Light has the *form and character* of the Holy Spirit, *Christ's nature; it very often makes it known*.] (trans. mine)

Here, first, "form" (*heow*) and "character," "office," or even "person" (*had*) alliteratively co-reflect, emphasizing the role of manifestation, of bodying forth, the unseen spiritual essence, and this is explicitly tied to Christ in the following line. What is the *heow ond had* that light possesses? It is Christ's nature, *Christes gecyndo*, which, crucially, makes itself known. Light bears the nature of Christ, which is a making-known of itself: *Christes gecyndo* alliterates with *gecyðeð* in the culminating alliterative pairing of this sequence, stretching across an entire verse line. Christ's nature is to announce itself, to make his spiritual identity visible in the world. An ensuing discursus turns the light into the divine fire that makes its way back to its origin in heaven, again entwining the physical with the spiritual (or declining to distinguish the two) (emphasis mine):

> Gif hit unwitan ænige hwile
> healdað butan hæftum, hit ðurh hrof wædeð,
> bryceð ond bærneð boldgetimbru,
> seomað steap ond geap, stigeð on lenge,
> clymmeð on gecyndo, cunnað hwænne mote

fyr on his frumsceaft on Fæder geardas,
eft to his eðle, ðanon hit æror cuom.
Hit bið eallenga eorl to gesihðe,
ðam ðe gedælan can Dryhtnes ðecelan,
forðon nis nænegu gecynd cuiclifigende,
ne fugel ne fisc ne foldan stan,
ne wæteres wylm ne wudutelga,
ne munt ne mor ne ðes middangeard,
ðæt he forð ne sie fyrenes cynnes.

(lines 233–46)

———————

[If the unwise keep it for any while without containment, it will make its way through the roof, breach and burn the building, hang high and wide, rise along the length, climb in kind; it seeks when fire may (go) *to its origins in the father's realm, back to its homeland, thence it first came.* It is entirely visible to a man, to him who is able to share(/divide) the Lord's torch, for there is no species living, neither fowl nor fish nor terrestrial stone, nor water's wave nor branch of wood, nor peak nor moor nor this middle earth, that is not manifest from the nature of fire.] (trans. mine)

There is potential in all of creation to figure forth the nature of Christ. The Word was made flesh. It is the particular quality of poetic words such as those we see here to do so, to fit like to like and thus embody the dualities and mysteries of the Word that was made flesh in verbal forms.

Though the *Solomon and Saturn* dialogues have been marginalized, they stand as important testament to the Insular reception of the Word, a tradition steeped in enigma and devoted to the Word's polyvalence as well as the endless nature of learned pursuit. That the dialogues do not deserve their marginal status is further attested by their existence in more than one manuscript—a great rarity in the Old English corpus. They offer a kind of tour de force, a display of the energy and range represented by the wisdom tradition's fusion of multiple sources of learning. The wisdom tradition flirted with heterodoxy, but it also provided some of the most powerful engines of inquiry in the Christian tradition. The next and final chapter will turn to the manuscript context for *Solomon and Saturn*. Focusing on CCCC 41 (which contains the beginning of *Solomon and Saturn I*), I will consider the

apparent scheme of one marginal compiler for concealing and revealing the Word. His or her work challenges much of what we think about orthodoxy, about reading, about compilation and assemblage in manuscripts. But it is no more outlandish than the pyrotechnics of the *Solomon and Saturn* dialogues or of the *Enigmata* of Aldhelm or of Virgilius Maro Grammaticus's grammars of the twelve Latins. Nor, for that matter, is it any more outlandish than many of the devotional practices and apocryphal narratives that pervade medieval culture both early and late.

Concealing Is Revealing,
Part 2

The Shadow Manuscript in the Margins of CCCC 41

Qui quaerit, invenit.

[S/he who seeks, finds.]
　　　—Matthew 7:8

The last chapter showed the way that enigmatic texts in the wisdom tradition pursue something essential about the nature of the Word in their elaborate, even opaque concealments. In this final chapter I will show that such contemplative concealment appears to have extended beyond what we think of, somewhat anachronistically, as textual composition, to compilation practices, which characterize both authorship and the arrangement (*mise-en-livre*) of manuscript collections. In this I join work by Arthur Bahr and others arguing for the readability of the compilational poetics of medieval manuscripts.[1] The chapter will bring into relief the way the Word could function as an ordering principle on every scale, and highlight the truly distinctive semiotics of the "assemblage."[2] Not only do texts signify differently

(as wholes) depending on the company they keep in a codicological environment, but context may also suggest the activation or salience of only some portion of a copied text. Further, "some portion" may indicate only specific words or phrases or sections or, instead, general themes that may or may not reflect the text's original use or rhetorical function. The selection and ordering of extremely, radically disparate texts, in other words, may depend upon principles other than whole text or "deep" meaning. If I am at all correct in approaching my central focus, the compiled marginalia of Cambridge, Corpus Christi College MS 41 (henceforth CCCC 41marg) in this way, then John Miles Foley was even more right than he knew to suggest that we should be careful about assuming that a "word" was a word in the medieval context. Just as in oral traditions a "word" might denote a phrase, verse, line, or even theme, with regard to manuscript compilation we may have been too quick to assume what a text is or does and how it may signify in its context. I share with Bahr a sense that formalist approaches to arrangement may bring coherence where coherence has remained elusive, and I have been practicing a formalist, constellated reading practice throughout this book. In CCCC 41marg, one of the two manuscript witnesses to *Solomon and Saturn I*, we see the verbal esotericism surrounding the Word and the topographies of the Incarnational surface coming together in manuscript culture, beyond the showcase monuments to Insular manuscript art such as the Book of Kells, the Lindisfarne Gospels, and the Book of Durrow. I focus in depth on this single manuscript compilation, whose eclectic and strikingly arranged marginalia pose a tantalizing puzzle. The many texts in these margins tease and admonish the reader to seek and to find something hidden among their many words, letters, and leaves, offering throughout a persistent, recurring encouragement central to what they conceal and, indeed, to the kind of reading they themselves present: *qui quaerit invenit* ("s/he who seeks, finds").

THE MANUSCRIPT

CCCC 41 was written in an unknown location in the first half of the eleventh century.[3] Its main text is the Old English translation of Bede's *Historia ecclesiastica*, written by two scribes working at the same time whose plans were ambitious but never carried to comple-

tion.[4] The manuscript is unusual on account of its huge amount of marginalia, written soon after the writing of the main text, which extend throughout, appear to be in a single hand, and seem to exhibit purposeful organization that has nothing obvious to do with the content of the main text.[5] For some reason, someone roughly contemporary with the writing of the main text of the manuscript saw fit to fill the margins with material not obviously related to the main text. The manuscript has long fascinated scholars and has been featured in special seminars on manuscript evidence and stand-alone studies focused on the marginalia.[6] This marginal material is fascinatingly varied, ranging from mass prayers in Latin to Old English charms to the fragmentary *Solomon and Saturn I*, to name only a few highlights.

Most recent attempts to account for the marginalia in CCCC 41 have focused on either the liturgical material or the "other," not both. Sarah Larratt Keefer ("Margin as Archive") and Christopher Hohler, for example, argue that the mass prayers, arranged in internally coherent groupings, should be taken on their own and were perhaps copied into CCCC 41 in preparation for later recopying in a full missal that would be usable in performance. Keefer and Hohler have nothing and nothing good, respectively, to say about the material in the middle of the manuscript, which includes the beginning of *Solomon and Saturn I*. Karen Louise Jolly ("On the Margins") and Richard Johnson, on the other hand, attempt to read the more elusive, eclectic material in some sort of unified fashion. Jolly finds a theme of "protection" running throughout the texts and posits the charm formulas in the middle as a particular example of practical literacy. For her, the margins collect texts useful for a provincial community, a design combining and eliding the distinction between secular and ecclesiastical, and suggesting a Christian practice that had absorbed pre-Christian tradition. Johnson focuses on the evident Irish influence on the manuscript and on the prevalence of the archangel Michael as a symptom of this influence. I believe it is possible to go further. Though Jolly does not address the entire compilation, she provides a table cataloging every text, along with its sources, which I reproduce as chapter appendix 1.[7]

My reading here of CCCC 41marg is the first attempt to read the marginalia in their entirety, to encompass the whole. It has long been scholarly practice to see manuscript texts as extractable from context, since manuscripts were put together over time, often decades, with rationales for inclusion often difficult to discern, shifting over time, or

arbitrary. However, CCCC 41 displays an unusual degree of unity and apparent planning. The marginalia take up the whole of its nearly five hundred pages, appear in a single hand, and are spaced in ways that imply intentionality. My thought experiment has been, therefore, to suspend the usual assumptions (of arbitrariness in all things but doctrine) and consider the evidence. What I believe I have found is a manuscript within a manuscript, a shadow manuscript taking up the margins of this vernacular Bede. This shadow manuscript is devoted to the careful exposition of the Word in all of its mystery and power, including its multiple levels of ontology and multiple genres and registers. If I am correct, the manuscript is a striking artifact of Insular Incarnationalism.

THE COMPILATION SCHEME

CCCC 41marg is structured in such a way that it embodies the person of Christ, the Word. It begins with the Incarnation and ends with the Resurrection. Its opening phrase is "Dne Ih Xpe creator" ("Domine Iesu Christe, creator"; "O Lord Jesus Christ, creator"), invoking the Word that was with God at creation, and it ends, on page 488, with an account of the Resurrection and a vision of the heavenly Jerusalem (along with two visual images embedded in the text, which I will discuss in due course). There are, moreover, microcosmic recapitulations throughout the compilation of this trajectory from the creator Word to resurrected Christ. The first mass of the manuscript, for example, on pages 2 through 6, begins with Christ the creator, as quoted above, and ends with Christ's glorified, Trinitarian person, "te . . . qui in trinitate perfecta gloriaris" ("you who in perfect Trinity are glorified"). This mass is for Candlemas, a feast in Epiphany that celebrates the perception of the Incarnate Christ. Placed here, it provides a synopsis for CCCC 41marg, announcing the shape and theme of the whole. Just as so many visual images depict Christ as equivalent to his book, this compilation frames itself Incarnationally as equivalent or coextensive with Christ, opening with the creator Word that was made flesh and dwelt among us and closing with the resurrected, glorified Christ who reigns eternal. The arc, however, is not narrative but textual and semiotic, and its structure is more like an onion, with a protected core, than a linear progression. That is, what we see in

CCCC 41marg is not a biographical narrative of the life of Christ. Rather, at the center is *Dextera*, Christ, the right hand of God, deployed in ways that stress his metonymic connection to humanity and his role in the manifest creation. Fascinatingly, then, the compilation exploits both the linear temporality of salvation history (creation to Ascension) and a spatial dimension in terms of something holy and profound residing at its core.[8] The texts leading into the center of the manuscript direct a reader to seek and to find, first the cross and then the Word itself.

The opening section of the compilation is arranged to invoke the nature of the Incarnation, taking a reader from the Candlemas opening with its précis for the whole manuscript to a collect (i.e., recited by all) for the Purification of the Virgin (7). This invokes the emblem of Christ's human nature as flesh, his mother, Mary, and involves a thematic coherence that depends on neither narrative realism nor exposition. Overall, these liturgical texts move from Lent to Advent, stressing the mortal need for the divine presence.

After the Purification prayer there appears a sequence of prayers, mostly in order, for the season of Lent (8–39). Seen in isolation, these texts might be taken as archived material meant to be recopied for use in performance (as Keefer suggests), or, as Hohler suggests, as reform texts supplementing the library of a humble parish.[9] But seen in light of the rest of the compilation, including the liturgical texts immediately to follow, the Lenten prayers take on a different or perhaps additional function. Coming after the Purification's invocation of Mary's body, and before the Advent texts I am about to describe, the Lenten prayers constitute a meditation upon flesh and its fallenness, upon the dramatic need for atonement that Advent will assuage. Strikingly, the Lenten sequence does not lead up to a climactic Easter text. The prayers for Easter are brief, lacking the directions seen in the other mass texts, and their focus is upon the paschal "adoption" of mankind as sons of God. Easter is framed as the final point of the chiasmus between God and man, in which Christ has descended so that we might ascend, and yet the texts here do not themselves mark this end. In their understatement they serve rather as but one marker upon a larger way.[10] That the emphasis here is not solely upon the theologically primary fact of the Resurrection is further clarified by the position of the Easter texts not directly in the *Temporale* sequence but between the feast of St. Benedict (March 21; 45) and that for Sts.

Phillip and James and the Invention of the Cross (May 11; 60). Bene-
dict was the institutor of monastic discipline, the deposition of the
body in obedience. Phillip is described as having "found Christ" (John
1:43) and James was granted a vision of him (1 Cor. 15:7), associating
both with the finding of the cross—an association that perhaps ex-
plains how these particular elements came together in this particular
feast. The celebration of Easter, the Lord's resurrection, is rather
dwarfed here, even muted, by a focus on the body and its need for the
divine and capacity to perceive it. Again, the effect of the manuscript's
sequence for Lent is to foreground the plight of humanity in lament-
ing its fallenness and readying itself for the reception of the divine.

Advent responses and antiphons run from page 61 to page 75, end-
ing with verses for St. Stephen, who was granted a vision of Christ at
the right hand of God. After a break in the marginalia of forty-six
pages (that is, forty-six pages of empty margins), the first extensive
vernacular text appears: an apparent fragment of the Old English
Martyrology corresponding to "Yule" or Christmas week, from De-
cember 25 to 31. The first vernacular text, that is, treats the advent of
the Incarnation. The vernacular is again paired with the sensible pres-
ence of the Word. The Martyrology is a collection of homiletic narra-
tives on the various saints of the liturgical calendar, attested in frag-
mentary form in a total of six medieval manuscripts.[11] Yet CCCC 41's
Christmas week texts represent the sole manuscript witness for this
portion of the calendar. Christ is born, here, in the vernacular flesh.
The celebrands for the week include Christ, Anastasia (Dec. 25),
Theodata (Dec. 22), Eugenia (Dec. 25), Stephen (Dec. 26), John the
Evangelist (Dec. 27), the Holy Innocents (Dec. 28), and Sylvester
(Dec. 31). The section devoted to Christ's birth is striking in its ac-
count of the portents that appeared in that year. Men saw "ears of
wheat" growing on trees, and blood flowed from their bread. A lamb
in Egypt had the power of speech, and an ox in Rome foretold of
"good wheat" that the Romans would not live to consume. These are
clearly Incarnational images: the bread of life begotten from the tree
of life (which is also the cross), the prefigured Eucharist, the lamb.
The writer explains the images in precisely these terms, invoking the
chiasm between God and man: "eall þis tacnode þæt seo clæne fæmne
cende sunu swa hire næfre wer ne gehran ac se ðe hæfde fæder on
heofnum butan meder ⁊ hæfde þa modur on eorðan butan fæder"
("All this signified that the pure virgin bore a son in such a way that

no man had ever touched her but he who had a father in heaven with-
out a mother and had that mother on earth without a father").[12] We
have gone from liturgy to homilies and from Latin to Old English
with pages 122 through 132, after the forty-six-page hiatus, but the
apparent disjunction is superficial. The Old English texts for Christ-
mas week inaugurate what will become an increasingly intense search
for the Lord.

After a break of one page (133), the marginalia open onto an Epiph-
any that becomes ever more surprising the further it draws the reader
toward the Incarnate Christ. Mass prayers in Latin (134–39) plead for
the Lord to draw near and to show his face (translations are mine):

> The virgin Mary conceived through the cooperation of the holy
> spirit. . . . Hence his ineffable divinity brought it about that we man-
> age, with your assistance, to discern your face without confusion/
> unalloyed . . . whose Incarnation we celebrate. (135)

> Be near, omnipotent Lord, gather your power, we ask, and come.
> (136)

> Come and show us your face, Lord. (138)[13]

The final mass (158) is for the priest "pro se" ("for himself"), ending
with an invocation of the Incarnation specifically as a healing force:
"CÐ qui pro amore hominum factus in similitudine carnis peccati . . .
& in specie vulnerati medicus ambulavit hic nobis dominus" ("Lord
Christ who for love of men was made in likeness of the flesh of sin . . .
and in the form of the ailing walked (as) a healer; this lord among us";
trans. mine).[14] The juncture of the human nature of Christ with the
human nature of bodies in need of healing is ever-present in the mar-
ginalia to come, as Jolly has emphasized and as we shall see. The heart
of this "shadow" manuscript is the presence and working of the divine
in the sensible world, the place of the Lord among us. It is instructive
to consider analogues to the passage I just quoted. The common ver-
sion of this mass has a longer version of the last phrase, which includes
"hic nobis dominus" as part of a list of things Christ is to man:

> hic nobis dominus et magister salutis, advocatus et judex, sacrificium
> et sacerdos. (*Patrologia Latina* 121:921)

[here among us/this one to us [is] Lord and minister of salvation, advocate and judge, sacrifice and priest.]

That the CCCC 41 text stops at the invocation of "lord among us" is a sign of intention, of the shaping of the text for present purposes. Christ walks as a healer, the Lord among us. This—Christ "among us"—is exactly what the marginalia will gradually disclose as they initiate the reader into their secrets.

Thus far, then, the compiling scribe has, through his or her principles of selection and arrangement, crafted a specific kind of experience using entirely orthodox (or mostly orthodox) materials. Incarnation is announced at the outset, followed by the long sequence for Lent. Advent and Epiphany follow. The promise of God appearing among us is the unifying thread throughout. In the revelatory core of the marginalia, the compilation becomes considerably more difficult and opaque, paradoxically, as it reveals more intimately the nature of the Word. For example, we begin to see not only arrangements of ecclesiastical texts but the introduction of material so shocking and offensive to Hohler (a liturgical scholar) that he pronounced it "abominable" (278).

MASHUPS IN THE MARGINS: WIÐ YMBE (THE BEE CHARM) AND CHRIST'S EARTHY SUBSTANCE

The first such abomination is what I will call a "mashup"—a textual portmanteau, to borrow a term from linguistics—that combines a Latin votive prayer with a famous Old English text that has long been extracted from its context and placed among other texts also deemed to be "charms."[15] The combined significance of this mashup is difficult to discern and depends, I contend, upon both reading the two texts together and the larger context of CCCC 41marg. "Wið ymbe" ("against a swarm"), the better known of the two texts, is apparently a formula for keeping a hive from swarming (the text contains verse portions that are usually printed in lines, which I reproduce here):[16]

Wið ymbe nim eorþan ofer wearp mid þinre swiþran handa under þinum swiþran fet 7 cwet:

 fo ic under fot funde ic hit

```
        hwæt eorð mæg          wið ealra wihta gehwilce
        ⁊ wið andan            ⁊ wið æminde
        ⁊ wið þa micelan       mannes tungan
⊦ wið on forweorp ofer greot þonne hi swirman ⁊ cweð:
        sitte ge sige wif      sigað to eorðan
        næfre ge wilde         to wuda fleogan
        beo ge swa gemindige   mines godes
        swa bið manna gehwilc  metes ⁊ eþeles (182)
```

[Against a swarm take earth throw it over with your right hand under your right foot and say, "I take under foot, I found it. *Hwæt!* Earth is able against every kind of creature and against anger and against unmindfulness and against the great tongue of man," and on that throw sand when they swarm and say, "Settle you, victory wife, journey to earth; never fly wild to the woods. Be as mindful of my good as is every man of food and home."] (trans. mine)

This charm has received extensive treatment on its own and in the context of other charms, Germanic and Indo-European folklore, and historical and modern apiculture.[17] What has not received as much attention is the fact that the text is the second element in a mashup. It is copied directly under the much less discussed Latin prayer, together with which it fills, exactly, the left margin of page 182. Below are the two texts as they appear in the manuscript, lineated as they appear in their marginal space. I have emphasized some apparent parallels between the two. Italics mark lists of items to be warded off or, conversely, protected; boldface marks invocations of "earth" and its power. I discuss each parallel in further detail below.

pietatem tuam quaesimus domine	[your mercy we pray, lord
nostrorum absolue uincula	absolve us from the chains
delictorum & intercedente	of our sins and with Blessed
beata mariae cum omnibus	Mary interceding with all
sanctis tuis. regem nostram	your saints, protect our king
atque pontificem. siue	and pope and
omnem congregationem	all the congregation
illi comissam. & nos famu	in his care, and us
los tuos & seniorem nostram	your servants and our elder
cum suis fidelibus atque locum	with his faithful and this place

in omni loco sanctitate eius	in every place with his holiness,
custodi. omnesque afinitate	and with all affinity
& familiaritate nobis iunc	and familiarity, purge us
tus. seu omnes Christianos a uitis	together, all Christians,
purga uirtutibus inlustra.	of vice, fill (us) with virtue,
pacem & sanitatem atque	grant us peace and health
salutem nobis tribue. *hostes*	and salvation, *remove*
uisibiles & inuisibiles re	*visible and invisible*
moue. amicis et inimicis	*foes, enlarge our love*
nostris caritatem largire.	*for friends and enemies,*
& omnibus fidelibus uiuis at	*and to all the faithful living*
que defunctis in terra uiuen	*and dead in heaven*
tium & requiem eternam	*also grant eternal rest.*
concede. Per. **deus qui nos singu**	**God, who alone by**
laris corporis tu ostiam to	**the sacrifice of your body**
tius mundi soluisti delicta	**atoned for the sins of all the world,**
hanc oblationem placatus maculas	**with this appeasing offering**
scelorum nostrorum absterge	**blot out the stains of our faults**
& omnium Christianorum fideli	and forgive the sins of all faithful
um uiuorum & defunctum	Christians living and dead
peccata dimitte eisque	and grant them
premia eterne concede per.	eternal rewards.
wið ymbe nim eorþan ofer	Against a swarm take earth,
wearp mid þinre swiþran	throw it with your right
handa under þinum swi	hand under your right
þran fet ⁊ cwet fo ic un	foot and say, "I take
der fot funde ic hit	under foot, I found it.
hwæt eorð mæg wið	*Hwæt! Earth is able against*
ealra wihta gehwilce	*every kind of creature*
⁊ wið andan and wið æmin	*and against anger and against*
	unmindfulness
de ⁊ wið þa micelan	*and against the great*
mannes tungan ⁊ wið	*tongue of man,"* and
on forweorp ofer greot	over that throw sand
þonne hi swirman ⁊ cweð	when they swarm and say,
sitte ge sige wif sigað	"Settle you, victory wife, travel
to eorðan næfre ge	to earth; never
wilde to wuda fleogan	fly wild to the woods;
beo ge swa gemindige	be as mindful

mines godes swa bið	of my good as is
manna gehwilc me	every man of
tes ⁊ eþeles	food and home."][18]

There is evidence that the texts were in fact separate and copied on different occasions, however close together these occasions may have been, in that the writing of the Old English text appears to have been begun too close to the line above (the last line of the Latin text), causing the scribe to angle the line down toward the ruling of the main text as he or she wrote (see fig. 5.1). The result is a couple of awkwardly slanting lines before the lines right themselves. Despite the subtle distinctness of the two texts, however, the scribe had all sorts of options for keeping them unmistakably distinct, from keeping a line blank to using another margin for the Old English to choosing another page entirely. Instead, he or she opted to mash them up into a single column precisely coextensive with the left margin space. There was an effort, therefore, to make these two things one or to juxtapose them at the very least.

Both of these texts share a "listiness" in the form of a passage that lists parallel items to be guarded against or protected (italicized above), and I initially tried to think of these structural similarities as the salient link between them. However, the more important shared element, mutually emphasized by these two texts, is, I think, an invocation of "efficacious earth," earthly substance infused with power, here protective, propitious power (rendered in bold).[19] The Old English charm proclaims, with the oratorical *hwæt!*, that earth has power against "every kind of creature," anger and unmindfulness, and social enmity. The votive prayer it follows beseeches, "God who alone by the sacrifice of your body paid the sins of the whole world, with this appeasing offering blot out the stains of our faults." The vernacular charm effectively combines two elements that are separate in the Latin text, the desire for protection in the world and the invocation of Christ's corporeal sacrifice. It takes the list of items to be warded off (italics) and combines them with the protective earthly substance (boldface). In doing so, the charm doubly evokes the Incarnation, concretizing in the vernacular (divine) ideas from the Latin and affirming earth, the very substance of the Incarnation, as powerful here, now, in the world. This establishes the basic element of the Incarnational mystery, the flesh of the Word.

Figure 5.1. Cambridge, Corpus Christi College MS 41 (CCCC 41), p. 182. Marginal mashup of Latin prayer and Old English *wið ymbe* bee charm. The Parker Library, Corpus Christi College, Cambridge.

The enumerated body parts of the prescribed action in the *wið ymbe* formula, in particular the right hand, take on further significance in light of texts to come, which emphasize the right hand as an Incarnational metonym. Christ is Dextera, the right hand of God, who sits at the right hand of God. He also has hands and feet in kind with us, the humankind that needs his healing touch. The figural and the literal, the metonymic and the metaphorical, are in extremely complex blends here, and I would assert that the constant in all the flux is the term, the word, *dextera*. For this philosophic mode—and I suggest that it is one, however implicit and unsystematic—the (to us) familiar Neoplatonic emphasis on the signified at the expense of the signifier is reversed. Since Christ is the Word and has valorized the appearance of the word by the mystery of the Incarnation, the word and words are not mere conveniences or husks. They can convey in themselves—mysteriously—the divine.

The earthy nature of the flesh of the Incarnation has thus been invoked by the mashup of the Latin prayer and the Old English charm. Earth itself bears power by virtue of the Incarnation. The next two groupings in CCCC 41marg, on pages 192 to 194 and 196 to 198, provide two crucial (this will come to seem a pun) steps in the revelation of the Word: establishing metonymy heuristically as a key attribute and then introducing the Word's specifically verbal nature. I will discuss metonymy in a bit more detail here. An important attribute of divinity in Catholic observance (though always a sticky wicket in doctrine) is the proliferation of devotional objects and intercessory agents. The saints, along with Mary and some of the angels, play a large role in hearing prayers and interceding on our behalf, even acting in the world as agents of divine will. In doing so, these figures bear a metonymic relation to divinity, which, as more austere doctrine asserts, is not itself divisible but rather both singular and ineffable. The saints represent Christ, God, and the Trinity metonymically, as associates or proxies. These figures in turn are represented by their own parts, pieces, and attributes, in relics and ritual devotion. In the synecdochic function of metonymy, the tiniest particle of a saint or other holy figure (the cross, Christ himself) carries its indivisible power. Thus, pages 192 to 194 are masses for All Saints Eve and All Saints, and these masses invoke the basic metonymic function of the saints. They represent, that is, the idea of metonymic intercession, which is essential to the highly abstruse *Solomon and Saturn I*

fragment that comes next. The *Wið ymbe* mashup thus condenses the protective power of the Incarnation into the vernacular poetic invocation of earth, and the masses for All Saints deploy that power in spinoff forms, metonymic agents of the Word.

SOLOMON AND SATURN I: THE WORDS OF THE WORD

The *Solomon and Saturn I* text, as I discussed in chapter 4, invokes the Pater Noster as a metonym for Christ, emphasizing the verbal nature of the Word and its metonymic iterability in further words, letters, and signs. Again, this manuscript, on pages 196 to 198, contains lines 1 through 93 of the poem, breaking off near the bottom of 198, after the letter *T* (see fig. 5.2). What becomes clear in this manuscript context, however, is that the copyist seems to stop (ending at the bottom of the page, after the letter-warriors have begun their routing of the devil) with a purpose. There was room for the scribe to add more of the poem at the bottom of the page if more was available in the exemplar, as the preceding pages each include one further line in the bottom margin, not to mention the space that remains to the right of the last graph, *T*. This portion of the poem establishes that the words of Christ condense the virtue of all books into themselves. As Saturn says, "swylce ic næfre on eallum þam fyrn gewrytum findan ne mihte soðe samode ic sohte þa git hwylc wære modes oððe mægen þrymmes elnes oððe æhte eorlscip se ge palmtwigoda pater noster" ("Such I never could find in all the ancient writings truly gathered; I sought still what may be by bravery or force of courage or possession of nobility the palmtwigged Pater Noster"; lines 7b–12; trans. mine). The Pater Noster is what Saturn was seeking all along in (apparently heroic) ancient texts. Further, Christ's words have power, specifically redemptive power, as they avert damnation on judgment day and open the gates of heaven, and they participate in creation itself ("guardian of water . . . keeper of the waves' herds . . . splendor of worms, forest of the beasts, guardian of the wilderness"; "flodes ferigend . . . yþa yrfeweard . . . wyrma wlenco, wildeora holt, westenes weard"; lines 80–83). They take many forms, from the "door of the deaf" ("deafra duru"; line 78a) or the creator's hall ("scippendes seld"; line 79b) to a golden object studded with gems (line 63). Finally, they

Figure 5.2. CCCC 41, p. 198. *Solomon and Saturn I* fragment. The Parker Library, Corpus Christi College, Cambridge.

both stand in for Christ the Word (*pro Logo*; line 89a) and themselves break into parts that stand for the whole, in the individual letters that do battle against the devil—and this is where the text breaks off, at the end of the page on which the letter-warrior sequence had begun, on the crosslike letter *T*, which, as I discussed in chapter 2, the Book of Kells graces with Christ's image multiple times. CCCC 41marg hereafter begins a journey toward the finding of the cross, the archmetonym for Christ. Seen in this light, not only does the *Solomon and Saturn I* fragment seem complete and purposeful, but the masses just before it become legible, as they invoke throughout the ideas of intercession between divine and human and of metonymic standing-in for Christ by bearing his power. Thus, by this point the marginalia have begun to disclose, by increments, aspects of the nature of Christ, first with the invocation of earthly substance infused with power (the *wið ymbe* mashup), then with the introduction of metonymy as a powerful partaking of and parceling out of that power (All Saints), and finally with a meditation upon how these attributes are involved in the nature of the Word as such (*Solomon and Saturn I*): the Word is iterable, particulable, salvific, apotropaic.

SEEK AND YE SHALL FIND: CHARMS FOR FINDING, CHARM FOR THE EYES

The next group of texts poses an extremely difficult set of conundrums, but these serve both to conceal and to reveal the literally crucial Christological metonym that is the next stage of the journey. The cross must be "found" by the reader, as it was found in Christian legend. Pages 206 to 208 again pair Old English and Latin, this time with the English texts first and the Latin second. The texts are bound by a theme and lexeme of "concealment," represented by the cognates Old English *helan* ("to conceal, hide") and Latin *celare* ("to hide").[20] The three texts in Old English are all written in the bottom margin of page 206, beginning with leftover space on the last line of the main text. All are charm formulas for the retrieval of stolen cattle. The Latin texts take up the bottom margins of 207 and 208 and comprise a rearranged portion of St. Seachnall/Secundinus's (5th c.) hymn to St. Patrick, followed by another charm for lost property. After a significant gap in the line, a very short formula in Old English for "eye-ache"

(*eahwærce*) closes the section. Many contortions have been undergone to make sense of this section's eclecticism, working from an assumption that the theft formulas are primarily theft formulas, recorded for practical use as such. This assumption necessitates some kind of explanation for the appearance of extraneous material such as a hymn to St. Patrick.[21] The solution to the troubling presence of the hymn fragment has been that it was an accident involving a page turn in the exemplar (Hollis 146–48; discussed in Jolly, "On the Margins" 155). None of these texts needs to be read as a mistake, however. Together, they encourage a reader to find what may or must not remain concealed, to clear his or her eyes and see it.

All the texts in this section (except for the brief eye formula at the very end, which, as I argue, goads the reader to look and see) announce their Christological association in explicit and precisely suggestive terms. Here is the opening of the first: "Ne forstolen ne forholen nan uht þæs ðe ic age þe ma ðe mihte herod urne drihten ic geþohte sanctae ead elenan ꝥ ic geþohte crist on rode ahangen swa ic þence þis feoh to findanne" ("Neither stolen nor hidden [be] any bit of what I own, any more than could Herod [steal or hide] our Lord; I have thought of blessed St. Helena and I have thought of Christ hung upon the rood, as I think to find these cattle"; trans. mine).[22] The text invokes Christ's Incarnation in the reference to Herod's slaughter of the innocents, then both the Crucifixion and the invention of the cross. These references announce what I suggest is the purpose of this text here in this manuscript context, regardless of its additional or customary practical use value in recovering property (which surely was the impetus for it originally). The invocations function almost as puns that reliteralize idiomatic metaphors. "I thought of Christ hung upon the rood"—one should actually think of Christ upon the rood. The cattle to be found become indices of the cross, rather than the other way around. The second formula invokes Christ's birth and crucifixion as well, beginning,

Ðis man sceal cweðan þonne his ceapa hwilcne man forstolenne cyð
ær he ænyg oþer word cweðe:

Bethlem hattæ seo burh	ðe crist ongeboren wæs
seo is gemærsod	ofer ealne middangeard
swa þeos dæd wyrðe	for mannum mære per crucem christi

[This one shall say when his property has been stolen: before he says any other words let him say, "Bethlehem is called the town where Christ was born; it is famous over all the earth, so let this deed become known among men, *per crucem Christi.*"] (trans. mine)[23]

Here the place of Christ's birth serves as a token of a "famous" thing, lending rhetorical weight to the theft, which is to be similarly disclosed and made "famous." After its initial invocation of the cross above ("per crucem christi"), this formula further involves the cross as it continues,

⁊ gebide þe ðonn þriwa east ⁊ cweð þriwa + xpi ab oriente reducat ⁊ in west ⁊ cweð crux xpi ab occidente reducat ⁊ in suð ⁊ cweð crux xpi a meridie reducat ⁊ in norð ⁊ cweð crux xpi abscondita sunt & inventa est judeas crist ahengon gedidon him dada þa wyrstan hælon þæt hi forhelan ne mihton swa næfre ðeos dæd forholen ne wyrðe per crucem xpi

[And pray you then thrice to the east and say thrice *crux Christi ab oriente reducat* (will recover it from the east) and in the west and say *crux Christi ab occidente reducat* (will recover it from the west) and in the south and say *crux Christi a meridie reducat* (will recover it from the south) and in the north and say *crux Christi abscondita sunt & inventa est* (they were hidden and it was found). The Jews hanged Christ and did to him the worst of deeds. They hid what they could not hide. So let this deed never be concealed, *per crucem Christi.*] (trans. mine)

This second formula, obviously, features prominently the cross and its concealment and recovery.

The final theft formula on page 206 neglects to mention either Christ or cross, but this neglect may be both conspicuous and purposeful, raising the stakes as it challenges and encourages the reader to seek and find. The text prescribes that if a horse or cow is stolen, one should sing over its hoof-track (the sign of its absence) "no man may conceal it" ("ne mæg hit nan man forhelan") and drip the wax from three candles three times. If some other kind of animal has been lost, the text prescribes the following, apparently to be sung in different bodily positions ("on iiii healfa ðin, ærest uprihte"; "on your four sides, first upright"): "⁊ petur pol patric pilip marie bric-

git felic in nomine . dei . ⁊ chiric qui querit invenit" ("and Peter, Paul,
Patrick, Phillip, Mary, Bridget, Felix, in the name of God and the
Church, who seeks will find"). The admonition that he who seeks will
find is, of course, of biblical origin (Matt. 7:8, part of the Sermon on
the Mount). Christ's words on the Mount include the Pater Noster,
which the *Solomon and Saturn* texts spin into an elaborate metonym
for Christ the Word. Here in this formula, the cross has seemingly dis-
appeared, but what appears instead may be a tantalizing word puzzle
of exactly the sort beloved by the writers of the wisdom tradition. If
we keep in mind the "clue" the reader has just encountered in *Solo-
mon and Saturn I* (on 196–98), the power of the Pater Noster and its
association with wordplay and letterplay, we might be primed to see
the list of names as patterned and highly restricted: P. . . P. . . P. . . P. . .
M. . . B. . . F. All the names begin with labial sounds (made by the
lips), and the list is frontloaded with four *P*'s, with the result that
the nasal [m], voiced variant [b], and fricative [f] all serve to emphasize
that initial *P*, to point back to it. "Nomine Dei" comes next, then the
strange spelling of the Old English word *chiric* (found only eight
times in the corpus, compared to 627 times for *ciric*), embedded in a
Latin formula.[24] (P . . . (N)omine Dei), Ch—who seeks will find!:

> petur pol patric pilip marie bricgit felic in nomine . dei . ⁊ chiric qui
> queri[t] invenit

> p . . . p . . . p . . . p . . . m . . . b . . . f = P N(omine) Dei, Ch(iric)
> (Latin-OE)

> → Pater Noster, Nomen Dei, Christus: *qui querit invenit*

I suggest that this admonition serves as a scriptural message but also
a textual one about what one should seek right here, in this present mo-
ment of concealment and in the ongoing textual journey of which this
moment is only one part. All those paths lead ultimately to Christ, in
his very own words. The combination of Latin (*Nomine Dei*) and Old
English (*chiric*) presents yet another amalgamating union echoing the
hypostatic union. The words articulating "in the name of God and the
Church" combine the disparate languages, with the vernacular word
concealing and revealing the Incarnate solution, Christ.

The Old English theft formulas on pages 206 to 207 thus emphasize
the Incarnation and the cross and call to mind the verbal gymnastics of

Solomon and Saturn I as they encourage the reader to look, ultimately, for Christ. The Latin texts that appear on pages 207 to 208 are unified by an emphasis on finding and loosing what was hidden and bound; they end with the brief Old English formula for the eyes that forms a thematic echo for the Latin phrase that closes the Old English formulas on page 206, "he who seeks will find." The first Latin text, the portion of the hymn to St. Patrick, rearranges the stanzas so that the first lines praise the saint as liberator of captives and Trinitarian exegete, possibly "girt with the sound of the Lord":

Xps illum siue elegit in terris ficarium
qui de gemino captiuos liberet seruitio
plerosque: de seruitute quos redemet hominum
in numeros de sabuli obsoluit dominio.
Ymnos cum apocalipsi salmosque cantat dei
cousque et edificandum dei tractat pupulum
quem legem in trinitate sacre credent nominis
tribusque personis unam.
Sona domine praecintus diebus ac noctibus
intermissione deum oret.

———————

[Christ chose that one as vicar on earth, who liberates captives from a double bondage and more: he redeems men in numbers whom he absolves from the dominion of the devil, he sings hymns with the apocalypse and psalms of God, which he expounds to edify the people of God, which scripture they believe, in the Trinity, sacred of name, one in three persons. Girt with the sound/belt of the Lord day and night (without) ceasing he prays to God.] (trans. mine)[25]

Past treatments of this text in CCCC 41 have focused on the entire hymn as it appears elsewhere, not on what actually appears here, but the attributes of Patrick praised here seem almost a continuation of *Solomon and Saturn I*.[26] Patrick releases people from the devil's bonds with the language of God. That language is itself bound up in the Trinitarian mystery. This excerpt of the hymn of St. Patrick thus fits into the copyist's scheme.[27] Patrick liberates and reveals, and is specifically devoted to the revelatory (Apocalypse) and laudatory (Psalms) language of scripture, which is itself associated with the Trinity and thus the words of the Word. This exordium bears a punctuation mark,

Figure 5.3. CCCC 41, detail of p. 207. Partial *Hymn of Secundinus* in praise of St. Patrick, with recovery formula (*crux Christi reducat . . .*). The Parker Library, Corpus Christi College, Cambridge.

and the rest of the line, about the space of a word, is left blank (see fig. 5.3). The last line on the page (207) brings the abrupt reappearance of the cross, with the same refrain, *crux Christi reducat*, seen in the second Old English formula on page 206. The text continues from the bottom of 207 onto page 208:

> crux Christi reducat crux Christi periit et inuenta est habracham tibi uias montes silua semitas fluminas andronas cludat isaac tibi tenebras inducat crux iacob te ad iudicium ligatum perducat iudei Christum crucifixerunt persimum sibi metipsum perpetrauerunt opus celauerunt quod non potuerunt celare sic nec hoc furtum celatur nec celare possit per dominum nostrum [space] wið eahwærce genim læfre neoðowearde cnuwa ⁊ wring ðurh harwenne cla ⁊ do sealt to wring þonne in þa eagan

> ───────────

> [cross of Christ bring it back, cross of Christ was lost and found; Abraham may close to you the ways, mountains, forest, paths, rivers, Andreas(?),[28] Isaac bring you to darkness, cross, Jacob lead you bound to judgment. The Jews crucified Christ and perpetrated for themselves the worst. They concealed the work that they could not conceal, thus neither will this *furtum* be concealed nor can it be concealed, because of our Lord. Against an eye-ache take the lower part of a fresh rush, pound and wring it through a gray cloth and put salt on it; then wring it into the eye.] (trans. mine)

With this passage the search for the cross intensifies. The Old Testament patriarchs are invoked here as obscurers in what I think is a

careful sequence that has been neglected, in part because of the focus on this text as a charm and in part because of the apparent corruption of the name *Andreas* ("Andronas" in the manuscript). In my reading, the text warns that "Abraham" would "close the ways" for Andreas, the first disciple. "Isaac" would bring the cross to darkness. "Jacob," finally, would lead the cross or Christ himself bound to judgment, as the next sentence suggests in its lament over the Jews' betrayal of the Lord. The Old Law, in other words, leads you down the path to the Crucifixion. All of these phrases could also, it is true, be read as jussive subjunctives—"may Abraham close the ways"; "may Isaac bring you to darkness"—but in such a reading *crux* in "crux iacob" is either an odd interjection or must be attributed to Jacob.[29] Neither of these possibilities seems satisfactory, and on the contrary, my reading connects this passage in a coherent way with what is around it.[30] Rather than a discrete charm text oddly situated amid other material, this section of the Latin portion of 206 through 208 can be read as an integral component of a whole.[31]

The cross is definitely the focal point of this text, under any reading, the Jews having "concealed what could not be concealed." The passage harnesses the biblical concealment, directing its energy in turn toward the word I have left untranslated above, *furtum* ("neither will this *furtum* be concealed"). The word is ambiguous: "furtive thing," such as a theft, but also "device," "artifice," or "stratagem." *Furtum*, I think, thus refers both to a theft of property, based in the original context for the theft charms recorded here, *and* to the divine enigma whose immediate emblem is the cross, the cross which at this point in the compilation a reader is being urged to seek. Is it possible that the reader is unable to perceive it? The tag formula at the end of the section teases at just such a suggestion: clear the eyes so that you may see (for, as we remember, "he who seeks will find"; "qui querit invenit"). These two ideas ("qui quaerit invenit" and healing the eyes to see) are brought together, after all, by their placement at the end of their respective pages, in contrasting languages to the texts they follow. In this co-reflection, the biblical admonition to seek and find has a vernacular, practical addendum in the formula for the eyes. The cryptic metonymy of the Word, by this point, has been established, a Word that became flesh and was bound up with the (still-elusive) cross, both of which the reader must clear his or her eyes to find.

EUREKA: THE CROSS IS FOUND

After a fifteen-page gap in the marginalia, the cross is found (224–25; see appendix 2). In another mashup, a hymn to the cross is sutured to an Invention mass. The reader has found the cross, just as the cross was found by St. Helena. It will not be a final destination, but it is an important milestone. The metonymic relation of the cross to Christ is invoked in the hymn's first line:

Salue crux que in corpore christi dedicata es & ex menbris eius tam-
quam margaretis ornata. (224)

[Hail, cross, who were dedicated by the body of Christ and adorned by his members even as pearls.] (trans. mine)

The cross takes its sanctity as well as its beauty from the Incarnate body of Christ. The hymn goes on to emphasize this proper relation, taking what seems possibly to have originated as a careful response to controversy over images and turning it to present purposes:

Ecce adoro te non sicut metallum.
Ecce adoro te non sicut idolum.
Ecce adioro te non sicut simulacrum.
Ecce adoro te non sicut fantasma.
Sed adoro dominum iesum christum qui pependit in te.

[Behold, I adore you not as metal.
Behold, I adore you not as an idol.
Behold, I adore you not as an image.
Behold, I adore you not as a figment (=fiction).
But I adore the Lord Jesus Christ who hung upon you.] (trans. mine)

The speaker does not adore the cross as metal, idol, or representation. The cross is adored because it once bore Christ. It touched his Incarnate body. It took part in the salvific drama.

The Invention mass mashed up with the hymn emphasizes the finding of the cross in commemorating that event, but in doing so it also features elements seen elsewhere in the compilation, in particular

the double typological chiasm between the tree of knowledge that brought sin and the tree of the cross that brought redemption, and between Eve and Mary:

> Deus qui hunigeniti filii tui pretiosa sanguine uiuifice crucis uexillum sanctificare uoluisti. concede quaerimus eos qui eisdem sanctae crucis gaudent honore tua quoque ubique protectione saluari...
> Christus Dominus aeterne deus. Qui salutem humani generis in ligno crucis constituisti. Unde mors oriebatur inde uita regurgeret & qui in ligno uincebat in ligno quoque uinceretur...
> sic []ni_ in adam & in eva omnes homines moriuntur. ita & in xpo & in sancta maria & in ligno crucis uiuificabuntur. per mulierem & lignum mundus prius periit. per mulieris uirtutem ad salutem reddidit. per christum...
> Tribue ut uitalis tuitione ligni ab omnibus muniamur aduersis. (224–25)

> [God who desired by the precious life-giving blood of your only begotten son to sanctify the sign of the cross, grant, we ask, those who rejoice in honor of the same holy cross the protection of salvation....
> Lord Christ, eternal God, who instituted the salvation of mankind on the wood of the cross, whence death arose thence life would resurge, and who on wood conquered, wood on which he had been vanquished....
> As in Adam and Eve all men die, so also in Christ and St. Mary and in the wood of the cross they will be brought to life. Through the woman and the wood the world first perished. Through the virtue of a woman it has returned to health. In Christ....
> Grant that we may be given the teaching of the living wood against all adversities.] (trans. mine)

We have seen the close association between Mary and the cross; *The Dream of the Rood* invokes it. Mary is also associated with Christ's flesh and with the Incarnational palmtwig she is given before her assumption (in Blickling Homily XIII). The significance of the wood of the cross, its "teaching," which is the final emphasis of the liturgy recorded here, is something that will be carried forward in the marginalia. It will be transformed into images such as the *blæd* and the

palmtwig (which has already appeared in *Solomon and Saturn I*), which expand its range of reference while retaining its historical and typological ties to the cross and to Christ.

IN THE MIDDLE: FOUR HOMILIES AND A MASHUP OF THE WORD

As elsewhere in Christian tradition, the cross is both pointer and vehicle, conveying people to Jesus. It is not surprising that after the finding of the cross we should encounter Christ, but the manner in which this occurs in CCCC 41marg is by way of concealing-cum-revealing. Thus, the Christ embedded in the heart of four apocryphal Old English homilies on pages 254 through 301 (at the heart of the manuscript itself) has been difficult to discern. Commentators have generally taken a mashup charm in Latin on 272 separately from the homilies, and have considered the homilies in terms of their respective sources rather than in terms of one another and the present compilation. To make matters even more confusing, Raymond Grant published one of the four (on the assumption of the Virgin) along with two other homilies from CCCC 41marg that are not in this immediate group: the homily/hymn to Saint Michael on 402 through 417, and the final text of the compilation, the homily on the Passion and Ascension, 484 through 488 (*Three Homilies*). The four homilies in the present group, surrounding the mashup apparently devoted to the Incarnate Word, are on the soul and body, the assumption of the Virgin, Doomsday (including a tour through the "seven heavens," with material from the Apocalypse of Thomas), and Easter (with material from the Gospel of Nicodemus), though a vivid aspect of this last is a scene of the Last Judgment as well.[32]

Here, as elsewhere, mashups appear to be meaningful. The text at the center of the four homilies brings together scriptural invocations of *dextera*, the right hand, with a generic Latin charm formula whose bulk is a list of exorcised body parts ending with an invocation of the Trinity. The Old English homilies appear to have been placed around this Latin charm and concern the ontology of the body and the soul, their properties of appearance and transformation, and the relation of these to Christ and his Incarnate body. They thus support and take part in a vernacular meditation upon a profound ontological problem,

the very nature of the Incarnation not as theological abstraction but as a "fact" of the world, a property of nature as it was understood, as including the supernatural. I will lay out this central Incarnational formulation first and then consider the four homilies that may be seen to function as its supporting commentary.

As mentioned, the Latin text appears in the left margin of page 272 with an Old English rubric, "wið ealra feo[n]da grimnessum" ("against the dangers of all enemies"; see fig. 5.4). The first Old English homily precedes and envelops the charm text and is written in more and more of the marginal space of each page, in a failed attempt, perhaps, to fit it in before the beginning of the charm. I have separated the mashup, below, into rhetorical units that appear to carry elements important to the Christological bricolage, and I have rendered these elements in boldface, though the entire text is reproduced:

Dextera domini fecit uirtutem **dextera** domini exaltauit me non moriar sed uiuam & narrabo opera domini [Ps. 117/118:16–17]

Dextera glorificata est in uirtute **dextera** manus tua confringit inimicos & per multitudinem magestatis tue contreuisti aduersarios meos misisti iram tuam & commedit eos [Exod. 15:6–7]

Sic per **verbo veritatis** amedatio sic eris in mundissime spiritus fletus oculorum. tibi gehenna ignis

Cedite. a capite. a capillis. a labiis. a lingua. a collo. a pectoribus ab universis. conpaginibus membrorum eius ut non habeant potestatem diabulus ab homine isto/a . N . de capite de capillis . Nec nocendi . Nec tangendi . Nec dormiendi . Nec tangendi . nec insurgendi . nec in meridiano . nec in uisu . nec in risu . nec in fulgendo [illegible digraph—Ac?] effuie .

Sed **in nomine domini nostri ihu xpi** qui cum patre & spiritu sancto uiuis & regnas deus in unitate spiritu sancti per omnia secula secula seculorum.

———————

[The **right hand of the Lord** has created strength. The **right hand of the Lord** has exalted me. I shall not die but live and tell the works of the Lord.

The **right hand** is glorified in strength. Your **right hand** destroys enemies and through the greatness of your majesty you have confounded my adversaries; you have sent your anger and consumed them.

Figure 5.4. CCCC 41, p. 272. *Dextera* mashup in Latin, followed by continuation of apocryphal homilies in Old English. The Parker Library, Corpus Christi College, Cambridge.

As through the **word of truth** from a lie, so will you, unclean spirit of weeping of the eyes (?), be through yourself in(to) the pit of fire.[33]
Depart from the hair, from the lips, from the tongue, from the neck, from the chest, from all the joints of his limbs, so that the devil may not have power over this man, N, of the hair of the head not of harming, nor touching nor rising at noon,[34] nor in seeing nor in laughing nor in flashing, and flee,
But in **the name of our lord Jesus Christ** who with the father and Holy Spirit lives and reigns god in the unity of the Holy Spirit in every age forever.] (trans. mine)

The sources for this mashup have been thoroughly discussed.[35] Two biblical passages extol *dextera*, the right hand of the Lord, uttering the word four times in a way that makes this shared element unmistakably the focus.[36] The exorcistic list of body parts is common in Irish remedies and clearly derives from that tradition (Jolly, "On the Margins" 164–65). In between there is the syntactically and semantically awkward "sic . . . sic" injunction against an unclean spirit ("as through the word of truth from a lie, so will you . . ."). Jolly's review of analogues is helpful, as it illuminates the background for this formula (164–65). It clearly derives from formulas that draw upon God's separating of the sky from the land, good from bad, truth from a lie to suggest that a demon will be separated from the body of a sufferer. Here, though, the foregrounded element is the *verbo veritatis* ("word of truth"), and the body part that happens to be specified is the eyes, whose pervasiveness in these marginalia I have suggested is meaningful in a context where the reader is challenged to look, find, and see. Dextera, the right hand of the Lord, *is* the Word of truth, who took on human flesh, itemized as the limbs and parts of the exorcism's list. The culminating invocation ("Sed in nomine domini") is a precise statement of Trinitarian doctrine that completes the rather neat circle of the formula here, recapitulating as it does the arc of the marginalia as a whole that is repeated so many times in microcosm. Christ is the right hand of God, the Wisdom through which all things were created, through which God worked his will in the old dispensation before the Incarnation. His Incarnation brought the Word into flesh, as we see in the *verbo veritatis* juncture above, followed by its list of corporal members. Ultimately, the "name of the lord" (which preserves the verbal nature of the Word) rejoins its Trinitarian fellows in

the doxology at the end. Here, at the very heart of the marginalia, we have a somewhat epic microcosm of the whole.

Around the microcosm, whose center is the Word, lie the homilies. If I may take a moment to reflect, I would introduce the vernacular homilies that surround this central microcosm in the following way. For a medieval Christian, the Incarnational mystery, as articulated in an enigmatic fashion as above, was a central fact of the universe in a way that requires effort for a modern secularist to grasp. We may think about the fact that a supermassive black hole sits at the center of the Milky Way (and other galaxies), for example, and draw out the implications of that fact for our understanding of the universe. In the medieval Christian context, the Incarnation, which partook of created time, and the way it related to the eternal nature of the Trinity were similar "facts"—givens of the world—and they required similar effort to understand. The four vernacular homilies surrounding the Dextera mashup may be seen, as I have said, to spin out from its central Incarnational proposition. They consider, respectively: the ultimate nature of human flesh, in the soul and body homily that surrounds the Dextera mashup; the nature of Mary and her body as exceptional/exemplary flesh; what one might call the ecology of eschatology, or the nature of the locales in which human fate will play out;[37] and finally the nature of Christ's resurrected, glorified body. This point in the marginalia functions as a hinge, for after this space of philosophical consideration, the texts take on something like the "applied science" of Incarnational knowledge. The focus turns to the effects of the Incarnation in the world and the human response to this presence. I will discuss the four core homilies in order.

The ways in which moral reality is manifest in the body and the body's appearance are not necessarily obvious, particularly in a dualistic framework, but in the complex ontologies of the Middle Ages the moral permeated the physical and sensual. The soul and body homily that precedes and incorporates the Dextera mashup in CCCC 41marg (254–80) has as its extended prelude the common homiletic theme of the fearsomeness of hell and the fleetingness of the world, but its climax is contrasting scenes of judgment, in which first a righteous soul and body and then a wicked are examined; the form, or *hiw*, of each manifests its moral quality, just as the *hiws* of the devil and the Pater Noster manifest spiritual qualities in the *Solomon and Saturn Pater Noster Prose* (in CCCC 422).[38] In the first examination scene, the

righteous soul bears witness in praise of its body, giving it credit for good works in life. The homilist remarks, "Hu fægere ⁊ hu mildelice heo spricð seo saul to hire lichoman" ("How fair and how mildly it speaks, the soul, to its body"; 269), upon which,

> bryt se lichama mæniefealdum bleon. ærest he bið on medmiceles mannes hiwe. Ðonne æt niehstan on ðam fægerestan mannes hiwe. Swa ætmetistan þæt he ðara wirta fægernesse lilian ⁊ rosan. ⁊ swa ðonne on forð þæt he hæfð gelic hiw golde ⁊ silfre. ⁊ swa ðam deorwyrþestan gym cynne ⁊ eorchnan stanum. ⁊ æt niehstan þæt he glitenaþ swa steorra. ⁊ lyhteð swa mona ⁊ beortað swa sunne. þonne heo beorhtast scineð. (269–70)

[the body takes on many colors/forms: first it is in the form of a regular man; then in the form of the fairest man, so much that he has the beauty of the lily and the rose. And so then it goes on that he has a form like gold and silver, and also like the most precious kind of gem and jewel stones. And then he will glitter like a star and gleam like the moon and shine like the sun when it shines brightest.] (trans. mine)

The soul and body are invited to reunite, and when they do, they take the form of the "fairest angels" ("beoð on ðæra fægerestan engla hiwe"; 270). After the soul recounts its virtues, the body shows, it would seem, its true colors, manifesting visually the value of its earlier good works. In turn, the wicked body is denounced rather than praised by its wretched soul, which seems, like its virtuous counterpart, not to have had control of the body in the manner of the driver of a car, but rather to have been stuck inside a body with its own moral agency.[39] This appears to blend a dualism of body and soul with a model in which volition is mortal. The soul is so frustrated by the body's life of sin because it, presumably, had no part in choosing that sin, belonging as it does to the spiritual realm in a spirit/flesh dyad. At the same time, however, the body itself, in possessing agency, defies such a dyad even while it cannot express its agency through speech. It is thus at once a lump of inert matter and a subject capable of virtue or vice, expressing rather precisely the paradox of flesh that also extended to "woman" in medieval authoritative traditions. Women are incapable of higher reasoning and subject to male guardianship and authority, but they are also powerful, dangerous, and devious in

their ability to seduce the male virtues into sin. Confirming the account of the hapless soul, the wicked body manifests its own panoply of forms:

ðonne stent þæt deade flæsc onswornod ⁊ ne mæg nan ⁊ wyrde sellan þam his gæste ⁊ swæt swiðe laðlicum swate ⁊ him feallað of unfægere drapan ⁊ bryt on moni hiw hwilum he bið swiðe laðlicum mengelic þonne wonnað he ⁊ doxat oðre hwile he(?) bið blac ⁊ æc hiwe hwilum coll sweart þonne sworeð he ⁊ næfð nan hiw buton hrefe sweart[40] ⁊ gelice seo saul hiwað on yfelu bleoh swa same swa se lichoma ⁊ bið gyt wyrsan hiwes ⁊ standað butu swiðe forhte ⁊ bifiende bidað domes. (276–77)

[Then that dead flesh stands confounded and may not give any answer to its spirit and sweats very loathsome sweat and gruesome drops fall from it and take on many colors. It is quite hideously particolored, then it darkens and dims, at times it is light and pale, at times coal-black, then it blurs and has no form but a black covering and likewise the soul appears in an evil form, in the same manner as the body, and yet in a worse form, and both stand very frightened and, trembling, await judgment.] (trans. mine)

It is ultimately dull formlessness that characterizes both body and soul in a state of wickedness, just as bright beauty characterizes the righteous. But the very sequence is revelatory, allowing us to perceive different aspects of sin and virtue as we contemplate their fate. This kind of revelation through sequence is related to late antique and medieval aesthetic *varietas* (Carruthers 135–64), and it is also related to paratactic variation in both Celtic and Germanic poetics. It has a mixed heritage, like other aspects of medieval culture. Enumeration becomes the dominant feature in this homily as it shifts from the Last Judgment theme to a long warning about the devil's many (many) arrows, each a different kind of sin, with which he threatens us always, bow bent in our direction.

Interestingly, a list of the different forms of the Lord similar to the one in *Solomon and Saturn I* (and one that clarifies some of that poem's opacity) attends the pageant of forms in the homily. When the righteous body and soul are reunited, they call out at once in a litany of praise:

Domine þu wære ær eallum woruldum ⁊ þu ricsast á ofer ealle worulda ⁊ þu byst á in ecnesse *Domine*. næs næfre þin fruma ne nu næfre þin ende ne gewurðeð ne ðin miht ne ateorað nænegum ðæra þe ðin bebodu healdað þu eart lyfes wyrhta ⁊ þu eart lofsang ealra haligra ⁊ þu eart hyht heofendra ⁊ þu eart ealræ worulde hælend ⁊ þu eart geswencedra manna ræst. ⁊ þu eart blindra manna leoht ⁊ dumbra spræc ⁊ deafra gehyrnes ⁊ hreofra clænsung ⁊ healtra gang ⁊ ealra bitern[] þu eart se swetusta stenc. ⁊ ealle unrote magon on þe blissian ⁊ þu eart ealra worca wyrhta ⁊ earlra wæstma fruma ⁊ ealra þystra onlihting. ⁊ ealle winsumnesse findað þa ðe þe lufiað ⁊ ealre gedrefednessa þu eart se æþelesta wylla. (270–71)

[Lord, you were before all ages and you will reign forever over every age and you will be forever in eternity Lord. There was never your beginning nor never will come your end nor will your might diminish for any of those who keep your commands. You are life's creator and you are the hymn of all the holy and you are the joy of the grieving and you are the savior of all the world and you are the overworked men's rest. And you are the blind men's light and the speech of the dumb and the hearing of the deaf and the cleansing of the soiled and the going of the lame and of [i.e., amid] all bitterness you are the sweetest smell. And all the sorrowful may rejoice in you and you are the doer of all deeds and origin of all produce and illumination of all darkness. And those who love you find every delight and of [i.e., amid] all affliction you are the noblest will.] (trans. mine)

The Lord is the supplement to every shortcoming, the answer to every question, the origin of every good. An encompassing, absolute totality is a logical implication here, and were this in the orthodox tradition, influenced more strongly by Neoplatonism, the ultimate transcendence of the godhead would be the emphasis. But in the enumerative mode, as a way of experiencing and contemplating the nature of Christ, it is not ultimate transcendence but particularity, multiplicity, and change that are the focus.[41] The Incarnation is the sensible manifestation in the world, after all, of what is otherwise invisible and beyond. Recall the forms of the Lord's metonym, the Pater Noster, which are directly counterposed to the forms of the devil in the *Solomon and Saturn Pater Noster Prose* text of CCCC 422. It is one thing to assert that Christ defeats the devil. It is another to take a reader

through thirty stages of change, iterating thirty fresh and distinct encounters with particularity, recognition, understanding. Any teacher knows that this kind of repetition is necessary for deep, integrated learning. Each time a concept is addressed in yet another way, new neural connections form. There is not a single, two-dimensional entry in the mind's database but rather a set of experiences with so many ties to the rest of the mind that it becomes integral to its larger structure. The wisdom tradition manifests these principles in ways that have baffled modern scholars expecting philosophical consistency, economy, and orthodoxy.

The Lord's capacity for shapeshifting is tied directly to the Incarnation and frames the transformations of the soul and body at judgment as well as the many forms of the devil's snares facing us, unseen as such, in the world. This first vernacular homily adjoining the mysterious articulation of the Incarnation (the Dextera mashup) connects the transformational capacity of the Lord, the idea that he takes on many forms and is many things to us at once, to other kinds of transformation important to our salvation.[42] A human being may break bad or make good, resulting in palpably different eternal outcomes whose aesthetic distinctness is meant to shock and persuade. The devil himself lies in wait not with a single strategy or appearance, but with a quiver of harms that are more terrifying and insidious because they are aspects of our own selves, manifest as the real weaponry of the battlefield and the imagined implements of folktale (clearly the arrows of the devil evoke the "elf-shot" scattered throughout the remedy corpus, for example).[43]

The other homiletic commentary surrounding the Dextera mashup similarly draws out aspects of the Incarnation, considering its ramifications for the human beings who share in the nature of Christ. The assumption of the Virgin (280–87) clarifies the nature of Christ's flesh and the remainder that is left behind in the world to proliferate even after Mary's departure. Prominent in this regard is the palmtwig that Mary receives near the Mount of Olives. This version of the *Assumptio* ties the preaching mission of the apostles to Mary's anticipation of her death and to her receiving of the palmtwig.[44]

We are told that after Christ's Ascension, he sent (literally "lifted" or "carried") the apostles throughout the world on their teaching mission, and Mary sat in a house by the Mount of Olives, the site of his Ascension:

Hwæt la hefende ure dryhten his apostolas geond ealne middangeard mancyn to læranne þa sæt Maria in hire huse be Oliuetes dune. (280)

[Lo, as our Lord was sending his apostles across all the earth to teach mankind, then sat Mary in her house by the Mount of Olives.] (trans. mine)

Christ's body, Mary, the Incarnational locale of the Mount, and the preaching of the gospel are all compressed into this sentence. On a day when Mary is weeping with longing to see Christ's face, an angel appears with a message and a gift:

Hwæt la! I have brought you this palmtwig from Paradise for you to have borne before your bier, and now, within three days, you will be departing from your body. (trans. mine)

[Hwæt la þis palmtwig of niorhxwange ic þe brohte þæt þu gedo þæt he sie boren beforan þinre bære 7 nu binnan þy þriddan dæge þu bist ferende of lichoman] (280)

The angel explains that Mary will soon see the Lord, her son, again, with all his angels, and then he departs. When he does so, the palm shines "very brightly . . . as the morning star," and Mary takes it up to the Mount of Olives to give thanks. When Mary does in fact die (after all the apostles have been whisked to her side) and her resplendent soul is taken to Paradise, John and Peter have a humble-quarrel over who will bear the palmtwig before her bier. John says Peter is more senior, but Peter repeats the ubiquitous assertion that John was the disciple with special privilege, he whom Jesus loved (reclining on his breast in the scriptural account, John 13:23). John carries the palm-twig, making resonant the homily's opening mention of Christ's having commended Mary to John while he hung on the cross, "This is your mother; this is your son" ("þis is þin modor . . . þis is þin suna"; 280). Peter, the keeper of the keys and head of the church in the world, processes at the head of the bier, and Paul, the great evangelist, at the foot. That Mary's body, remnant of Christ's body in the world, is surrounded by the representatives of Christ in the world (announcer of the Word in John, Peter the head of the church, Paul the epistolary) presents a significant tableau. Mary is symbolic of the

church, which on earth retains its tie to the Lord in heaven; he is the head and we are the body.

After the set of miracles involving the Jews struck blind after accosting the body and the palmtwig restoring their sight, Mary's body is buried in an empty tomb, as Jesus's was, and after three days Jesus comes and it rises. Unlike the bodies at the Last Judgment in the prior homily, Mary's body without her soul has the power of speech, and it praises the Lord before it ascends with him into the clouds. Her body is intimately linked to his. We hear no more of the palmtwig after Mary's burial, but it is in fact what remains on earth after her and her son's departure. The last words of this homily aver that the apostles were lifted back to where they had been preaching and teaching before, "confessing the great might of God who lives and reigns in every age forever without end" ("hi wæron secgende drihtenes word 7 ondettende godes þa micelan mihte se liofað 7 ricsað in ealra woruda [*sic*] woruld a butan ende"; 287). The palmtwig, the CCCC 41marg compilation will attest again later, is the vehicle of their teaching.

The sending out of gospel teaching across the world gestures into the "present" time of the CCCC 41 compiler. In the early eleventh century, as for the preceding several centuries, the word was being preached and people were converting. The end times were perhaps very near. The rest of the CCCC 41marg largely concerns itself with this interim period of "now" between the Ascension and the Apocalypse to come. The two final homilies in this core homiletic group concern the end times, the shape of the world to come, and the interventions the Lord will make before we enter into the eternal dispensation. The penultimate homily (287–95) concerns the landscapes of the end times and otherworldly realms, both celestial and infernal. It offers something of a tour of this terrain. In the final homily (295–301), Christ reappears as the focus, and his acts to bring about the ultimate fate of the world take up the bulk of the narrative: Harrowing of Hell followed by Last Judgment followed by the final ascent and eternal reign. The homily preserves a fascinating scene in which Mary, Michael the Archangel, and Peter each intervene to plead for one-third of the damned souls after judgment:[45]

Ðonne arist Sancta Maria 7 hio gæð forð 7 hio on nihð to ussum hælende 7 hio bideþ þæt he hire for gife þone ðriddan dæl þæs forworhtan weredes 7 he alifeð hire 7 hio gæð þonne 7 ascætð þone

þriddan dæl þara saula ⁊ geset gode on þa swiðran healfe. Þonne arist
Sanctus Michael ⁊ he gæð forð ⁊ he nihð to ussum hælende ⁊ he bid
þæt he him forgife þonne ðriddan dæl þæs forwyrhtan weredes ⁊ he
alifeð him ⁊ he gæð þonne ⁊ scætð þone þriddan dæl þæra saula geset
gode on swiðran hand. Ðonne arist Sanctus Petrus ⁊ he gæð forð ⁊ he
nihð to ussum drihtne ⁊ he bid þæt he him forgyfe þonne þriddan dæl
þæs wyrhtan weredes ⁊ he alyfeð him ⁊ he gæð þonne ⁊ ascætð þæne
þrid dæl ðara saula ⁊ ge set gode on ða swiðran healfe ⁊ nimað þonne
þa deofolo ða lafe. (300–301)

[Then St. Mary will rise up and she will go forth and she will approach
our savior and she will ask that he will give her a third portion of the
cursed host and he will grant it to her and she will go then and take up
the third part of the souls and set them on the right side of God. Then
St. Michael will arise and he will ask that he give him a third portion of
the cursed host and he will grant it to him and he will go then and take
up the third portion of the souls and set them on God's right hand.
Then St. Peter will arise and he will go forth and he will approach our
Lord and he will ask that he give him the third portion of the cursed
host and he will grant it to him and he will go then and take up the
third portion of the souls and set them at the right hand of God and
then the devils will take the remainder.] (trans. mine)

Is there any remainder? The result is either that everyone ends up
saved, or that only the remainder after three cullings of one-third is
sent to hell. If the former is doctrinally objectionable, the latter is un-
just in the extreme. The rhetorical effect, however, is to emphasize
mercy and salvation (and the "right hand"). In confirmation of this
beneficent focus, Christ turns to the blessed souls and recounts the
reason for their salvation, and it is that all their works of worldly char-
ity were in fact done to him—that is, the Incarnate Christ received the
actions they performed in the world. Just as God acts on earth
through his Incarnate right hand, so do our actions affect God:

When I was hungry then you gave me food. When I was thirsty then
you gave me drink. When I was naked then you clothed me. When I
was an exile then you took me in. When I was sick then you attended
me. (cf. Matt. 25:36; trans. mine)

[þa me hingrede þa sealde ge me mete þa me þirste ða sealde ge me
drincan . þa ic wæs nacod þa gyredi ge me . þa ic ælðiodig þa an fen-
gon ge min þa ic wæs untrum þa fondode ge min] (301)

Then the Lord rises from judgment and takes all of the blessed up to
heaven, including those

> who now here in the kingdom of earth desire that kingdom and later
> will be deserving and keep our Lord's command, and the Lord will
> live and reign with the father and the son and the holy ghost forever,
> world without end. (trans. mine)
>
> _____
>
> [ðe nu her on middangearde þæs rices girna ond æft earniað ond ure
> *dominis* bebodu healdað ond se drihten lifað ond ricsaþ mid feder ond
> mid suna ond mid þam halgan gaste a worulda a woruld aa butan
> ænegum ende] (301)

The concern of this homily and of the entire group of homilies it
closes is the relationship of humanity to the Incarnational arc of the
Lord. Our actions in the world are ultimately actions wrought upon
the Lord's very body, and when that body makes its final ascent to the
heavens, so may we. The focus of the marginalia of CCCC 41 from
this point on, having established the nature of the Incarnation and its
relation to human beings, will be on humanity, on the presence and
working of the Incarnate Lord in human life, on the human body, on
human governance in the world.

CHARMS FOR THE BODY

After a twenty-five-page hiatus, the marginalia resume with an as-
sertion of the human side of the Incarnation. Page 326 contains three
Latin remedies, with Old English rubrics, for eyes, ears, and a "great
sickness," respectively. The remedy for the eyes is the longest, and it
stresses metonymy and multiplicity of forms. It relates the eyes of the
sufferer to the eyes of the blind brother of Tobias in the Book of
Tobit. This asserts a quasitypological likeness between the scriptures
and the real world. It affirms the very act of relating or associating:
"heal the eyes of this person, N (*Nomen/Nama*, "Name here?"), as

you healed the eyes of the brother of Tobias." The remedy calls the divine by a list of epithets that affirm Christ's multiform potential and also invoke the similar lists of epithets appearing earlier in the compilation, in *Solomon and Saturn I* and in the homilies considered above:

> hand (mead?) of the parched, foot of the lame, health of the sick, resurrection of the dead, happiness of martyrs and all saints.

> _____

> [manus(?) aridorum pes claudorum sanitas egrorum resurrectio mortuorum felicitas martirum & omnium sanctorum.][46]

Thus the formula links the human sufferer both to scripture and to the many forms of Christ. With its companion formulas for ears and general sickness, it serves to re-ground the Incarnate Christ in the physical form of the human body.

The refocusing of the marginalia's Incarnationalism upon the human body above may be seen as something of a setup for what follows (after a three-page break), which ramifies from the Incarnational body, tying together the basic worldly act of almsgiving, the role of the Word in creation and its link to physical procreation, and the mysterious verbal-cum-material nature of the Word. It is a mashup tour de force. Or, of course, it could be a sequence of randomly selected, unrelated items recorded in the margin of page 329. Alternatively, it could be a sequence of apotropaic items that happen to share glancing relation to Christ, since in Christianity most invocations involve him. As everywhere in this chapter, I am pursuing a strong reading of the evidence, with, I believe, strong support for doing so in the structure and themes of the compilation. On page 329, a Latin blessing for a donation of alms is conjoined to a Latin prayer for a painless childbirth, with the common but enigmatic SATOR palindrome, associating the Pater Noster, the cross, and Christ, between them (see fig. 5.5). The text begins flush with the top line of the main text and takes up roughly two-thirds of the outer margin. Each of the three components of the mashup begins on a new line with no blank lines between:

> Creator & sanctificator pater & filius & spiritus sanctus qui es uera
> trinitas & unitas precamur te domine clementissime pater ut elemosina

Figure 5.5. CCCC 41, p. 329. Mashup: Latin blessing of alms, SATOR palindrome, Latin childbirth formula. The Parker Library, Corpus Christi College, Cambridge.

ista fiat misericordia tua ut accepta sit tibi pro anime/a famuli tui ut sit
benedictio tua super omnia dona ista. per.
+sator. arepo. tenet. opera. rotas.
Deus qui ab initio fecisti hominem & dedisti ei in adiutorium simili-
tute sibi. ut crescere. & multiplicare. da sup terram huic famulae tuae.
N. ut prospere & sine dolore parturit—

[Creator and sanctifier, father and son and holy spirit, who is true
trinity and unity, we pray you Lord, most merciful father, that this
almsgiving may be your mercy, that it may be acceptable to you for
the soul of your servant, that your blessing may be over all these gifts.
In . . .
+ *sator arepo tenet opera rotas*
God, who from the beginning made man and gave him a helpmeet
like himself that they should grow and multiply, grant over the earth
to this your servant, N, that [she] may succeed and give birth without
pain.] (trans. mine)

It is clear to me that the three parts are, to the scribe, three distinct
parts, since he or she begins each component on a new line. However,
he or she also chooses to record them as one block, even though great
amounts of blank space were available had there been a desire to dis-
play them separately. Jolly is dismissive of Storms's suggestion that
the two Latin texts are linked by the theme of "creation," perhaps
since Storms was prone to Frazerian fancies of fertility cults and
primitive paganism that are no longer acceptable in serious scholar-
ship ("On the Margins" 170). However, in light of the marginalia more
broadly, this mashup may be seen to do several very interesting and
integrated things. It does in fact invoke the function of creator at the
outset and situate this role within the Trinity, as we have seen many
times thus far. The second Latin text takes up the theme of creation
and specifically the creation of man and woman, not only valorizing
human procreation but also tying it to the Word's creation of the
world. The creator of the world deigned to become a part of that
world: the Word became flesh.

It is hard to see it as insignificant that these two ideas (creation and
procreation) should be joined by the enigma of the SATOR palin-
drome, which is a complex signifier-puzzle that embodies the nexus of

the Word, the Pater Noster, the cross, creation, and transformation.[47] The five quasi-Latin words of the palindrome, first, contain all the letters of *PATER NOSTER* twice over, with a shared *N* plus two *A*'s and two *O*'s, allowing the formation, for example, of the following cruciform diagram:

```
        P
        A
  A     T     O
        E
        R
P A T E R N O S T E R
        O
        S
  A     T     O
        E
        R
```

Here, *PATERNOSTER* forms a cross, and the letters *alpha* and *omega* adorn its quadrants. The Pater Noster, the cross, and the cosmological alpha and omega form a single structure, signifying their shared referent in Christ. Christ suffered on the cross, which thereafter stands for him and points and conveys sinners to him; the Pater Noster prayer comprises the words of Christ, which we are to direct back to him; Christ as the Alpha and the Omega is both the creative right hand of God and the end of all creation. It may be significant, too, that the crux of the Pater Noster cross is the shared *N*. After all, the Pater Noster and its letters are not themselves the prayer, but a metonymic name/*nomen* for the prayer. The *N* at the crux of the cross formed by *Pater Noster* may point, therefore, to *Nomen Dei*, and further, this may enlist the otherwise conventional *N* placeholders (for *Nama/Nomen*) found in many of the formulas prior to this point in the manuscript. As the formula for theft on 206 telegraphs *P . . . Nomine Dei, Ch* in a way that I read as signifying the referential chain that ends in Christ, so may this *N* link up with the many variable or placeholder *N*'s, providing a culminating signifier. All those previous *N*'s were not simply "name" but point the way to the Name, the

name of God, of Christ, Logos, the Word that begins and ends creation itself. This ultimate Name itself forms the crux of this extremely polyvalent sign (the whole SATOR structure).

The SATOR formula forms other structures, as well, for instance an acrostic square:

SATOR
AREPO
TENET
OPERA
ROTAS

No matter which direction you read—left to right from the top, top to bottom from the left, bottom to top from the right, right to left from the bottom—the words read exactly the same, suggesting a special quality of Christ the Word, his ability to remain himself even through transformation and transposition. In this structure, too, the cross holds (literally, the word *tenet*, "he/it holds") a central position, with *N* as the crux. From late antiquity through the medieval period, the SATOR formula presented a potent embodiment of Incarnational mystery, a kind of mandala by which the nature of the Word could be both articulated and explored, using modes other than referential, expository language. Here, in the context of a mashup of two Latin texts, one must not underestimate the interpretive possibilities for SATOR AREPO TENET OPERA ROTAS, a Christological, Incarnational formula of some subtlety and wide popularity. Surely Jolly is correct that the formula functions apotropaically, that it pragmatically signifies "protection" ("On the Margins" 170). However, it may have another valence, a signifying function within its mashup, as well. The Latin prayer invoking the Word as creator is yoked to a Latin prayer invoking the creation of humanity and the procreative process. The yoke, as it were, the juncture in the middle, is a string of words encapsulating the Incarnation. This is how the Incarnation makes itself known in the world; this is how we come to see it. It has to do with the body and bodies, with works in the world. At its heart, though, is the Word, the words that form a cross, that are the beginning and the end of creation, that have at their center the very name of God.

The knowledge of the Incarnation in the world, the revelation of its nature that has taken such readerly effort to perceive, is knowledge with power in the world. The marginalia henceforth focus on the means by which first individuals and then collectivities gird themselves with this Incarnational learning. Pages 350 to 353 contain a metrical text in Old English that straddles the line between prayer and charm.[48] Storms characterized it as a "journey charm," following the ASPR edition, though printed within the same decade, and Jolly emphasizes the text's protective theme and its harmony with Christian allegory (against previous findings of pagan residue). As with other texts in CCCC 41marg, however, the Old English charm prayer resonates within its manuscript environment. It has a ring structure involving lexical repetition, beginning with the repetition of *gyrd* (belt or girdle, recalling the girdle of St. Patrick in the *Hymn of Secundinus*, on 208) and ending with multiple repetitions of *blæd* ("blade," of a leaf or an oar). The girdle is at the outset a kind of general "girdle of the Lord" that the speaker puts around himself and that by the end, I will argue, is revealed to be the palmtwig itself, polyvalent sign tantamount to the Word. The text breaks into three sections, and the first section into three "movements," as below:[49]

(Mvt. 1:) I secure myself in this girdle and in God's keeping pray:
 against the sore sickness
 against the sore stroke
 against the grim terror
 against the great fear that is evil to all
 and against all the evil that comes into the land.
(Mvt. 2:) A victory song I sing
 a victory belt I bear,
 victory of word and deed.
(Mvt. 3:) May it profit me, not hinder me tomorrow,
 nor my stomach ache
 nor ever make me fear for my life
 but save me, Almighty and Son, Beneficent Spirit,
 lord worthy of all glory.

 [Ic me on þisse gyrde beluce ⁊ on godes helde bebeode:
 wið þane sara sice
 wið þone sara slege

> wið þone grymma gryre
> wið ðone micela egsa þe bið eghwam lað
> ⁊ wið eal þæt lað þe into land fare
> syge gealdor ic begale
> sige gyrd ic me wege,
> word sige ⁊ worc sige
> se me dege, ne me merne gemyrre
> ne me maga ne geswence
> ne me næfre minum feore forht ne gewurþe
> ac gehæle me ælmihtigi ⁊ sunu frofre gast
> ealles wuldres wyrdig dryhten]

In these three opening movements, the girdle is first announced and given protective qualities ("I secure myself . . . against . . . against . . . against all evil"). Then it appears at the center of a little three-phrase unit invoking "victory" (*sige*):

(Mvt. 2) syge gealdor ic begale [A victory song I sing,
 sige *gyrd* ic me wege, a victory *belt* I bear,
 word sige ⁊ worc sige word-victory and work-victory]

Sige appears in every phrase, four times in all, uniting the present "song" and the girdle of holy protection, culminating in the final merism.[50] The victory song and the victory belt are, respectively, "word-victory" and "work-victory." The girdle is thus associated with effective force in the world, with "work." The third and final movement of this opening section appeals to the Trinity as the ultimate source of the desired protection ("ac gehæle me ælmihtigi ⁊ sunu frofre gast").

After the first three movements, a middle section of the text turns from the *gyrd* object to scriptural learning as its source of protection. Figures from first the Old Testament and then the New ("I have heard of Abraham and Isaac and such men; Moses and Jacob . . . and also Mary the mother of Christ and also the brothers Peter and Paul") are called to the aid of the speaker "against all enemies." Then, becoming more specific, the four gospel writers are singled out and invoked as helm (Matthew), byrnie (Mark), sword (Luke), and shield (John), which are together "eall engla blæd, eadiges lare" (*blæd* of all angels, learning of the blessed). The third and final section appears to turn the

ambiguous term *blæd* into an image of the *navis crucis*, the ship of the cross that ferries us to salvation.[51] I will discuss the word in much more detail below, but the crux of its ambiguity is that its senses include a kind of visible *numen*; a flowering plant; "victory"; and "oar"; among other connotations. *Blæd* is a polyvalent sign like the palmtwig.

> I now beseech:
> victorious mercy of God, a good vessel,
> mild and calm wind on/from/to the shore,
> winds to traverse the roaring water,
> ever salutary against all enemies;
> may I find a friend against that,
> may I remain in the protection of the almighty,
> secure against the evil ones. Let my life's worth
> be established in the *breath-gust (i.e., spirit)* of the angels
> and in the *whole/sound hand*, the fruit of the kingdom of heaven
> for as long as I must remain in this life, amen.

> [bidde ic nu
> sigere godes miltse sið fæt godne
> smylte ⁊ lihte wind were þum
> windas ge fra/on circinde wæter
> simbli gehaleþe wið eallum feondum
> freond ic gemete wið þæt
> ic on þis ælmihgian on his frið wunian mote
> belocun wið þa laþan, se me lyfes eht
> on engla bla *blæd* gestaþelod
> ⁊ inna halre hand hofna rices *blæd*
> þa hwile þe ic on þis life wunian mote amen]
> (352–53)

The appearance of the term *blæd* three times in such close proximity, including twice right at the end, makes it clear that the word is important to the meaning of this final section of the poetic prayer. I left the first instance of the word ("*blæd* of all angels, learning of the blessed") untranslated above because its sense becomes most clear in light of its contrast with the other instances as well as a consideration of the term more broadly across the corpus. Here in this third section, the poet is

enlisting multiple senses of this ambiguous word. Its core meaning is "leaf, leaf-blade, flower," as is clear both from its Indo-European root and its usage from prose texts to glosses.[52] This core meaning has a metaphorical extension in poetry (not unlike that of *fruit* in Modern English), to something like "success, prosperity." This, for instance, is the sense of the word in *Beowulf* ("Beowulf wæs breme blæd wide sprong"; line 16). In this poetic sense, the word is often paired with some form of *beorht* (bright), often indicating a divine or quasi-divine, heroic level of flourishing.

The metonymic extension of *beorht blæd* may be illustrated best by its appearance in *Azarias*, where it seems to indicate solely the appearance of a divine nature or origin. When the king describes the angel that he sees walking around in the fiery furnace unharmed with the three youths, he says, "hafað beorhtne blæd" ("[he] has a bright *blæd*"; line 178), rendering the Vulgate Latin "species quarti similis filio Dei" ("the appearance of the fourth is like a son of God"; Dan. 3:92). Here the phrase does not denote a success or prosperity—it is not deriving a sense of "prosperity" from a sense of "flowering." Rather, it appears to be deriving a sense of "heroic or divine status" from the conventional poetic use of the phrase *beorht blæd*. However, it is also possible that in addition to this indexing of the tradition, the poem is also reliteralizing it, making it doubly resonant here. One might see the king waxing poetic, remarking upon a visage so striking it is a *blæd*, a flower. The Latin phrase *filio Dei* further suggests Christ and a reading in which the bright blade evokes a version of the palm-twig.[53]

Given this range of senses, the first appearance of *blæd* in the CCCC 41marg prayer is thoroughly ambiguous. "*Blæd* of the angels, learning of the blessed" might be rendered "flower," "produce," "harvest," "success," "divine appearance," or even "spirit." This list is made even longer, however, by the very specific sense invoked by the nautical imagery that immediately follows in the *navis crucis* passage. For *blæd* was also enlisted in yet another sense, to render "oar-blade," under the influence, I suspect, of Latin *palmula*, "oar-blade," which is related to *palma*. (Old English also possessed a designated word for "oar," *ar*, and *arblæd* is attested in the glosses.) Thus, retroactively, the *engla blæd* comes to signify an oar-blade, and the human spirit is imagined sailing upon the sea in search of the safe harbor of the

heavenly kingdom. Then we reach the final two instances of *blæd*, which I reproduce from above:

> se me lyfes eht
> on engla bla *blæd* gestaþelod
> ꝛ inna halre hand hofna rices *blæd*

> ─────────

> [Let my life's worth
> be established in the *breath-gust (i.e., spirit)* of the angels
> and in the whole/sound hand, the *fruit* of the kingdom of heaven]

The word *bla* in the manuscript is otherwise unattested, and this is a particular crux. However, I argue that this is a compound, *bla-blæd*, by which the poet is specifying a meaning for the ambiguous *blæd*. *Bla-* may be derived from *blawan* ("blow") and carry the meaning of that verb to the compound. This is not a *leaf-blæd* or an *ar-blæd*, but a *bla-blæd*, the "blowing" sense of *blæd*. Thus, while the earlier instance turned out to denote an oar-blade, this one denotes the spirit. The third instance cleverly invokes the "leaf" or "fruit" (and perhaps the "victory," "success," and "divine appearance") sense of *blæd*, as it funnels its interpretation through the phrase *halre hand*, the "whole," perhaps salvific hand, to which it is appositive. This enables the cross-linguistic triangulation from *hand* and *blæd* to Latin *palma* and, behind it, not only *palmtwig* but *dextera*. The palmtwig, which is in fact the right hand of the Lord, is the hidden referent here, concealed but revealed. A comparable depiction is found in the Leofric Missal (9th–11th c.), where the "right hand of the Lord gleams with the flowers [here, the dates] of Easter" ("dextera nam domini fulget cum floribus paschae"), illustrating the double sense of *palma* (see fig. 5.6). This passage in CCCC 41 plays with the various senses of the word *blæd* to force the reader to engage with polysemy, even across languages. More broadly in the poetic prayer as a whole, the dilation whereby one term has multiple senses, or terms give way to other terms, embodies an ethos of transformation that is radically Incarnational. The learning of the gospel is the belt with which we gird ourselves for protection as well as both the palm-blade of victory and the oar-blade of the *navis crucis*. In this way we see (imagining ourselves the target readers for the compilation) that the Word is many

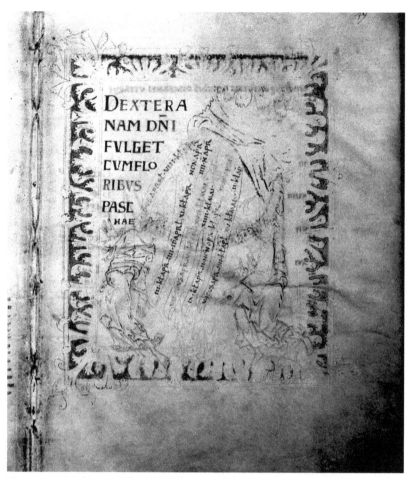

Figure 5.6. Leofric Missal, MS Bodley 579, fol. 49r. "Dextera nam domini fulget cum floribus paschae"—the right hand of the lord "gleaming with the flowers of Easter." The Bodleian Libraries, University of Oxford.

things to us, surrounding our bodies, enlightening our minds, conveying us to heaven.

MASSES FOR ALL

Thus far the focus has been upon the individual, whose body needs healing and whose person needs the enlightenment of the Word. Pages 370 to 373 broaden the scope to consider how the collective may engage with the Word. These pages contain mass prayers for first

one apostle, then multiple apostles; one martyr, then multiple martyrs; one confessor, then multiple confessors; followed by the Virgin, followed by the king. If we may read these texts' placement here, it may be that they represent the political and institutional means by which we "gird" ourselves with the power of intercessors. Each mass would also involve the Eucharistic rite, along with the calling down of the Word through holy words. However, these masses also concern the figures (apostles, martyrs, the king) with the worldly influence to carry out the divine will in the here and now. Apostles, martyrs, and confessors did this in their exemplary lives. The Virgin brought the divine into the world and herself exemplifies the capacity of the flesh of the world to be made clean. Her special role as intercessor continued throughout the medieval period. The responsibility of the king is to rule according to divine principles. These masses thus concern the practical, sensible (versus abstract, spiritual, intellectual) means by which the faithful act as agents of the Word in their communities. They stress the intercessory power of the celebrated figures, and the bridging of the corporeal and the spiritual. The mass for a single apostle ends, "Having taken/perceived the sacraments, Lord, we pray humbly that through the intercession of that one, your blessed apostle, the observances we make in solemnity may bring us healing." ("Perceptis domine sacramentis suppliciter exoramus . ut intercedente beato illo apostolo tuo ueneranda gerimus solemnitate nobis proficiant ad medellam"; 370; trans. mine). The *perception* of the sacraments ("perceptis . . . sacramentis") is here linked to the apostle's intercession. The mass for the king prays for his health in spirit and body (*anime corporisque*) and emphasizes his transit to the divine realm: "from this course to the eternal may he arrive at his inheritance" ("de cursum ad aeternam perveniat hereditatem"; 373; trans. mine). The mass for martyrs evokes contact with Christ himself as it invokes the intercession of the saints (in a formulation that anticipates later sensualist-spiritualist treatments of the Incarnation): "Grant us, we ask, Lord, through the intercession of these your saints, that when we touch with our mouth, we grasp with a pure mind" ("presta nobis domine quaesimus intercedentibus sanctis tuis illis . utque ore contingimus pura mente capiamus"; 371; trans. mine).[54] One remembers here the practice of kissing images or reliquaries in addition to the ingestion of the Eucharist, a sacramental apperception that has to do with touching the divine.

MICHAEL THE ARCHANGEL

Pages 402 to 417 contain an Irish-influenced hymn or homily on St. Michael the Archangel that has challenged interpretation, but in fact it continues the theme of intercession, praising Michael as God's agent throughout biblical history and joining that history, through the figure of Michael, to the "present" place and time. I say "hymn or homily" because the text is a kind of hybrid.[55] It begins homiletically:

> Men ða leofestan us is to worðianne ⁊ to mærsianne seo gemind þæs halgan heah engles Sanctae Michaeles se wæs wundorlic ærendraca ðæs ælmihtigan dryhtenes . . . (402)
>
> _____
>
> [Beloved men, let us honor and proclaim the remembrance of the holy archangel St. Michael. He was the splendid messenger of the almighty Lord.] (trans. mine)

This is a standard homiletic opening, and the identification of Michael as the *ærendraca* of the Lord fits his appearance throughout the text. However, what begins as homily slides into liturgy, as "This is the holy Archangel, St. Michael, who . . ." structures the bulk of the text before a homiletic close. Michael is given credit for acting as God's emissary in Old Testament history, that is, before the coming of the Lord. According to this text, it was Michael who took Abel's soul to heaven after he had been murdered by Cain. Michael warned Noah of the impending flood. Michael aided the patriarchs in the lands of the Gentiles. Michael slew Egypt's firstborn. Michael guided God's people in the wilderness. Michael guided the builders of Solomon's temple. Michael protected the three youths in the fiery furnace. Crucially, the text does not credit the archangel with any New Testament action whatsoever. Rather, the list skips ahead to Michael's role, which we saw in the Old English *Transitus Mariae* homily (pages 280–88 of the manuscript), in receiving Mary's soul and escorting it to heaven. Then he is credited with a litany of eschatological roles and attributes: leader of the righteous into the gates of heaven, intercessor with God, warden of the heavenly city, gatherer of the Lord's harvest, the shepherd of the Lord's flock, sower of Christ's fields and the separator of wheat from chaff, implementer of judgment, shining star in heaven, captain who ferries souls to the heavenly shore, scourge of nonbelievers,

slayer of the dragon-fiend Lucifer, waker of the dead at the Lord's be-
hest. Finally, Michael is credited with attributes as emissary in the here
and now (leaving New Testament history, or Christ's time on earth,
as the sole era in which he did not play this role). Michael cheers those
in mourning, heals the sick, succors the needy, helps the struggling,
inspires students, and enlightens teachers. Thus, the "homilymn" for
St. Michael affirms the archangel's role as emissary in the world, the
agent of God in the absence of Christ's physical body, another kind of
stand-in. He is the angelic complement to the Incarnation.

With the close of this text the marginalia have completed a course
from anticipating the Incarnation to considering its mysterious nature
to contemplating its manifestations in the present world within a
timeline governed by salvation history. As the marginalia began with
a synopsis of the whole, so will they close, with liturgical responses
recapitulating first the Incarnational revelation and then its present
implications before ending upon the Incarnational endgame, Christ's
Passion and Resurrection.

LITURGY AGAIN

The first set of responses, on pages 475 to 477, draws upon disparate
biblical texts to recapitulate the drama of the Incarnation.[56] The in-
cipits begin with Job and invoke the transitory nature of the flesh, its
status as dust and wind, before ringing upon themes central to CCCC
41marg: "My face will not be hid from thee" (Job 13:20); "Thou shalt
call me, and I will answer thee: to the work of thy hands thou shalt
reach out thy right hand" (*dexteram*; Job 14:15); "Who can discover
the face of his garment? Or who can go into the midst of his mouth?"
(Job 41:4); "Hast thou eyes of flesh, or shalt thou see as man seeth?"
(Job 10:4). Responses from Tobit depict the despairing, blind Tobias
who recognizes his returning son, and the angel Raphael who must
return "to him who sent me"—thus offering a typological tableau of
Christ's coming and his return to heaven. Text from Judith invokes
the power of God and the sinfulness of a people, glorifying the name
of the creator-lord. Verses from Maccabees invoke the creator and
the builder of the temple. Genesis 32:30 proclaims, "I have seen the
Lord face to face." Baruch offers a command to "open thy eyes and
behold," and responses about Martin invoke signs, the Alpha and

Omega, eyes (several times), and the sacraments. These liturgical responses highlight the need for Christ's presence, his status as sign, creator, and "right hand," and the importance of the eyes in perceiving him. The very themes that appear so cryptically at the heart of the compilation reassert themselves here at the end.

Pages 482 to 483 contain responses and mass prayers concerning the human response to the Incarnation in the world. Responses invoke John the Baptist's recognition, in utero, of Christ in utero, followed by encomia to John the Evangelist, Peter, and Paul—emissaries with archetypal evangelizing and pastoral missions. Page 483 contains a mass for the king and bishop and all Christians that focuses on the twin needs of prayer for and protection against the pagans. Here, again, the biblical setting precedes the present day. The biblical evangelists spread the word across the earth, and in the "present" of the manuscript, Christians must continue that mission even while they seek to preserve themselves against the very objects of their outreach. This was a real scenario, as a condition of several armistices with Viking leaders, for example, was their conversion to the faith.[57]

A PASSION/ASCENSION HOMILY:
WORD, FLESH, IMAGE

The final text of the marginalia of CCCC 41 is, deeply fittingly, not only composed of words but involves two modes of representation at once. Pages 484 to 488 contain a Passion homily in Old English that ends with the Resurrection and Ascension, recounting the completion of the Incarnational journey.[58] The text is written after the end of the main, Bedan text, using as much of the final page as possible (with virtually no marginal space left over—it effectively takes over the manuscript here at the end). As Grant's edition shows, the homily is a conflation of all four gospels, another kind of mashup that directly pertains to the Incarnation, collating the disparate words of the gospel word into one text. Further, on pages 484 and 485 the text is written partly around and partly over and through two incomplete drawings, one on each page (see figs. 5.7 and 5.8). All commentators agree that the figure on 484 is a partial rendering of the crucified Christ.[59] He bears a halo and is leaning to one side with one arm outstretched upon what appears to be the outline of the crossbeam. The second image, on 485, has been variously interpreted; an angel is the most frequent sug-

Figure 5.7. CCCC 41, p. 484. Colophon ending main text, followed by Passion homily, with embedded image. The Parker Library, Corpus Christi College, Cambridge.

Figure 5.8. CCCC 41, p. 485. Passion homily with embedded image. The Parker Library, Corpus Christi College, Cambridge.

gestion.[60] The figure is standing upon a cloud with billowy hair similar to that in the Christological image atop the St. John portrait page in the Book of Kells (fol. 291v). His arms are cocked at the elbows in a "W" posture, hands raised. I think it is likely, given everything that has come before, that this second figure is also Christ—Christ glorified.

As I have attempted to demonstrate, the ethos and mode of the wisdom tradition is that one goes about revealing the enigma of the Word that was made flesh through elaborate and multifarious modes of concealment, since these best approximate its nature. Previous chapters have treated the other attributes of the Incarnation important to the Insular paradigm: the doubleness of the hypostatic union, its perceptibility and iterability, its verbal nature, its topography. Here at the end of the marginal scheme of CCCC 41—if it is a scheme as I have suggested—two visual images blend inextricably with the text. They were clearly drawn in before the text was written, since the writing in places "jumps over" the image to leave it unmarred. The writing also, however, sometimes goes right through the image, melding Christ's flesh with the writing surface of the vellum page. And the images are partial, suggesting that the text completes them. Physical book, writing, and image all merge in such a moment. Christ's ascended body, in the clouds, has the same nature, though the image is smaller, perhaps to suggest that it is less apparent to us, less accessible, as it recedes. The writing goes through this body, too—through the head, arm, belly, and knee of the figure. His feet, buoyed by clouds, are even with a perfect mandorla-shaped tear in the manuscript page. Read as part of the mise-en-page, that hole appears as essential to the nature of the Incarnation as the positive substance of Christ's flesh, just as the empty footprints on the Mount of Olives are potent signs of his absent presence and present absence. Mary's womb was, again, the portal through which the Word entered the world, and the piercing of his flesh at the Crucifixion was the portal through which he left. Again and again in medieval representation, these two openings are conflated, asserted to be the same. But he returned and in Christian eschatology will return again. The mandorla becomes a sign that the door between this world and heaven remains open through the very flesh of the Word. The imprint of the mandorla opening is quite clear on the last two pages of the manuscript, marking a presence with its absence (see figs. 5.9 and 5.10). On the page where readers are assured of the resurrection of the body, a kind of seal made by Christ's body, which is a sign of his

Figure 5.9. CCCC 41, p. 487. The Parker Library, Corpus Christi College, Cambridge.

Figure 5.10. CCCC 41, p. 488. The Parker Library, Corpus Christi College, Cambridge.

presence and his absence as well as an echo of the patristic notion of the God's image as an "impress" in humanity, verifies that promise.

APPENDIX 1

Contents of CCCC 41marg

Reprinted with the kind permission of Karen Louise Jolly from Jolly, "On the Margins," 174–79.

The following chart maps the use of margins in CCCC 41. The six columns use the following abbreviations:

Column 1, Type, classifies the material
 B = Blank (unused) margins
 margins that have been cut off are indicated in Column 5, Text
 L = Liturgical material
 S = Sanctorale
 T = Temporale
 V = Votive Masses, as well as sundry other blessings and
 prayers
 F = Formulas, including possible formulas (F?)
 H = Homilies
Column 2, Pg, indicates page numbers in CCCC 41
Column 3, Mar, indicates which margins are used
 low = lower
 up = upper
 out = outer
Column 4, Lang, indicates language of the text and headings
 Lat = Latin
 OE = Old English
 head = heading or title
Column 5, Text, gives the name of the text as identified in the MSS or other sources
Column 6, Correlations, lists sources and variants traced thus far, with references to secondary sources:
 ASMMF = R. J. S. Grant, "Cambridge, Corpus Christi College, MS 41," *ASMMF*, vol. 11, ed. T. Graham, R. J. S. Grant, P. J. Lucas, and E. M. Treharne (Tempe, AZ: ACMRS, 2003), 1–27.

Grant = *Cambridge, Corpus Christi College 41: The Loricas and the Missal*, ed. R. J. S. Grant (Amsterdam: Costerus, 1978).

Hohler = C. Hohler, review of R. Grant, *Cambridge, Corpus Christi College 41: The Loricas and the Missal* (Amsterdam: Costerus, 1978), in *MÆ* 49 (1980), 275–78.

Keefer = S. Larratt Keefer, "Margin as Archive: The Liturgical Marginalia of a Manuscript of the Old English Bede," *Traditio* 51 (1996), 147–77. Referred to by section numbers in the article (I–V).

James = M. R. James, *A Descriptive Catalogue of the Manuscripts in the Library of Corpus Christi College, Cambridge* (Cambridge: CUP, 1912) I, item 41.

Johnson = R. F. Johnson, "Archangel in the Margins: St Michael in the Homilies of Cambridge, Corpus Christi College 41," *Traditio* 53 (1998), 63–91.

Storms = G. Storms, *Anglo-Saxon Magic* (The Hague: Nijhoff, repr. 1975).

1	*2*	*3*	*4*	*5*	*6*
Type	*Pg*	*Mar*	*Lang*	*Text*	*Correlations*
LS	2–7	low	Lat; OE head p. 2	Candlemas prayers: Feast of the Purification of the Virgin Mary, Feb. 2	Keefer I: comp. to 11 10th–11th c. massbooks, pontifical-benedictionals, incl. *Jumièges*, *Leofric*, CCCC 422 (Grant)
LT	8–9 10–17	up/out up; low	Lat.	Masses: Sexagesima to Quadragesima and their Feria	Keefer II, IV, V: 10th–11th c. massbooks, incl. *Jumièges* & *Leofric*; CCCC 422 (Grant)
LT	10–11	low	Lat.	Ash Wednesday benedictions: 2 prayers for blessing ashes	Keefer III: pontificals & benedictionals, incl. *Jumièges* & *Leofric*; CCCC 422 (Grant)
LTS	18–36	up, out; low	Lat.OE head p. 21	Masses: Sundays and Feria to Good Friday; Natale Sancti Gregorii Papae March 4 (18–19); p. 21 repetition of Feria II from p. 20; music not. p. 19.	Grant: *Jumièges* & *Leofric*; CCCC 422

1	2	3	4	5	6
Type	Pg	Mar	Lang	Text	Correlations
B	37				
LT	38–39	up	Lat.	Passion Sunday proper prayers	Grant: *Jumièges* & *Leofric*
B	40–44				
LV	45	up, out	Lat.	Mass for St Benedict March 21	Grant: *Jumièges* & *Leofric* Hohler: Tours source
LT	46–47	up, out; low	Lat.	Office for Easter Eve; breaks off abruptly	Grant: *Jumièges* & *Leofric*
B	48–59				
LS	60	up, out; low	Lat.	Feasts of Sts Philip and James; Invention of the Cross. Ends with May.	Grant: *Jumièges* & *Leofric*
LT S	61–71	up out (65)	Lat.	Advent Antiphons & Responsories to Christmas Eve	not in *Jumièges* & *Leofric*; ASMMF #61.a–t
B	72–73				
LT	74	up	Lat.	Saturday Christmas mass prayers	Grant: *Jumièges* & *Leofric*
LT	75	up, out	Lat.	Antiphons for Christmas octave	not in *Jumièges* & *Leofric*
B	76–121				
L/ H?S	122–32	out, low	OE	Martyrology selections for Dec. 25–31, ending abruptly p. 132 outer/27	not found in other surviving OE martyrologies ASMMF #65.a–f
B	133				
LT	134–39	up, out	Lat.	Latin musical incipits and proper prayers for Advent office material	Grant: *Jumièges* & *Leofric*
B	140–57				
LV	158	up, out	Lat.	*missa quam sacerdos pro se debet*; ends with Preface.	Grant: *Jumièges* & *Leofric*
B	159–81				
LV	182	out/1–32	Lat.	untitled collect and secret from *alia* for a *missa pro uiuis et defunctis*	Grant: *Jumièges* & *Leofric*; *Fulda* (Keefer)?; comp. CCCC 422; Hohler: St Gall Sacramentary Triplex

1	*2*	*3*	*4*	*5*		*6*
Type	Pg	Mar	Lang	Text		Correlations
F		33–51	OE	*wið ymbe* bee formula.		many variants, incl. 9th c. Latin Codex S. Gall 190; 10th c. OHG Lorscher Bienensegen
B	183–91					
LSV	192–94	up, out, low	Lat.	Offices, November Kalendar, All Saints		Grant: *Jumièges* & *Leofric*; CCCC 422
B	195					
F?	196–98	up, out, low	OE	*Solomon and Saturn,* untitled; ends abruptly.		CCCC 422
B	199–205					
F	206–08	low	OE Lat.	A. 206/1–9: theft remedy, *Ne forstolen ne forholen nanuht þæs ðe ic age.* B.206/10–15: theft remedy, *Ðis man sceal cweðan ðonne his ceapa hwilcne man forstolenne.*C. 206/ 16 . . . 208/4: theft remedy, *Gif feoh sy undernumen* D. 207/1–8: Lat *Hymnus S. Secundini in Laudem S. Patricii.* E. 208/4–5: OE remedy *Wið eahwaeroce.*		A–C many variants B *Lacnunga* CXLIX D *Irish Liber Hymnorum*
B	209–23					
LV	224–25	out, low	Lat.	untitled set of proper prayers from *Missa de Sancta Cruce,* including *ad populum* for Invention of the Cross, 3 May		Grant: *Jumièges* & *Leofric*; CCCC 422
B	226–53					
H	254–80	out, up	OE	Last Judgment homily, penitential with body-soul dialogue		Vercelli Homily 4; CCCC 201 Part
F	272	out/ 1–35	Lat OE head	*wið ealra feoda grimnessum* Ps.117/118, 16–17; Ex. 15, 6–7		Roman Psalter 10th c. Vienna 685; *Pontifical of Passau Lacnunga LXIII; Leechbook III*:lxii.4;

1	2	3	4	5	6
Type	Pg	Mar	Lang	Text	Correlations
				Orationes contra Daemoniacum exorcism of body parts: Orationes super energumino baptizato	Leofric; Durham Ritual; Stowe Missal; Irish Liber Hymnorum; Antiphonary of Bangor
H	280–87	up, out	OE	Assumption homily St Michael	Transitus Mariæ; Gospel of Pseudo-Melito
H	287–95	low, out	OE Lat. head	Doomsday homily St Michael	Apocalypse of Thomas; Vercelli Hom. 15, Blickling 7, CCCC 162, Oxford Bodleian Hatton 116 no. 3
H	295–301	out, up, low?	OE Lat. head	Easter homily St Michael	Gospel of Nicodemus; Exeter Bk Christ III; Vercelli Homily 8; Caesarius, Gregory Homelia Prima
B	302–25	out		cut: 303/04, 311/12, 315/16, 317/18	
F	326	out	Lat OE head	wið sarum eagum wið sarum earum wið magan seocness	Lacnunga CL; Durham Ritual Cambridge, Gonville and Caius College 379, f. 49a (12th c.)
B	327–28	out		cut	
F	329	out	Lat.	Latin Alms blessing SATOR palindrome childbirth prayer	Hohler: York Manual, Manuale Norvegicum. widespread late antique Medit. Pontifical Romano-Germanique
B	330–49			corner cut: 345–46	
F	350–53	out	OE	OE Journey formula	Storms: OHG and OS journey charms; with Irish elements?
B	354–69	out		cut: 355/356	
L S V	370–73	up, out	Lat.	Masses for the Common of Saints and for king	Grant: Jumièges & Leofric; CCCC 422
B	374–401				

1	2	3	4	5	6
Type	Pg	Mar	Lang	Text	Correlations
HF?	402–17	out	OE	OE Archangel Michael hymn	Johnson: Irish, Coptic influence
B	418–74				
LV	475–78	out	Lat.	Responses: Sep–Nov (Job, Tobias, Judith; minor prophets; Martin).	Grant & James
B	479–81				
LV	482	up, out, low	Lat.	Responses: untitled musical incipits, antiphons, for John Baptist, Peter, Paul.	Grant & James; sequenced in ASMMF #105.a–m
LV	483	up, out (damgd.)	Lat. OE head	*For þone cyng ⁊ for þone bysceip ⁊ for eall cris . . . (missa contra paganos)* for soul of dead person.	Grant: *Jumièges & Leofric* ASMMF #106
H	484–88	end of text	OE	OE Passion	Matt. 26–27

APPENDIX 2

Hymn to the Cross/Invention Mass, CCCC 41 224–25

Note that *per* = "per dominum nostrum Iesum Christum" ("in the name of our Lord Jesus Christ"). Other terms that remain untranslated (such as *alia, secreta, collecta*) are liturgical directions for the performance of the mass. See Billett, Pfaff, Jones, and Beddingfield.

Salue crux que in corpore christi dedicata es & ex menbris eius tamquam margaretis ornata. Ante que te dominus ascenderet. Terrenum timorem habuisti. Modo uero atimorem caelestium obtinens per uoto suspenderes. Scis enim in te credentibus quanta gaudia habeas. & quanta munera preparata suscipias. Securus ergo gaudens uenio ad te. quia amator tuus semper fui. & desideraui implecti te. O bona crux quae de corem & pulchritudinem de membris domini suscepisti. Diu sollicite quaesita aliquando concupiscendi anime preparata. Ecce adoro te non sicut metallum. Ecce adoro te non sicut idolum. Ecce

adioro te non sicut simulacrum. Ecce adoro te non sicut fantasma. Sed
adoro dominum iesum christum qui pependit in te. Qui non uult mor-
tem peccatoris. sed ut conuertatur & uiuat. Da nobis domine ueniam
corde constitutis. Ut non dimiantur dies nostri in peccatis nostris. Sed
in tua caritate. & in omnibus operibus tuis. bonis uitam nostram fini-
amus. per. alia. Deus qui hunigeniti filii tui pretiosa sanguine uiuifice
crucis uexillum sanctificare uoluisti. concede quaerimus eos qui eis-
dem sanctae crucis gaudent honore tua quoque ubique protectione sa-
luari. per. secreta. Haec oblatio domine ab omnibus nos purget offen-
sis qui in ara crucis etiam totius mundi tullit offensa prefatio. Christus
Dominus aeterne deus. Qui salutem humani generis in ligno crucis
constituisti. Unde mors oriebatur inde uita regurgeret & qui in ligno
uincebat in ligno quoque uinceretur. sic enim credimus quod ihs mor-
tuus est & resurexit ter[]ia die. ita & deus cum eo. Sic []ni in adam &
in eva omnes homines moriuntur. ita & in xpo & sancta maria & in
ligno crucis uiuificabuntur. per mulierem & in lignum mundus prius
periit. per mulieris uirtutem ad salutem reddidit. per christum. post
com. Ad esto domine [r]s noster. & quos sanctae crucis letari fecisti
honore eius quoque perpetuis defende sub sidiis. Per. ad populum.
Deus qui preclara salutifere crucis inuentione hodierne nobis festiuita-
tis gaudia dedicasti tribue ut uitalis tuitione ligni ab omnibus mu-
niamur aduersis. per.

[Hail, cross, who were dedicated in the body of Christ and adorned
by his members even as pearls. Before the Lord ascended you, you
held mortal fear. In true fashion you willingly suspended fear, obtain-
ing heaven. You know truly you have great rejoicing in you from be-
lievers, and what offerings are prepared, you accept. In the future,
therefore, I shall come to you rejoicing. For your lover I have always
been. I have desired to be embraced by you. O good cross that takes
beauty and grace from the members of the Lord, long anxiously
sought by the ready spirit of the desiring one. Behold, I adore you not
as metal. Behold, I adore you not as an idol. Behold, I adore you not
as an image. Behold, I adore you not as a figment. But I adore the
Lord Jesus Christ who hung upon you, who does not desire the death
of the sinner, but that he may convert and live. [Mass begins] Grant
us, Lord, the prize constituted in the heart. That our days will not end
in our sins, but in your love, and in all your good works may we
make our life. per. alia. God who desired by the precious living blood

of your only begotten son to sanctify the sign of the cross, grant, we ask, those who rejoice in the same holy cross the honored protection of salvation. *per. secreta.* May this offering purge us of all offenses, Lord, who bore the offense of the whole world on the altar of the cross. *prefatio.* Lord Christ eternal God, who instituted the salvation of mankind on the wood of the cross, whence death arose thence life would resurge, and who on wood conquered, wood on which he had been vanquished. Thus truly we believe that Jesus died and arose on the third day, also God with him. As in Adam and Eve all men die, so also in Christ and St. Mary and in the wood of the cross they will be brought to life. Through the woman and the wood the world first perished. Through the virtue of a woman it has returned to health. In Christ. *post comm.* Be near, Lord our king(?), and by the might of the holy cross perpetually defend those whom you have made to rejoice in its honor. *per. ad populum.* God who dedicated the celebration of the splendid invention of the salvific cross for us, grant that we may be given the teaching of the living wood against all adversities. *per.*] (trans. mine)

APPENDIX 3

CCCC 41 350–53

Ic me on þisse gyrde beluce ⁊ on godes helde bebeode:
 wið þane sara sice
 wið þone sara slege
 wið þone grymma gryre
 wið ðone micela egsa þe bið eghwam lað
 ⁊ wið eal þæt lað þe into land fare
 syge gealdor ic begale
 sige gyrd ic me wege,
 word sige ⁊ worc sige
 se me dege, ne me merne gemyrre
 ne me maga ne geswence
 ne me næfre minum feore forht ne gewurþe
 ac gehæle me ælmihtig ⁊ sunu frofre gast
 ealles wuldres wyrdig dryhten

swa swa ic gehyrde heofna scyppende abrame ⁊ isace ⁊ swilce men
moyses ⁊ iacob ⁊ dauit ⁊ iosep ⁊ elian ⁊ o/anno/an ⁊ elizabet saharie
⁊ ec marie modur christes ⁊ eac þæge broþru petrus ⁊ paulus ⁊ eac
þusend þira engla

> clipige ic me to are wið eallum feondum
> hi me ferian ⁊ friþian ⁊ mine fore nerian
> eal me gehealdon men gewealdon
> worces farende si me wuldres hyht
> hand ofer heafod haligra rof
> sigerofra sceate soð fæstra
> engla biddu ealle bliðu mode
> þæt me beo hand ofer heafod
> matheus helm marcus byrne leohtlifes rof
> lucas min swurd scerap ⁊ scir ecg
> scyld iohannes wuldre gewlitegod wega serafhin
> forð ic gefare frind ic gemete
> eall engla blæd eadiges lare
> bidde ic nu
> sigere godes mitse sið fæt godne
> smylte ⁊ lihte wind were þum
> windas ge fra/on circinde wæter
> simblige haleþe wið eallum feondum
> freond ic gemete wið þæt
> ic on þis ælmihgian on his frið wunian mote
> belocun wið þa laþan, se me lyfes eht
> on engla bla (lila?) blæd gestaþelod
> ⁊ inna halre hand hofna rices blæd
> þa hwile þe ic on þis life wunian mote amen

[I secure myself in this girdle and in God's keeping pray:
> against the sore sickness
> against the sore stroke
> against the grim terror
> against the great fear that is evil to all
> and against all the evil that comes into the land,
> a victory song I sing
> a victory belt I bear,
> victory of word and deed.
> May it profit me, not hinder me tomorrow,

nor my stomach ache
nor ever make me fear for my life
but save me almighty and son, beneficent spirit,
lord worthy of all glory.
Just as I have heard of the creator of heaven, of Abraham and Isaac
and such men: Moses and Jacob and David and Joseph and Elias and
Onnan and Elizabeth Zacharias (?) and also Mary the mother of
Christ and also the brothers Peter and Paul and also a thousand of
their angels,
I call them to my aid against all enemies
to carry and protect me and preserve my journey
entirely keep me, command mankind.
Going about my business be it hope of glory,
hand upon head, stalwart of the holy,
treasure of the triumphant righteous,
command of angels all rejoicing.
That to me is a hand upon head:
Matthew helm, Mark byrnie, strong of life's light,
Luke my sword sharp and sheer-edge,
shield John, seraphin gloriously glorified of ways,
forth I go, may I find a friend,
(oar)blade of all angels, learning of the blessed.
I now beseech:
victorious mercy of God, a good vessel,
mild and calm wind on/from/to the shore,
winds to traverse the roaring water,
ever salutary against all enemies;
may I find a friend against that,
may I remain in the protection of the almighty,
secure against the evil ones. Let my life's worth
be established in the (lily?) blade of the angels
and in the holy hand, the fruit (blade) of the kingdom of
 heaven
for as long as I remain in this life, amen.] (trans. mine)

Conclusion

Bidde ic eac æhwylcne mann
bregorices weard þe þas boc ræde
⁊ þa bredu befo, fira aldor,
þæt gefyrðrige þone writre wynsum cræfte
þe ðas boc awrat bam handum twam . . .

*[I ask also every man—lord of a kingdom—who may read this
book and hold its covers—leader of men—that he prosper the
writer of delightful skill who wrote this book with his two
hands.]*

 —Cambridge, Corpus Christi College MS 41

The "shadow manuscript" in the margins of CCCC 41, for which I
have argued in the last chapter, is not the only unusual thing about the
manuscript. I have not discussed in any depth its main text, the Old
English translation of the *Historia ecclesiastica*, but in addition to
being a particularly free adaptation and also incomplete (mostly as
evinced by empty spaces for ornamental capitals), it has an extra piece
at the end. The main text ends with not just the usual two envois,

translated from the Latin in the voice of Bede, but a third, attested uniquely here, in Old English meter. Fred Robinson showcased these three colophons, arguing for a codicological reading in which all three made rhetorical sense together, as a unit, even though the unique third colophon in CCCC 41 was clearly a rogue addition; thus Robinson insisted that manuscript arrangement forms as important a reading context as original intent. He had a philological aim in his codicological reading, which was to suggest that all three colophons should be read in the same rhetorical voice, the real or ventriloquized voice of Bede. While I disagree with Robinson's reading, I concur unequivocally with his insistence that the manuscript forms a unique reading context. The third colophon, in the vernacular and in verse, may be seen as a kind of hinge, whose turning opens upon a horizon of possibility for the subsequent marginal writing and links the vernacular main text, as I will argue, to its Incarnational "shadow." Such a moment affords me the opportunity to consider some of the wider contexts for the argument of this book.

In the *Historia*'s first—and only fully genuine—colophon, Bede's prayer is to see God "face to face" after a life spent drinking in the scriptures, and its imagined intimacy is between the writer and God:

[A]nd ic bidde ðe nu goda hælend þæt þu me milde forgeafe swetlice drincan þa word ðines wisdomes þæt þu eac swylce forgyfe þæt ic æt nyhstan to ðe, þam wylle ealles wisdomes, becuman mote symle ætywan beforan þinre ansyne (Robinson, "Bede's Envoi" 12)[1]

[And I pray you now, good savior, that you have mercifully granted me to drink, sweetly, the words of your wisdom, that you also so grant that I may finally come to you, the wellspring of all wisdom, ever to appear before your face.] (trans. mine)

As the only authorial ending to the *Historia*, this first colophon makes a tight circuit between Bede's scholarly life of reading and writing and his direct knowledge of Christ (*hælend*; "savior") in heaven. Bede imagines the hereafter as a tracing of the sweet words of the Word to their source. The second colophon, originally a preface to Bede's text, imagines copies of the *History* going out to the very locales whose history it records and asks for the prayers of the people there:

[e]ac þonne ic eaðmodlice bidde þæt on eallum ðam þe ðis ylce stær
tobecume ures cynnes to rædenne oððe to gehyrenne, þæt hi for
minum untrumnessum modes and lichaman gelomlice and geornlice
þingian mid ðære upplican arfæstnesse Godes ælmihtiges and on
gehwylcum heora mægðe þas mede heora edleanes me agyfan þæt ic
þe be syndrigum mægðum oð þam hyhrum stowum, ða þe ic gemyn-
delice and þam bigengum þancwyrðlice gelyfde geornlice ic tilode to
awritenne þæt ic mid eallum þingum þone westm arfæstre þingunge
gemete (Robinson 12)

[Also I then humbly pray that among all those of our people to whom
this same history should come to be read or heard, that they will often
and zealously intercede with the high justice/divine mercy of God al-
mighty for my weaknesses of mind and body, and among all of their
tribes grant me the mead of their recompense, that I who labored to
write about the different tribes or their important places, those which
I believed memorable and in conduct worthy of admiration, that I
might gain in all things the fruit of merciful intercession] (trans. mine)

As a preface, this envoi serves as an introduction of sorts, com-
mending the text and its author to readers. As colophon, it refocuses
attention upon the here and now and opens the closed circuit between
Bede and God outward to include other participants in the *Historia*'s
textual community.

The third colophon, finally, brings a reader to the site of the pres-
ent page, the book in the scribe's hands which was made by hands,
an intimate, material nexus of writing and reading, which also happens
to gesture toward further iterations, further writing: "þæt he mote
manega gyt mundum synum geendigan" ("that many still he may fin-
ish with his hands"):

[B]idde ic eac æhwylcne mann,
bregorices weard þe þas boc ræde
and þa bredu befo, fira aldor,
þæt gefyrðrige þone writre wynsum cræfte
þe ðas boc awrat bam handum twam
þæt he mote manega gyt mundum synum
geendigan, his aldre to willan
and him þæs geunne se ðe ah ealles geweald,

rodera waldend, þæt he on riht mote
oð his daga ende drihten herigan.
 Amen. Geweorþe þæt.

<div align="right">(Robinson 12–14)</div>

[I, too, ask every man, ruler of a realm, who may read this book and take up its boards, lord of men, that he prosper the writer with delightful skill who wrote this book with his two hands, that many yet he may finish with his hands, at his lord's will, and for this may he who has dominion of all grant him, ruler of the skies, that he may fittingly, until the end of his days, praise the Lord. Amen. May it come to pass.] (trans. mine)

This passage emphasizes the material work of scribal hands, since hands seem to be the central focus—those of the lordly reader which may extend beneficence to the writer in reward for both present and future handiwork.[2] At the end of this Old English rendering, this vernacularization of the Latin *Historia*, the scribe has layered his voice upon the palimpsest, a ghostly chorus comprising already Bede himself and his physical hand, any number of scribes who had copied his Latin, the original translator into Old English, and any subsequent scribes copying and adapting that version in their own hands (see figs. C.1 and 5.7).[3] It is possible to see this emphasis upon the present manuscript, and this gesture toward further writing, as granting an impetus for "the rest" of CCCC 41, its second act, the continuation of its story in the margins.

I have heretofore not addressed why CCCC 41 in particular would have made a suitable repository for an Incarnational shadow manuscript, but I do believe both the text (the *Historia ecclesiastica*) and its status as vernacular translation, as well as the presence of the metrical colophon focused on manual production and the materiality of writing, are important, and important in a way that draws together some of the themes of the present book, the one you hold in your hands. Bede's vision of English destiny, as I discussed in chapter 1, is inherently Incarnational. There is an obvious parallel between Christ's mission to humankind and the Christian mission to Britain, a parallel that explains some of Bede's conflicted antipathy to the Celtic church, which uncooperatively blurs this symmetry. The version of Bede's history recorded in CCCC 41 is, further, the vernacular translation, a

Figure C.1. CCCC 41, p. 483. Beginning of the metrical colophon, with alternating lines in red. The Parker Library, Corpus Christi College, Cambridge.

version intended to make accessible what had been inaccessible to many, just as Christ's coming made visible what had been invisible, as Bede, following Gregory, characterized the Incarnation. Thus, Christ comes to earth, Christianity comes to the English, Bede's history is turned into English. There is a single ethic at work in this (admittedly very schematic) sequence, and it has to do with bringing God to humanity in such a way that humanity may perceive him. As a manuscript of the Old English Bede, CCCC 41 is therefore already in some sense dedicated to the logic of revelation, visibility, and manifestation. The verse colophon makes a radical intervention, however, by invoking not only text but also the physical act of writing and the material presence of hands and manuscript. This emphasis is picked up by the marginal scheme in the repeated inscription of *dextera*, the hand of creation. The very nature of manuscript production involved the sacrificial preparation of bodies to receive language, just as Mary's flesh received the Word—another Incarnational parallel of which medieval people were well aware. It is directly below the colophon, on page 484, that the image-text amalgamation of Christ appears. In both form and content, then, CCCC 41 presented the marginal scribe with an already prepared canvas for his or her arcane exposition of the Word. Seen in this light, CCCC 41marg functions—as do more traditional marginalia—as commentary and gloss upon the Incarnational logic that inhered in the main text and in the physical manuscript. In CCCC 41's margins, as I have argued, a reader finds further revelation, a textual embodiment that takes a devotional turn. The margins incorporate elements of Insular learning, themselves marginalized by orthodoxy, and afford them space alongside—literally—the authority of Bede.

In the early ninth century it was possible, as the Book of Kells attests, to structure an entire manuscript around the idea of the sacramental Word. Kells is a display copy, and its Incarnationalism is unapologetic. Christ is everywhere in the book's pages and is equated with those pages. By the eleventh century, perhaps, such sacramental Incarnationalism has been, as I have said, marginalized, which is to say that placing Kells and a manuscript like CCCC 41 side by side may tell us something about how representation and what Curtis Gruenler has called "spiritual participation" fared across the early period (13–21). Indeed, in light of much recent work in literary studies focused on the tenth-century Benedictine reform, it seems clear that one effect of

the reform was to sideline the fulsome Incarnationalism of earlier works.[4] Yet I hope I have shown that while Incarnational poetics may have been pushed to the margins in the reform period, it nevertheless remained robust as well as often ingenious in its eclecticism and experimental style.

Taking an even longer view, I have suggested in this book that the formal experimentation in relation to Christian theology that would proliferate in the vernacular writing of the later Middle Ages has a longer history. While Cristina Maria Cervone and Simone Marchesi both pin vernacular writers' treatment of the enigmatic Word to knowledge of Augustine, making him a sort of fons et origo of an Incarnational poetics, Gruenler has located the phenomenon somewhat differently, in a particular ethos that might prevail or at least appear at various points in history. Writing of William Langland's "poetics of enigma," he notes that "Langland's poem, like the enigmatic Grail stories of Chretien de Troyes and Wolfram von Escherbach and like Dante's *Commedia*, emerges when fruit from the tree of Latin theological discourse falls into the soil of vernacular culture, where it sprouts into many different forms, from mysticism to the novel, related to the original tree not necessarily by theological aims but by an ethos of interpretive community and a sense of spiritual participation" (21). While Gruenler identifies the enigmaticism of *Piers Plowman* as a kind of first in English vernacular writing, the many Insular phenomena from the early period that I have treated may also be seen to have sprouted from the fruitful encounter between vernacular culture and Latinity, in communities where interpretation could flourish, such as monastic centers, and where participation, which is to say, a spirituality not restricted to hieratic ritual alone, characterized to some extent both praxis and theology.[5]

While there are continuities between the early and later medieval periods, there are also important differences. If a longer history of both "vernacular theology" and Incarnational poetics is to be written, it will have to encompass the fact that in the earlier period, vernacularity is not restricted to the vernacular, nor does it carry lay associations. It is certainly not "popular." Many of the texts in the wisdom tradition, for example, are in Latin and engage in elaborate play with both its textuality and its authority. I have thus not wished to place too much emphasis upon vernacularity per se by focusing, for instance, only on vernacular writing or on a contrast between Latinity

and vernacularity. Regarding the "lay" associations of later medieval vernacular piety, these simply do not characterize the demographics of early Insular literary culture or the Incarnational discourse I have discussed. In the early Insular landscape we find elite coteries writing for an in-crowd. What I have tried to suggest is that the very makeup of this elite was not exactly authoritative nor always in line with later orthodoxy.[6]

As scholars of the later medieval period have suggested, and as some early medievalists have also begun to explore, a history of medieval Incarnational theology must countenance both explicit and implicit evidence and not only the polemics of named authors. The evidence from the early period is mixed, unsurprisingly, but it suggests that according to a potent and historically conditioned cultural formation, the Word had come to the world and could be made manifest in the present day. It was no longer ineffable but supereffable, if still enigmatic, thanks to the Incarnation. The tissue of sensory experience could be a touching of the divine, not as *ratio* or Neoplatonic "form," but as the very flesh of the Word. This way of conceiving of the sensible word persisted throughout the period, even as it came to be challenged by more authoritative dogma. One of the implications of this book is that this basic orientation is in fact the default we might assume when approaching English texts across the span of the medieval period. An exceptional familiarity with the Augustinian tradition, and later with Scholastic thought, was just that: exceptional. In the vernacular piety of individuals not trained in these approaches to the Word we might expect what I am calling the default Incarnationalism to obtain. This removes the need for some of the awkward gestures toward knowledge of Augustinian enigmaticism to which I have pointed. We need not surmise that Julian of Norwich, for example, or the anonymous author(s) of the *Dialogues of Solomon and Saturn* were improbably steeped in Augustinian language theory. There was a default "theory" of the Word and its relation to words that was available in Britain from the earliest cultivation of Christian learning on the island, and it did not go away.

Perhaps this is also the place to consider the larger, contemporary setting for this book. Doing so is a particularly urgent concern given the field's ongoing self-examination (which feels at times like a post-mortem) over its insularity, its racism, its conservatism in so many respects. I hope that although I have focused on a geographic area, the

island of Britain, I have not simply reinscribed an Insular approach within the field. My aim in focusing on Britain has been to isolate the way that, in that context, a way of conceiving of sensory contact with the Word could and did flourish because it was spared the early crackdowns and controversies that befell similar veins of thought on the Continent. Byzantine iconophiles met with condemnation as early as the fourth century.[7] "Realist" interpreters of the Eucharist such as Paschasius Radbertus were refuted among the Carolingians, with the resulting controversies driving ever-tightening control over lay piety and access to the sacraments. In its atmosphere of relative freedom, cultural factors in Britain conditioned its Incarnationalism in unique ways. I have suggested that the Irish influence on early Christianity was significant, that oral tradition as well as heteroglossia mattered, and that the asymmetries of power characteristic of a contact zone are important to remember in relation to this period. It is my hope that rather than setting up monoliths and closing off spaces, I have opened up space for multiplicity, complexity, and unexpected lines of connection. If the field of early medieval studies is to thrive, it must accept that every act of framing, every delimiting articulation of a project, archive, or object of study, is "constellative" rather than "objective." What might the field look like, in terms of our relations with one another and of the research resulting from our many angles of approach to the past, if we saw our multifariousness as a strength rather than a sign of corruption?

N O T E S

PREFACE

1. Though monumental carving preexisted Christianity in Germanic ter-
ritories, building was usually in wood, not stone, and stone came to be a sign
of Romanizing affiliation. See Hawkes, "*Iuxta Morem Romanorum*," in Kar-
kov and Brown 71–72.

2. See Chazelle, "The Eucharist in Early Medieval Europe," in Levy et
al. 205–49.

3. See Cervone; Gruenler; and Eleanor Johnson (both works).

INTRODUCTION

1. "Et si sanctus erat ac potens uirtutibus ille Columba uester, immo et
noster si Christi erat, num praeferri potuit beatissimo apostolorum principi,
cui Dominus ait: 'Tu es Petrus, et super hanc petram aedificabo ecclesiam
meam, et portae Inferi non praeualebunt aduersus eam, et tibi dabo claues
regni caelorum'?" (306).

2. "Facta est autem haec quaestio anno dominicae incarnationis
DCLXquarto, qui fuit annus Osuiu regis uicesimus secundus, episcopatus
autem Scottorum, quam gesserunt in prouincia Anglorum, annus tricesimus"
(Bede, *Ecclesiastical History* 308).

3. Bede's longer remarks are as follows:

How frugal and austere [Colman] and his predecessors had been, the place
itself over which they ruled bears witness. When they left, there were very
few buildings there except for the church, in fact only those without
which the life of a community was impossible. They had no money but
only cattle; if they received money from the rich they promptly gave it to
the poor; for they had no need to collect money or to provide dwellings

for the reception of worldly and powerful men, since these only came to the church to pray and to hear the word of God. The king himself used to come, whenever opportunity allowed, with only five or six thegns, and when he had finished his prayers in the church he went away. If they happened to take a meal there, they were content with the simple daily fare of the brothers and asked for nothing more. The sole concern of these teachers was to serve God and not the world, to satisfy the soul and not the belly. For this reason the religious habit was held in great respect at that time, so that whenever a cleric or a monk went anywhere he was gladly received by all as God's servant. If they chanced to meet him by the roadside, they ran towards him and, bowing their heads, were eager either to be signed with the cross by his hand or to receive a blessing from his lips. Great attention was also paid to his exhortations, and on Sundays the people flocked eagerly to the church or the monastery, not to get food for the body but to hear the word of God. If by chance a priest came to a village, the villagers crowded together, eager to hear from him the word of life; for the priests and the clerics visited the villages for no other reason than to preach, to baptize, and to visit the sick, in brief to care for their souls. They were so free from all taint of avarice that none of them would accept lands or possessions to build monasteries, unless compelled to by the secular authorities. This practice was observed universally among the Northumbrian churches for some time afterwards. But enough has been said on this subject." (3.26, p. 311)

["Quantae autem parsimoniae, cuius continentiae fuerit ipse cum prodecessoribus suis, testabatur etiam locus ille quem regebant, ubi abeuntibus eis excepta ecclesia paucissimae domus repertae sunt, hoc est illae solummodo sine quibus conuersatio ciuilis esse nullatenus poterat. Nil pecuniarum absque pecoribus habebant; siquid enim pecuniae a diuitibus accipiebant, mox pauperibus dabant. Nam neque ad susceptionem potentium saeculi uel pecunias colligi uel domus praeuideri necesse fuit, qui numquam ad ecclesiam nisi orationis tantum et audiendi uerbi Dei causa ueniebant. Rex ipse, cum oportunitas exegisset, cum quinque tantum aut sex ministris ueniebat, et expleta in ecclesia oratione discedebat. Quodsi forte eos ibi / refici contingeret, simplici tantum et cotidiano fratrum cibo contenti nil ultra quaerebant. Tota enim fuit tunc sollicitudo doctoribus illis Deo seruiendi, non saeculo; tota cura cordis excolendi, non uentris. Vnde et in magna erat ueneratione tempore illo religionis habitus, ita ut, ubicumque clericus aliqui aut monachus adueniret, gaudenter ab omnibus tamquam Dei famulus exciperetur. Etiam si in itinere pergens inueniretur, adcurrebant, et flexa ceruice uel manu signari uel ore illius se benedici gaudebant; uerbis quoque horum exhortatoriis diligenter auditum praebe-

bant. Sed et diebus dominicis ad ecclesiam siue ad monasteria certatim, non reficiendi corporis sed audiendi sermonis Dei gratia, confluebant, et siquis sacerdotum in uicum forte deueniret, mox congregati in unum ui-cani uerbum uitae ab illo expetere curabant. Nam neque alia ipsis sacerdo-tibus aut clericis uicos adeundi, quam praedicandi baptizandi infirmos ui-sitandi et, ut breuiter dicam, animas curandi causa fuit; qui in tantum erant ab omni auaritiae peste castigati, ut nemo territoria ac possessiones ad con-struenda monasteria, nisi a potestatibus saeculi coactus acciperet. Quae consuetudo per omnia aliquanto post haec tempore in ecclesiis Nordan-hymbrorum seruata est. Sed de his satis dictum."] (310)

While Bede clearly sides with orthodoxy per se as defined by Roman prac-tice, he holds up Irish practice as truly exemplary; it seems to put some of his contemporaries to shame—"enough has been said on this subject."

4. Joseph Nagy describes how intertwined oral traditions and Christian authority became in early Ireland. Specifically, Nagy discusses a traditional tale type in which a mediating figure meets a bearer of tradition from the other word, and brings his tales to a new audience ("Close Encounters of a Traditional Kind"). In Christian texts, the mediator is St. Patrick and the figures from the other world are heroes of the pre-Christian past. Through St. Patrick, characters such as Cú Chulainn attain Christian salvation and their pre-Christian stories are carried forward into the present. This dynamic of accommodation is elaborated in Nagy's *Conversing with Angels and An-cients*.

5. See Lockett 374–422, inter alia.

6. See Niles, *God's Exiles*; and O'Camb (all works). By recognizing "vernacular learning" as a phenomenon, I do not suggest that it was a mono-lith. Far from it. The poetry of the Exeter Book, the anonymous homilies, and the vernacular oeuvre of Ælfric himself are quite disparate. This rather proves that vernacularity provided a platform on which various experiments could be staged.

7. Brandon Hawk has recently argued similarly, recognizing Christiani-ties rather than a unified orthodoxy for the period. See 1–13.

8. See Baker; Dockray-Miller; Ellard; Kim (both works); Livingstone; Miyashiro, "Decolonizing Anglo-Saxon Studies"; Rambaran-Olm, "Anglo-Saxon Studies"; Remein; and Wilton. See also Karkov, *Imagining Anglo-Saxon England*.

9. Donna Beth Ellard recognizes this love in the grief work she pre-scribes for the field and in the melancholia that characterizes its present state. Karkov relies on the concept of melancholy as well (*Imagining Anglo-Saxon England*).

10. See Garnett.

11. The Domesday Book, for example, employs the standard of "as it was in the reign of Edward the Confessor" to verify property claims (erasing the intervening rule of Harold Godwinson) (Garnett 41–71). See also Symes.

12. The classic source for Anglo-Saxonism's role in Protestant apologetics as well as American national identity is Frantzen, *Desire for Origins* (esp. 1–95), though the deserved notoriety of that scholar's antifeminist polemics and antipathy to critical race studies is important to acknowledge. See also Ellard; Miyashiro (both works); and Niles, *Idea of Anglo-Saxon England*.

13. See 25–26, inter alia. See also Karkov, *Imagining Anglo-Saxon England*.

14. The activist scholar Dorothy Kim has voiced this point loudly and consistently over the last several years, mostly on social media or in person, but see also her introduction to the *Literature Compass* special issue *Critical Race and the Middle Ages*; "The Question of Race in *Beowulf*"; and the Medievalists of Color statement of support for Mary Rambaran-Olm's resignation from the (former) International Society of Anglo-Saxonists: https://medievalistsofcolor.com/race-in-the-profession/statement-of-support-for-dr-mary-rambaran-olm/.

15. For recent overviews of the invention of the idea and the scholarly field devoted to it, see Ellard as well as Niles, *Idea of Anglo-Saxon England*; see also Momma, *From Philology to English Studies*; and Frantzen, *Desire for Origins*.

16. Clare Lees's work as editor of the *Cambridge History of Early Medieval English Literature* deserves special recognition for its approach to heterogeneity and diversity in early Britain. See 1–16 in particular.

17. For another recent medievalist use of the "contact zone," see Leet.

18. For notable (and mostly quite recent) exceptions, see Davis (both works); Ellard; Kabir and Williams; Karkov, "Postcolonial"; Miyashiro (both works); Treharne; Trilling, *Aesthetics of Nostalgia*; and Young. A torrent of work is certain to follow the recent controversies over white supremacy and inclusion. See Schuessler for an overview, in addition to note 8 above. See also Andrews and Beechy.

19. When specifying English-speaking peoples or their products, I will use *English* or *Old English* (when discussing language specifically), except in cases where *English* would be misleading, seeming to describe language where that is not meant (as in the case of a text in Anglo-Latin, for example). In such cases, I may use *Anglo-Saxon*.

20. Both American and English nationalism make overtures to the Anglo-Saxon past as inheritance and cultural patrimony. For example, Thomas Jefferson gave pride of place to Old English in the founding curriculum of the University of Virginia, and he wanted Hengest and Horsa, the legendary

brothers at the vanguard of Anglo-Saxon settlement in Britain, on the national seal of the United States (see Frantzen 15–18). More recently, in an English context, Paul Kingsnorth has linked his vision of English econationalism to a pre-Conquest Anglo-Saxon identity and a time before the devolution of land to private ownership. Kingsnorth's calls to reclaim English identity as the lost patrimony of Anglo-Saxon England are particularly irresponsible for the refusal to acknowledge the reality of the time in between—for example, colonialism, empire, industrialization—which cannot simply be blamed on Norman hegemony.

21. Examples of this phenomenon include the white nationalist march on the University of Virginia campus in Charlottesville in 2018, whose location cited Jefferson's Anglo-Saxonism and whose perverse heraldry included symbols of pseudo-Anglo-Saxon allegiance, such as the *eþel* ("homeland") rune, ᛟ, which has been discussed in various fora online and most coherently in a paper by Adam Miyashiro at the 2018 International Congress on Medieval Studies, Kalamazoo, MI, "*Beowulf* and Its Others: Sovereignty, Race, and Medieval Settler-Colonialism." Less obviously nefarious examples of popular interest include the flurry of new translations and adaptations of *Beowulf* in the new millennium, as well as the extraordinary cultural phenomenon of Peter Jackson's Lord of the Rings films and, I would argue, the even more extraordinary popularity of the frightfully grotesque, pseudo-medieval *Game of Thrones* (I have read all the books; they are wonderful stories). Set in a fictionalized version of Britain, with a wall to keep out barbarians to the north, *Game of Thrones* is clearly a veiled homage to the "Anglo-Saxon" world imagined as a kind of brutal caricature (see anything online tagged with "Real Middle Ages"), stripped of all morality, depicting power and lust as the sole forces of its world.

22. This is not even to mention the proximity of also-Christian British to the west and, eventually, originally pagan Norse in the northeast, or the further complicating regime change that brings a different controlling gaze to the documentary evidence after the Conquest.

23. Celia Chazelle, "The Eucharist in Early Medieval Europe," in Levy et al. 210; see n22 for a bibliography of recent scholarship on this topic.

24. See Wood.

25. Theodore, from Tarsus in Asia Minor, and Hadrian, a North African, arrived in 669 (five years after the Synod of Whitby), to assume the episcopal see and the abbacy, respectively. See Lapidge, "The School of Theodore and Hadrian."

26. Michael Lapidge suggests that Aldhelm, in addition to his education by the Irish abbot Máeldub, spent a period of time at Iona, studying with Adamnán ("The Career of Aldhelm" 26–30).

27. See Herren, *Hisperica Famina* 2, 3.

28. See chapter 4 for a deeper discussion of Aldhelm's adaptation of the riddles of Symphosius.

29. Perhaps most famously, Umberto Eco pronounced the Book of Kells a work of "cold-blooded hallucination" (14). Nineteenth- and twentieth-century English nationalist philology, in particular, was not sympathetic to the Irish tradition. See Wright, *Irish Tradition* 1–48, for an overview of the treatment of Irish "symptoms" in medieval scholarship. See also Anlezark 12–41; and Herren, "Hisperic Latin."

30. The phrase "mantic obscurantism" is Carey's (24).

31. See Wright, "From Monks' Jokes to Sages' Wisdom" 216, esp. n58, for overview of the *immacallam* genre. The gloss of "mutual conversing" is Wright's. For a deeper background see Nagy, "Close Encounters" and *Conversing with Angels and Ancients* 1–22 and 203–6. See also Carey.

32. Wright, "From Monks' Jokes to Sages' Wisdom."

33. Similarly, Aldhelm's riddles, for their part, are an esoteric reimagining of Symphosius's trifles.

34. Law 39–40.

35. For an overview of the grammatical tradition, see Irvine, *Making of Textual Culture.*

36. "Sed hanc non solum incorporalem uerum etiam summe inseparabilem uereque immutabilem trinitatem cum uenerit uisio quae *facie ad faciem* nobis promittitur, multo clarius certiusque uidebimus quam nunc eius imaginem quod nos sumus. *Per* quod tamen *speculum* et *in* quo *aenigmate* qui uident sicut in hac uita uidere concessum est non illi sunt qui ea quae digessimus et commendauimus in sua mente conspiciunt, sed illi qui eam tamquam imaginem uident ut possint ad eum cuius imago est quomodocumque referre quod uident et *per imaginem* quam conspiciendo uident etiam illud uidere coniciendo quoniam nondum possunt *facie ad faciem*" (*De Trinitate* 15.23.44, p. 522). See Cervone for sensitive discussion of Augustine and metaphor (19–26). Another excellent recent discussion is Marchesi's. See also Irvine 169–89.

37. See Derrida 3–73.

38. For Augustinian *sermo humilis*, and for the juggernaut of its tie to realism in the Western literary tradition, see Auerbach, *Literary Language* 25–66, and, more generally, *Mimesis.*

39. For Irish obscurantism and floridity, see Herren, *Hisperica Famina* 3–56 and *Cosmography of Aethicus Ister* xi–lxxviii; Law; and Denis Meehan's introduction to Adamnán, 1–18. Law is particularly focused on Hisperic style as a means of approaching the Word. See also Wright, "From Monks' Jokes to Sages' Wisdom"; and Carey.

40. Lest there be any mistaking Augustine's Platonist emphasis on the ultimate, transcendental signified, I include, as Colish does in her account of

Augustine's theory of signs, the climactic scenes before his mother Monica's death in the *Confessions*:

> We were conversing together very sweetly. . . . Between ourselves we won-
> dered . . . what the future eternal life of the saints would be like. . . . And
> when speech had brought us to the point where no sensuous delight and
> no corporeal light whatever could compare with the joy of that life, . . .
> lifting ourselves with a more ardent yearning to that life, we traveled gradu-
> ally through corporeal things and through heaven itself. . . . And still we
> ascended, by inward thought, by speech, and by marveling at Your works.
> And we came to our own minds and transcended them, in order to arrive
> at the place . . . where life is that Wisdom by Whom all these things were
> made. . . . And while we were speaking and longing for it, we attained it, in
> some slight degree, with the undivided striving of the heart. . . . Then we
> returned to the noise of our mouth, where words both begin and end.
> (9.10.23–24, Colish 33)

> [Conloquebamur ergo soli ualde dulciter et praeterita obliuiscentes in ea
> quae ante sunt extenti quaerebamus inter nos apud praesentem ueritatem,
> quod tu es, qualis futura esset uita aeterna sanctorum, quam nec oculus
> uidit nec auris audiuit nec in cor hominis ascendit. Sed inhiabamus ore
> cordis in superna fluenta fontis tui, fontis uitae, qui est apud te, ut inde pro
> captu nostro aspersi, quoquo modo rem tantam cogitaremus. Cumque ad
> eum finem sermo perduceretur, ut carnalium sensuum delectatio quantali-
> bet in quantalibet luce corporea prae illius uitae iucunditate non compara-
> tione, sed ne commemoratione quidem digna uideretur, erigentes nos ar-
> dentiore affectu in id ipsum perambulauimus gradatim cuncta corporalia
> et ipsum caelum, unde sol et luna et stellae lucent super terram. Et adhuc
> ascendebamus interius cogitando et loquendo et mirando opera tua et ue-
> nimus in mentes nostras et transcendimus eas, ut attingeremus regionem
> ubertatis indeficientis, ubi pascis Israhel in aeternum ueritate pabulo, et ibi
> uita sapientia est, per quam fiunt omnia ista, et quae fuerunt et quae futura
> sunt, et ipsa non fit, sed sic est, ut fuit, et sic erit semper. Quin potius
> fuisse et futurum esse non est in ea, sed esse solum, quoniam aeterna est:
> nam fuisse et futurum esse non est aeternum. Et dum loquimur et inhia-
> mus illi, attingimus eam modice toto ictu cordis; et suspirauimus et reli-
> quimus ibi religatas primitias spiritus, et remeauimus ad strepitum oris
> nostri, ubi uerbum et incipitur et finitur] (147–48).

Augustine and his mother strive through the available, corporeal means to-
ward a vision beyond the corporeal, and the best they come to is "some slight
degree" of success, which, of course, cannot be described in words. They fall

back down to earth, into a discourse described in totally materializing language, the "noise of our mouth"—noise, almost incoherent, in a fleshly locale "where words both begin and end." This strikes a rueful note, a regret about the reality of embodiment, that one always finds in Augustine. The two continue with their mouths, though, speculating about the direct experience of the divine:

> If, for any man, the tumult of the flesh were silent; if the image of the earth, the waters, and the air were silent; if the poles were silent; if the soul itself were silent, and transcended itself by not thinking about itself; if dreams and imaginary revelations were silent—for to him who listens, they all say, "We did not make ourselves, but He Who abides in eternity made us"—if, having said this, they were silent and He spoke, raising our ears to Himself Who made them, not by the voices of angels, nor by the noise of the thundercloud, nor by the riddles of a simile (*per aenigma similitudinis*), but by Himself, Whom we love in these things; were we to hear Him without them, . . . and if it continued like this, . . . would it not be entering into the joy of the Lord? (9.10.25, Colish 34).

> [Se cui sileat tumultus carnis, sileant phantasiae terrae et aquarum et aeris, sileant et poli et ipsa sibi anima sileat, et transeat se non se cogitando, sileant somnia et imaginariae reuelationes, omnis lingua et omne signum et quidquid transeundo fit si cui sileat omnino— quoniam si quis audiat, dicunt haec omnia: "non ipsa nos fecimus, sed fecit nos qui manet in aeternum"—his dictis si iam taceant, quoniam erexerunt aurem in eum, qui fecit ea, et loquatur ipse solus non per ea, sed per se ipsum, ut audiamus uerbum eius, non per linguam carnis neque per uocem angeli nec per sonitum nubis nec per aenigma similitudinis, sed ipsum, quem in his amamus, ipsum sine his audiamus, sicut nunc extendimus nos et rapida cogitatione attingimus aeternam sapientiam super omnia manentem, se continuetur hoc et subtrahantur aliae uisiones longe imparis generis et haec una rapiat et absorbeat et recondat in interiora gaudia spectatorem suum, ut talis sit sempiterna uita, quale fuit hoc momentum intellegentiae, cui suspirauimus, nonne hoc est: *intra in gaudium domini tui*?] (148)

The literally unspeakable vision of the Godhead is what Augustine here imagines. For Augustine and the Platonic tradition, the Word is ineffable and utterly separate from the present reality. It is only glimpsed by insight, by the flash of the intellect that is lost as soon as it is perceived. Whether by the plain speech of preaching or the inspired poetic language of scripture, we are directed ultimately to the Word we can never fully grasp until we see him "face to face."

41. See Lockett 375–80.

42. See Bynum, *Resurrection of the Body* xviii, inter alia, and *Christian Materiality*; Celia Chazelle, "The Eucharist in Early Medieval Europe," in Levy et al. 209–10, esp. n22 (for further references); and Lockett.

43. In Levy et al., see Chazelle, "The Eucharist in Early Medieval Europe" 205–49, at 240–49; Lizette Larson-Miller, "The Liturgical Inheritance of the Late Empire in the Middle Ages" 13–58; Elizabeth Saxon, "Carolingian, Ottonian and Romanesque Art and the Eucharist" 251–324, at 258–82; Gary Macy, "Theology of the Eucharist in the High Middle Ages" 365–98, at 365–66.

44. For the Eucharistic controversies in this era, see Chazelle, "Figure, Character, and the Glorified Body"; Chazelle, "The Eucharist in Early Medieval Europe," in Levy et al. 205–49; and Lockett 375–80.

45. Lockett 378–80.

46. Paschasius says that Christ is physically present in the Eucharist in a way that is usually indetectable, and that miraculous visions, in which the Eucharist actually looks like what it is, confirm this. See Lockett 376–77; Chazelle, "Figure, Character, and the Glorified Body" 6–7. Ratramnus, however, takes a Platonic line and insists that the Eucharist is "truly present," but only as a figure of the historical body of Christ (Lockett 377–78). As Chazelle explains, both writers make recourse to sign theory in their discussions of the nature of the Eucharistic presence, linking the Eucharist to the Word ("Figure, Character, and the Glorified Body," esp. 15–19). Paschasius says that the Eucharistic presence is real just as a "character" or grapheme presents a real unit of language; Ratramnus, on the other hand, asserts the arbitrary nature of such a linkage, its status as (mere) "figure."

47. See Lockett 374–422.

48. See Lockett 179–81, 213–22.

49. Lockett 224–27. For discussion of Isidore, see chapter 4. Wright, "From Monks' Jokes to Sages' Wisdom" 212.

50. For Bede's affinity for Gregory, see Meyvaert; DeGregorio.

51. See also Demacopulous.

52. *XL homiliarum* 29, Hurst 232.

53. Homily 1.19, 188. I will discuss Bede's concept of the "sacraments of Christ's humanity" more fully in the following chapter.

54. There is another source for the legend as well, the anonymous *Vita* produced at Whitby between 704 and 714, which, according to Frantzen, Bede did not know. See Frantzen, "Bede and Bawdy Bale" 18–19.

55. See Karkov, "Post 'Anglo-Saxon' Melancholia"; Harris 47–54; Frantzen, "Bede and Bawdy Bale."

56. For the Synod of Whitby, again, see Bede, *Ecclesiastical History* 3.25–26, pp. 298–309.

57. See, for example, Romans 8:3–4: "For what the law could not do, in that it was weak through the flesh, God sending his own Son, in the likeness of the flesh and of sin, hath condemned sin in the flesh; That the justification of the law might be fulfilled in us, who walk not according to the flesh but according to the spirit" (Duay-Rheims). ["Nam quod inpossibile erat legis in quo infirmabatur per carnem Deus Filium suum mittens in similitudinem carnis peccati et de peccato damnavit paccatum in carne ut iustificatio legis impleretur in nobis qui non secundum carnem ambulamus sed secundum spiritum" (Vulgate).] It is rather a commonplace that the early English tended toward Old Testament legalism in their Christianity. This was no doubt due in part to the coming of Christianity as a religion of and by "the book," but the tribalism and vengefulness of the patriarchs also more closely resembled the society of the early English, as evidenced most clearly in the law codes (see Oliver). Wulfstan II of York (d. 1023) of course embodies the way "law" often subsumes both sacred and secular in the period. Yet my point about Christ being synonymous with the law is more philosophical: Insular writers do not separate works from grace, flesh from spirit. In Insular writing, Christ came as a fulfillment of the law, but that fulfillment takes the form of a messianic patriarch who still wields the scepter of judgment. One earns paradise through *observance*, through obedience.

58. This is the Vulgate text for Paul's "through a glass, darkly" in 1 Corinthians 13:12. "Videmus nunc per speculum in aenigmate; tunc autem facie ad faciem" ("We see now through a mirror, in an enigma; but then [we shall see] face to face"; trans. mine). See Cervone's discussion, 19–22.

59. For the "double Incarnation," see Pulliam 28–29.

60. See Bolter and Grusin 3–62; Rubin 1–14; Lord 13–29; and Amodio 1–12. On "thickness" and "quiddity" in the context of Cervone's Incarnational poetics, see Cervone 4.

61. Cervone (1–7) treats these words in John as a motivating puzzle for writers, and in particular, opens up its not-quite-metaphoric strangeness in a way that suggests why it would be so productive.

62. For a review of the New Formalism, see Levinson. See also Loesberg; Best and Marcus; and Love. For the New Materiality and thing theory, see Bennett; and Bill Brown (all three works). See also Todd for a critique of these approaches in a wider context of Western scholarship's neglect of Indigenous knowledge.

63. For later medieval scholarship, see K. Robertson; Bynum, *Christian Materiality*; Carruthers; Knapp; E. Johnson (both works); Nolan; Raybin and Fein; Chaganti. For the New Materialism in early medieval scholarship, see Paz; Lockett; and the review in Trilling, "From Metaphors to Metaphysics." For formalism and aesthetics, see the volume edited by John Hill, as

well as Ramey; Zacher; Trilling, *Aesthetics of Nostalgia*; Maring; Tyler; and E. Johnson, *Practicing Literary Theory.*

64. Maura Nolan has been advocating for the notion of heterotemporality in medieval texts for some time, now, of course, but the concept has not been widely recognized in early medieval scholarship.

65. For an example of the former, see Wade.

66. See Bynum, *Christian Materiality* 37–176.

67. For the latter, see Foley 7–8, and Maring 14–16 and 36–40.

68. See Jakobson 95–114.

69. I take "Incarnational poetics" from Cervone, whose work I gratefully acknowledge.

70. For the dating of *De locis sanctis*, see D. Meehan's introduction to Adamnán, 9–11.

CHAPTER ONE

A portion of this chapter has appeared previously as Tiffany Beechy, "Consumption, Purgation, Poetry, Divinity: Incarnational Poetics and the Indo-European Tradition," *Modern Philology* 114, no. 2 (2016): 149–69, https://doi -org.proxy.uchicago.edu/10.1086/686999.

1. Of course, as Saussure asserted, the link between signifier and signified is usually arbitrary in language; it is the basic ground making language possible as a system (67–69). In this light, the Incarnation serves as a metaphor for language and not the other way around.

2. This is true even for the orthodox tradition, albeit metaphorically, since "Christ's body" becomes the church on earth, whose humanity is shared with Christ.

3. This way of thinking about materiality as a spectrum of practices is suggested by Bynum. See *Christian Materiality.*

4. For the English emphasis on the Incarnation as a making visible see Raw 63–67.

5. See, for instance, Bede, Homily 1.19, 188. For Bede's affinity for this phrase and its origin with Gregory's *Moralia* see Arthur Holder's note in Bede, On the Song of Songs *and Selected Writings* 327n37.

6. See Bede, Homily 2.8, 72–73.

7. In the English tradition, the "leap of the mind" is heavily inflected by Gregory's reading of the Song of Songs, in which the leaps are Christ's. Thus, in the English tradition, reaching to God through representation is from the beginning bound up with the Incarnation.

8. Noble's is the essential account of these controversies in their relation to artistic representation.

9. See Raw 54–64 and Noble for brief and extended treatments, respectively, of the iconoclastic controversies.

10. "Deus ab aeterno in aeternum existens uerus ut erat hominem ex tempore adsumens in unitatem suae personae uerum quem non habuerat" (*Homiliae evangelii* 58).

11. *XL homiliarum* 29; see the same idea in, for example, Bede's Homily 1.7.

12. "Ipsa lux inuisibilis ipsa Dei sapientia carne in qua uideri posset induta est" (*Homiliae evangelii* 55).

13. "Sic ergo hoc in loco quod dicitur, *et uerbum caro factum est*, nihil aliud debet intellegi quam si diceretur, et Deus homo factus est carnem uidelicet induendo et animam" (*Homiliae evangelii* 58).

14. "*Videamus* ergo, inquiunt, *hoc uerbum quod factum est* quia ante quam factum esset hoc uidere nequiuimus; *quod fecit dominus et ostendit nobis*, quod incarnari fecit dominus et per hoc uisibile nobis exhibuit" (*Homiliae evangelii* 47–48).

15. "Gloriam Christi quam ante incarnationem uidere non poterant homines post incarnationem uiderunt aspicientes humanitatem miraculis refulgentem et intellegentes diuinitatem intus latitantem" (*Homiliae evangelii* 58).

16. Raw 73 highlights the English emphasis on the divine quality of light.

17. The Mount of Olives as physical locale associated with Christ's body will recur throughout this book, as it is imagined consistently as a locus of Incarnational power.

18. "Quibus omnibus manifeste cognouerunt quod huiuscemodi gloria non cuilibet sanctorum sed illi solum homini qui esset in diuinitate unigenitus a patre conueniret" (*Homiliae evangelii* 58–59).

19. "Et sancti quidem homines lux sunt recte uocati dicente ad eos domino: *Vos estis lux mundi;* et apostolo Paulo: *Fuistis aliquando tenebrae nunc autem lux in domino*" (*Homiliae evangelii* 55).

20. "Speremus nos per humanitatis eius sacramenta quibus inbuti sumus usque ad contemplandam diuinitatis eiusdem gloriam posse pertingere" (*Homiliae evangelii* 134).

21. See Kramer 8.

22. Regarding the Incarnational quality of sweet, poetic words, see my article "Consumption, Purgation, Poetry, Divinity," and Carruthers, *Experience of Beauty* 80–134.

23. As I will discuss, the "crux," as literal "cross" and as *Chi* of the holy name, drew together these elements of hypostasis and metonymic representation in a way that fully invested *chiasm* with Christological significance. It at once embodies the dynamism of the Incarnation-Ascension and the verbal quality of the Logos.

24. This vibrancy of things has been reintroduced, one could say, into Western philosophy, though it is important to point out that cultures around the world are rolling their eyes. Animisms of many kinds, from those of Indigenous societies to Buddhist ontology, have always held the world to be alive with multifarious sentience and agency. See, again, Todd for a recent critique of Western critical myopia. See also Smith and Kimmerer, for approaches to Indigenous and Western science.

25. Bede, *Ecclesiastical History* 4.24.

26. Translation my own. "Uerbis poeticis maxima suauitate et compunctione conpositis, in sua, id est Anglorum, lingua proferret" (Bede, *Ecclesiastical History* 4.24, p. 414).

27. The Irish tradition construes this relationship somewhat differently. Rather than a spatial relationship of traverse between the heavens and the earth, there is a timeline on which a saint reaches back to the "ancients" for wisdom and forward to the "angels" for salvation. It is striking, however, that both traditions manage to salvage the vernacular literary inheritance and harmonize it with Christianity. See Nagy, *Conversing with Angels and Ancients.*

28. Dumitrescu 46–48. That she traces close parallels between Cædmon's story and that of the mute youth, as well as between the latter and the story of Imma's chains being loosed by the recitation of liturgical language (4.22), corroborates what I have observed regarding Bede's practice of using mirrored passages to amplify a theme or set in motion a sequence of semiotic correspondences (such as the divine inspiration → vernacular poetry : eucharist → liturgical praise sequence, which implies a semiotic correspondence or even identity relation between God's presence in the Eucharist and both liturgical language and vernacular poetry). Bede habitually makes recourse to schematic formulations such as these, which in their formalism are "poetic" and in their devotion to the Word are Incarnational.

29. Dumitrescu (46) discusses this anecdote, which appears in the dedicatory epistle to Bede's verse *Life of Cuthbert.*

30. Bede's poetic healing also provides an articulation of the reflexive nature of poetry: it is not just any body part that his singing affects, but the very organ giving form to the song.

31. "Her sagað on þyssum halegum bocum be ælmihtiges dryhtnes godspelle, þe he him sylfum þurh his ða halegan mihte geworhte mannum to bysene ⁊ to lare. ⁊ he sylf gecwæð his halegan muðe: "þeah man anum men godspel secge, þonne bio ic þæronmiddan" (196). ("Here it talks in these holy books about the gospel of the almighty Lord, which he himself through his holy might made as an example for men and for their teaching. And he himself said with his holy mouth: 'Though you should speak the gospel to [just] one man, then am I there among you'"; trans. mine.)

32. Dumitrescu 44–45.

33. My reading of Bede's disparate moments as connected may seem forced, but it reflects his mode of writing and his conviction that history itself reflects the divine plan; there are no coincidences, and similar moments amplify revelation. Bede makes use of formal or structural signification in addition to more referential language.

34. There are four extant Old English poems that contain an embedded cryptographic "signature" spelling *Cynewulf*. Most readers take this to indicate the poet's name. See Bjork.

35. Gospel Homily 29, *XL homiliarum*, col. 1218; trans. Hurst 233.

36. The semantics of *freonoma* is slightly different from the account given in the dictionaries—it covers Latin *cognomen*, originally "nickname" but gradually a noble surname, but in the Old English corpus never refers without qualification to a surname or family name. In fact, it appears most frequently for names given by popes to English bishops. It also refers to a given name at least twice—Benedict and Cwenburh, both from the Old English Bede. The two uses I will discuss in this chapter are the sole evidence in the *Dictionary of Old English* entry for the sense "noble name." All the attestations of the word may be viewed using the Dictionary of Old English Web Corpus or the *Dictionary of Old English*.

37. Typological cross-temporality is a feature of orthodox exegesis as well. In an Incarnational poetic, however, such linkages are asserted through form. They are embodied, not expounded.

38. For my previous discussion of Blickling IX/Vercelli X, including this passage, see Beechy, *Poetics of Old English* 54–72.

39. See Robinson, Beowulf *and the Appositive Style*.

CHAPTER TWO

1. See, again, Cramp, "The Insular Tradition: An Overview" in Karkov et al. 283–99. See also Schapiro, *Language of Forms* 7–8 inter alia. For a recent account of the history of scholarship on Irish "oddity," see O'Loughlin 9–11. See also Wright, *Irish Tradition* 24–48.

2. Eco, Preface 12. Ælfric and Alcuin are obvious English detractors. On the continent, Benedict of Aniane and St. Jerome before him condemned the writing of Insular commentators, particularly the Irish. See Wright, *Irish Tradition* 38n159 and 41–42. As Suzanne Lewis paraphrases Benedict, he "warned against the intellectual tricks growing out of the overly subtle refinement, twisted logic, and verbal virtuosity practiced in the Trinitarian theology of the scholars of his day, 'maxime apud Scotos'" (140).

3. See Karkov and Brown, especially Webster; see also Karkov et al. Seeking to account for these elements, Leslie Webster (in Karkov and Brown

15) links both figural ambiguity, as when beasts morph into other beasts or into humans, and doubling, as when figures flank an object, mirroring each other on both sides, with apotropaic (protective) functions. Apotropaic power is amply present in a repurposed Christian stylistic language, in which twinned and ambiguous forms call forth the divine presence. Regarding the "baroque": while Eco applied *baroque* to Kells and I take up Gilles Deleuze's study of baroque style in chapter 3, I also want to acknowledge Emily Thornbury's work in progress on baroque style in early medieval literature.

4. Pulliam 23–31, inter alia. For comprehensive introductions to the Book of Kells, see Pulliam; Meehan; Henry; Farr; Schapiro, *Language of Forms*. I have sometimes drawn silently on observations common to several scholars.

5. For references to patristic treatments of the "double Incarnation" see Pulliam 28–29.

6. See Schapiro, *Language of Forms* 30–53.

7. Keefer was the first to suggest that these two images were meant to co-relate and that both may represent Christ ("Use of Manuscript Space" 103).

8. Keefer suggests that both images, the fish and the "bread," refer to the miracle of the loaves and fishes. That the disk is more likely meant to signify the Eucharist is suggested by the three dots in the center, which Keefer reads as the salt prescribed in many English rituals, but which often, as I will discuss below, signifies the fruit of the "true vine," Christ—an Incarnational reference.

9. See M. Brown, "Bearded Sages and Beautiful Boys."

10. In Greek the first letters of "Jesus Christ, Son of God, Savior" spell out the word for "fish," *IXΘΥΣ* (*ichthys*). See Augustine, *De civitate dei* (18.23). See also Meehan 50. Keefer rather dismisses this reading for the fish ("Use of Manuscript Space" 102), but Suzanne Lewis presents evidence for it among both patristic and Irish writers (144–45).

11. Keefer, "Use of Manuscript Space" 103, briefly touches upon this alike-but-different aspect of the Durham Ritual mirroring, relating it to the liturgical formulas of the pages' main text, also "related and yet unalike."

12. From pagan antiquity the flesh of the peacock was thought to resist corruption after death; this, along with the bird's splendor, may have provided the impetus for its association with Christ. See Meehan 57.

13. See Tilghman 295–96. Karkov has discussed crucifixion historiation of the letter *T* in Cambridge, Corpus Christi College (CCCC) 422, p. 53 ("Text and Image in the Red Book of Darley" 136).

14. See Schapiro, *Language of Forms* 7–27 and 128–55, for the similarly nonmimetic mixing of field and frame and figure. The notion that all artistic representation aspires to visual, literal verisimilitude is, in my view, one of the

grosser fallacies of the modern era, in medievalism and in literary studies, and has been abetted by bias toward classical ideals.

15. The Temptation page in particular has been the subject of ongoing speculation and debate, and one of the main points of difficulty may be attributed to its multimodality. See Ambrose, who represents a prominent vein of scholarship committed to whole-image consistency, a depiction of a single biblical event rather than some aspects of that event superimposed upon oblique typological and iconographic amplifications. Since exegetes had no trouble insisting upon several simultaneous levels of allegorical meaning, it seems unsurprising that visual exegetes should operate similarly.

16. A flabellum is a ceremonial fan used to keep pests away from the Eucharist.

17. I am by no means the first to read the incipits together as a coherent whole, and my account of these illustrations is heavily indebted to the work of Françoise Henry, Bernard Meehan, and Heather Pulliam in particular.

18. See Pulliam 209–10, for further discussion of Kells' display status and further references.

19. See B. Meehan 50–54; Pulliam 129–30.

20. Pulliam considers many of the lions in the manuscript, particularly those not clearly associated with Christ, to depict hostile entities, forces opposed to Christ or his followers. This may be accurate, but I am troubled by the frequent depiction of two lions to the left in images where there is a Christological lion to the right. An examination of all double lions in the major illuminated pages suggests, rather, that the double lions maintain the iconography of Christ's divinity and power and deploy it in a motif familiar from the Insular plastic arts, doubled beasts as guardians (Webster, in Karkov and Brown 18–19). The apotropaic function of the Eucharist and of the gospel is a prominent element in Kells.

21. See John 13:23, 19:26, 20:2, 21:7, 21:20.

22. It must be said that the seated posture of John looks more like a birth squat, an impression strengthened by the prominent hollow formed by his robes between his knees. It may be that in this portrait we have a visual depiction of the "pregnancy of the poet" motif that Amy Mulligan has documented in the Celtic tradition. It would be most fitting for John to be drawn in this way, birthing the gospel word just as Mary birthed Jesus.

23. Schapiro, *Language of Forms* 25. Schapiro observes the pen and the inkwell and notes the pen's contact with the frame. He also notes the contact of the book John holds in his hand with both the frame and John's halo. While he labels these details the product of "wit" and fine skill, he does not offer an interpretation.

24. See also Pulliam 185.

25. See also Karkov's discussion of the representation of John in textual forms (for example, display capitals that suggest his writings, not his person), in "Text and Image in the Red Book of Darley" 145.

26. "Nativitas XPI in Bethlem Judeae Magi munera offerunt et infantes interficiuntur Regressio" ("The birth of Christ in Bethlehem of Judæa; the wise men present gifts; the slaying of the children; the return"). See Sullivan 9.

27. See Pulliam 23–31, 192–93.

28. I quote from the fragment of *Solomon and Saturn I* in CCCC 41 (the other version is in CCCC 422), which ends where I have ended the quotation. I will be discussing CCCC 41, and this poem's place in that manuscript, in detail in chapter 5. If the Pater Noster letters stand in for Christ, as I argue, and further, as I argue in chapter 5, the purpose of the fragment is to demonstrate such Christological standing-in, then it is noteworthy that the fragment itself ends on *T*, sign of both cross and Christ.

29. CCCC 422 has *ierne*, "the angry one," an accusative direct object agreeing with the apparently uninflected *prologa prima*, the letter *P*. Anlezark glosses the CCCC 41 form *yorn* as a variant of *ierne*, but it is also readable as an uninflected adjectival root *georn*, "eager."

30. See my discussion in chapter 4, but suffice it to say that I would translate *prologo prim* as something like "the first one standing for the Logos."

31. The head also intersects the *iota*, another sacred letter.

32. Pulliam in particular emphasizes the equal, inextricable roles of word and image in the Book of Kells.

33. In Kells, again, these lions are often present on pages associated with Christ or the gospel in the world and often seem to underscore some kind of threat.

34. See Pulliam 23, for discussion and references.

35. I will discuss the mandorla more extensively in chapter 3.

36. An outlier is Schapiro, who speculates that the mice and the bread represent the hermits Paul and Anthony, who shared a loaf of bread in the desert (*Language of Forms* 188–89). For Schapiro, that the bread shared by the mice is the Eucharist indicates a "reconciliation of the hermit and the church," hence, perhaps, Irish asceticism and orthodoxy (189).

37. See Toner. Schapiro quotes the poem as well, with little commentary.

38. Trans. Toner.

Messe ocus Pangur bán,
cechtar nathar fria shaindán:
bíth a menmasam fri seilgg,
mu menma céin im shaincheirdd.

Caraimse fos, ferr cach clú,
oc mu lebrán, léir ingnu;
nī foirmtech frimm Pangur bán:
caraid cesin a maccdán.
Ō ru biam, scél cen scis,
innar tegdais, ar n-ōendís,
tāithiunn, dīchrīchide clius,
nī fris tarddam ar n-áthius.
Gnáth, hūaraib, ar gressaib gal
glenaid luch inna línsam;
os mé, du-fuit im lín chéin
dliged ndoraid cu ndronchéill.
Fūachaidsem fri frega fál
a rosc, a nglése comlán;
fūachimm chēin fri fēgi fís
mu rosc rēil, cesu imdis.
Fāelidsem cu ndēne dul
hi nglen luch inna gērchrub;
hi tucu cheist ndoraid ndil
os mē chene am fāelid.
Cia beimmi a-min nach ré
nī derban cách a chēle:
maith la cechtar nár a dán;
sugaigthius a óenurán.
Hē fesin as choimsid dáu
in muid du-ngní cach ōenláu;
du thabairt doraid du glé
for mu mud cēin am messe.
 (Toner 3–4)

39. The manuscript is CCCC 41 (11th c.), a manuscript that appears to have been deeply influenced by Irish learning.

40. The idea of many paths to the one truth is central to the abstruse work of Virgilius Maro Grammaticus, according to Vivien Law. See chapter 4.

41. For an introduction to the Ruthwell Cross, see Cassidy. For Bewcastle, see Page, "The Bewcastle Cross." See also Fred Orton, "Rethinking the Ruthwell and Bewcastle Monuments: Some Deprecation of Style; Some Consideration of Form and Ideology," in Karkov and Brown 31–67.

42. Most of the panels of the Franks Casket, a possible reliquary from the eighth century, feature animals as well. For the Franks Casket, see Webster, "The Iconographic Programme."

43. See Orton, in Karkov and Brown 48; Page, "The Bewcastle Cross" 38–41.

CHAPTER THREE

"No ideas but in things" is the famous maxim from the American poet William Carlos Williams. It appears in two of his poems, "A Sort of a Song" (2:55) and "Paterson" (1:263–66).

1. It may seem counterintuitive to resist a "Logocentric" reading of something that in fact has the Logos at its center, but, again, there are different ways of conceiving of this Logos. For the more authoritative orthodox tradition (and for both iconoclasts and "soft" iconophiles), Logos is a material absence and only a spiritual presence, from an earthly perspective, and surface must lead to transcendence. For another vein of thought (the strongly iconophilic), the Incarnation makes surface itself worthy of attention; the surface is suffused with Logos, as hypostatic presence. Another way of stating this is to say that Christ's dual nature is distinct from the way God suffuses creation generally. The Incarnation *glorified* Christ's humanity.

2. Here as elsewhere I assume a first-person perspective imaginatively aligned with that of the medieval audience. I do not intend by this to indicate any actual allegiance to doctrine on my part, nor do I assume any such allegiance on the part of the reader.

3. See B. Brown (all three works, but especially "Thing Theory" for an introduction); Paz, esp. 1–33.

4. Historicism has presented an ideological regime in medieval studies, underwriting a rather reductive and selective view of what often abstruse and heterogeneous cultural artifacts "must" mean and authorizing at the same time an avoidance of engagement with debates and advances in literary and cultural studies more broadly. See my review of Niles, *God's Exiles*, in *Modern Philology* 118, no. 1 (August 2020): https://www.journals.uchicago.edu/doi/10.1086/709508.

5. See also Greenblatt.

6. In his introduction to Adamnán, *De locis sanctis*, Denis Meehan proposes 679–82 for the years of Arculf's voyage (11). This is to say that Meehan takes Adamnán at his word, that Arculf really existed. O'Loughlin is not as certain about this and considers Arculf's function as literary device. It may be productive to think of Arculf alongside "Aethicus Ister," the supposed geographical informant of Pseudo-Jerome in the *Cosmographia* (see chapter 4). Where Adamnán's Arculf describes the holy lands, Aethicus describes the not-holy lands of the East.

7. From Bede, *De locis sanctis* 18.4–5, CCSL 175 279–80:

Haec de locis sanctis, prout potui, fidem historiarum secutus exposui et maxime dictatus Arculfi, Galliarum episcopi, quos eruditissimus in scripturis presbyter Adamnanus lacinioso sermone describens tribus libellis conprehendit. Siquidem memoratus antistes desiderio locorum sanctorum patriam deserens terram repromissionis adiit, aliquot mensibus Hierosolimis demoratus est ueteranoque monacho nomine Petro duce pariter atque interprete usus cuncta in circuitu, quae desiderauerat, auida intentione lustrauit. Nec non Alexandriam, Damascum, Constantinopolim Siciliamque percucurrit. Sed cum patriam reuisere uellet, nauis, qua uehebatur, post multos anfractus uento contrario nostram, id est Britaniorum, insulam perlata est, tandemque ipse post nonnulla pericula ad praefatum uirum uenerabilem Adamnanum perueniens iter pariter suum et ea, quae uiderat, explicando pulcherrimae illum historiae docuit esse scriptorem. Ex qua nos aliqua decerpentes ueterumque litteris comparantes tibi legenda transmittimus, obsecrantes per omnia, ut praesentis saeculi laborem non otio lasciui torporis, sed lectionis orationisque studio tibi temperare satagas. (For *laciniosus*, see Lewis and Short; see also Denis Meehan's introduction to Adamnán 6.)

[These things regarding the holy lands, insofar as I was able, I have reported following the reliable histories and largely the dictates of Arculf, bishop of the Gauls, which the priest Adamnán, most learned in the scriptures, transcribing in difficult discourse (*lacinioso sermone*), put into three books. The bishop recounted how, deserting his native land through yearning for holy places, he came to the land of redemption and, for some months, was delayed in Jerusalem, and with an old monk by the name of Peter as a guide and interpreter together on the journey, which he had desired, he traveled with eager intention. He passed through Alexandria, Damascus, Constantinople, and Sicily. But wishing to see once again his homeland, the ship by which he was borne, after many vagaries in adverse wind, conveyed him to our island, that is, Britain, and finally after no few small hazards came to the venerable man Adamnán. By relating his journey and those things he saw, he instructed/taught him [Adamnán] to be the writer of a most lovely history, from which we send you some excerpts to read along with comparable writings of authorities, beseeching in all, that you busy yourself to temper the work of the present age not with ignorant idleness but with the study of reading and speaking.]

8. See Wright, *Irish Tradition* 42–43.

9. "Hibernia autem et latitudine sui status et salubritate ac serenitate aerum multum Brittaniae praestat, ita ut raro ibi nix plus quam triduana remaneat; nemo propter hiemem aut faena secet aestate aut stabula fabricet iu-

mentis; nullum ibi reptile uideri soleat, nullus uiuere serpens ualeat" (1.1, p. 18).

10. "Nam saepe illo de Brittania adlati serpentes, mox ut proximante terris nauigio odore aeris illius adtacti fuerint, intereunt; quin potius omnia pene quae de eadem insula sunt contra uenenum ualent. Denique uidimus, quibusdam a serpent percussis, rasa folia codicum qui de Hibernia fuerant, et ipsam rasuram aquae inmissam ac potui datam talibus protinus totam uim ueneni grassantis, totum inflati corporis absumsisse ac sedasse tumorem" (1.1, pp. 18–20).

11. See Tom Conley's translator's foreword to Deleuze, xv.

12. For a book-length treatment of the *De locis sanctis* that considers, as I do, Adamnán's text to be a crafted theological text and not a straightforward travelogue, see O'Loughlin.

13. "Hinc ergo non neglegenter annotandum est quanti uel quaiis honoris haec electa et praedicabilis ciuitas in conspectu aeterni genitoris habeatur, qui eam sordidatam diutius remanere non patitur, sed ob eius unigeniti honorificantiam citius eam emundat, qui intra murorum eius ambitum sanctae crucis et resurrectionis ipsius loca habet honorifica" (42).

14. Muslim occupation in Jerusalem began in 638—within the lifetime of Adamnán, who was born around 624.

15. "Hoc mirabile oleum honorem protestatur Mariae matris Domini nostril Iesu Christi" (118).

16. Similarly, O'Loughlin reads the cleansing rains that come to Jerusalem after the market season sacramentally (35).

17. See, for extended treatments, Bynum, *Christian Materiality*; Chaganti, *Medieval Poetics of the Reliquary*.

18. *On the Song of Songs I*, Sermon 2, 8–15.

19. Bynum discusses late-medieval examples in which the exact measure of various parts of Christ, usually the side wound, constitutes a kind of relic—the physical, spatial measurement is a kind of contact with Christ's body (*Christian Materiality* 94–99).

20. For a recent discussion of the footprints, see Bynum, *Dissimilar Similitudes* 221–58.

21. *Palmtwig*, while functioning in Blickling as a kind of symbolic thing, a real object with symbolic resonance, functions in the Old English *Solomon and Saturn* poems as metaphor, metonym, and adjective, playing upon the term's associations with Christ as well as on the nature of signs themselves as they relate to the Word. See chapter 4 as well as my "The 'Palmtwigode' Pater Noster Revisited."

22. See Bynum, *Jesus as Mother* 133.

23. I sometimes decline to reproduce Morris's capitalization, as in the case of *Halga Gast*, which attributes a potentially misleading theological

specificity to the phrase as it may or may not refer to the Third Person of the Trinity. I likewise decline to reproduce the accent marks, though they are scribal.

24. For Mary as a container, see Bynum, *Christian Materiality* 86–93.

25. See chapter appendix.

26. I call this "antisemitism" in rejection of what I see as precious distinctions restricting a properly defined *antisemitism* to modernity. Jews have been blamed, oppressed, reviled, and murdered with the blessing of the state since at least the Roman era.

27. I do not generally distinguish between *object* and *thing* in this book, but note here the way in which these objects behave like things in the senses that thing theory emphasizes. They are not easily delineated by one term or sense. There is a remainder, a thickness and agency, to their presence. See B. Brown (all works); Bennett.

28. For the relation of the physicality of Catholic devotion to fetish in Chaucer, see Dinshaw. See also Gayk.

29. The Rothschild Trinity image is also clearly suggestive of a set of combined genitalia, a kind of hermaphroditic, complete cosmos.

30. Indeed, Karkov notes that "green is the colour that symbolizes life, the fertility of the earth and paradise," and that in Cambridge, Corpus Christi College 422, "it is used more specifically in the crucifixion miniature to identify the *tau* cross as a tree of life cross" ("Text and Image in the Red Book of Darley" 141). The cross on which Christ's body was crucified is also the tree of life symbolic of the natural world, and Mary serves as a reminder of his role in the natural processes of creation.

31. See Bynum, *Christian Materiality* 195–208, for discussion of the side wound, including its depiction as a vagina, esp. 361–62n54, for full references to the scholarly literature.

32. See Karkov, "Text and Image in the Red Book of Darley" 143, for discussion of a wound in a CCCC 422 Crucifixion image (page 53 of the manuscript) that similarly schematizes Christ's dual nature, resting "approximately half way between the hands of God and Mary."

33. It is overwhelmingly Christ himself, especially Christ in majesty, risen, ascended, or ascending; less frequently Mary and Christ are together. In one instance I have surveyed, from the *Old English Hexateuch*, the fallen Lucifer is surrounded by a mandorla that mirrors or inverts that of Christ, or God, in glory (BL Cotton MS Claudius B.iv [11th c.], fol. 2r, reproduced in Michelle Brown, *Manuscripts from the Anglo-Saxon Age* 128). For attempts to trace the history of the mandorla, see Brendel; Schapiro, "The Image of the Disappearing Christ"; Chang. Brendel stresses the function of the mandorla in representing the visual revelation of the divine (16), while Schapiro notes the importance of the act of seeing in early English repre-

sentations of the Ascension (150). Chang describes the Eastern origins of both the mandorla as a halo representing divine radiance and the motif of footprints attesting to the absent presence of the divine figure (originally the Buddha).

34. Sometimes the wound stands in for Christ's entire body, with hands and feet (Bynum 96). In some of the images Bynum considers, the mandorla is depicted among the *arma Christi*, the implements of Christ's torture, along with his clothing and the cross itself. These objects were associated with the physical reality of Christ's bodily suffering. In the image from Paris BN MS Fr. 574 (ca. 1320; Bynum 64), a completely abstract vertical mandorla is placed within the same frame as Christ's robe and loincloth, implying a link between the mandorla and Christ's flesh. Extreme wear of the mandorla indicates that it has been rubbed and kissed to the point of effacement.

35. For an introduction to the *Visio Pauli* in both Latin and Old English, see Healey.

36. See *Sir Gawain,* lines 2171–76.

37. Bede's account of the healing physical words from Irish books is another example.

38. See my *Poetics of Old English* 58–59.

39. As chapter 5 will also discuss, the bounded shape that contains something revelatory at the center structures other Incarnationally oriented manuscripts as well.

40. Krapp emends MS *surgum* to *sorgum* "sorrows." In light of Lockett's work on the "hydraulics" of mental distress in early medieval England, the MS reading seems at least possible. Here we have a context in which mental distress of exactly the kind Lockett describes, an intense roiling, is coupled with literal liquid in the imagery of the cross's bleeding. Similarly, this is a religious poem about an event (the Passion) that an English scribe and perhaps the poet would have read or heard about in Latin. Thus, when writing or composing, the very similar roots of Latin *surg-* and Old English *sorg-* would form a poetic nexus, a node of interlinguistic meaning. Given that coincidence and the fullness of possibility it represents, the MS reading is, I suggest, preferable, even though it represents a borrowing from Latin lexicalized in Old English. A bilingual, ambitraditional English cleric would have no trouble parsing it.

41. The image of celestial transit I take from Jodi Byrd's *Transit of Empire*, where it has central analytic force.

42. See Bayless, "The Fuller Brooch"; Bruce-Mitford. See also Ambrose.

43. Others note the presence of the Eucharistic wafer but do not connect it to the Incarnation through the senses. Barbara Raw does make the connection between the Eucharistic Host on the Fuller Brooch and the representation of the senses but does not identify the human figure as Christ Incarnate,

opting instead to read the presence of the Host as emphasizing "the spiritual implications of the senses" (73). See Raw 71–73.

44. Note, further, the ears and nose of the central figure. I do not think it is beyond the pale to note how lamblike this figure appears, even as compared to the other human figures on the brooch, whose ears and noses have a somewhat similar character.

CHAPTER FOUR

Epigraphs from Anlezark 64 and *Aldhelmi Opera* 149. Translations are my own. For Aldhelm Lapidge gives "tell what my name is." *Fungor* is a deponent verb that takes an ablative object. Its usual meaning is "make, do, perform, complete" (Lewis and Short).

1. See Law; Hansen; and Wright, "From Monks' Jokes to Sages' Wisdom." See also *Cosmography* xi–cxiii; Anlezark 12–41; and my "Wisdom and the Poetics of Laughter." See also Ziolkowski.

2. For a recent (and entertaining) account of play in the enigmatic tradition see Weaver.

3. See Harris and Reichl on prosimetric form.

4. As Mikhail Bakhtin explained, plural voices can be made to resolve into one (the *dialectic* so apparent to a Soviet intellectual) or allowed to proliferate and coexist, even in dissonant relations, as in the *dialogism* he credited in the novel.

5. See Wright, "From Monks' Jokes to Sages' Wisdom."

6. I have already acknowledged the long and often tendentious dispute over the extent or mere existence of Irish influence upon Western Christendom. Again, I am not primarily concerned with the "winners" in terms of what positions emerged as orthodox and official policy in the Carolingian empire and under subsequent monastic reforms. Rather, I am interested in the group of extremely interesting texts that show Irish "symptoms" and have been written off as outliers for their very interest as well as their heterodoxy, as though only the historical winners mattered.

7. Or, at the other end of the spectrum, sententious and obvious. I leave out of this discussion the gnomic tradition, whose statements are associated more with Old Testament wisdom than with New Testament Christology or soteriology.

8. Law accepts Herren's dating of circa 650, though, as she notes, proposals have ranged from the fifth to the ninth century (2–3).

9. Herren explains the term *Hisperic* as an alteration of *hespericum*, "of the land of the West," usually indicating Italy as opposed to Troy (*Hisperica Famina* 1:133). Though Herren dismisses the idea that the term could have

been a mangling of *hibernicum*, referring to Ireland, he does not consider the possibility that the Irish faminators were making a pun, referring to themselves as Hisperic, as Ireland was indeed a land of the (far) west. See also Herren's memorably titled "Hisperic Latin: Luxuriant Culture-Fungus of Decay."

10. *Hisperica Famina* 1:17. Hisperic style is the exact opposite of the Augustinian *sermo humilis* or plain style that helped to seed, in Auerbach's view, the western preference for realism. The validity of such a view aside, it is clear from the discomfort of western-trained scholars in either the Auerbachian or the exegetical tradition that the Irish tradition presents difficulties almost irreconcilable to the mind: "The whole history of Hisperic scholarship at times seems to vacillate between lunacy and despair" (Herren, *Hisperica Famina* 3). Rather than adjust expectations to the evidence of the texts, however, until recent decades the best recourse has been simply to sweep inconvenient texts out of sight.

11. Israel comprised twelve tribes, and Christ had twelve disciples. 144 (12 × 12) is, further, a number associated with the Apocalypse.

12. It may also be stressed that tenth-century "hermeneutic" Latin, with its Aldhelmian penchant for variety and copiousness, has Hisperic style as a precedent, though it is currently the fashion to see tenth-century trends as innovations linked to the Benedictine reform and thus in terms of rupture rather than continuity. See, for example, Niles, *God's Exiles*; and Weaver.

13. Weaver (47), who cites Lapidge on *Symphosius* as a nickname (Aldhelm, *Prose Works* 62n20). My discussion of Aldhelm's *enigmata* also owes much to Saltzman's article in *Speculum*. See also his book *Bonds of Secrecy: Law, Spirituality, and the Literature of Concealment in Early Medieval England* (Philadelphia: University of Pennsylvania Press, 2019), esp. 161–207.

14. Symphosius 621, line 7.

15. I do not follow Lapidge and Rosier's capitalization of pronouns.

16. See Wright, "From Monks' Jokes to Sages' Wisdom"; and my "Wisdom and the Poetics of Laughter" 136–37.

17. Aldhelm's rejection of the Castalian nymphs here is similar to the one that precedes his invocation of "verbum de Verbo" in the preface to the *Carmen de virginitate*, which I discussed in chapter 1. See Thornbury for a discussion of this trope in relation to English poets' reception of pagan literary motifs. Thornbury sees Aldhelm's rejection as both a claiming and a defanging of a pagan poetic form.

18. It is worth noting here that the *Enigmata* share this emphasis on the variety of creation in connection with wisdom and the learned tradition with another obscure wisdom text, the *Cosmographia of Aethicus Ister*, by Pseudo-Jerome, edited by Michael Herren. This work shares features of the Old English *Solomon and Saturn* dialogues and Aldhelm's riddles. The authorial

voice, "Jerome," expresses his "keen study" among the philosophers in a manner similar to the searching Saturn of the Old English dialogues. He frames his account of Aethicus's wide-ranging "cosmography" as concerning "ineffable creation" and its paradoxical (because *effed*) differentiation:

> God instituted the first beginning of all miracles, and in the first instance established the foundation miraculously and powerfully through his dispensation, when in his wisdom and with utmost effort he placed all creatures unseparated and incomposite into a structure with a single action; and those creatures that he made out of nothing he produced and extended in multiple form, and instantaneously all things in their diversity were gathered into one place like a high heap of new crops. As we have seen, he stored some seeds and various grasses joined together in a single pile of remarkable structure, and other grasses, having been winnowed, he divided into separate heaps. Thus he divided unformed matter into many species. And so, one and the same structure was drawn up into a single unformed mass; he divided this matter into many species. (*Cosmography* 3–5)

> [Primum omnium initium mirabiliorum Deus instituit, illudque fundamentum principaliter posuit sua dispensatione mirabiliter atque potenter, quando omnes creaturas indiuisas atque inconpositas in sua sapientia in aedificium summopere in unam ergatam instituit; atque eas quas ex nihilo fecit multipliciter prolatas dilatauit, et omnes creaturas quas ex nihilo fecit incunctanter omnia quasi aceruum eminentem nouorum frugum diuersaque in unum collecta. Nonnulla recondere semina, ut uidimus, in unam congeriem, gramina disparilia mira structura coaptata, et alia uentilata separatim diuidere gramina. Materiam autem informem sic in multas species diuisit. Vnam itaque atque idem statuam in una massa informe fuisse institutam; ipsam autem materiam in multas species diuisit.] (*Cosmography* 2–4)

The *Cosmographia* furthermore clearly shares the ethic of pluralism of Virgilius's grammars, as Aethicus explains that he has opted to document what the scriptures and authorities have left out about the world and encourages his readers to pick and choose what may seem useful to them, to exercise discernment among his copia.

19. The Latin reads:

> Creatura
> Conditor, aeternis fulcit qui saecla columnis,
> Rector regnorum, frenans et fulmina lege,
> Pendula dum patuli vertuntur culmina caeli,

Me varium fecit, primo dum conderet orbem.
Pervigil excubiis: numquam dormire iuvabit,
Sed tamen extemplo clauduntur lumina somno;
Nam Deus ut propria mundum dicione gubernat,
Sic ego complector sub caeli cardine cuncta.
Segnior est nullus, quoniam me larbula terret,
Setigero rursus constans audacior apro;
Nullus me superat cupiens vexilla triumphi
Ni Deus, aethrali summus qui regnat in arce.
Prorsus odorato ture flagrantior halans
Olfactum ambrosiae, necnon crescentia glebae
Lilia purpureis possum conexa rosetis
Vincere spirantis nardi dulcedine plena;
Nunc olida caeni squalentis sorde putresco.
Omnia, quaeque polo sunt subter et axe reguntur,
Dum pater arcitenens concessit, jure guberno;
Grossas et graciles rerum comprenso figuras.
Altior, en, caelo rimor secreta Tonantis
Et tamen inferior terris tetra Tartara cerno;
Nam senior mundo praecessi tempora prisca,
Ecce, tamen matris horno generabar ab alvo
Pulchrior auratis, dum fulget fibula, bullis,
Horridior ramnis et spretis vilior algis.
Latior, en, patulis terrarum finibus exto
Et tamen in media concludor parte pugilli,
Frigidior brumis necnon candente pruina,
Cum sim Vulcani flammis torrentibus ardens,
Dulcior in palato quam lenti nectaris haustus
Dirior et rursus quam glauca absinthia campi.
Mando dapes mordax lurconum more Ciclopum,
Cum possim iugiter sine victu vivere felix.
Plus pernix aquilis, Zephiri velocior alis,
Necnon accipitre properantior, et tamen horrens
Lumbricus et limax et tarda testudo palustris
Atque, fimi soboles sordentis, cantarus ater
Me dicto citius vincunt certamine cursus.
Sum gravior plumbo: scopulorum pondera vergo;
Sum levior pluma, cedit cui tippula limphae;
Nam silici, densas quae fudit viscere flammas,
Durior aut ferro, tostis sed mollior extis.
Cincinnos capitis nam gesto cacumine nullos,
Ornent qui frontem pompis et tempora setis,

Cum mihi caesaries volitent de vertice crispae,
Plus calamistratis se comunt quae calamistro.
Pinguior, en, multo scrofarum axungia glesco,
Glandiferis iterum referent dum corpora fagis
Atque saginata laetantur carne subulci;
Sed me dira famis macie torquebit egenam,
Pallida dum iugiter dapibus spoliabor opimis.
Limpida sum, fateor, Titanis clarior orbe,
Candidior nivibus, dum ningit vellera nimbus,
Carceris et multo tenebris obscurior atris
Atque latebrosis, ambit quas Tartarus, umbris.
Ut globus astrorum plasmor teres atque rotunda
Sperula seu pilae necnon et forma cristalli;
Et versa vice protendor ceu Serica pensa
In gracilem porrecta panum seu stamina pepli.
Senis, ecce, plagis, latus qua panditur orbis,
Ulterior multo tendor, mirabile fatu;
Infra me suprave nihil per saecula constat
Ni rerum genitor mundum sermone coercens.
Grandior in glaucis ballena fluctibus atra
Et minor exiguo, sulcat qui corpora, verme
Aut modico, Phoebi radiis qui vibrat, atomo;
Centenis pedibus gradior per gramina ruris
Et penitus numquam per terram pergo pedester.
Sic mea prudentes superat sapientia sofos,
Nec tamen in biblis docuit me littera dives
Aut umquam quivi, quid constet sillaba, nosse.
Siccior aestivo torrentis caumate solis,
Rore madens iterum plus uda flumine fontis;
Salsior et multo tumidi quam marmora ponti
Et gelidis terrae limphis insulsior erro,
Multiplici specie cunctorum compta colorum,
Ex quibus ornatur praesentis machina mundi,
Lurida cum toto nunc sim fraudata colore.
 Auscultate mei credentes famina verbi,
Pandere quae proterit gnarus vix ore magister
Et tamen infitians non retur frivola lector!
Sciscitor inflatos, fungar quo nomine, sofos.
 (Aldhelm, *Aldhelmi Opera* 145–49)

20. The indispensable edition, with full discussion of the manuscripts and comprehensive bibliography, is Anlezark. A later Solomon and Saturn di-

alogue was published separately along with a closely analogous *Adrian and Ritheus* in 1982 (Cross and Hill).

21. I leave out of this discussion a fifth, later Solomon and Saturn dialogue, as does Anlezark. That dialogue, in prose, is found in the Southwick codex (12th c.) of the *Beowulf* manuscript, BL MS Cotton Vitellius A.xv, where it is joined by a copy of the Old English translation of Augustine's *Soliloquies* and a copy of the Old English apocryphal *Gospel of Nicodemus*. This prose *Solomon and Saturn* is edited by Cross and Hill.

22. Anlezark's 2009 edition allowed scholars to view the various texts as mutual context for one another in print for the first time, and digital access to the two main manuscripts is now available via the Parker Library on the Web, hosted by Stanford University. Just as the Solomon and Saturn dialogues have more in common across texts than their two interlocutors, the two Corpus Christi College manuscripts, 41 and 422, do as well. The history of *Solomon and Saturn*'s piecemeal publication has obscured the fact that these texts are paired with the same kind of material in their two manuscripts—material so similar, in fact, that Raymond Grant posited a common source. See Grant, *Cambridge, Corpus Christi College 41* 50. See also Hohler's energetic rebuttal.

23. See Carey.

24. Significantly, "se gepalmtwigoda pater noster" is in the nominative, making it not the object of *sohte* but a copulative predicate: "hwylc wære . . . se gepalmtwigoda pater noster" ("I sought still what might be, by virtue of courage or power or wealth, the palmtwigged Pater Noster.") The implication is that the Pater Noster is something elusive, hidden in other forms and attributes, something to be perceived through careful looking. Something very much like the Logos.

25. "Hungor he ahieðeð, helle gestrudeð, / wylm toweorpeð, wuldor getimbreð. / He is modigra middangearde, / staðole strengra ðonne ealra stana gripe" (lines 73–76; Anlezark 66).

26. "He bið seofan snytro ond saule hunig / ond modes mealc" (lines 66–67a; Anlezark 66).

27. CCCC 41 has *prologo prim*, and CCCC 422 *prologa prima*. Both readings are difficult, and I suggest that *prologo prim* records a punning attempt to convey that *P* is the first ("prim") letter to stand "pro Logo"—for the Logos—while the latter manuscript has smoothed out the locution to make it more Latinate, turning *prologo* into a recognized Latin word, *prologa*, whose sense can just be forced to fit the context. *P* can be read as the "prologue" or first utterance, one supposes, though *prima* is thus rendered redundant. It seems certain that the scribes were grappling with the difficulties of the enigmatic language and not simply copying blindly. See Anlezark's discussion, 50–51 and 107.

28. The passage's schematic use of counterpoint is also analogous to Aldhelm's *Creatura* riddle (*Enigma* 100), with its pairs of opposites, and to the set of oppositions in the Irish *Pangur Bán* poem (see chapter 2).

CHAPTER FIVE

1. See, in addition to Bahr, Nichols and Wenzel, and Johnson and Van Dussen. With thanks to Sharon Rowley. In the context of Old English, Mary Rambaran-Olm, John D. Niles, and Brian O'Camb have advanced codicological readings of or within the Exeter Book. See Rambaran-Olm, *John the Baptist's Prayer* 58–59.

2. Assemblages capture the arrangements that coalesce under variable framing. The classic work is Deleuze and Guattari. See also Bahr 37–38. Books on a library shelf, posts on a website, items entered at different times in a codex all take on variable significance as members of different assemblages. For example, *Beowulf* signifies differently depending on whether you place the poem amid archaeological evidence from Scandinavia; historical narrative from English kingdoms between the eighth and tenth centuries; long epic poems from around the world; or with its manuscript fellows: a saint's life, fantastical travel narratives about the East, and a retelling in heroic verse of the deuterocanonical Book of Judith.

3. In presented but not yet published work, Sharon Rowley, whose edition of CCCC 41 is forthcoming, has suggested, following Stokes (142), the southwest of England—perhaps Crediton—as the likely place of origin. Rowley also notes the manuscript's "western-facing" Irish emphasis. Her edition of the main text of the manuscript is forthcoming; the marginalia in their entirety have never been edited. I completed a transcription and translation of the marginalia in the course of research for this chapter and plan to publish an edition.

4. See Ker, along with James; Grant, *Cambridge, Corpus Christi College 41* 1–4; O'Keeffe, *Visible Song* 72–75; Anlezark 5–6; Rowley 23–24; and Budny 501–24.

5. Patricia O'Connor's doctoral work and publications, however, argue for an essential relationship between the main text and the marginalia in CCCC 41. Karin Olsen, on the other hand, finds not much connection between the two at all.

6. See, for instance, Keefer, "Margin as Archive"; Grant, both titles; Bredehoft; R. Johnson; Jolly, "On the Margins"; and O'Connor.

7. See also Bredehoft; Grant, *Cambridge, Corpus Christi College 41*; and Keefer, "Margin as Archive."

8. The resemblance in my description to a reliquary, which holds the holy within, is intentional.

9. Keefer, "Margin as Archive" 147–51.

10. It may be that the Easter service was well represented in the compiler's other liturgical books, and so only supplementary texts were recorded here. Nevertheless, once certain texts are chosen and set down, they take on their own life as part of the present compilation.

11. See Rauer 18–25. The manuscripts are: London, BL Add. 23211, fol. 2; London, BL Cotton Julius A.x, fols. 44–175; Cambridge, Corpus Christi College 196 1–110; London, BL Cotton Vitellius D.vii, fols. 131r–132r; CCCC 41 122–32; London, BL Add. 40165 A.2, fols. 6–7; London, BL Harley 3271, fol. 92v.

12. I transcribe from the manuscript and the translation is mine, but the text and translation are printed in Rauer 34–35.

13. uirgo maria spiritus sancti cooperatione concepit . Ut quod angelica nuntiauit sublimitas uirginea crederet puritas . ineffabilis perficeret deitas illius itaque; obtamus te opitulanti cernere faciem sine confusione . cuius Incarnationis gaudemus sollemnitate (135)
prope esto domine et omnipotens . Excita quaesimus domine potentiam tuam et ueni (136)
Ueni et ostende nobis faciem tuam domine. (138)

14. An alternative reading takes *hic* adverbially: "and in the form of the ailing the Lord walked here among us." With thanks to Charles D. Wright.

15. I take the term *mashup* from music mixing, where two (or more) elements are combined to form a new composition. Like in sampling, the mashed-up elements carry references to their original contexts—at least for an audience familiar with those contexts. But the mashup is not determined exclusively by those contexts. It is not a mere sum of its parts. The Incarnation itself is a kind of mashup, a union between God and man, something I am arguing the compiler sought to express through the mise-en-page evident in CCCC 41.

16. See *Anglo-Saxon Minor Poems* 125 (charm 8). Also printed in Storms as item 1, 132.

17. See Jolly, "On the Margins" 148–53, esp. notes 49–50 for bibliography. For additional work see O'Connor.

18. Translation mine in consultation with Jolly, "On the Margins" 150, with thanks to Charles D. Wright for suggestions. It should be clear that I am a light editor of my Latin transcriptions. "Corporis tu" should obviously read "corporis tui," for example, but I consider it more important to allow a reader to perceive the actual character of the compiler's Latinity than to maximize legibility. In other words, I am not producing an edition but curating a

critical reading experience that countenances opacity and confusion, under a digital dispensation in which apparatus of all kinds are but a click away.

19. O'Connor separates the Latin text into collect (recited by all) and secreta (recited by the officiant), and reads both the Latin and Old English portions as complements to the main Bedan text, from book 3, chapter 17, which "recounts how King Æthelwald asked Bishop Cedd to accept a grant of land and build a monastery upon it, and how upon accepting Bishop Cedd consecrated the land through prayer and fasting" (51). Bredehoft considers the *Wið ymbe* text to be the earliest layer of the marginalia, and it is fascinating to imagine a scenario in which O'Connor's thesis is correct: these texts bless the earth, and were inserted in the margin to flesh out, as it were, Bede's account of Cedd's blessing, whereupon this mashup then, subsequently, became the anchor in a compilational scheme devoted to the Word.

20. Jolly provides a good bibliography for this group and a brief but cogent discussion ("On the Margins" 154–61). See also Patricia O'Connor's forthcoming article, "The Curious Incident of the Cattle Theft Charms in the Margins of Cambridge, Corpus Christi College 41."

21. For an attempt, with careful and accurate descriptions of the evidence, see Jolly, "On the Margins" 158.

22. Printed in *Anglo-Saxon Minor Poems* 125–26 (charm 9). Also printed in Storms as item 15, 208–10.

23. Printed in *Anglo-Saxon Minor Poems* 126 (charm 10). Also printed in Storms as item 13, 206.

24. Dictionary of Old English Web Corpus.

25. See also Jolly, "On the Margins" 156n70 and 157. Parts of the text extant elsewhere are missing, such as the last half of the last line of the *Ymnos* stanza, which should read, "docetque substantiam" ("and teaches [one] substance"). This version has left out the single substance shared by the Trinity. A possible, very speculative reason would be that the present context seeks to emphasize Christ's unique Incarnate substance, which he shares with creation. It should be noted, too, that the hymn is abecedarian (we have the XYZ stanzas here), so its inclusion represents yet another grammatically, "literally" oriented text. With thanks to Charles D. Wright for some corrections.

26. See Jolly, "On the Margins" 158n93 for references.

27. I argue that the excerpt of the Hymn fits the present scheme even given the tradition Jolly cites, according to which the last three stanzas circulated independently as a blessing on the authority of Patrick himself (158).

28. Jurasinski et al. 187. Andreas was the first disciple, the first who had to "find" and recognize the Lord as the Lord.

29. I do not want to dismiss the possibility that "crux iacob" is a kind of epithet, however, in light of other charms that invoke the cross along with

some figure other than Christ. For example, the so-called *Æcerbot* charm in British Library MS Cotton Caligula A.vii (Storms item 8, 172–77; *Anglo-Saxon Minor Poems* 116–18) invokes "Crux Matheus, crux Marcus, crux Lucas, crux sanctus Iohannes" (*Anglo-Saxon Minor Poems* 117), though this is in a ritual context of placing four "signs of Christ" ("Cristes mæl") made out of wood into holes in the ground. Are the crosses therefore in a posessive relationship with the four evangelists, or is the cross (of Christ) addressed each time, along with another of the four evangelists, thus eliciting their intercessory aid? In any case, it does seem another degree more strained to use Old Testament figures in any kind of possessive relation to the cross, but perhaps no more strained than staging a debate between the biblical King Solomon and the pagan Saturn.

30. Though undoubtedly it would be hard to find a parallel for this apparently "negative" treatment of the patriarchs, they are being referenced here as obscurers, and obscuring is a vital function on the path to salvific revelation in the wisdom tradition. Concealing is revealing. The patriarchs may obscure the truth if we stop with them, but if we continue on, they have helped reveal the Word.

31. I am not trying to resurrect New Criticism in suggesting this kind of harmony and completeness, but I do think that seeking readings that make sense of immediate contexts is preferable to (often source-studies-based) modes that insist upon discrete textual integrity at the expense of immediate context.

32. See Grant's introduction to *Three Homilies* 1–12. See also Volmering.

33. I am thus following Jolly to some extent in reading *amedatio* as a version of *a mendacio*, a suggestion she in turn takes from Hohler (Jolly, "On the Margins" 163; Hohler 278). It is a difficult crux. Karl Jost suggested the following reconstruction of the line: "sic per verba emendatio sit" ("thus through [these] words a cure shall be effected"; 104). With thanks to Charles D. Wright.

34. No doubt "nec in meridiano" is a reference to the "noonday demon" of acedia, the depression that could plague monastic life. See Wenzel, with thanks to Charles D. Wright.

35. See Jolly, "On the Margins" 163–67.

36. Jolly briefly mentions the possibility that the choice of the passages is for the lexeme *dextera*: "Perhaps these verses become linked because of their repetition of 'dextera' and their common theme of God's power exalting and protecting" ("On the Margins" 164).

37. Recall, too, the importance of locales in the *De locis sanctis* of Adamnán (and Bede).

38. See T. Hall for an overview of the moralistic but widely varying depictions of body and soul in early medieval homiletics and theology.

39. For a rich and lucid discussion of these behaviors of the soul and body, see Lockett 30–41, inter alia.

40. Charles D. Wright (personal communication) suggests emending to "hrefne sweart," for "raven black."

41. See also Wright, *Irish Tradition* 262 and following.

42. For the theme of transformation in relation to liturgical prayer and the sacrament of the Eucharist, see also Karkov, "Text and Image in the Red Book of Darley" 143.

43. See A. Hall; and Jolly, *Popular Religion.*

44. See Grant, *Three Homilies* 13–16; Clayton, *Cult of the Virgin Mary* 232–35, for background to the *Transitus/Assumptio Mariae* tradition in early medieval Britain. The version of the homily in CCCC 41 and Blickling Homily XIII are textually distinct, though they share basic narrative features.

45. For background, see Clayton, "Delivering the Damned."

46. Latin (from Greek) *maenomenon mel* denotes honey, and it is possible that MS *manu-* conveys a word for mead, since it succors *aridorum,* the parched. See Kelhoffer. Jolly gives "the poor" for *aridorum,* presumably following variants in other manuscripts ("On the Margins" 165). See Jolly, "On the Margins" 165–67, for her treatment of these formulas, including list of variants.

47. See Jolly, "On the Margins" 167–70; and Grant, *Cambridge, Corpus Christi College 41* 18–22, for exposition and discussion of the SATOR palindrome as well as references. See also Ernst.

48. See as well Jolly's discussion, "On the Margins" 170–72. Full text and translation are printed in chapter appendix 3, Storms, item 16, 216–19; *Anglo-Saxon Minor Poems* 126–28. As is no doubt clear by this point, I have no great investment in nice distinctions between "prayers" and "charms" as representing orthodox Christian practice opposed to pagan residues in folk practice. For a study that considers charms themselves as liturgical, see Arthur.

49. Since the lines are irregular, I opt here to print not according to metrical lines but according to rhetorical units. This has the advantage of rendering parallel structures especially visible. See *Anglo-Saxon Minor Poems* or Storms for a more traditionally lineated edition. I take the concept of "movements" in Old English verse from Carol Braun Pasternack's important study of form and texture in Old English poetry.

50. A merism is a word or phrase pairing that breaks a whole into two complementary or contrasting parts.

51. See Maring 114–25 for a discussion of the *navis crucis* in relation to Old English literature and Christian typology.

52. Watkins; Dictionary of Old English Web Corpus; Bosworth and Toller.

53. Yet another possibility lies in the partial homophone *blæːd* with a long vowel, which denotes a blowing, breath, wind, or spirit. It is derived from a separate Indo-European root and is cognate with *blawan* ("to blow"). It seems unlikely in context that the king, reporting what he *sees*, describes the "spirit" of the angel, but it is a possibility.

54. The text here is altered from the more usual "ut quae ore contingimus pura mente capiamus" ("so that what we touch with our mouth we may grasp with a pure mind"). With thanks to Charles D. Wright.

55. The text is edited and translated by Grant, *Three Homilies* 56–67. For hybridity in Old English literature, see Garner. See also Maring.

56. I will not transcribe the incipits here, as they are incipits only and the manuscript is freely available for viewing in digital form via the Parker Library on the Web.

57. Examples include the treaty of Alfred and Guthrum in 878 and the treaty of Æthelred and Olaf Trygvasson (a confirmation rather than a conversion-baptism) in 994.

58. The homily is edited and translated by Grant, *Three Homilies* 80–101.

59. See Budny 523; Grant, *Three Homilies* 3–4.

60. See Grant, *Three Homilies* 3–4, esp. note 4 for further references.

CONCLUSION

CCCC 41 483; edited in Robinson, "Bede's Envoi" 12–14.

1. I cite Robinson's edition of all three colophons for convenience but decline to adopt all his capitalization or other editorial conventions.

2. Robinson, focusing on the rhetoric linking all three colophons in a chain of "I ask's" or "ic bidde's," which he took to indicate that all were in the voice of Bede, played down the distinctiveness of this metrical denouement and the profound shift in focus that it performs.

3. See also Gameson 22–23.

4. See Lockett; Niles, *God's Exiles*; O'Camb (all works); and O'Keeffe, *Stealing Obedience*.

5. Though this book has focused on an Incarnationalism in some ways at odds with reformist orthodoxy, the enigmatic poetics of the Exeter Book, associated by Niles and O'Camb with Benedictine Reform monasticism, may also be seen to partake of this tradition of poetic participation in the enigma of the Word. Certainly a fruitful line of inquiry would be to explore the relationships between O'Camb's and Niles's "monastic poetics" and the Incarnational poetics that developed before and outside of the reform movement. It

would enrich our understanding of the ways that tradition and innovation (existing praxis and reformist imperatives) interacted.

6. As Bynum (*Christian Materiality*) has shown, much later cloistered practice also diverged from what we might expect based on theological tracts as guides to praxis. Brandon Hawk's 2018 work on apocryphal homilies argues much the same thing, that apocrypha were not marginal but central to preaching and practice in early medieval Christianity, particularly the decentralized Christianity of Britain.

7. See Noble 17–18.

WORKS CITED

PRIMARY WORKS

Printed Sources

Ælfric. *Catholic Homilies*. The First Series. Early English Text Society, Second Series 17. Oxford: Oxford University Press, 1997.

Acts of Nicea. *Sacrorum Conciliorum nova et amplissima Collectio*. Vol. 13. Edited by Giovanni Domenico Mansi. Florence: n.p., 1867. Translated by Daniel J. Sahas in *Icon and Logos: Sources in Eighth-Century Iconoclasm* (Toronto: University of Toronto Press, 1986).

Adamnán. *De locis sanctis*. Edited by Denis Meehan. Scriptores Latini Hiberniae 3. Dublin: Dublin Institute for Advanced Studies, 1958.

Alcuin. Letter to Hygbald. *Epistolae Karolini Aevi II*. Monumenta Germaniae Historica, Epistolae 4. Edited by E. Dümmler. 181–84 (no. 124). Berlin: Weidmann, 1895, 1957, repr. 1994. Translated by Donald A. Bullough in "What Has Ingeld to Do with Lindisfarne?" *Anglo-Saxon England* 22 (1993): 122–25.

Aldhelm. *Aldhelmi Opera*. Monumenta Germaniae Historica, Auctores Antiquissimi 15. Edited by Rudolf Ehwald. Berlin: Weidmann, 1961.

———. *The Poetic Works*. Translated by Michael Lapidge and James Rosier. Cambridge: D. S. Brewer, 2009.

———. "The Prose *De virginitate*." In *The Prose Works*, translated by Michael Lapidge and Michael Herren, 59–132. Cambridge: D. S. Brewer, 2009.

Anglo-Saxon Minor Poems. Anglo-Saxon Poetic Records VI. Edited by Elliott Van Kirk Dobbie. New York: Columbia University Press, 1942.

Anlezark, Daniel, ed. and tr. *The Old English Dialogues of Solomon and Saturn*. Anglo-Saxon Texts 7. Cambridge: D. S. Brewer, 2009.

Augustine. *De civitate dei: Libri XI–XXII*. Corpus Christianorum, Series Latina 48. Edited by B. Dombart and A. Kalb. Turnhout: Brepols, 1955.

————. *Confessionum: Libri XIII.* Corpus Christianorum, Series Latina 27. Edited by Lucas Verheijen. Turnhout: Brepols, 1981. Translated by Gary Wills as *Saint Augustine*: Confessions (New York: Penguin Classics, 2006).

————. *In Iohannis evangelium tractatus.* Corpus Christianorum, Series Latina 124. Edited by R. Williams. Turnhout: Brepols, 1954. Translated by John Rettig as *Tractates on the Gospel of John* (Washington, DC: Catholic University of America Press, 1988).

————. *De Trinitate: Libri XV.* Edited by W. J. Mountain. Corpus Christianorum, Series Latina 50 and 50A. Turnhout: Brepols, 1968. Translated by Edmund Hill as *The Works of Saint Augustine: The Trinity* (Hyde Park, NY: New City Press, 1991).

Azarias. In *The Exeter Book*, Anglo-Saxon Poetic Records III, edited by George Philip Krapp and Elliott Van Kirk Dobbie, 88–94. New York: Columbia University Press, 1936.

Bede. *Ecclesiastical History of the English People*, edited and translated by Bertram Colgrave and R. A. B. Mynors. Oxford: Oxford University Press, 2007.

————. *Homiliae evangelii.* Corpus Christianorum, Series Latina 122. Edited by David Hurst. Turnhout: Brepols, 1955. Translated by Lawrence T. Martin and David Hurst as *Homilies on the Gospels.* 2 vols. (Kalamazoo, MI: Cistercian, 1991).

————. Life of Cuthbert. *Bedas metrische Vita s. Cuthberti.* Edited by Werner Jaager. Leipzig: Mayer, 1935.

————. *De locis sanctis.* Corpus Christianorum, Series Latina 175. Edited by J. Fraipont. Turnhout: Brepols, 1965.

————. On the Song of Songs *and Selected Writings.* Translated and edited by Arthur Holder. New York: Paulist Press, 2011.

The Beowulf *Manuscript: Complete Texts and the* Fight at Finnsburg. Edited and translated by R. D. Fulk. Dumbarton Oaks Medieval Library. Cambridge, MA: Harvard University Press, 2010.

Klaeber's Beowulf. 4th ed. Edited by R. D. Fulk, Robert E. Bjork, and John D. Niles. Toronto: University of Toronto Press, 2008.

Bernard of Clairvaux. *On the Song of Songs I.* Kalamazoo, MI: Cistercian, 1971.

Bernardus Silvestris. *Commentary on the First Six Books of Virgil's* Aeneid. Translated and edited by Earl G. Schreiber and Thomas E. Maresca. Lincoln: University of Nebraska Press, 1979.

Biblia Sacra: Iuxta Vulgatam Versionem. Edited by Roger Gryson, Robert Weber, and Bonifatius Fischer. 4th ed. Stuttgart: Deutsche Bibelgesellschaft, 1994.

Blickling Homilies. Edited by R. Morris. Early English Text Society, Original Series 58, 63, 73. Oxford: Oxford University Press, 1967.

Boethius. *Philosophiae consolatio.* Corpus Christianorum Series Latina 94. Edited by L. Bieler. Turnhout: Brepols, 1984. Translated by Richard Green as *The Consolation of Philosophy* (New York: Macmillan, 1962).

Christ II. In *The Exeter Book,* Anglo-Saxon Poetic Records III, edited by George Philip Krapp and Elliott Van Kirk Dobbie, 15–27. New York: Columbia University Press, 1936.

Cosmography of Aethicus Ister: Edition, Translation, and Commentary. Edited by Michael Herren. Publications of the Journal of Medieval Latin 8. Turnhout: Brepols, 2011.

Cross, J. E., and T. D. Hill, eds. *The Prose Solomon and Saturn and Adrian and Ritheus.* Toronto: University of Toronto Press, 1982.

The Dream of the Rood. In *The Vercelli Book,* Anglo-Saxon Poetic Records II, edited by George Philip Krapp, 61–65. New York: Columbia University Press, 1932.

Gerald of Wales. *Giraldi Cambrensis Opera.* Vol. 5. Edited by James F. Dimock. London: Longman's, 1867. Translated by John J. O'Meara in *History and Topography of Ireland* (New York: Penguin, 1982).

Gregory the Great. *Registrum Epistularum Libri VIII–XIV, Appendix.* Corpus Christianorum, Series Latina 140A. Edited by Dag Norberg. Turnhout: Brepols, 1982. Translated by John R. C. Martyn in *The Letters of Gregory the Great,* vol. 3 (books 10–14). Medieval Sources in Translation 40 (Toronto: Pontifical Institute of Medieval Studies, 2004).

———. *XL homiliarum in Evangelia in libri duo.* Vol. 2. *Patrologia Latina* 76. Edited by J. P. Migne. Paris: n.p., 1849. Translated by David Hurst as *Forty Gospel Homilies,* Cistercian Series 123 (Kalamazoo, MI: Cistercian, 1990).

Hisperica Famina. 2 vols. Edited and translated by Michael Herren. Toronto: Pontifical Institute of Medieval Studies, 1974 and 1987.

Isidore of Seville. *Etymologiarum sive Originum libri XX.* 2 vols. Edited by W. M. Lindsay. Oxford: Oxford University Press, 1911. Translated and edited by Stephen A. Barney, W. J. Lewis, J. A. Beach, and Oliver Berghof as *The "Etymologies" of Isidore of Seville* (Cambridge: Cambridge University Press, 2006).

Jerome. "Liber interpretationis hebraicorum nominum." *S. Hieronymi Presbyteri Opera.* Corpus Christianorum, Series Latina 72. Edited by P. de Lagarde, G. Morin, and M. Adriaen. Turnhout: Brepols, 1959.

Langland, William. *Piers Plowman.* 2nd ed. Edited by A. V. C. Schmidt. Research in Medieval Culture 10. Kalamazoo, MI: Medieval Institute, 2011.

Leo I. *Tractatus LXXIV: De ascensione Domini* 4. *Tractatus septem et non-aginta.* Edited by A. Chavasse. 2 vols. Corpus Christianorum, Series Latina 138–38A. Turnhout: Brepols, 1973.

Lucretius. *On the Nature of Things.* Edited and translated by W. H. D. Rouse, revised by M. F. Smith. Cambridge, MA: Harvard University Press, 1924.

Messe ocus Pangur Bán. Edited and translated by Gregory Toner in "Messe ocus Pangur Bán: Structure and Cosmology," *Cambrian Medieval Celtic Studies* 57 (2009): 1–22.

Ohlgren, Thomas H., ed. *Anglo-Saxon Textual Illustration.* Kalamazoo, MI: Medieval Institute, 1992.

Old English Martyrology: Edition, Translation, and Commentary. Edited and translated by Christine Rauer. Anglo-Saxon Texts 10. Cambridge: Boydell and Brewer, 2013.

Origen. *On First Principles.* Translated by Rowan Greer. New York: Paulist Press, 1979.

Patrologia Latina, vol. 121. Edited by J. P. Migne. Paris: Garnier, 1880.

Prudentius. *The Psychomachia of Prudentius: Text, Commentary, and Glossary.* Edited by Aaron Pelttari. Oklahoma Series in Classical Culture 58. Norman: University of Oklahoma Press, 2019. Translated by H. J. Thomson in *Prudentius,* vol. 1 (Cambridge, MA: Harvard University Press, 1949).

Sidney, Sir Phillip. *Defence of Poesy.* Edited by Gavin Alexander. New York: Penguin, 2004.

Sir Gawain and the Green Knight. In *The Poems of the Pearl Manuscript: Pearl Cleanness, Patience, Sir Gawain and the Green Knight.* Edited by Malcolm Andrew and Ronald Waldron. Exeter Medieval Texts and Studies. Exeter: University of Exeter Press, 2008.

Storms, Gottfried. *Anglo-Saxon Magic.* The Hague: Martinus Nijhoff, 1948.

Symphosius. *Aenigmata.* Edited by Fr. Glorie. Corpus Christianorum, Series Latina 133A. Turnhout: Brepols, 1968. Translated by T. J. Leary as *Symphosius,* The Aenigmata: *An Introduction, Text and Commentary* (London: Bloomsbury, 2014).

Tacitus. *Agricola and Germania.* Translated by H. Mattingly, revised by S. A. Handford. New York: Penguin, 1970.

The Vercelli Book. Anglo-Saxon Poetic Records II. Edited by George Philip Krapp. New York: Columbia University Press, 1932.

Vercelli Homilies. Edited by Donald Scragg. Early English Text Society, Original Series 300. Oxford: Oxford University Press, 1992.

Virgil. *Aeneid.* Edited by J. W. Mackail. Oxford: Clarendon, 1930. Translated by David West as *The Aeneid* (New York: Penguin, 1991).

Virgilius Maro Grammaticus. *Virgilius Maro Grammaticus Opera Omnia.*

Edited by B. Löfstedt. Munich: K. G. Saur, 2003. Edited and translated by Vivien Law in *Wisdom, Authority, and Grammar in the Seventh Century: Decoding Virgilius Maro Grammaticus* (Cambridge: Cambridge University Press, 1995).

William of Malmesbury. *Gesta pontificum Anglorum*. Vol. 1: *Text and Translation*. Edited and translated by Michael Winterbottom. Oxford: Oxford University Press, 2007.

Williams, William Carlos. *Collected Poems*. 2 vols. Edited by A. Walton Litz and Christopher MacGowan. New York: New Directions, 1986.

Manuscript Sources

Bernward Gospels of Hildesheim. Hildesheim, Dom- und Diözesanmuseum, Domschatz 18.

Blickling Homilies. Scheide Library, Princeton University MS 71.

Book of Durrow. Trinity College Dublin MS 57.

Book of Kells. Trinity College Dublin MS 58.

British Library, MS Add. 23211.

British Library, MS Add. 40165 A.2.

British Library, Cotton MS Caligula A.vii.

British Library, Cotton MS Claudius B.iv.

British Library, Cotton MS Julius A.x.

British Library, Cotton MS Vitellius A.xv, "The *Beowulf* Manuscript."

British Library, Cotton MS Vitellius D.vii.

British Library, Harley MS 3271.

Cambridge, Corpus Christi College MS 41, "The Parker Bede," Parker Library on the Web.

Cambridge, Corpus Christi College MS 422, "The Red Book of Darley," Parker Library on the Web.

Cambridge, Corpus Christi College MS 196, Parker Library on the Web.

Cambridge, University Library MS Gg. 5.35.

Durham Cathedral Library MS A.IV.19, "The Durham Ritual."

Exeter Book. Exeter Cathedral Library MS 3501.

Harley Psalter. British Library, Harley MS 603.

Leofric Missal. Bodleian Library, MS Bodl. 579.

Lindisfarne Gospels. British Library, Cotton MS Nero D.IV.

Paris Bibliothèque nationale MS Fr. 574.

St. Gall Gospels. St. Gallen, Stiftsbibliothek, Cod. Sang. 51.

St. Paul Irish Codex. Unterdrauberg, Carinthia, Kloster St. Paul MS 25.2.31, "The Reichenau Primer."

Tiberius Psalter. British Library, Cotton MS Tiberius C.VI.

Utrecht Psalter. Utrecht, Universiteitsbibliotheek, MS Bibl. Rhenotraiectinae I NR 32.

Vercelli Book. Biblioteca Capitolare di Vercelli, MS CXVII.

SECONDARY WORKS

Ambrose, Kirk. "The Sense of Sight in the Book of Kells." *Notes in the History of Art* 27, no. 1 (2007): 1–9.

Amodio, Mark C. *Writing the Oral Tradition: Oral Poetics and Literate Culture in Medieval England.* Notre Dame, IN: University of Notre Dame Press, 2004.

Andrews, Tarren, and Tiffany Beechy, eds. *Indigenous Futures and Medieval Pasts.* Special issue. *English Language Notes* 58, no. 2 (2020).

Arthur, Ciaran. *'Charms,' Liturgies, and Secret Rites in Early Medieval England.* Anglo-Saxon Studies. Woodbridge: Boydell Press, 2018.

Auerbach, Erich. *Literary Language and Its Public in Late Latin Antiquity and in the Middle Ages.* Bollingen Series 74. Translated by Ralph Manheim. New York: Pantheon, 1965.

———. *Mimesis: The Representation of Reality in Western Literature.* Translated by Willard R. Trask. Princeton, NJ: Princeton University Press, 2003.

Bahr, Arthur. *Fragments and Assemblages.* Chicago: University of Chicago Press, 2013.

Bailey, Richard N., and Rosemary Cramp, with contributions by Raymond I. Page and David L. Schofield. *Corpus of Anglo-Saxon Stone Sculpture,* vol. 2, *Cumberland, Westmorland, and Lancashire North-of-the-Sands.* New York: Oxford University Press, 1984.

Baker, Peter. "Anglo-Saxon Studies after Charlottesville: Reflections of a University of Virginia Professor." *Medievalists of Color.* May 5, 2018. https://medievalistsofcolor.com/race-in-the-profession/anglo-saxon-studies-after-charlottesville-reflections-of-a-university-of-virginia-professor/.

Bakhtin, Mikhail M. *The Dialogic Imagination.* Translated by Caryl Emerson and Michael Holquist. Austin: University of Texas Press, 1981.

———. *Problems of Dostoyevski's Poetics.* Translated by Caryl Emerson. Minneapolis: University of Minnesota Press, 1984.

Bayless, Martha. "The Fuller Brooch and Anglo-Saxon Depictions of Dance." *Anglo-Saxon England* 45 (2016): 183–212.

———. *Parody in the Middle Ages: The Latin Tradition.* Recentiores: Later Latin Texts and Contexts. Ann Arbor: University of Michigan Press, 1996.

Bedingfield, M. Bradford. *The Dramatic Liturgy of Anglo-Saxon England.* Woodbridge: Boydell Press, 2002.

Beechy, Tiffany. "Consumption, Purgation, Poetry, Divinity: Incarnational Poetics and the Indo-European Tradition." *Modern Philology* 114, no. 2 (2016): 149–69.

———. "The 'Palmtwigede' Pater Noster Revisited: An Associative Network in Old English." *Neophilologus* 99, no. 2 (2015): 301–13.

———. *The Poetics of Old English.* London: Routledge, 2016.

———. "Wisdom and the Poetics of Laughter in the Old English Dialogues of Solomon and Saturn." *Journal of English and Germanic Philology* 116, no. 2 (2017): 131–55.

Bennett, Jane. *Vibrant Matter: A Political Ecology of Things.* Durham, NC: Duke University Press, 2010.

Best, Stephen, and Sharon Marcus. "Surface Reading: An Introduction." *Representations* 108 (Fall 2009): 1–21.

Billett, Jesse D. *The Divine Office in Anglo-Saxon England: 597–c. 1000.* Henry Bradshaw Society Subsidia 7. London: Boydell Press, 2014.

Bjork, Robert, ed. *The Cynewulf Reader.* Basic Readings in Anglo-Saxon England 4. London: Routledge, 2001.

Bolter, Jay David, and Richard Grusin. *Remediation: Understanding New Media.* Cambridge, MA: MIT Press, 2000.

Bosworth, Joseph, and T. Northcote Toller, eds. *An Anglo-Saxon Dictionary.* Oxford: Oxford University Press, 1980. Online at www.bosworthtoller.com.

Bredehoft, Thomas A. "Filling the Margins of CCCC 41: Textual Space and a Developing Archive." *Review of English Studies* 57, no. 232 (2006): 721–32.

Brendel, Otto. "Origin and Meaning of the Mandorla." *Gazette des Beaux Arts* 25 (1944): 5–24.

Brown, Bill. *A Sense of Things: The Object Matter of American Literature.* Chicago: University of Chicago Press, 2003.

———. *Things.* Chicago: University of Chicago Press, 2004.

———. "Thing Theory." *Critical Inquiry* 28 (2001): 1–22.

Brown, Michelle. "Bearded Sages and Beautiful Boys: Insular and Anglo-Saxon Attitudes to the Iconography of the Beard." In *Listen, O Isles, unto Me: Studies in Medieval Word and Image in Honour of Jennifer O'Reilly*, edited by E. Mullins and D. Scully, 278–90. Cork: University College Cork, 2011.

———. *Manuscripts from the Anglo-Saxon Age.* Toronto: University of Toronto Press, 2007.

Bruce-Mitford, R. L. S. "The Fuller Brooch." *The British Museum Quarterly* 17, no. 4 (1952): 75–76.

Budny, Mildred. *Insular, Anglo-Saxon, and Early Anglo-Norman Manuscript Art at Corpus Christi College, Cambridge: An Illustrated Catalogue.* Kalamazoo, MI: Medieval Institute, 1997.

Bynum, Caroline Walker. *Christian Materiality: An Essay on Religion in Late Medieval Europe.* New York: Zone Books, 2011.

———. *Dissimilar Similitudes: Devotional Objects in Late Medieval Europe.* New York: Zone Books, 2020.

———. *Jesus as Mother: Studies in the Spirituality of the High Middle Ages.* Berkeley: University of California Press, 1982.

———. *The Resurrection of the Body in Western Christianity, 200–1336.* New York: Columbia University Press, 1995.

Byrd, Jodi. *The Transit of Empire: Indigenous Critiques of Colonialism.* Minneapolis: University of Minnesota Press, 2011.

Carey, John. "Obscure Styles in Medieval Ireland." *Mediaevalia* 19 (1996): 23–39.

Carruthers, Mary. *The Experience of Beauty in the Middle Ages.* Oxford-Warburg Studies Series. Oxford: Oxford University Press, 2013.

Cassidy, Brendan, ed. *The Ruthwell Cross.* Index of Christian Art Occasional Papers 1. Princeton, NJ: Princeton University Press, 1992.

Cervone, Cristina Maria. *Poetics of the Incarnation: Middle English Writing and the Leap of Love.* Philadelphia: University of Pennsylvania Press, 2012.

Chaganti, Seeta. *The Medieval Poetics of the Reliquary: Enshrinement, Inscription, Performance.* Basingstoke: Palgrave Macmillan, 2008.

Chang, Cornelius. "Body of Bliss: Radiant Holiness in Eastern Pre-Christian Sources and the Mandorla Motif in Art along the Silk Road to Byzantium." *Knotenpunkt Byzanz: Wissensformen und kulturelle Wechselbeziehungen* 36 (2012): 819–46.

Chazelle, Celia. "Figure, Character, and the Glorified Body in the Carolingian Eucharistic Controversy." *Traditio* 47 (1992): 1–36.

Clayton, Mary. *The Cult of the Virgin Mary in Anglo-Saxon England.* Cambridge Studies in Anglo-Saxon England 2. Cambridge: Cambridge University Press, 1990.

———. "Delivering the Damned: A Motif in Old English Homiletic Prose." *Medium Ævum* 55 (1986): 92–102.

Colish, Marcia L. *The Mirror of Language: A Study in the Medieval Theory of Knowledge.* Rev. ed. Lincoln: University of Nebraska Press, 1983.

Davis, Kathleen. *Periodization and Sovereignty: How Ideas of Feudalism and Secularization Govern the Politics of Time.* Philadelphia: University of Pennsylvania Press, 2007.

———. "Periodization and the Matter of Precedent." *Postmedieval: A Journal of Medieval Cultural Studies* 1, no. 3 (2010): 354–60.

DeGregorio, Scott. "The Venerable Bede and Gregory the Great: Exegetical Connections, Spiritual Departures." *Early Medieval Europe* 18 (2010): 43–60.

Deleuze, Gilles. *The Fold: Leibniz and the Baroque.* Translated by Tom Conley. Minneapolis: University of Minnesota Press, 1993.

Deleuze, Gilles, and Félix Guattari. *A Thousand Plateaus: Capitalism and Schizophrenia.* Translated by Brian Massumi. Minneapolis: University of Minnesota Press, 1987.

Demacopulous, George. "Gregory the Great and the Pagan Shrines of Kent." *Journal of Late Antiquity* 1, no. 2 (2008): 353–69.

Derrida, Jacques. *Of Grammatology.* Translated by Gayatri Chakravorty Spivak. Baltimore: Johns Hopkins University Press, 1998.

Dictionary of Old English. University of Toronto. https://tapor.library.uto ronto.ca/doe/.

Dictionary of Old English Web Corpus. University of Toronto. https://tapor. library.utoronto.ca/doecorpus/.

Dinshaw, Carolyn. "Eunuch Hermeneutics." *English Literary History* 55, no. 1 (1988): 27–51.

Dockray-Miller, Mary. "Old English Has a Serious Image Problem." *JSTOR Daily,* May 3, 2017. https://daily.jstor.org/old-english-serious-image-prob lem/.

Dumitrescu, Irina A. "Bede's Liberation Philology: Releasing the English Tongue." *PMLA* 128, no. 1 (January 2013): 40–56.

Eco, Umberto. *Art and Beauty in the Middle Ages.* Translated by Hugh Bredin. New Haven, CT: Yale University Press, 2002.

———. Preface to *The Book of Kells.* Simbach am Inn: Faksimile Verlag, 1990.

Ellard, Donna Beth. *AngloSaxon(ist) Pasts, postSaxon Futures.* Goleta, CA: Punctum Books, 2019.

Endres, William. "Rhetorical Invention in the Book of Kells: Image and Decoration on their Flight to Meaning." Ph.D. diss., Arizona State University, 2008.

Ernst, Ulrich. *Carmen Figuratum: Geschichte des Figurengedichts von den antiken Ursprüngen bis zum Ausgang des Mittelalters.* Cologne: Böhlau, 1991.

Farr, Carol. *The Book of Kells: Its Function and Audience.* British Library Studies in Medieval Culture 4. Toronto: University of Toronto Press, 1998.

Fleming, Robin. *Britain after Rome: The Fall and Rise, 400–1070.* London: Penguin, 2011.

Foley, John Miles. *Immanent Art: From Structure to Meaning in Traditional Oral Epic.* Bloomington: Indiana University Press, 1991.

Frantzen, Allen. "Bede and Bawdy Bale: Gregory the Great, Angels, and the 'Angli.'" In *Anglo-Saxonism and the Construction of Social Identity,* edited by Allen J. Frantzen and John D. Niles, 17–39. Gainesville: University Press of Florida, 1997.

———. *Desire for Origins: New Languages, Old English, and Teaching the Tradition.* New Brunswick, NJ: Rutgers University Press, 1990.

Gameson, Richard. *The Scribe Speaks? Colophons in Early English Manuscripts.* H. M. Chadwick Memorial Lectures 12. Cambridge: Cambridge University Press, 2002.

Garner, Lori Ann. *Hybrid Healing: Old English Remedies and Medical Texts.* Manchester: Manchester University Press, 2022.

Garnett, George. *The Norman Conquest: A Very Short Introduction.* Oxford: Oxford University Press, 2009.

Gayk, Shannon. "'To wonder upon this thyng': Chaucer's *Prioress's Tale.*" *Exemplaria* 22, no. 2 (2010): 138–56.

Geertz, Clifford. "Thick Description: Toward an Interpretive Theory of Culture." *Interpretation of Cultures.* New York: Perseus, 1973.

Grant, Raymond. *Cambridge, Corpus Christi College 41: The Loricas and the Missal.* Costerus: Essays in English and American Language and Literature, New Series 17. Amsterdam: Rodopi, 1978.

———. *Three Homilies from Cambridge, Corpus Christi College 41*: The Assumption, St. Michael, and the Passion. Ottawa: Tecumseh Press, 1982.

Greenblatt, Stephen. *The Swerve: How the World Became Modern.* New York: W. W. Norton, 2012.

Gruenler, Curtis A. Piers Plowman *and the Poetics of Enigma: Riddles, Rhetoric, and Theology.* Notre Dame, IN: University of Notre Dame Press, 2017.

Hall, Alaric. *Elves in Anglo-Saxon England: Matters of Belief, Health, Gender, and Identity.* Anglo-Saxon Studies 8. Cambridge: Boydell & Brewer, 2007.

Hall, Thomas N. "The Psychedelic Transmogrification of the Soul in Vercelli Homily IV." In *Time and Eternity: The Medieval Discourse*, edited by Gerhard Jaritz and Gerson Moreno-Riaño, 309–22. Turnhout: Brepols, 2003.

Hansen, Elaine Tuttle. *The Solomon Complex: Reading Wisdom in Old English Poetry.* Toronto: University of Toronto Press, 1988.

Harris, Joseph, and Karl Reichl, eds. *Prosimetrum: Crosscultural Perspectives on Narrative in Prose and Verse.* Cambridge: D. S. Brewer, 1997.

Harris, Stephen. *Race and Ethnicity in Anglo-Saxon Literature.* Studies in Medieval History and Culture 24. London: Routledge, 2003.

Hawk, Brandon W. *Preaching Apocrypha in Anglo-Saxon England.* Toronto Anglo-Saxon Series. Toronto: University of Toronto Press, 2018.

Healey, Antonette Di Paolo, ed. *The Old English Vision of St. Paul.* Speculum Anniversary Monographs 2. Cambridge, MA: Medieval Academy of America, 1978.

Henry, Françoise. *Book of Kells*. London: Thames and Hudson, 1974. Repr. Knopf, 1977.

Herren, Michael, ed. and tr. *The Cosmography of Aethicus Ister: Edition, Translation, and Commentary*. Publications of the Journal of Medieval Latin 8. Turnhout: Brepols, 2011.

———. "Hisperic Latin: Luxuriant Culture-Fungus of Decay." *Traditio* 30 (1974): 411–19.

———. *The Hisperica Famina*. Vol. 1. Pontifical Institute of Mediaeval Studies 31. Toronto: Pontifical Institute, 1974.

———. *The Hisperica Famina II: Related Poems*. Pontifical Institute of Mediaeval Studies 85. Toronto: Pontifical Institute, 1987.

———. "Some New Light on the Life of Virgilius Maro Grammaticus." *Proceedings of the Royal Irish Academy* 79C (1979): 27–71.

Hill, John M., ed. *On the Aesthetics of* Beowulf *and Other Old English Poems*. Toronto: University of Toronto Press, 2010.

Hohler, Christopher. Review of Raymond Grant, *Cambridge, Corpus Christi College 41: The Loricas and the Missal*. *Medium Aevum* 49, no. 3 (1980): 275–78.

Hollis, Stephanie. "Old English 'Cattle Theft Charms': Manuscript Contexts and Social Uses." *Anglia* 115 (1997): 139–64.

Hollywood, Amy. "That Glorious Slit: Irigaray and the Medieval Devotion to Christ's Side Wound." In *Luce Irigaray and Premodern Culture: Thresholds of History*, edited by Theresa Krier and Elizabeth D. Harvey, 105–25. Routledge Studies in Renaissance Literature and Culture 4. London: Routledge, 2004.

Howlett, David. "Inscriptions and Design of the Ruthwell Cross." In *The Ruthwell Cross*, edited by Brendan Cassidy, 71–93. Index of Christian Art Occasional Papers 1. Princeton, NJ: Princeton University Press, 1992.

Irigaray, Luce. *Sexes and Genealogies*. Translated by Gillian Gill. New York: Columbia University Press, 1993.

Irvine, Martin. *The Making of Textual Culture: "Grammatica" and Literary Theory, 350–1100*. Cambridge: Cambridge University Press, 1994.

Jakobson, Roman. *Language in Literature*. Cambridge, MA: Belknap, 1990.

James, M. R. *A Descriptive Catalogue of the Manuscripts in the Library of Corpus Christi College, Cambridge*. Cambridge: Cambridge University Press, 1912.

Johnson, Eleanor. *Practicing Literary Theory in the Middle Ages: Ethics and the Mixed Form in Chaucer, Gower, Usk, and Hoccleve*. Chicago: University of Chicago Press, 2013.

———. *Staging Contemplation: Participatory Theology in Middle English Prose, Verse, and Drama*. Chicago: University of Chicago Press, 2018.

Johnson, Richard. "Archangel in the Margins: St. Michael in the Homilies of Cambridge, Corpus Christi College 41." *Traditio* 53 (1998): 63–91.

Johnston, Michael, and Michael Van Dussen, eds. *The Medieval Manuscript Book: Cultural Approaches.* Cambridge Studies in Medieval Literature. Cambridge: Cambridge University Press, 2017.

Jolly, Karen Louise. "On the Margins of Orthodoxy: Devotional Formulas and Protective Prayers in Cambridge, Corpus Christi College MS 41." In *Signs on the Edge: Space, Text, and Margin in Medieval Manuscripts,* edited by Sarah Larratt Keefer and Rolf H. Bremmer Jr., 135–83. Mediaevalia Groningana New Series 10. Leuven: Peeters, 2007.

———. *Popular Religion in Late Saxon England: Elf Charms in Context.* Chapel Hill: University of North Carolina Press, 1996.

Jones, Christopher A. "The Book of the Liturgy in Anglo-Saxon England." *Speculum* 73, no. 3 (1998): 659–72.

Jost, Karl. Review of Godfrid Storms, *Anglo-Saxon Magic. English Studies* 31 (1950): 101–5.

Jurasinski, Stefan, Lisi Oliver, and Andrew Rabin, eds. *English Law Before Magna Carta: Felix Liebermann and* Die Gesetze Der Angelsachsen. Medieval Law and Its Practice 8. Leiden: Brill, 2010.

Kabir, Ananya Jahanara, and Deanne Williams, eds. *Postcolonial Approaches to the European Middle Ages: Translating Cultures.* Cambridge: Cambridge University Press, 2005.

Karkov, Catherine E. *Imagining Anglo-Saxon England: Utopia, Heterotopia, Dystopia.* Woodbridge: Boydell Press, 2020.

———. "Post 'Anglo-Saxon' Melancholia." *Medium,* December 10, 2019, https://medium.com/@catherinekarkov/post-anglo-saxon-melancholia -ca73955717d3.

———. "Postcolonial." In *A Handbook for Anglo-Saxon Studies,* edited by Jacqueline Stodnick and Renée Trilling, 149–64. Oxford: Wiley Blackwell, 2012.

———. "Text and Image in the Red Book of Darley." In *Text, Image, Interpretation: Studies in Anglo-Saxon Literature and its Insular Context in Honour of Éamonn Ó Carragáin,* edited by Alastair Minnis and Jane Roberts, 135–48. Turnhout: Brepols, 2007.

Karkov, Catherine E., and George Hardin Brown, eds. *Anglo-Saxon Styles.* SUNY Series in Medieval Studies. Albany: State University of New York Press, 2003.

Karkov, Catherine E., Robert T. Farrell, and Michael Ryan, eds. *The Insular Tradition.* SUNY Series in Medieval Studies. Albany: State University of New York Press, 1997.

Keefer, Sarah Larratt. "Margin as Archive: The Liturgical Marginalia of a Manuscript of the Old English Bede." *Traditio* 51 (1996): 147–77.

————. "Use of Manuscript Space for Design, Text and Image in Liturgical Books Owned by the Community of St. Cuthbert." In *Signs on the Edge: Space, Text, and Margin in Medieval Manuscripts*, edited by Sarah Larratt Keefer and Rolf H. Bremmer Jr., 85–115. Medieaevalia Groningana New Series 10. Leuven: Peeters, 2007.

Kelhoffer, James A. "John the Baptist's 'Wild Honey' and 'Honey' in Antiquity." *Greek, Roman, and Byzantine Studies* 45, no. 1 (2005): 59–73.

Ker, N. R. *Catalogue of Manuscripts Containing Anglo-Saxon*. Oxford: Clarendon Press, 1957.

Kim, Dorothy, ed. *Critical Race and the Middle Ages*. Special Issue. *Literature Compass* 16, nos. 9–10 (2019).

————. "The Question of Race in *Beowulf*." *JSTOR Daily*. September 25, 2019. https://daily.jstor.org/the-question-of-race-in-beowulf/.

Kimmerer, Robin Wall. *Braiding Sweetgrass: Indigenous Wisdom, Scientific Knowledge, and the Teachings of Plants*. Minneapolis: Milkweed Editions, 2013.

Knapp, Peggy. *Chaucerian Aesthetics*. London: Palgrave, 2008.

Kramer, Johanna. *Between Earth and Heaven: Liminality and the Ascension of Christ in Anglo-Saxon Literature*. Manchester: Manchester University Press, 2014.

Lapidge, Michael. "The Career of Aldhelm." *Anglo-Saxon England* 36 (2007): 15–69.

————. "The School of Theodore and Hadrian." *Anglo-Saxon England* 15 (1986): 45–72.

Laugerud, Henning, Salvador Ryan, and Laura Katrine Skinnebach, eds. *The Materiality of Devotion in Late Medieval Northern Europe: Images, Objects, and Practices*. Dublin: Four Courts, 2016.

Law, Vivien. *Wisdom, Authority, and Grammar in the Seventh Century: Decoding Virgilius Maro Grammaticus*. Cambridge: Cambridge University Press, 1995.

Lee, Christina. "Threads and Needles: The Use of Textiles for Medical Purposes." In *Textiles, Text, Intertext: Essays in Honour of Gale R. Owen-Crocker*, Edited by Maren Clegg Hyer and Jill Frederick, 103–18. Woodbridge: Boydell, 2016.

Lees, Clare A., ed. *The Cambridge History of Early Medieval English Literature*. Cambridge: Cambridge University Press, 2013.

Leet, Elizabeth S., ed. *Contact Zones: Fur, Minerals, Milk, and Other Things. Postmedieval: A Journal of Medieval Cultural Studies* 11, no. 1 (2020).

Levinson, Marjorie. "What is New Formalism?" *PMLA* 122, no. 2 (2007): 558–69.

Levy, Ian Christopher, Gary Macy, and Kristen Van Ausdall, eds. *A Companion to the Eucharist in the Middle Ages*. Leiden: Brill, 2012.

Lewis, Charlton T., and Charles Short. *A Latin Dictionary*. Oxford: Clarendon, 1879. Perseus Digital Library. https://www.perseus.tufts.edu.

Lewis, Suzanne. "Sacred Calligraphy: The Chi Rho Page in the Book of Kells." *Traditio* 36 (1980): 139–59.

Livingstone, Josephine. "Racism, Medievalism, and the White Supremacists of Charlottesville." *The New Republic.* August 15, 2017. https://newrepublic.com/article/144320/racism-medievalism-white-supremacists-charlottesville.

Lochrie, Karma. "Mystical Acts, Queer Tendencies." In *Constructing Medieval Sexuality*, edited by Karma Lochrie, Peggy McCracken, and James A. Schultz, 180–200. Minneapolis: University of Minnesota Press, 1997.

Lockett, Leslie. *Anglo-Saxon Psychologies in the Vernacular and Latin Traditions*. Toronto: University of Toronto Press, 2011.

Loesberg, Jonathan. *A Return to Aesthetics: Autonomy, Indifference, and Postmodernism*. Redwood City, CA: Stanford University Press, 2005.

Lord, Albert B. *The Singer of Tales*. Cambridge, MA: Harvard University Press, 2000.

Love, Heather. "Close Reading and Thin Description." *Public Culture* 25, no. 3 (2013): 401–34.

Marchesi, Simone. *Dante and Augustine: Linguistics, Poetics, Hermeneutics*. Toronto: University of Toronto Press, 2011.

Maring, Heather. *Signs That Sing: Hybrid Poetics in Old English Verse*. Gainesville: University Press of Florida, 2017.

McWhorter, John. *Our Magnificent Bastard Tongue: The Untold History of English*. New York: Avery, 2009.

Meehan, Bernard. *The Book of Kells: An Illustrated Introduction to the Manuscript in Trinity College Dublin.* London: Thames and Hudson, 1994.

Meyvaert, Paul. "Bede and Gregory the Great." Jarrow Lecture, 1964. Jarrow on Tyne: H. Saxby, 1964. Reprinted in *Bede and His World: The Jarrow Lectures*. Edited by Michael Lapidge. Aldershot: Variorum Press, 1994.

Miyashiro, Adam. "Decolonizing Anglo-Saxon Studies: A Response to ISAS in Honolulu." *In the Middle*, July 29, 2017, http://www.inthemedievalmiddle.com/2017/07/decolonizing-anglo-saxon-studies.html.

———. "Our Deeper Past: Race, Settler Colonialism, and Medieval Heritage Politics." *Literature Compass* 16, nos. 9–10 (2019).

Momma, Haruko. *From Philology to English Studies: Language and Culture in the Nineteenth Century*. Cambridge: Cambridge University Press, 2012.

Mulligan, Amy. "'The Satire of the Poet is a Pregnancy': Pregnant Poets, Body Metaphors, and Cultural Production in Medieval Ireland." *Journal of English and Germanic Philology* 108 (2009): 481–505.

Nagy, Joseph Falaky. "Close Encounters of the Traditional Kind in Medieval Irish Literature." In *Celtic Folklore and Christianity: Studies in Memory of*

William W. Heist, edited by Patrick K. Ford, 129–49. Santa Barbara, CA: McNally and Loftin, 1983.

———. *Conversing with Angels and Ancients: Literary Myths of Medieval Ireland.* Ithaca, NY: Cornell University Press, 1997.

Nichols, Stephen G., and Siegfried Wenzel, eds. *The Whole Book: Cultural Perspectives on the Medieval Miscellany.* Recentiores: Later Latin Texts and Contexts. Ann Arbor: University of Michigan Press, 1996.

Niles, John D. *God's Exiles and English Verse: On the Exeter Anthology of Old English Poetry.* Exeter: University of Exeter Press, 2019.

———. *The Idea of Anglo-Saxon England, 1066–1901: Remembering, Forgetting, Deciphering, and Renewing the Past.* Wiley Blackwell Manifestos. Chichester: Wiley Blackwell, 2015.

Noble, Thomas F. X. *Images, Iconoclasm, and the Carolingians.* The Middle Ages Series. Philadelphia: University of Pennsylvania Press, 2009.

Nolan, Maura. "Making the Aesthetic Turn: Adorno, the Medieval, and the Future of the Past." *Journal of Medieval and Early Modern Studies* 34, no. 3 (2004): 549–75.

O'Camb, Brian. "Bishop Æthelwold and the Shaping of the Old English *Exeter Maxims.*" *English Studies* 90, no. 3 (2009): 253–73.

———. "*Exeter Maxims, The Order of the World*, and The Exeter Book of Old English Poetry." *Philological Quarterly* 93, no. 4 (2014): 409–33.

———. "The Proverbs of Solomon and the Wisdom of Women in the Old English *Exeter Maxims.*" *Review of English Studies* 64, no. 267 (2013): 733–51.

———. "Toward a Monastic Poetics: *Exeter Maxims* and the Exeter Book of Old English Poetry." Ph.D. diss., University of Wisconsin–Madison, 2009.

O'Connor, Patricia. "'Sitte Ge Sigewif, Sigað to Eorðe': Settling the Anglo-Saxon *Bee Charm* within Its Christian Manuscript Context." *Incantatio* 7 (2018): 46–71.

O'Keeffe, Katherine O'Brien. *Stealing Obedience: Narratives of Identity and Agency in Later Anglo-Saxon England.* Toronto Anglo-Saxon Series. Toronto: University of Toronto Press, 2012.

———. *Visible Song: Transitional Literacy in Old English Verse.* Cambridge Studies in Anglo-Saxon England 4. Cambridge: Cambridge University Press, 2006.

Oliver, Lisi. *The Beginnings of English Law.* Buffalo: University of Toronto Press, 2002.

O'Loughlin, Thomas. *Adomnán and the Holy Places: The Perceptions of an Insular Monk on the Locations of the Biblical Drama.* New York: T&T Clark, 2007.

Olsen, Karin. "Thematic Affinities between the Non-Liturgical Marginalia and the *Old English Bede* in Cambridge, Corpus Christi College 41." In

Practice in Learning: The Transfer of Encyclopaedic Knowledge in the Early Middle Ages, edited by Rolf H. Bremmer Jr. and Kees Dekker, 133–45. Walpole, MA: Peeters, 2010.

Page, R. I. "The Bewcastle Cross." *Nottingham Medieval Studies* 4 (1960): 36–57.

Pasternack, Carol Braun. *The Textuality of Old English Poetry.* Cambridge: Cambridge University Press, 1995.

Paz, James. *Nonhuman Voices in Anglo-Saxon Literature and Material Culture.* Manchester: Manchester University Press, 2017.

Pfaff, Richard W. *The Liturgy in Medieval England: A History.* Cambridge: Cambridge University Press, 2009.

Pratt, Mary Louise. "Arts of the Contact Zone." *Profession* (1991): 33–40.

Pulliam, Heather. *Word and Image in the Book of Kells.* Dublin: Four Courts, 2006.

Rambaran-Olm, Mary. "Anglo-Saxon Studies [Early English Studies], Academia and White Supremacy." *Medium*, June 27, 2018, https://medium.com /@mrambaranolm/anglo-saxon-studies-academia-and-white-supremacy -17c87b360bf3.

———. John the Baptist's Prayer *or* The Descent into Hell *from the Exeter Book: Text, Translation and Critical Study.* Anglo-Saxon Studies 21. Cambridge: D. S. Brewer, 2015.

Ramey, Peter. "The Riddle of Beauty: The Aesthetics of *Wrætlic* in Old English Verse." *Modern Philology* 114, no. 3 (2017): 457–81.

Rauer, Christine, ed. and tr. *Old English Martyrology: Edition, Translation, and Commentary.* Anglo-Saxon Texts 10. Cambridge: Boydell and Brewer, 2013.

Raw, Barbara. *Trinity and Incarnation in Anglo-Saxon Art and Thought.* Cambridge: Cambridge University Press, 1997.

Raybin, David, and Susanna Fein, eds. *Chaucer and Aesthetics.* Special issue. *The Chaucer Review* 39, no. 3 (2005).

Remein, Daniel. "ISAS Should Probably Change its Name." 2017. Blog post. https://www.academia.edu/34101681/_Isas_should_probably_change_its _name_ICMS_Kalamazoo_2017.

Robertson, D. W., Jr. "Historical Criticism." In *English Institute Essays: 1950*, edited by Alan S. Downer, 3–31. New York: Columbia University Press, 1951.

———. *A Preface to Chaucer: Studies in Medieval Perspectives.* Princeton, NJ: Princeton University Press, 1962.

Robertson, Kellie. "Medieval Materialism: A Manifesto." *Exemplaria* 22, no. 2 (2010): 99–118.

Robinson, Fred C. "Bede's Envoi to the Old English *History*: An Experiment in Editing." *Studies in Philology* 78, no. 5 (1981): 4–19.

———. Beowulf *and the Appositive Style.* Knoxville: University of Tennessee Press, 2014.

Rowley, Sharon M. *The Old English Version of Bede's* Historia Ecclesiastica. Anglo-Saxon Studies 16. Cambridge: D. S. Brewer, 2011.

Rubin, David C. *Memory in Oral Cultures: The Cognitive Psychology of Epic, Ballads, and Counting-out Rhymes.* New York: Oxford University Press, 1995.

Saltzman, Benjamin A. "*Vt hkskdkxt*: Early Medieval Cryptography, Textual Errors, and Scribal Agency." *Speculum* 93, no. 4 (2018): 975–1009.

Saussure, Ferdinand de. *Course in General Linguistics.* Translated by Roy Harris. Chicago: Open Court, 1986.

Schapiro, Meyer. "The Image of the Disappearing Christ: The Ascension in English Art around the Year 1000." *Gazette des Beaux Arts* 6, no. 23 (1943): 133–52.

———. *The Language of Forms: Lectures on Insular Manuscript Art.* New York: Pierpont Morgan Library, 2005.

Schuessler, Jennifer. "Medieval Scholars Joust with White Nationalists. And One Another." *New York Times,* May 5, 2019, https://www.nytimes.com /2019/05/05/arts/the-battle-for-medieval-studies-white-supremacy.html.

Sidney, Philip. *Sidney's "The Defence of Poesy" and Selected Renaissance Literary Criticism.* Edited by Gavin Alexander. New York: Penguin, 2004.

Sims-Williams, Patrick. *Irish Influence on Medieval Welsh Literature.* Oxford: Oxford University Press, 2011.

Smith, Linda Tuhiwai. *Decolonizing Methodologies: Research and Indigenous Peoples.* London: Zed Books, 1999.

Stokes, Peter. *English Vernacular Minuscule from Æthelred to Cnut, circa 990–circa 1035.* Cambridge: D. S. Brewer, 2014.

Sullivan, Edward. *The Book of Kells.* London: "The Studio," 1927.

Symes, Carol. "Doing Things beside Domesday Book." *Speculum* 93, no. 4 (2018): 1048–1101.

Tamoto, Kenichi, ed. *The Macregol Gospels* or *The Rushworth Gospels.* Amsterdam: John Benjamins, 2013.

Thornbury, Emily V. "Aldhelm's Rejection of the Muses and the Mechanics of Poetic Inspiration in Early Anglo-Saxon England." *Anglo-Saxon England* 36 (2007): 71–92.

Tilghman, Ben C. "The Shape of the Word: Extralinguistic Meaning in Insular Display Lettering." *Word & Image* 27, no. 3 (2011): 292–308.

Todd, Zoe. "An Indigenous Feminist's Take on the Ontological Turn: 'Ontology' Is Just Another Word for Colonialism." *Journal of Historical Sociology* 29, no. 1 (2016): 4–22.

Tolkien, J. R. R. "*Beowulf*: The Monsters and the Critics." *Proceedings of the British Academy* 22 (1936): 245–95. Reprinted in *Beowulf: A Verse Trans-*

lation, translated by Seamus Heaney and edited by Daniel Donoghue, 103–30. New York: W. W. Norton, 2002.

Toner, Gregory. "Messe ocus Pangur Bán: Structure and Cosmology." *Cambrian Medieval Celtic Studies* 57 (2009): 1–22.

Treharne, Elaine. *Living through Conquest: The Politics of Early English, 1020–1220.* Oxford: Oxford University Press, 2012.

Trilling, Renée. *The Aesthetics of Nostalgia: Historical Representation in Old English Verse.* Toronto: University of Toronto Press, 2009.

———. "From Metaphors to Metaphysics: Exploring Anglo-Saxon Materialisms." *Exemplaria* 31, no. 3 (2019): 235–44.

Tyler, Elizabeth. *Old English Poetics: The Aesthetics of the Familiar in Anglo-Saxon England.* York: York Medieval Press, 2006.

Volmering, Nicole. "The Old English Account of the Seven Heavens." In *The End and Beyond: Medieval Irish Eschatology*, edited by John Carey, Emma Nic Cárthaigh, and Caitríona Ó Dochartaigh, 285–306. Aberystwyth: Celtic Studies, 2014.

Wade, Erik. "Language, Letters, and Augustinian Origins in the Old English Poetic *Solomon and Saturn I.*" *Journal of English and Germanic Philology* 117, no. 2 (2018): 160–84.

Watkins, Calvert, ed. *The American Heritage Dictionary of Indo-European Roots.* New York: Houghton Mifflin, 2000.

Weaver, Erica. "Premodern and Postcritical: Medieval Enigmata and the Hermeneutic Style." *New Literary History* 50, no. 1 (2019): 43–64.

Webster, Leslie. "The Iconographic Programme of the Franks Casket." In *Northumbria's Golden Age*, edited by Jane Hawkes and Susan Mills, 227–46. Stroud: Sutton, 1999.

Wenzel, Siegfried. *The Sin of Sloth: Acedia in Medieval Thought and Literature.* Chapel Hill: University of North Carolina Press, 1967.

Wilton, David. "What Do We Mean by *Anglo-Saxon*?: Pre-Conquest to the Present." *JEGP* 119, no. 4 (2020): 425–56.

Wood, Ian. "The Mission of Augustine of Canterbury to the English." *Speculum* 69, no. 1 (1994): 1–17.

Wright, Charles D. "From Monks' Jokes to Sages' Wisdom: The *Joca Monachorum* Tradition and the Irish *Immacallam in dá Thúarad*." In *Spoken and Written Language: Relations between Latin and the Vernacular Languages in the Earlier Middle Ages*, edited by M. G. Garrison, M. Mostert, and A. P. Orban, 199–225. Turnhout: Brepols, 2013.

———. *The Irish Tradition in Old English Literature.* Cambridge: Cambridge University Press, 1993.

Young, Helen. "Whiteness and Time: The Once, Present, and Future Race." In *Studies in Medievalism XXIV: Medievalism on the Margins*, edited by

Karl Fugelso, Vincent Ferré, and Alicia C. Montoya, 39–49. Cambridge: D. S. Brewer, 2015.

Zacher, Samantha. *Preaching the Converted: The Style and Rhetoric of the Vercelli Book Homilies.* Toronto: University of Toronto Press, 2009.

Ziolkowski, Jan, ed. and tr. *Solomon and Marcolf.* Cambridge, MA: Harvard University Press, 2008.

INDEX